AN ENDURING IMAGE

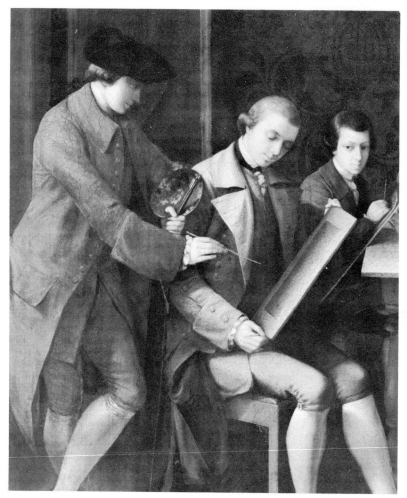

Detail from *The American Academy* by Matthew Pratt.
Courtesy of the Metropolitan Museum of Art, gift of Samuel P.
Avery, 1897.

AN ENDURING IMAGE

AMERICAN PAINTING FROM 1665

By Lillian Freedgood

ILLUSTRATED

THOMAS Y. CROWELL COMPANY
NEW YORK

Designed by Klaus Gemming

Manufactured in the United States of America

L. C. Card 71-101928

ISBN 0-690-26619-7

1 2 3 4 5 6 7 8 9 10

To Morton and Laura

Foreword

IN ORDER to understand the story of American painting, one must try to see the artist in the perspective of the times in which he lived. Although the artist has always been regarded as a member of a caste apart, and, in fact, frequently worked outside the mainstream of American life, he was and is very much a creature of his time.

Like all other Americans he has been party to the particular prejudices, taboos, tastes, fashions, and social, economic, and moral pressures of his day. And this has been as true of the artist who defied contemporary conventions as of the artist who conformed to them.

Men like Albert Bierstadt and Frederick E. Church won fame and fortune, not because they were exceptionally gifted, but because they were in perfect harmony with their age. They painted their huge panoramas of America's natural wonders when the West was being opened and the United States was embarked on a policy of vast territorial expansion. Americans were proudly conscious of their destiny, and the paintings of Bierstadt and Church gave vivid representation to their dreams. By the same token, Thomas Eakins, who would in time be recognized as one of America's greatest artists, was doomed to failure because in the pursuit of his vision he chose to swim against the prevailing currents of his day. Yet Eakins the rebel, if we are to judge him, must be seen as no less a product of his times than Bierstadt and Church were of theirs.

Throughout the book I have taken pains to indicate where the United States stood historically, what great and small events were taking place, what trends and traditions existed while a given artist was alive and painting, so that the reader may better understand the man in relation to his times, and thus gain a better understanding of his work.

Contents

Illustrations

AN ENDURING IMAGE

I The Beginnings

IN 1492, when Columbus, hoping to find a new trade route to the Indies, discovered America instead, European painting had already touched sublime heights. The Italian Renaissance, that era of unparalleled artistic genius, was in full swing. Flanders, Germany, and the Netherlands could exult in the imperishable talents of their artists. And before the *Mayflower* beached on Plymouth's rocky shores, Spain, too, had added new names to the roster of immortals. But these were countries that had been climbing toward the refinements of civilization for centuries.

Thus, much more than an ocean divided the Old World from the New. America was a wilderness, inhabited by primitive peoples called Indians (the explorers thought they were "natives of the Indies" and so named them Indians). What art the Indian practiced was almost entirely decorative—brightly colored designs applied on tepees, clothing, rugs, baskets, and other articles of use. In certain of their religious ceremonies the Navaho tribes used a type of pictorial incantation, called sand painting. They "painted" their pictures by sifting colored sand onto the ground, composing the sand into definite shapes and patterns. But the picture had to be wiped away at once to insure the effectiveness of the "spell." It was in the Navahos' method of "painting" that Jackson Pollock, the leader of twentieth-century abstract expressionism, found inspiration for his revolutionary "drip" technique. However, Pollock was an exception. In general, the Indian left no mark and had no influence on the course of American art.

Approximately a quarter century elapsed between 1620, when the English established a solid foothold in the New World, and the beginnings of what we now accept as American art. A new land must be tamed for living before its people can

find the time, the energy, and the interest for such luxuries as art. The most urgent task was to carve a home out of the wilderness. It was to be well over two centuries after Columbus' landfall and over a century after the Pilgrims landed at Plymouth before America could boast of a painter of genuine stature. Yet in the flow of history, that was not a great deal of time. In art, as in more ordinary things, the new country was to be a prodigy.

The first drawings of the New World were not *of* America but *about* America, and were done by foreign explorers or settlers who were rarely, if ever, more than amateurs. Their pictures were not meant to hang in art galleries, but to show, as accurately as possible, what the land looked like and how the people lived. They were part of a business report on the advantages of investment in the New World, compiled for the ruling powers of Europe.

The best of these early drawings were done by Jacques Le Moyne de Morgues, a Frenchman, and John White, an Englishman. Le Moyne came to Florida in 1564 and diligently recorded his observations of life in one of the first attempts at American colonization. Fortunately, when the Spaniards destroyed the settlement the following year, Le Moyne was lucky enough to escape to England with his pictures intact. They were later published and for many years served as one of the prime sources of information about the New World.

John White, who had taken part in Sir Walter Raleigh's expedition to colonize Roanoke, Virginia, in 1585 and who had returned in 1587 as governor of the ill-fated settlement, published in London his investigations of the area. White's carefully detailed drawings of the flora and fauna and Indian life and customs provided the British throne with its first look at the American wilderness.

Spain, the Netherlands, France, and England, recognizing the rich potentials of this wilderness, were quick to lay claim to

the New World. Following her defeat of the Spanish Armada in 1588, England embarked on a determined campaign to add America to her list of territorial possessions. With the colonization of Massachusetts by the Pilgrims, England had taken a long step toward establishing her domination of the New World. After losing New York to the British, the Dutch made one halfhearted, vain attempt to recapture the area, and then went off to settle in more distant, but more profitable, colonies. Spain and France, however, did not easily relinquish their holdings in the New World. But they lacked the manpower and the tenacity of the British. Eventually Spain and France lost, ceded, or sold their properties and departed, leaving behind only isolated traces of their cultures. In the shaping of the American nation, England was to be the most important force.

It was not the beauty of the land, but more practical considerations that lured men to America. Some came in the hope of carving out a more prosperous life for themselves; some came in search of religious and political freedom; and some were attracted by the idea of adventure. The first settlers were a mixed lot, but they soon subordinated their social and intellectual differences in the common goal of domesticating the land. The refinements of art or its practice had no place in a life that was bitter, hard, and fraught with danger. What few paintings the early colonists possessed were family portraits brought from their homeland and cherished not as works of art (which few of them were) but as a tie to the old country.

In time, when the worst of their difficulties were over and they had begun to acquire some of the niceties of life, the colonists began to show some interest in painting. Yet even then the impulse for having their likenesses put on canvas had less to do with art than with the need to have their records brought up to date.

LAYMEN AND LIMNERS

THE FIRST AMERICAN ARTISTS were not American. Nor were they artists, at least not in the contemporary sense of the word. They were self-taught craftsmen who came to the New World from many different lands. Their trade was painting—house painting, coach painting, sign painting. They also painted funerary decorations, heraldic emblems, and designs on furniture. Some of these artisans added *limning*—a medieval term for portraiture—to the already extensive list of services they performed. But few of these men put a premium on portrait painting as a special skill. In their estimation, it was just another of the many jobs they were willing to do.

A demand for portraits existed, though it was hardly the most lucrative branch of the limner's trade. The majority of people could scarcely afford to indulge themselves in what, according to the standards of that time, were deemed luxuries. But a painted likeness, or *effigy* as it was also called, was the sole means of preserving a visual record of the members of a family. Portraits also served as reminders to be sent to relatives across the Atlantic. Or, when death came, as a memento of the final image of the deceased.

The limner didn't work in a studio with his materials neatly laid out by his side. With his paints and canvas strapped to his back or secured in a bag, he traveled from one settlement to another—on foot, by coach, or by horse. He acquired customers by advertising his talents in the local newspaper (if there was such) or by knocking at doors like a tradesman or peddler. As long as there was a call for his services, he stayed in the area. When business fell off, he promptly packed his wares and moved on to new territory.

The limner was almost invariably self-taught and had little or no knowledge of the fundamentals of art. Such principles as *technique* (the artist's skill in handling his paints and brushes

as well as the way in which he painted) and *composition* (the combination of the various elements in a picture into a harmonious, unified arrangement) were outside his ken. He had never been trained in *draftsmanship* (the skill of drawing an object accurately and sensitively). The anatomical structure of the human body was a mystery to him, and *perspective* (a system for representing three-dimensional objects on a flat surface to give the illusion of depth and distance) was equally enigmatic. The limner never thought about *style* (the distinctive manner of artistic expression), but simply painted what he saw as best he could.

The limner's method of working was as medieval as his appellation. He knew nothing about the intrinsic properties of color, nor anything much about how to mix his colors. A red mouth was arbitrarily red, a blue eye arbitrarily blue, regardless of any nuances of tone in the actual mouth or eye. And whether he painted a sign or a living human being, he rendered his subject in a flat, two-dimensional manner with barely a hint of roundness or depth. Strive as he might for a lifelike quality, his subjects stared woodenly out of the canvas, and even members of different families bore a strong resemblance to each other.

Yet in spite of, or more likely because of, his rude and uncultivated way of painting, the limner's portraits have an unaffected simplicity and a sincerity that are quite appealing. Here and there a limner's work showed a special ability that made it far superior to the general run of likenesses. Such are the remarkably sensitive and adroitly composed portraits of *John Freake* and *Mrs. Freake and Baby Mary* as well as the powerfully stylized likeness of *Ann Pollard*.

The limner seldom bothered to sign his canvases. Occasionally he inscribed the name and possibly the age of his subject, but with a kind of modesty that reflected his limited talent, he usually left no clue to his own identity. Because of this, few limners are known by name. Those who specified their sub-

jects are called by the names of the people they painted—for example, "The Freake Limner," Freake being the name of the sitter. Those who never bothered to inscribe either their own names or those of their subjects and those limners whose work has been lost must remain among the anonymous pioneers of American art.

The first known limners (i.e., the first to be known by name) plied their trade in and around New Amsterdam. After the English took the city from the Dutch in 1664 and, adding insult to injury, renamed it New York, portraiture began to flourish. Ironically, under English rule the Dutch residents of New York State began to prosper, and as soon as they could afford it, they indulged their taste for painting. In Holland art had been a part of everyday life, not only for the rich but for the middle class as well. So, faring well under the thumb of their conqueror in the New World, the Dutch burghers renewed tradition and began accumulating sober and simple portraits to hang in their well-furnished, tidy houses.

We know little more about these early limners than the fact that their names were recorded in documents of the period; they seem like frail spectres emerging from a distant past. Jacobus Gerritson Strycker, a Dutchman who came to New Amsterdam in 1651, may have been the first of the limners to work in the colonies. He was listed in the local records as a magistrate, merchant, farmer, tailor, and limner, but no trace of his limning skill survives. Henri or Hendrick Couturier, a member of a painter's association in the Netherlands, may have been the first professional to practice in America. He came to New Amsterdam in 1649 and was supposed to have painted likenesses of a number of the city's residents, including Governor Peter Stuyvesant. Evert Duyckinck, also of Dutch origin, arrived in 1638. He was a maker, stainer, and painter of glass and a limner, all of which abilities he handed down to his son and grandson. Though none of Evert's work has been found,

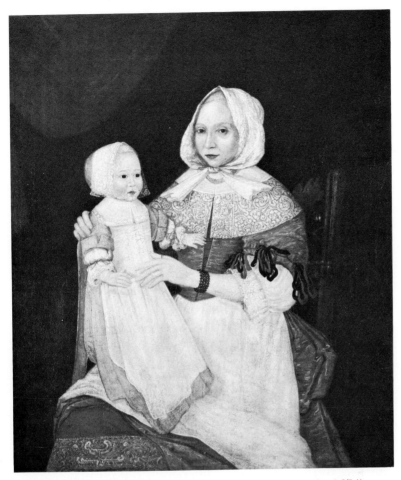

The Freake Limner: *Mrs. Freake and Baby Mary* (*c.* 1674).
Courtesy of the Worcester Art Museum.

two of his son's portraits exist. They are typical of the like-
nesses turned out by the average limner.

A New England silversmith named Jeremiah Dummer may
have been one of the first native-born colonials to become a
limner. We do not know if the signed portraits of his wife and
of himself, dated 1691, were done by his hand or by someone
else who inscribed Dummer's name as the subject. Somewhat
more substantial was Captain Thomas Smith, a sailor and

limner who came from Bermuda around 1650 to the New England area where he is thought to have painted a number of portraits including his own. We assume he is the author of the portraits on the evidence of a bill paid to him by Harvard College for rendering a likeness of the Reverend William Ames. Whether or not Smith was the painter, the portraits attributed to him are marked by a crude yet strong sense of character. John Foster also worked in New England at about the same time. He may have authored several likenesses in oil, but it is known that he produced the first woodcut of a portrait and was the first wood engraver in America.

These were the beginnings, the first stirrings of the artistic impulse. Whatever its shortcomings, the limners' work represents the earliest contribution to American painting. Their portraits, most often crude and untutored and only rarely touched with genuine felicity, nevertheless stand as an indelible monument to the men, women, and children whose strength and courage laid the foundation of the American nation.

A FANCY FOR SATINS

FROM THE VERY START there was no holding the speed with which the country grew. By 1700, just eighty years after the Pilgrims arrived, the colonies stretched from Maine to South Carolina and held a combined population of almost 300,000 people. Fifty years later there were approximately 1,500,000 predominantly English-speaking colonists on American soil, and people of other nationalities coming all the time. Cities were growing in size and number. Mercantile and shipping industries were thriving; farms and plantations were prospering. There were fortunes to be made in many areas, and the end was nowhere in sight.

Educational facilities kept pace with the growing country.

The colonies could boast of numerous colleges. More and more printing establishments were being founded to fill the demand for books, newspapers, and periodicals. The increasing prosperity of the country also reflected itself in the greater number of imposing and elegantly furnished new homes. Americans could look with more than satisfaction at the comforts and security they had culled from the wilderness in so short a time.

Now, when the "upper-class" colonist sat for his portrait, he was relaxed and confident in the fine velvets, satins, and laces in which, not so long ago, he had sat rigid and uncomfortably aware that this was his Sunday best. The provincial limner no longer met his needs. A more refined talent was required to portray him with the polish befitting a gentleman, someone who could duplicate the textured opulence of his clothes. From Europe and the British Isles, where artists were accustomed to flattering aristocratic clients, came men who could in some measure indulge the vanity of their subjects. Though they were not regarded as painters of any significance in the countries of their birth, they nevertheless brought with them a more graceful brush than the limner's, and a knowing eye for the sheen of an expensive pair of breeches.

One of the first to arrive—strangely enough in this day when painting was no occupation for a lady—was an Englishwoman named Henrietta Johnston. Sometime between 1705 and 1710 she settled in Charleston, South Carolina, where she painted overly delicate pastel portraits of the gentry. So far as is known, her unconventional profession created no scandal, possibly because the gallant Southerners understood that she had turned to art only when the ill health of her husband, a clergyman, compelled her to earn a living.

Her immediate successor was Jeremiah Theus, a Swiss national who came to Charleston around 1739. In addition to portraits he declared himself capable of painting "landscapes of all sizes, crests and coats of arms for coaches and chaises."

Theus's portraits were plodding and literal, but he knew how to put a shine on pearls and satins. Despite his pedestrian talents, Theus became known as "the court painter" because of his popularity with Charleston's *haut monde,* and he went to his reward a rich and honored man.

Justus Engelhardt Kuhn, a German, came to Maryland about 1708 to paint members of the Southern aristocracy. His figures, which stand in doll-like stiffness, have a certain "old-fashioned" charm. But it was his background settings that particularly endeared him to his clientele. Allowing his imagination the freest rein, he placed his wealthy subjects in surroundings that sometimes rivaled the splendors of Versailles.

The Northern colonies also offered a marketplace for the portraitist. John Watson, a Scot, settled in New Jersey in 1714. Peter Pelham, a professional engraver, came from England to Boston in 1726 to instruct Americans in the arts of reading, writing, dancing, and painting. He gained a kind of back-door immortality as the stepfather and teacher of America's first native-born genius, John Singleton Copley.

In 1757 Thomas McIlworth left the British Isles to set up shop in New York City. For the next decade he traveled from that city to Schenectady and Albany, painting fairly competent likenesses of the state's wealthier residents. The Englishman William Williams, a former scenic designer, advertised his willingness to do "painting in general" and to teach young gentlemen drawing and music. Williams stayed in Philadelphia from 1746 until the late 1760's and there gave some instruction to young Benjamin West, the future president of the Royal Academy of Arts and painter to King George III of England.

Gustavus Hesselius, the son of Swedish intellectuals and cousin of the noted religious philosopher Emanuel Swedenborg, came to Philadelphia in 1711. In partnership with one John Winter he publicized his skill in painting "done in the best Manner" as well as in such lesser crafts as "Landskips, Signs, Shewboards, Ship and House Painting." Despite his

claims, Hesselius reveals little genuine ability, though several of his later portraits show some insight into the characters of his subjects. He is worth noting, however, as the first man in America to paint pictures based on mythological and religious themes, both highly unpopular subjects for art in those days because such paintings offended Puritan principles. In fact, the predominant religious groups of the time were hardly favorable to the fine arts. The Puritans and Presbyterians disparaged its practice as a "luxury of leisure" and a "decoration of wealth," while the Quakers "abjured" the profession.

John Smibert (1688–1751), who introduced Americans to the art of the European masters, was the first well-trained painter to work in the Colonies. His smooth brushwork, use of color, and ability to model a head were better than anything Americans had as yet seen. The nineteenth-century historian Henry T. Tuckerman in his *Book of the Artists* recalls one critic's comment that if Smibert "was not an artist of the first rank, the Arts being then at a very low ebb, yet the best portraits we have of the eminent divines of New England and New York, who lived between 1725 and 1751, are from his pencil."

Smibert began his career as an apprentice to a house painter in his native Scotland, but soon made his way to a London drawing academy. In 1717 he went to Italy, there spending three years studying the masters, making copies of their works and painting a number of portraits from life. He then returned to London, where he soon gained an excellent reputation as a portraitist. Several years later he was offered and accepted the post of professor of art in a college for "Indians" in Bermuda, planned by the Irish philosopher Bishop George Berkeley. At a time when such an enterprise was almost unheard of, Berkeley regarded the school as the first of many he would found on the American continent. In 1728 the bishop and Smibert sailed for Rhode Island where they were to await funds. When after two years the plan failed to mate-

rialize, Smibert left for Boston. Here he spent the remainder of his life.

To make known his talents, Smibert organized the first exhibition of art ever held in America, including in it a number of his portraits as well as his copies of the European masterworks. Bostonians didn't much care for his copies of the masters, but were quite favorably impressed with the handsome surface mannerisms of Smibert's portrait style. They were particularly taken by a large work called *Bishop George Berkeley and His Family*, which portrayed the bishop, members of his family, his secretary, a friend, and Smibert, who stands in left rear. According to Horace Walpole, the eighteenth-century English author and art historian, the Berkeley canvas was possibly the first picture containing more than one figure to be painted in America. Though the figures suffer from a certain monotonous similarity, they are fairly knowledgeably constructed, the colors luminous and the technique agreeably polished. While Bostonians showed their liking for Smibert's work, the city was still too small to support him as a full-time painter, so he opened an art-supply shop to round out his income.

The room in which Smibert painted was kept intact for many years after his death. To it came such soon-to-be-distinguished American artists as John Singleton Copley, John Trumbull, and Washington Allston. They (and others) came to learn something about color, composition, and technique from the first color copies of the masters they had ever seen. If eventually their respect for these copies dimmed when they saw the perfection of the originals, they were still willing to admit the debt owed, as Allston said, "to Smibert for the instruction he gave me—his work rather."

While some American painters looked to Smibert for their "instruction" in art, others found more stylish models of technical accomplishment in the likenesses of John Wollaston and Joseph Blackburn. The two Englishmen brought to

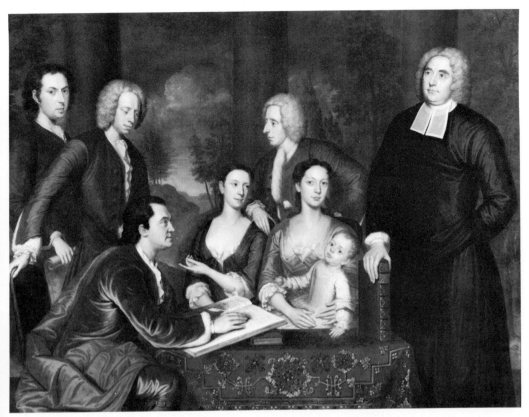

John Smibert: *Bishop George Berkeley and His Family* (1729).
Courtesy of the Yale University Art Gallery, gift of Isaac Lothrop
of Plymouth, Mass.

American art a smoothly elegant style reminiscent of British
court painting, in which great attention was paid to the pose
of the sitter and the decorative arrangement of the clothes.
Their portraits were artificial and lacking in character, but
they had a polish and charm that was much admired and imi-
tated by the rising generation of pre-Revolutionary painters.

Wollaston had an extremely successful career in America. In
the comparatively few years he lived in the country, he is
known to have painted approximately three hundred por-
traits—a number far in excess of the output of most of his
colonial contemporaries. He left London in 1749 and within
a short time had established an extensive practice in New
York, Maryland, and Virginia. Eight years later he went

abroad as a "writer" for the British East India Company. In the spring of 1758 he turned up in Philadelphia, but after a brief period of painting, he left for India, where among other things he seems to have been a magistrate in the city of Calcutta. In 1767 he reappeared, this time in South Carolina, to resume painting, and several months later he departed permanently for England.

Wollaston received his artistic training in London, where his specialty was "drapery painting"—that is, he painted the sitter's clothes, while another artist painted the head, a practice not uncommon in those days. His subjects, both men and women, bear a remarkable likeness to each other. Nevertheless, his felicity at enhancing the radiance of silks, satins, and brocades negated his other faults, and this accounts in great part for his enormous vogue. It is interesting to note that Benjamin West, later painter to the British crown, patterned his youthful efforts after Wollaston.

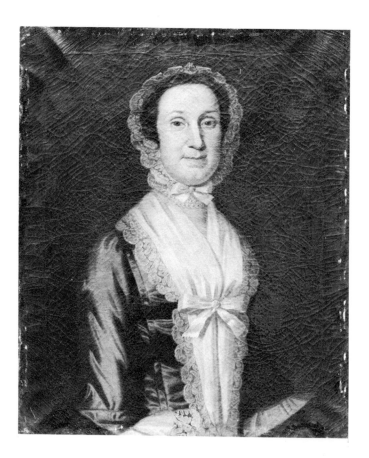

John Wollaston: *Mrs. Joseph Reade* (c. 1749–1752). Courtesy of the Metropolitan Museum of Art, gift of Mrs. Russell Sage, purchase, 1948.

Though he was not quite as successful as Wollaston, Joseph Blackburn's American stay was highly profitable. Little is known of Blackburn's life, but he also appears to have been trained as a "drapery painter" in London. He came to Boston in 1754 and, until his departure for England in 1763, painted likenesses in the New England area. A record of payment for several American portraits done in 1774 and 1778 indicates that he continued his career in his native land.

Blackburn's portraits, even more than Wollaston's, are affected and as alike as peas in a pod. Blackburn, too, had developed an agreeable formula that endeared him to fashionable colonials. He had a keen eye for the texture of opulent fabrics and a way of posturing his subjects as if they were members of the royal court. These abilities not only won him many clients but also exerted considerable influence on American painters, among them the very young John Singleton Copley.

There were other artists throughout the colonies who earned their wages as portraitists, but they were chiefly men of indifferent ability, whose sole aim was to please the public demand for shinier satins and richer velvets. The popularity of Smibert, Wollaston, and Blackburn had set the pattern for the new generation, and the English court style of painting, with its emphasis on surface finesse, now became the dominant style in American art.

NATIVE SONS

THE INCREASING AFFLUENCE of the colonies paced an increasing demand for portraits. A young man bent on a future in art could now be more sanguine about earning a living in that field. However, few parents with social ambitions urged such a career on their sons. It was considered a lower-class trade on a par with peddling or storekeeping, and less solidly conventional. Still, it was an honest means of support.

The requirements were minimal, and the training not arduous. The colonial painter had little artistic education. Few people were discerning enough to know or care that the artist scarcely knew how to draw, to mix colors, or to compose a picture. Even if a painter were anxious for such knowledge, he had nowhere to turn. There were no schools, no museums, no art galleries. Art books were expensive and hard to come by. Instruction of a sort was sometimes available, but only when the candidate was lucky enough to know a practicing artist and was sufficiently determined to seek out such a man.

Although contemporary painters were generous with their time and ungrudgingly passed on advice or help, it was largely a case of the halt leading the blind. Most "professional" artists were little better equipped or trained than the young men they presumed to counsel. If the fledgling wished to study great paintings, he had to rely on Smibert's copies of the masters. The only other method of self-instruction was to study the few inferior engravings of European paintings which had begun to trickle into America. But then the neophyte faced the almost impossible task of deciphering by himself the difficult problems of color and technique. How could the colonial know what colors the artist had used in the original work, how those colors had been applied, or how the brushwork had been handled when what he saw in front of him was a black-and-white engraved reproduction (an engraving was a drawing of the original picture done by incising lines into a metal plate, rubbing black ink into those lines, then printing the plate on a sheet of white paper).

In the end, no matter how he obtained his inadequate training, the colonial artist could only come to grips with the essentials of his craft through actual experience. Therefore, as soon as possible, the young painter set up his easel in one of the thriving centers of the colonies and advertised his specialities; or, more often, traveled as an itinerant or journeyman painter from town to town, wheedling a commission and

learning the fundamentals of art as he worked, much as the earliest limner had done. In more common parlance, he "earned while he learned."

Nathaniel Emmons (1704–1740), the first native-born American painter known by name, must have started in just such fashion. The only information we have is that he practiced in the Boston area and painted portraits in black and white. The fact that he worked in such a limited palette suggests that he got his information about his craft from engravings and was probably too timid to venture into the uncharted regions of color.

Also active in Boston were Joseph Badger (1708–1765) and John Greenwood (1727–1792). Badger was a house painter and glazier as well as a part-time painter of likenesses. His surviving canvases are amateurishly wooden, poorly drawn, and worked in dull, grayed colors. But in certain instances his pictures—chiefly those of children to whose innocence he evi-

Joseph Badger:
James Badger.
Courtesy of the
Metropolitan
Museum of Art,
Rogers Fund, 1929.

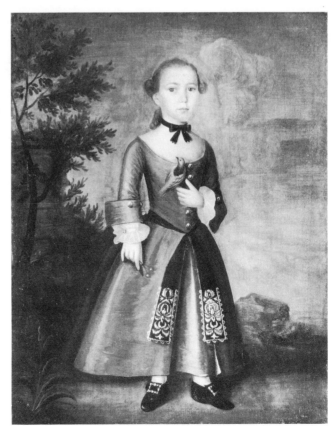

dently responded—attain a ghostly delicacy. Badger inherited
the mantle of Boston's leading painter on Smibert's death.
Badger's rise to fame is indicative of how little colonials
demanded from an artist and how few skilled professionals
there were at that time.

Greenwood's portraits are no better and no worse than
Badger's. But he is worth noting as one of the earliest Ameri-
can painters of genre, a term used to describe a picture of a
story or an event occurring in daily life. *American Sea Captains
Carousing in Surinam*, a lusty scene of drunken naval officers
tippling in a tavern, has a crude and vigorous humor. *Jersey
Nanny*, an engraving, portrays a large, slovenly woman.
Within its frame, the picture contains a rhyme exhorting all
ladies to "own her as a sister." It is doubtful whether Green-
wood himself would have claimed kinship, but he obviously
enjoyed needling the pompous vanities of his fellow colonials.

Of James Claypoole (1720–1796) it is recorded only that
he was adept in the "different branches of the painting busi-
ness," and that he won a certain degree of popularity in Phila-
delphia. His work has all been lost.

John Hesselius (1728–1778) became Philadelphia's most
prominent painter when his father Gustave died. He was also
the first teacher of the soon-to-be-famous Charles Willson Peale.
Hesselius started out as an itinerant portrait painter, traveling
extensively through Pennsylvania, Delaware, Maryland, and
Virginia before he settled in Annapolis. Although he must have
obtained his knowledge of painting from his father, John pre-
ferred to follow Wollaston's fashionable style. He succeeded so
well that it is sometimes difficult to distinguish the works of
one from the other.

Hesselius showed to best advantage in his portraits of chil-
dren, whom he painted with greater refinement and characteri-
zation than he accorded to adults. His portrait of *Charles Cal-
vert*, painted in 1762, shows a small boy dressed in a lustrous
pink satin suit, a blue silk cloak casually draped over one

shoulder and a gaily plumed hat atop his infant head. Pointing a chubby finger, the child looks at the rolling landscape, which one day he will inherit. Kneeling beside him is a well-dressed Negro slave, hardly older than his master but already aware that he belongs wholly to Charles. Whether by intent or not, the picture is a capsule vision of the life of the Southern aristocracy.

Albany and his native city, New York, provided John Mare (1739 – *c.*1795) with sufficient customers to keep him well occupied. He had learned about painting from his brother-in-law William Williams, but like most artists of his generation he patterned his style on Wollaston. Of particular interest is his portrait of *John Ketaltas,* in which a fly, resting on the sitter's arm, was painted with such vivid realism that people seeing it were always tempted to brush it off. This canvas is probably the earliest American example of *trompe l'oeil,* a French expression meaning "to fool the eye" and used to describe pictures that create an uncannily exact illusion of three-dimensional reality. Mare's other portraits were smoothly finished and warm in coloring, but much more conventional.

On the whole, the first generation of native-born American painters produced few canvases of any artistic merit. Even in view of the formidable handicaps under which they worked, the blame can only partially be ascribed to their inadequate training and meager backgrounds. While some were better painters than others, none had any outstanding qualities. Then, for the first time, there appeared a painter who possessed the vital ingredient that had been missing.

A TALENTED SHADOW: ROBERT FEKE

THE EARLY PERIOD of American art is like a graveyard of phantoms. Robert Feke, the first native-born talent, is one of the ghostly figures in that demesne. Except for several like-

nesses and a few vague facts that have resisted the dust of time, he might never have existed. The son of a Baptist minister, he was born in Oyster Bay, Long Island, sometime between 1705 and 1710 and left home, presumably in his teens, to become a mariner. Stories filtered back that he had been captured and imprisoned in Spain—why or how no one seems to know. About 1741 he turned up in Newport, Rhode Island, and spent the next nine years working as an itinerant portraitist in the New England and Philadelphia areas. Then, as if by magic, he vanished into thin air. Legend has it that he lived out his years as a sea captain and died in the Barbados. But there is no record or proof of it.

Apparently Feke had access to no more advantages than his colonial contemporaries, yet he was a far more able and accomplished artist. Though he wasn't "the most extraordinary genius" an overextravagant admirer called him, he was, without doubt, the first painter born on American soil to be endowed with that uncommon and mysterious commodity called talent.

Feke probably saw and learned something from Hesselius and Smibert, since he worked in Philadelphia and in Boston. Presumably, he was otherwise self-taught. Not unexpectedly, he followed the English style. But Feke had a sensitive and painterly eye. He had a good grasp of anatomy, and his colors were intelligently employed to give weight and substance to his figures. He was also a felicitous composer, breaking his space into interesting, well-balanced arrangements.

Feke's earliest canvas, *Isaac Royall and His Family*, dated 1741, was a complicated picture imitative of Smibert's group portrait, a most ambitious undertaking for a neophyte. The figures are stiff and the brushwork is still untutored. But even at this point Feke had more talent than the older painter. Seven years later Feke demonstrated how perceptive his eye and how deft his hand had grown in the full-length likeness of *General Samuel Waldo*. Feke understood the newly risen

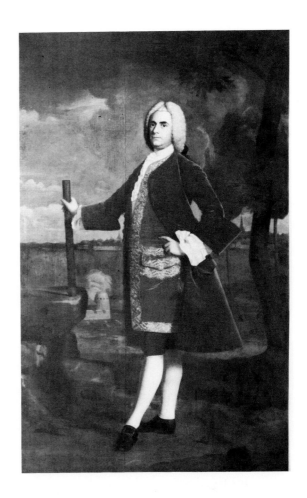

Robert Feke:
General Samuel Waldo
(*c.* 1748).
Courtesy of the
Bowdoin College
Museum of Art,
Brunswick, Maine.

upper-class American. The General stands solid and erect, dig-
nified and assured, but quite conciously aware of his author-
ity and social rank. The glowing color, the rich texture of the
clothing, and the landscape background, were handled with a
power and a skill that rose far above the standards of Feke's
contemporaries.

Feke represents a proud way station in the development of
American art. He was a natural and sophisticated talent, the
first of many to come. His superiority, however, must be mea-
sured in terms of what went before, not what came after. The
time was at hand when artists would appear who would no
longer be judged by the imperfections of the past but by uni-
versal critical standards.

II Lords, Ladies, and Colonials

In 1738, the same year that Benjamin West and John Single-ton Copley were born, all of Great Britain rejoiced at the birth of George III, the future king. In Virginia, a boy named George Washington was quietly celebrating his sixth birthday. All four were destined to play a role in history—West and Copley in the history of American art, King George and Washington in the history of the United States of America.

England's holdings in the colonies were expanding, and by 1763 George III was ruler of almost the entire eastern portion of the country. But Americans were getting restive under the repressive measures of the crown. They had bargained for freedom in the New World and had become instead subjects of the Old World. The desire for liberty, which had been growing ever stronger through the years, had brought the colonists to the brink of revolt. Patriots were already setting the stage for the drama of American independence.

The Revolution cast only the thinnest of shadows across West's and Copley's single-minded pursuit of art. Both left the colonies to spend the major portion of their lives in England, where they died. Yet it was not so much their lack of patriotism but their dedication to art and their unusual (for those times) breadth of vision that drove them to the Old World in search of greater knowledge. They were the first American artists of major stature and the first to insist on a wider scope for their talents than portraiture. With their appearance, American art wrenched itself away from everything that had gone before and began the journey that would eventually establish its leadership in the world of art.

PAINTER TO A KING: BENJAMIN WEST

IF DURING HIS DAY there had been a Horatio Alger award for Americans who achieve fame and fortune despite the handicaps of poverty, Benjamin West (1738–1820) would have been its most likely candidate. His was a spectacular rise from "rags to riches." Born of a humble Pennsylvania Quaker family, he became court painter to George III—King of England—and president of the Royal Academy of Arts. And when he died, West was entombed in St. Paul's Cathedral in company with Britain's most illustrious names.

West began life in Springfield Township, Pennsylvania, where, he claimed, he received his first art lessons from the local Indians who showed him how to mix colors and fashion brushes from the hairs of animals. At fifteen he was apprenticed to a tinsmith, but within three years he had made his way to Philadelphia to study with William Williams. Soon he was painting portraits at five guineas a head.

West was Fate's darling. The provost of the College of Philadelphia, captivated by West's talent and personal grace, offered to "make him to a certain degree acquainted with classical literature." This tutoring comprised the sole academic instruction of the future head of the Royal Academy, whom a member later described as "the first and last President. . . who found spelling a difficulty."

Unlike other young American artists, West dreamed of painting huge, important works like those found in European museums. To attain his goal, he knew that he would have to study abroad. Once again fortune provided the means. A group of wealthy Philadelphians, interested in sponsoring local talent, generously furnished the wherewithal for a three-year sojourn in Europe. In the summer of 1760 West departed for Rome on the first leg of his extraordinary career.

West's stay in Rome was a social and artistic triumph—the

young, handsome "savage" from the wilds of America became the darling of the aristocracy. Despite his active social life, West produced a number of portraits and several allegorical pictures, and he acquainted himself with the masterpieces housed in Rome. It was at this time that he learned about the new classical theory of art.

The recent discovery of a number of ancient Greek and Roman marbles had sparked a revival of interest in antiquity. Johann Joachim Wincklemann, a German archaeologist and scholar, exerted a profound influence on the cultural tastes of the mid-eighteenth and early nineteenth centuries with his principles of neoclassicism. Wincklemann equated beauty with the idealized perfection found in ancient Graeco-Roman art. In his view only those paintings that embodied certain rules could be considered truly excellent.

Such a work had to derive its inspiration from the noble simplicity and calm grandeur of ancient Greek or Roman art; its subject matter was to be drawn from such sources as ancient literature, the Bible, or mythology, and propounded the finer virtues of self-sacrifice, stoicism, or a universal moral lesson. Forms were outlined and painted in the smoothly rounded and idealized manner of antique sculpture. Color was cool and muted and applied within the outline.

Painting was divided into various categories, each graded according to its ability to fulfill these requirements. Historical or "grand manner" painting ranked as the most exalted branch of art. Portraiture, landscape, genre, and still life, in descending order, were considered inferior branches. Portraits were a necessity, but they could be "elevated" by posing the subject in a classical setting and depicting him or her in antique dress. This accounts for the many paintings and sculptures of women and, particularly, men clothed in ancient Greek or Roman costumes. Landscape could be used as background for classical paintings, but never as *the* subject of a

painting. (It is important to note that historical painting, which was also called history painting, did not mean *all* history. It referred only to, and was synonymous with, antiquity. Any later historical event was considered too recent and therefore unworthy.)

It was to these lofty heights that West aspired. He began the return trip to the colonies with a visit to England, and once again his reception was overwhelming. Rather than commit himself to the doubtful future that awaited him back home, he decided to remain in London. It was to be a permanent arrangement; he never again set foot in the colonies.

If Providence had formerly smiled upon West, she was now prepared to shower him with honors. His Italian canvases gained him immediate recognition, while his personal charm won him a number of influential friends, among them Sir Joshua Reynolds, one of England's greatest portraitists. West also acquired the powerful patronage of the archbishop of York, at whose behest he painted a historical narrative of patriotism and sacrifice entitled *Agrippina Landing at Brundisium with the Ashes of Germanicus.* The canvas caught the eye of George III, who promptly requested another such work.

In 1772, nine years after West arrived in England, West's countrymen were already planning armed rebellion against their royal oppressor. That same year West was appointed historical painter to His Majesty. He was careful to maintain a delicate balance between his mild sympathies for the colonies and his admiration for the king. Yet, oddly enough, West refused a baronetcy because of his American heritage.

West became Britain's major historical painter and his fame spread to the Continent through engravings of his pictures. He was one of four men selected by the king to form the Royal Academy of Arts (founded in 1768), of which Reynolds was first president. On Reynolds' death in 1792 West was

unanimously elected to fill the office, which he held until his own demise. He received many royal commissions, among them one for a series of murals for Windsor Castle.

When George III's insanity forced his deposition in favor of a regency of the Prince of Wales, West lost the royal patronage so vital to his career. His reputation declined sharply, and he became an object of scorn among the younger men. Lord Byron, in his poem "The Curse of Minerva," called him, "the flattering feeble dotard West,/Europe's worst dauber, and poor England's best. . . ."

West's fame may have suffered; his rank endured. He died an honored man, buried in St. Paul's Cathedral near the crypt of his noted colleague Sir Joshua Reynolds.

West sought to be a greater artist than he was. He had an intense desire to excel, but his ambition outstripped his talent. He confused uprightness with passion and position with greatness. West predated the neoclassicism of the noted French painter Jacques Louis David by some twenty years and even hinted at the rise of romanticism in his later work. But it was the grand imaginative fire of David's genius that made him, rather than West, the great leader of classical art. In West's hands nobility became a bourgeois virtue. The characters in his pictures are second-rate actors in a morality play.

West's true worth as an artist falls somewhere between the high esteem of George III and the low opinion of Byron. He was an able painter, not a great one; an innovator, not a revolutionist. He pleased rather than formed the aesthetic taste of his time.

Despite his low regard for such painting, West was an accomplished portraitist. His likenesses are suave, polished, and graceful.

The finest example of his historical paintings are *William Penn's Treaty with the Indians* and *The Death of General Wolfe.* The former picture, familiar to generations of American schoolchildren, shows Penn arranging for the peaceful and

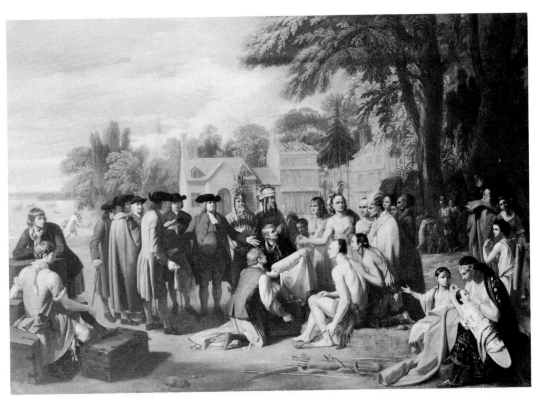

Benjamin West: *William Penn's Treaty with the Indians* (1771).
Courtesy of the Pennsylvania Academy of the Fine Arts.

honorable transfer of the land that later became the state of Pennsylvania. The latter work celebrates the heroic death of the British General James Wolfe in Quebec during the French and Indian War.

In both canvases, West departed quite radically from classical tradition by ignoring all reference to antiquity. He portrayed specific historical events of recent vintage, and his figures were dressed in contemporary costume. " . . . if, instead of the facts . . . I represent classical fictions," he responded to Reynolds' charge of vulgarization, "how should I be understood by posterity!" West had no desire to overthrow tradition; he only wanted to alter its formulas.

Shortly before the start of the nineteenth century, West began to move in another direction. Popular interest in events of supernatural character, the "awful sublime," had awakened

his own curiosity. His later canvases became increasingly romantic in style. They were imbued with emotion, filled with movement, and painted in a freer, more fluid brushwork. Most of his subject matter came from Biblical sources. In 1783 he began work on *Death on a Pale Horse,* an idea that occupied him for more than thirty years. A second sketch was produced in 1802, and the finished canvas completed in 1817, three years before his death. A scene of wildly rearing horses trampling on writhing figures, it is his most compellingly alive work.

West's lasting contribution was as a teacher in the first real school for American painters. Unfailingly generous, he welcomed into his home a steady flow of his young countrymen who came to learn the fundamentals of art. Most of his students resisted his interest in historical painting, preferring to work as portraitists. Nevertheless, it was through West that they became somewhat familiar with the higher standards that governed European art. Thus West was, in some measure, responsible for heading American art away from its homespun provinciality toward the mainstream of world art.

Benjamin West: *Death on a Pale Horse* (1802).
Courtesy of the Philadelphia Museum of Art.

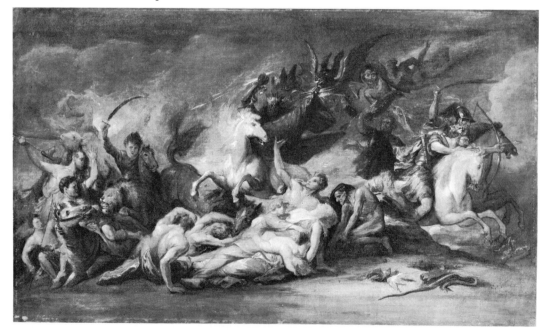

A COLONIAL MASTER:
JOHN SINGLETON COPLEY

> A taste of painting is too much wanting in Boston to afford any kind of help; and was it not for preserving the resemblance of particular persons, painting would not be known in the place. The people generally regard it as no more than any other useful trade, as they sometimes term it, like that of carpenter, tailor, or shoemaker, not as one of the most noble arts in the world, which is not a little mortifying to me.

THIS UNHAPPY STATEMENT, written sometime during the 1760's, was made by John Singleton Copley (1738–1815), then the most celebrated painter in the colonies.

Prodded by a gnawing ambition to achieve fame and fortune, and impatient with the restrictions of his "trade," Copley followed Benjamin West to London, hoping to emulate the latter's triumph. But he had neither West's hand for flattery nor his luck. The English never accepted Copley as they had West. Copley was just another American "who distinguished himself by historical pictures of great exactness and fidelity to truth . . . explored along lines of a theatrically conceived literalism."

What the English had no way of knowing was that in Copley the colonies had produced a master. Copley was America's first great painter. His American portraits—undimmed by the passage of time—are magnificent revelations of the spirit of the colonial peoples.

Gilbert Stuart, one of America's great portraitists, was at best grudging in his appreciation of the talents of fellow artists. Once, he labeled Copley's skin tones as so much "tanned leather." But even he was forced to admit that Copley's painting *Colonel Epes Sargent* was exceptional: "prick that hand and blood will spurt forth." So lifelike and so penetrating were Copley's colonial portraits that they made everything

that had been done before in America look clumsy and immature.

Yet, astonishingly, these portraits were painted by a man who had had little more training than Feke and less than Smibert or Wollaston. It was small wonder then that a contemporary admirer felt that Copley was all the more a genius and remarkable for having succeeded "with so little assistance from others and so few opportunities of seeing anything worth studying. . . ." It is a greater irony that, after Copley had gone to England to study, as he became a more sophisticated and elegant craftsman, the probing honesty of his earlier work should have been lost.

Copley was born in Boston and received his earliest training from his stepfather, the engraver Peter Pelham. Copley's youthful portraits, reflecting Blackburn's ideas of elegance, are worked with a clean precision characteristic of the engraver's art. Even at this age Copley's draftsmanship, his technical superiority, and his fine color sense were evident. At seventeen he was already a professional, and ten years later the finest portraitist in the colonies.

Copley's likenesses of the upright and intelligent New England merchants and their families are as enduring and distinguished as their prototypes. Aside from his astounding technical skill, it was his keen assessment of character and his absolute honesty that make his portraits so impressive. He could paint men or women with equal facility. His portraits of older people are remarkable for their insight into the personal character lying behind the diligently rendered sagging muscle and aging flesh.

Mrs. Sylvanus Bourne is a superb example of Copley's sensitivity. Flesh, cloth, and furniture glow in rich and varied textures; the figure is set down with masterful ease. Handsomely gowned, her hands folded over a book in her lap, Mrs. Bourne sits patiently, her face reflecting the wisdom of a lifetime.

Copley was irked by the narrow limits of American culture.

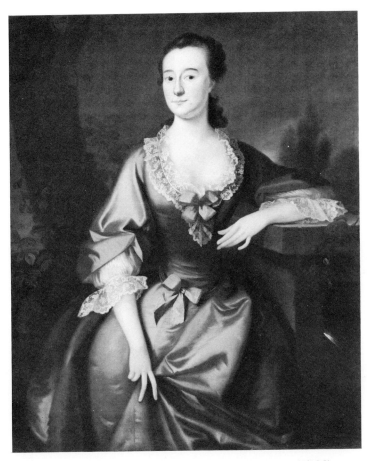

John Singleton Copley: *Mrs. Sylvanus Bourne* (1766).
Courtesy of the Metropolitan Museum of Art,
Morris K. Jesup Fund, 1924.

The constant round of painting nothing but likenesses did not
become, for him, more engaging with success. He was also
upset by the colonists' rebelliousness, finding it neither
"pleasing to an artist nor advantageous to the Art itself." A
portrait of his half brother, *The Boy with the Squirrel*, which
he sent to London in 1766, elicited a warm response from
Reynolds and an invitation to come to England. Yet Copley
wavered. "Were I as sure of doing well in Europe as here, I
would not hesitate. . . ," he wrote West. "My ambition whis-

pers to me to run this risk. . . ." But he still could not bring himself to act. Copley might never have declared himself had not the mounting passion for independence forced the issue. Rather than commit himself to the Revolution, he sailed for Rome in 1774, arriving in London the following year.

In Britain Copley developed the qualities he felt were indispensible to a career as a historical artist. He became a more fluent and elegant painter. With new assurance he embarked on a series of historical canvases, the first of which—*The Death of the Earl of Chatham in the House of Lords*—brought him recognition in this field. Within several years Copley produced a number of "grand manner" paintings. The best and most dramatic of these is *Watson and the Shark*, a picture based on an incident in the life of a friend of Copley's. Watson had fallen overboard, and the painting shows him being rescued from the gaping jaws of a shark. The canvas was well executed, well composed, but hardly a historical work. Although it portrayed a certain heroism in the men of the rescue party, their heroism was neither noble nor self-sacrificing. Also the painting contained no reference to antiquity, and the color was much too bright. The work received but faint praise. Though he bent his efforts in that direction, Copley never did rival West. Copley was a gifted painter, more so than West. But Copley couldn't attract the patronage so important to the historical painter.

In his early fifties, perhaps again inspired by West, Copley tried his hand at Biblical subjects. Here he was completely out of his depth. Of all his works, these are the least successful.

Though Copley was no longer as concerned with the character of his subjects, he was still a most careful workman. Sometimes the tedium of posing for him produced amusing and absurd situations. The daughters of George III and their menagerie of dogs and parrots noisily refused to submit to the long and frequent sessions he demanded. Only the king's stern

intercession restored order and made possible the completion of the painting.

The Knatchbull family portrait dragged on for seven years. During this time Mrs. Knatchbull died and was repainted as a hovering angel. However, the second Mrs. Knatchbull would allow no space to her predecessor, so the first wife was again removed, this time for good. During the seven years it took to complete the picture, two children died (their stepmother did not object to their presence), and four more were born.

Copley's prestige diminished toward the latter part of his life. His need for financial and artistic security now urged a return home. But as his timidity had made him reluctant to leave the colonies, so it now kept him from going back to a land he no longer knew—the United States of America. He died and was buried in England.

Copley's journey to London had not made him a greater artist as he hoped. It only enlarged his scope. Perhaps he had dallied too long in America to be able to rival the easy assurance of his British contemporaries. It was in America—and in spite of its provinciality—that Copley's artistic brilliance flamed. His English canvases, though more elegant and refined, never possessed the enduring strength and honesty of his colonial work. Yet, had he not gone to England, he would never have produced the historical pictures. If not quite masterpieces, they are nonetheless respectable works of art.

Copley became the new master, and his style the guideline for the rising generation of American painters. His protest against the insularity of American culture went all but unheard by the populace. Portraiture was still the mainstay of American art. But his cry "A taste of painting is too much wanting. . . ." was to strike a responsive echo in the hearts of other American artists.

III The American Academy

Copley was not the only American to go abroad. Others of his generation made their way across the sea, not to seek fame or fortune as Copley had, but rather to learn the fundamentals of art. Before the Revolution restricted such travel, a handful of aspiring painters went to London to study with Benjamin West. They were the first of an increasing number of Americans who later, after the war, continued to make the journey to West and to what constituted the first real school for American artists.

West did not hang out a shingle or take ads in American newspapers announcing the opening of a school. Reports of the honors being heaped on him and stories of his unstinting generosity began filtering back to the colonies. American painters were probably aware that there were other and better academies on the Continent. Perhaps it was a sense of inferiority and a certain reluctance to contend with the sophistication of European art students that sent them to London and West. West spoke their own language. Although few availed themselves of the opportunity, they could also see the work of, and take drawing lessons from, some of England's greatest portraitists at the Royal Academy of Arts, which had been founded in 1768.

There were, additionally, the problems of country. The Revolution was already in the minds and hearts of the colonists. Despite his attachment to the English king and his own prudent neutrality, West was not without some sympathy for the American cause. Like themselves, he had been born and raised in the colonies and at least could understand, if not agree with, their political position. Moreover, he knew the limitations of American art and could forgive the young artists

their provincialism and their circumscribed ambitions. Finally, his kindness and hospitality assured them of a warm welcome.

SCHOOL FOR AMERICANS:
THE FIRST PUPILS OF WEST

IT WAS LESS Matthew Pratt's yearning for artistic self-improvement than his incidental relationship to Mrs. West that gave him the unique distinction of being the first of West's American students. Aside from this fact and his painting of West's studio, Pratt might well have been one of the forgotten men of American art.

Pratt (1734–1805) was thirty years old when he came to London, a veteran of several years' study with his uncle, James Claypoole, a moderately well-known Philadelphia portraitist. Before going abroad, Pratt had spent eight years commuting between New York and his home city, painting pleasant likenesses of the residents. He remained in England four years, spending a little more than two years with West, then striking out on his own.

Pratt found it difficult to earn a living after his return to Philadelphia in 1768. So, much in the manner of the earlier limners, he fell back on sign painting for additional revenue. His signs became famous for their artistic qualities and added a great deal of beauty to the city's streets.

Pratt is noted for his delightful picture of West's establishment, *The American Academy*, which he painted a year after his arrival in England. The picture is one of the first American examples of a "conversation piece," a type of eighteenth-century English genre painting. The conversation piece was a group portrait, usually of family members or friends, painted less than life size and showing the figures engaged in some simple daily activity. In *The American Academy* West is

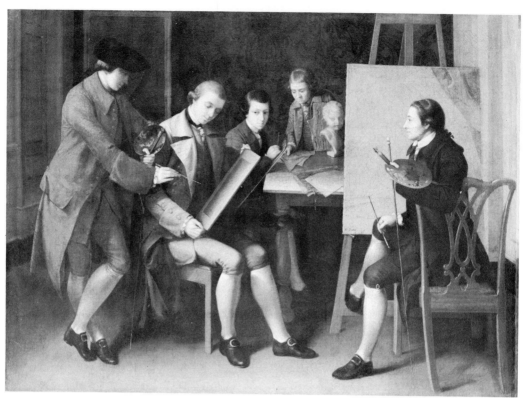

Matthew Pratt: *The American Academy* (1765).
Courtesy of the Metropolitan Museum of Art,
gift of Samuel P. Avery, 1897.

shown leaning over Pratt's shoulder, demonstrating a point to him and the three students present. The drawing is somewhat weak, but the figures are attractively disposed and the color has much warmth and clarity.

Other American painters soon came knocking at West's door. Abraham Delanoy (*c*.1740–*c*.1790), a New Yorker, arrived in 1776 for four years of study. His portraits of Mr. and Mrs. West are dry statements, reflecting little more than a competent hand. Delanoy's career after his return home was no more successful than Pratt's. He too became a sign painter though he was not half as good at it as Pratt.

Henry Benbridge (1744–*c*.1812), another Philadelphian, was actually not one of West's students. Benbridge had taken some lessons from Wollaston and then went abroad to Italy,

where he spent four years. On his way home Benbridge stopped in London to get some artistic advice from West. From London he went to Charleston, South Carolina, where he succeeded Theus as principal portraitist. Benbridge was a more polished workman than either Pratt or Delanoy, and his likenesses display some ability at drawing, but are otherwise undistinguished.

For the most part the original group of West's students seemed to have been little affected by their schooling. They returned home with their provincialism intact to pick up their careers where they had left off. Only two other painters came to West before the onset of the Revolution: Charles Willson Peale, who was a most remarkable man in his own way, and Gilbert Stuart, who became one of the greatest of American portrait painters.

"A MINOR LEONARDO":
CHARLES WILLSON PEALE

AFTER TWO-YEARS STUDY with West in London, Charles Willson Peale (1741–1827) boarded the boat for home. He was still wearing the same suit in which he had come, not out of necessity, but to flaunt his Americanism in defiance of the British. This "minor Leonardo," as the art historian Oliver Larkin called him, was a man of many talents—painter, inventor, scientist, humanitarian—but first and foremost, he was an American.

Born in Queen Annes County, Maryland, Peale started out as a saddlemaker's apprentice. He had an insatiable curiosity, and this, coupled with a mechanical aptitude and a boundless fund of energy, soon made him an expert in a variety of skills, including clock repairing, casting in bronze, and silversmithing. A chance observation of some pictures painted by an amateur determined his choice of art as a career. To his way

of thinking, art was no more special than any other craft. All that was needed was training; talent was superfluous. So at the age of twenty-one he gathered together some paint, brushes, canvas, and a book called *The Handmaid to the Arts* and entered into his new occupation.

Before long Peale realized that he needed some outside help. He took a few lessons from John Hesselius, repaying the kindness with the gift of a saddle. Then he applied to Copley, who lent him a canvas to copy. In 1767 several prosperous merchants, impressed with his ability, paid his expenses to study with West. He departed for London to learn, as he said, "the whole circle of the arts, excepting painting in enamel." Since West taught only painting in oils, Peale taught himself perspective, etching, and engraving. He returned to Philadelphia (where he settled permanently in 1776), from which base he traveled to Annapolis and Williamsburg painting likenesses. When Copley left for Europe, Peale became the most prominent painter in the colonies.

His painting entitled the *Peale Family* is a most affectionate and sympathetic portrait of himself, his wife, and his many children. (Almost all were named after revered masters in the arts and sciences.) The color is harmonious, the figures gracefully arranged. The drawing, however, has the awkwardness of the self-taught. In fact, with the exception of his *Staircase* picture, there was always something homespun about his canvases.

In 1776 the "furious Whig," as Peale was known for his libertarian ardor, enlisted as a common soldier in the Revolutionary army. He quickly rose to officer's rank. He fought at Trenton and Germantown, drew posters to help the war effort, and did miniature portraits of his men for their relatives. "He fit and painted, painted and fit," one of his soldiers commented. Upon his release in 1779 he jumped briefly into politics as a member of the Pennsylvania legislature.

In 1786 Peale founded the first museum of natural history

in the United States. He collected and mounted birds, animals, plants, and insects, which he classified with scientific accuracy and then set against painted backdrops of their natural habitats. The most unusual item in the museum was a skeleton of a mastodon found in Newburgh, New York—an extinct relative of the elephant and the first of its species ever to be assembled and shown. He directed the excavation and painted a picture of the proceedings called *Exhuming the Mastodon*. The museum also contained a double row of portraits of the Revolutionary leaders painted by Peale and his sons as a tribute to American independence.

Though he devoted the major part of the day to the gallery, Peale still painted. *The Staircase Group*, done in 1795 in the style of *trompe l'oeil*, is a life-size portrait of his sons Raphaelle and Titian going up a staircase. Peale surpassed himself in this most delightful canvas. Of all his paintings, this one alone has none of the provincialism that marks his other work. The natural movement and lifelike attitude of the boys are drawn with knowing skill; the simple composition, with its clever placement of the figures, is beautifully inventive. And the illusion of depth and space is created by an ingenious disposition of light and shade. When the picture was exhibited, it was set in a doorframe, and a step was added at the base to heighten the effect of its realism. The deception was so thoroughly convincing that George Washington was said to have nodded to the boys as he passed.

Peale's extraordinary energy and ingenuity kept his mind and his hands constantly busy. He invented windmills, stoves, vapor baths; devised new methods of constructing artificial limbs and false teeth and ways of embalming. He even built mechanical fans to shoo away flies. As if that weren't enough, he organized the Columbianum, an association of artists and sculptors, to provide an education for American artists in their own country. The organization held its first and last exhibition in 1795. But Peale's dream of an American art

school became a reality ten years later. With his son Rembrandt and sixty-nine distinguished artists and laymen, he helped found the Pennsylvania Academy of the Fine Arts.

Peale was an extraordinary man in an age in which there was no lack of such men. He was endowed with a lively, farsighted intelligence and many brilliant minor talents. He was, however, no Leonardo da Vinci. The comparison is to the diversity of his interests and not to the importance or value of his accomplishments. A painter whose work was often crudely provincial, he could, on occasion, produce pictures of remarkable sensibility. But no matter what he painted or how he painted it, Peale's art is imbued with the great affection he bore for his country and his fellow man.

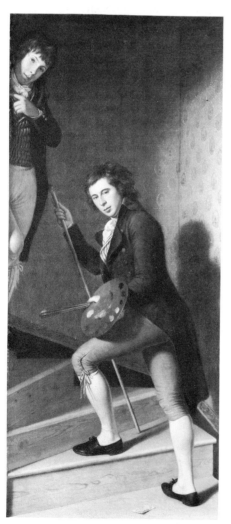

Charles Willson Peale:
The Staircase Group
(1795).
Courtesy of the
Philadelphia Museum of Art.
Photograph by A. J. Wyatt,
staff photographer.

Raphaelle Peale:
After the Bath
(1823).
Courtesy of the
Nelson Gallery-Atkins
Museum (Nelson Fund),
Kansas City, Missouri.

It was only natural that of the many children born to Peale, some should inherit their father's artistic talent. Raphaelle Peale (1774–1825) was a miniaturist and still-life painter, whose work was distinguished by the careful drawing and meticulous finish characteristic of the Dutch and Flemish schools. Though Raphaelle's pictures were not highly regarded in their time, these serene little canvases are now much esteemed for their glowing color and artful design.

Raphaelle had a gentle wit plus a fine artistic sense, both of which qualities he exploited in his well-known picture *After the Bath*. Against a dark background and covering almost the entire expanse of the canvas, Raphaelle painted a white sheet above which there emerged a feminine arm. Below, a small, bare foot shows. The unusual play of light and shade and the accented diagonal folds of the cloth create a boldly arresting composition, one that is nearly abstract in its conception and arrangement. There is a story that when his wife saw the painting, she angrily stalked out of the room, believing that Raphaelle had dared use a live, nude model. She need not have

worried; the figure was imaginary. But her behavior reflected the general attitude of American society, which condemned the use of nude models and even the depiction of nudity as obscene. It was an attitude which imposed severe limitations on American painters for many years.

Rembrandt Peale (1778–1860) was both talented and energetic. At seventeen he was one of the four Peales (his father, his brother Raphaelle, and his uncle James being the others) invited to paint Washington's "dismal countenance" as Rembrandt called it. A number of the portraits in his father's museum were painted by Rembrandt. His likeness of Thomas Jefferson is an especially sympathetic and perceptive character study of the aging statesman. Rembrandt was, however, an uneven painter. Some of his canvases are handled with skill and insight, while others are poorly executed and sorely overworked.

Rembrandt spent a brief period in Paris and in London where he took some instruction from West. He built his own museum in Baltimore, Maryland, and founded the city's first gasworks. He was so busy with other things that for a time he simply stopped painting.

In 1820 he "resumed the brush" to paint a huge allegorical canvas called *The Court of Death*. It depicts the ultimate victory of death over life and was intended to "strike the heart at once as with an electric glance." The picture was shown to thousands of enthusiastic spectators, who after paying their admission were also subjected to a lecture on morality. Exhibitions of this kind were a common form of popular entertainment in those days and one way in which an artist could earn a living. Rembrandt's canvas grossed more than eight thousand dollars during the first year and continued to have a successful run for more than half a century. Rembrandt was a practical man. When he was not hammering away at human sin, he was extolling the merits of illuminating gas and demonstrating its uses.

A third son, Rubens Peale (1784–1864) painted small and pleasing still lifes and nature studies that were inferior to those of Raphaelle. Rubens spent most of his life working in his father's and brother's museums and became an artist only in his later years.

The youngest painter in the family was Titian Ramsay Peale (1799–1885), one of the boys in the *Staircase* picture. Titian, who was taught the craft by his brother Rubens, was primarily a naturalist. His book on the insects of America, *Lepidoptera Americana* (now in the collection of the Philadelphia Academy of Natural Sciences), is embellished with precisely drawn, accurate illustrations.

The long list of artistic Peales includes Charles Willson's younger brother, James Peale (1749–1831), whose likeness Charles set down in *The Lamplight Portrait*. Essentially a painter of miniatures, James was also the author of a number of quietly appealing still lifes that resemble those of Raphaelle. Four of James' five children (three of them girls) turned out, not astonishingly, to be painters—of very modest ability, however.

A nephew, Charles Peale Polk, who received lessons from his uncle James, was also a painter. This Charles, unlike his namesake, was a painter of second-rate portraits of Connecticut Yankees. The last of the Peales to practice art was Rubens Peale's daughter Mary Jane, who died in 1902.

PEACHES FROM POTATOES: GILBERT STUART

ON JUNE 16, 1775—three short months after the first shot was fired at Lexington—Gilbert Stuart (1755–1828) sailed for London. His concern was not for his country, but the furtherance of his own career. When some eighteen years later he returned, it was as the foremost painter in the United States of America.

Stuart was an extraordinarily gifted artist. Unfortunately, he had his limitations. He was a head painter. No other aspect of portraiture had meaning for him. He could, but only when sufficiently challenged, handle the figure, drapery, and background. For the most part, however, he was too bored to bother with such elaborations. His flesh tones, normally radiantly aglow with life, could occasionally grow excessively pink. He was too often willing to sacrifice his artistic standards for financial gain.

Yet these are but minor flaws in the body of his work. He was a superb colorist and a painter with a genius for laying bare the inner character of his sitter. As West once said, Stuart could "nail the face to the canvas."

According to a friend, Stuart was even in his youth a "very capable, self-willed boy." Born in North Kingstown, Rhode Island, Stuart was raised in what he called "a hovel on Bannister's wharf" in the neighboring town of Newport. His exceptional aptitude for drawing heads caught the eye of Cosmo Alexander, a visiting Scottish painter, to whom Stuart became an apprentice. In 1772 Alexander took Stuart to Edinburgh to study, but the Scotsman's death put an end to Stuart's hopes. Stuart managed to work his way home as a hand on a coal boat, but the experience so unnerved him that he never again referred to it. After a short time he was back painting likenesses from commissions secured by an uncle. However, Stuart had no intention of spending the rest of his life as an itinerant portraitist in the colonies. England was his goal. And while other young men were taking up arms in defense of freedom, he packed his gear and sailed to the enemy's shores.

English portraitists were highly skilled painters who worked with consummate grace and delicacy. Stuart could not hope to compete with such formidable talents; he found no market in London for the dry, matter-of-fact style he had brought with him from the colonies. In 1778, after three years of aimless

floundering, he became a student of West. In the four years he worked under West, Stuart diligently applied himself to learning the fundamentals of art. To round out his artistic education, he also attended classes at the Royal Academy.

In 1782 Stuart exhibited his first mature work, a full-length portrait painted in the elegant style of the English. *A Gentleman Skating* is an exceptionally handsome picture, beautifully drawn, rich in color, and showing how brilliantly Stuart could handle the figure, the clothing, and the landscape background when he so desired. The portrait, unsigned as usual, created a sensation and put him in the front ranks of England's portraitists. The canvas was later bought by London's National Gallery and for many years was variously attributed to Gainsborough, Romney, and Raeburn, the great men of English portraiture. By the time he was thirty years old, Stuart was regarded as one of Britain's leading artists.

Fame was a heady wine. He married a girl half his age. He had always been careless with money, his own and others. Now he began to live in prodigal splendor. To pay for some of his excesses, he dashed out half-finished likenesses for which he demanded full payment in advance. This unseemly practice barely marred his reputation.

To escape the clutches of persistent creditors, he fled to Ireland in 1787 and was immediately taken up by the Irish gentry. To escape his Irish obligations, he departed for America sometime in late 1792 or early 1793.

Stuart had been absent for almost eighteen years. He had left a nation of British colonials on the verge of war and returned to a nation free and independent—the United States of America—with George Washington as the first President. Stuart settled briefly in New York, then moved to Philadelphia, at that time the seat of the federal government. News of his fame had preceded him, and no sooner had he set foot on his native soil than the "Stuart fever" began to spread. As in England and Ireland, the most distinguished of

American statesmen and social leaders came to be painted by his hand.

Less out of patriotism than because he knew it would enhance his prestige and his pocketbook, Stuart sought permission to paint the President. He eventually produced three likenesses: the Vaughn portrait, which shows a three-quarter view of the right side of Washington's head; the Lansdowne, a full-length study; and the Athenaeum portrait, a three-quarter view of the left side of Washington's head. It is this last portrait by which Washington is known to the world at large.

In 1803 Stuart followed the government to the new capital in Washington, D.C., where his many sitters included John Adams, Thomas Jefferson, James Madison, James Monroe, and John Quincy Adams. Two years later he settled permanently in Boston. Here the "'fever" raged with undiminished intensity. He was recognized as America's finest painter—an honor he accepted as rightly his—and was idolized by a group of young painters who reverently aped his style.

Stuart grew increasingly vain, quick-tempered, and insolent as he aged. "What a business is that of portrait painter," he complained. "You bring him a potato and expect he will paint you a peach." His acid tongue, his capriciousness, and his habit of taking snuff or drink offended many clients who thereafter betook themselves to less-talented but better-mannered painters.

Too old and too egocentric to reform and always desperately in need of money, Stuart continued his less than honorable business practices. He accepted money in advance for portraits he never completed and took money from one client for a portrait which he then sold to another. He kept the Athenaeum portrait for himself instead of giving it to the President, as custom would have dictated. He made innumerable copies of his Washington portraits for public sale, frequently combining, with unhappy results, different sections of each.

According to his daughter, he ground them out almost to the very last day of his life.

Stuart succumbed at the age of seventy-two, leaving his family penniless. Possibly in retribution for the years of suffering, his wife had him buried in the cheapest coffin available and then promptly "forgot" the site of the grave. It was located years later (by more interested parties) in Boston Common and is now marked by an engraved bronze palette.

"It is of no use to steal Stuart's color," West once remarked; "if you want to paint as he does, you must steal his eyes." Stuart was an investigator of human character, and almost infallibly the true character of his subject emerged from the bold brushstrokes and rapid, expert execution. He had no use for the traditional convention of making preliminary drawings on the canvas, then filling in the outlines with color. He believed in painting directly on the canvas with brush and color, blocking in the masses of light and dark, then building

Gilbert Stuart:
John Adams
(1823).
Courtesy of
Mr. Charles Francis
Adams.
Photograph courtesy of
the Frick Art Reference
Library.

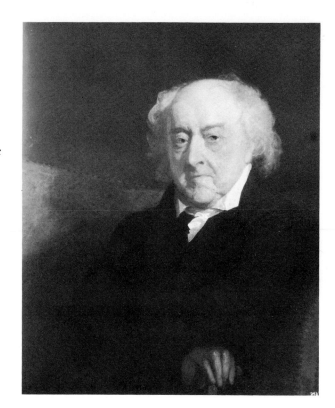

up the form with layers of fresh, clear color and an overlay of thin, luminous glazes.

When he painted the tight-lipped, wrinkled countenance of the elderly John Adams, Stuart was himself nearing seventy and suffering from a noticeable tremor of the hands. But neither Stuart's eyes nor his hand had lost their skill, and the painting reflects the enduring vitality and intelligence of the aged statesman. Stuart's portrait of *Mrs. Richard Yates* is a brilliantly conceived and executed study of a mature woman. With great subtlety he "nailed" her individuality on the canvas as she paused momentarily, her needle poised, to glance up from her sewing.

Copley had been the first painter of major stature in colonial America. Stuart was the first painter of major stature in the United States of America. He exerted a profound influence on the development of American portraiture. To the younger generation, anxious to shed their provincialism, he was the exemplar of the sophisticated perfection of the British portrait style. Where previously native artists had aped Copley's manner of painting, now Stuart became the master, and his the style to follow.

A PLEASANT JOURNEY: THE LATER PUPILS OF WEST

WEST, COPLEY, AND STUART had shown how valuable foreign training could be. With such shining examples of success in mind, young Americans began again to seek a more informed artistic education abroad. Since American artists had gone to West before the Revolution, it was only natural that after the war American artists should once more head for his studio.

One of the earliest to arrive was Mather Brown (1761–1831), a self-taught miniaturist and portrait painter in the New

York and New England areas. With good, hardheaded business sense, Brown combined his artistic career with wine-selling. Thus if he couldn't persuade a customer to take one article, he might persuade him to take the other or, hopefully, both.

In 1780 Brown went to Paris and the following year came to West. A twelvemonth later he set out on his own. He gained a considerable clientele from among the British upper classes with able but dull likenesses. He did so well that he never returned to America.

William Dunlap (1766–1839) spent four years with West, studying little and learning less. The "American Vasari" (as he was called after the great art historian of the Renaissance) earned his reputation not as a painter but as the author of the first comprehensive book on American art.

He was born in Perth Amboy, New Jersey. The accidental loss of his right eye in childhood in no way interfered with his decision to become an artist. He studied with William Williams, then, at eighteen, entered West's classes. In 1788 he returned to New York no wiser than before and tried vainly to find customers for his inferior pictures. He worked as a paymaster in the army, became an ardent Abolitionist, painted, wrote, and produced plays. His later years were plagued by poverty and ill health.

He began writing about art during the latter part of his life. *A History of the Rise and Progress of the Arts of Design in the United States* was published five years before his death. It is less an objective evaluation of American art than an autobiography. Many of the men who figure in the volume were personal acquaintances. Dunlap's critical assessment of their talents is acute and intelligent. But Dunlap could not resist sitting in judgment. He would occasionally condemn a talented painter for his lack of morality, then praise a mediocre one for being a model of propriety. Nevertheless, the book served for many years as the most informative work of its

kind, and it is to him that we are indebted for much of our knowledge of early American painters.

When he set himself up as a "miniature painter and hair-worker" in Philadelphia, Robert Fulton (1765–1815) had no inkling that he would become famous as the inventor of the steamboat. Though he had a keen interest in science, his chosen profession was art. He came to West in 1787 and remained for several years. By the time he went to Paris in 1793, his interests were reversed; engineering became his major occupation and painting simply a means of support.

To finance his scientific research, Fulton painted the first panorama ever to be seen in the French capital. Invented by a Scottish artist named Richard Barker in 1788, the panorama was a continuous painting on the walls of a circular room. It could also be a long painting mounted on poles which, when it was slowly unrolled, presented an unbroken scene of a landscape, a seascape, or even a battle. The panorama was the eighteenth-century version of the modern travelogue and became a popular form of public entertainment. For many artists it was a means of raising money. Such men as John Vanderlyn and Charles Willson Peale produced and exhibited their own panoramas. Peale even went so far as to add sound effects during the performance to heighten the realism of the scene. In later years the term *panorama* was used almost exclusively to describe huge canvases with an unlimited view of a landscape.

Fulton's panorama was his virtual swan song to the arts. He returned to the United States in 1806. The following year his steamboat *Clermont* made its historic 150-mile trip up the Hudson River from New York to Albany.

Ralph Earl's decision to attend West's school was as much motivated by a need for self-preservation as it was by the need for self-improvement. Earl (1751–1801), a rabid Tory, ran secret missions for the British during the Revolution. Rage

against his political activities rose to such intensity that, to save his skin, he hurriedly departed for the Continent in 1778, leaving behind a wife and children. He became a pupil of West's the following year.

Born either in Connecticut or Massachussetts, he appeared in New Haven shortly before the war, painting likenesses "in the manner of Copley." Despite his pro-Tory sentiments (or possibly because of them), he followed the Connecticut troops to Lexington and Concord. He made four small drawings of the battle, which were later engraved and marketed by a friend.

In 1785 Earl came back to Connecticut, leaving behind another wife and set of children in England. His political transgressions forgiven, his marital transgressions ignored, he settled down to a comfortable career as a portraitist.

Earl's hand was as unskilled as a limner's. His strength lay in his ability to capture the personality of his subject. The life-size portrait of *Roger Sherman* is exceptional for its primitive originality and depth of perception. Posed stiffly against a bare, dark background, Sherman sits on a wooden chair, staring out of the canvas with an unbending severity of countenance.

His years abroad had made Earl a more accomplished craftsman. His skill at delineating character remained intact, but now his color was richer, his brushwork a little more knowing. However, he never did learn to draw correctly. Among the best of his later canvases are the full-length portraits of the brothers *Daniel Boardman* and *Elijah Boardman*. Earl set each man against the background of his daily life—Daniel against the verdant New Milford countryside in which he lived and Elijah in front of the books and bolts of cloth that filled the shelves of his store.

Earl's talents declined in his later years. Dunlap wasted few tears on him. Earl "had considerable merit—a breadth of light

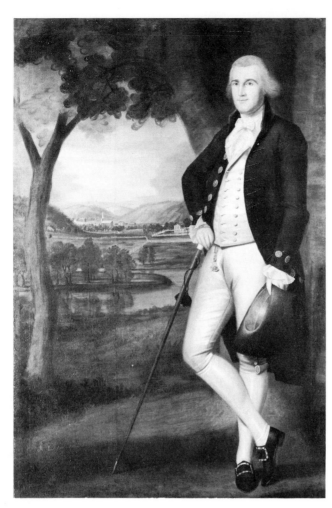

Ralph Earl:
Daniel Boardman
(1789).
Courtesy of the
National Gallery of Art,
Washington, D.C.,
gift of
Mrs. W. Murray Crane.

and shadow, facility in handling, and truth in likeness—"
Dunlap stated, "but he prevented improvement and destroyed
himself by habitual intemperance."

Earl's son, Ralph Eleaser Whiteside Earl (1785–1838) stud-
ied briefly with West. Ralph was a devoted friend of Andrew
Jackson, seventh President of the United States. After 1828 he
painted nothing but mediocre likenesses of "Old Hickory," for
which reason he was derisively known as "the King's painter."

Joseph Wright (1756–1793) had the distinction of being
the son of Patience Wright, the first woman sculptor in
America. She modeled effigies of people in wax, a skill she
perfected in England. Joseph was born in New Jersey, but

went to London to study with West and with his brother-in-law, the celebrated British portraitist John Hoppner. He returned to Philadelphia in 1783. Before his untimely death he had painted numerous portraits of Washington and Benjamin Franklin, sculpted a bust of the President, and designed the first official coins and medals for the United States mint. His pleasant little portraits are handled with much delicacy and grace.

Henry Sargent (1770–1845) painted solely for his own amusement. The only child of a wealthy merchant, he professed a desire to study art and in 1793 sailed to London,

Henry Sargent: *The Dinner Party* (*c.*1815–1820). Courtesy of the Museum of Fine Arts, Boston, gift of Mrs. Horatio Lamb in memory of Mr. and Mrs. Winthrop Sargent.

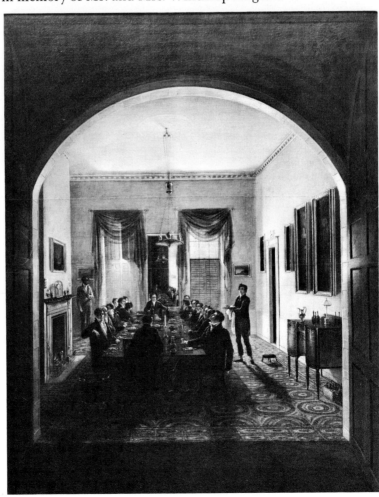

where he got some help from West and Copley. He returned to Boston with the intention of becoming a portraitist, but grew more interested in politics and painted only when the spirit moved him.

Sargent seems to have gained little from his contact with West and Copley. At one point, so that he could learn something about the handling of light and shade, he began collecting the masters of the Dutch school. (He could well afford them.) Sargent was primarily a portraitist, and his existing likenesses are almost uniformly of mediocre quality. He fared better when painting historical and anecdotal pictures. His historical canvases have disappeared, but there remain two large genre paintings which are amusing and informative descriptions of upper-class social life in the Boston of that time. While *The Dinner Party* and *The Tea Party* suffer from Sargent's weaknesses as a draftsman and colorist, they display his ability to handle indoor light and to create a balanced composition of many figures in a room.

For most of the artists who had journeyed across the Atlantic, the association with West had been but an agreeable interlude. They came home none the worse but little the better for their experience. Like their predecessors before them, they were more than happy to spend the rest of their lives painting faces.

Only three of West's later students—John Trumbull, Washington Allston, Samuel F. B. Morse—and one outsider, John Vanderlyn, dared aspire to loftier ambitions. They were condemned for their efforts, thwarted in their ambitions, and they died failures. But they accomplished, after death, what they had not been able to effect during their lifetime—they introduced the historic and romantic movements, thus enlarging the horizons of American art. And they became the first of America's major historical and romantic painters.

IV A Bitter Quartet

In 1785, four years before George Washington's inauguration, and four years before the onset of the French Revolution, Jacques Louis David started a revolt against France's Royal Academy of Painting and Sculpture. It was the first successful uprising against a ruling power in the world of art and an event of historic artistic consequence.

At that time John Vanderlyn was ten years old, Washington Allston six, and Samuel Morse would not be born for another six years. Only John Trumbull was of age, and he could have had no more than a glimmer of the dramatic significance of David's action. Yet each of the four Americans, as well as future painters, was to be affected in one way or another by the results of David's rebellion.

David had launched his rebellion in protest against the reactionary strictures imposed by the academy. But academies of art had not always been the enemies of progress. On the contrary, the formation of such an institution had been linked to the general advancement of art. The earliest organizations of this kind had originated in Italy, but in the seventeenth century France took the initiative. In 1648 Louis XIV founded the Royal Academy of Painting and Sculpture, which was later refounded under the French Republic in 1795 as the Académie des Beaux-Arts, or the Academy of Fine Arts. The institution had a dual character—it was a teaching body with two schools, one in Paris and another in Rome, and it was an honorific association dedicated to maintaining standards of artistic excellence. The academy reserved the right to exhibit the works of its members. And members were ranked strictly in accordance with the branch of art they practiced, with historical painters holding pride of place. The academy's

showcase was an annual exhibition known as the Salon—an occasion of great social and artistic importance.

The academy served as the prototype for all other such organizations including the National Academy of Design, for many years the most important school and society of artists in the United States. Because the Royal Academy of Painting and Sculpture was the sole institution devoted to the arts, it soon became all-powerful. And although there were minor differences between the French Academy and the National Academy of Design, both became the strongholds of conservatism and the symbols of reactionary establishments.

As the ruling power, the Royal Academy governed with an authority that permitted no deviation from conventional formula. It decided what was proper subject matter for a painting, what the style must be, and whether or not the canvas was worthy of hanging in the Salon.

For an aspiring painter, admission to the academy and to the Salon was a matter of artistic life or death. Its stamp of approval was a necessary prelude to a successful career. Without the academy's blessing, the young painter could, at best, console himself with dreams of posthumous glory, or, if he were made of sterner stuff, throw down the gauntlet in challenge.

The academy had been in untroubled existence for almost a century and a half before David contested its authority. In defiance of the frivolous rococo mannerisms of court painting favored by the academy, he invented a new concept of art which exalted classical and republican virtues. Benjamin West had been a forerunner of a neoclassicism that was similar in some respects to David's. But David created a more dynamic, forceful brand of neoclassicism to express a profound and passionate moral conviction.

No sooner had David won his battle than his became the reigning style. In breaking away from an established artistic tradition to found a new tradition, he set a precedent for all

ensuing revolts and unwittingly wrote the first line in the history of modern art. Thus, as soon as a rebel movement succeeded in overthrowing the existing academy, it established itself as the new academy. It, in turn, became the logical target for attack by a new set of rebels. Revolt followed revolt, demolishing one tradition after another until, in the present day, there are few, if any, traditions left in art.

The revolt against David's neoclassicism was not long in coming. More and more the neoclassicists began to invest their pictures with some emotional content. In the early part of the nineteenth century there arose a movement called romanticism, which opposed the cold, controlled intellectualism of David's neoclassic style, and instead espoused an art that was individualistic, imaginative, brightly colored, and intensely emotional. Romanticism derived its subject matter from a variety of sources—the Bible, literature, contemporary events, and episodes of Greek, Turkish, or Spanish origin. The events depicted were of an exciting, violent, or exotic nature—battle scenes, lion hunts, shipwrecks, the suffering of war refugees, murder and mayhem, were some of its themes. Canvases were invested with a grand, dramatic passion, while compositional devices and vivid color were employed to intensify the emotional content. The romantic movement, spearheaded by the French painters Théodore Géricault and Eugène Delacroix, succeeded in routing the academy of David. As the new academy it reached the height of its popularity around 1830 and was later deposed by another rebel movement.

Both the neoclassical movement and the romantic movements left their impress on Trumbull, Allston, Vanderlyn, and Morse. Trumbull, Vanderlyn, and Morse, following the dictates of their ambitions, became historical painters. But their historical canvases were imbued with romantic overtones. Allston was a complete romantic, but his work, unlike that of the French school, is of a serene and dreamlike nature.

In addition, two of these men—Trumbull and Morse—were to be intimately involved in the formation of America's own academy.

Trumbull, Allston, Vanderlyn, and Morse all studied in Europe, and, inspired by the great art they had seen there, they returned to America with dreams of their own immortality. They were determined to become their country's finest historical and romantic painters in the best European tradition. All four believed they could impose a European refinement that had been centuries in the making onto the raw American culture. They were woefully misguided.

What each of them forgot was that America wasn't Europe. On the Continent, particularly in France, art was supported by the king, the church, and the government, as well as by the nobility, the upper classes, and even the middle classes. There were superior art schools and exhibition facilities. There were magnificent masterworks hung in splendid museums. There were men of affluence, taste, and culture who appreciated and bought all kinds of painting and palaces and mansions large enough to house even the largest of "grand manner" pictures.

Except for an isolated individual, patrons of the arts didn't exist in America. The government acted as sponsor only on that rare occasion when a mural was needed to enhance a public building. Puritan religion forbade painting and sculpture in houses of worship. The few schools of art that came into existence early in the 1800's were of an inferior caliber and, as one artist said, "not likely to become of much importance either in the improvement of artists or the correction of public tastes." The Pennsylvania Academy of the Fine Arts, the earliest American art institute, held its first exhibition in 1811. The show consisted of plaster casts of antique statues, a handful of still lifes and landscape paintings, and a preponderance of undistinguished portraits. Almost half a century after the National Academy had been established, it was forced to close its doors for a few years for lack of funds. The

Metropolitan Museum of Art, the first great museum in America, was not founded until after the Civil War, in 1870.

The majority of American citizens were uninterested in the "correction" of their artistic tastes and were perhaps slightly offended by the whole idea. They had other matters to attend to. While an interest in art might be desirable, John Adams, second President of the United States, felt that the government and the economy must take precedence. Art was a luxury, he concluded, which Americans would have to do without for at least another two generations.

Yet in the face of these hard realities Trumbull, Allston, Vanderlyn, and Morse persisted. Their dreams turned to ashes—gray, dry, and bitter to the taste.

JOHN TRUMBULL

JOHN TRUMBULL (1756–1843) admitted no doubts as to his place in American art. He was, incontestably, the one and the only painter of the American Revolution. Artist, soldier, statesman, architect, friend of the great and near-great, he was an aristocrat by birth, training, and belief, and arrogant as befitted his station. He was a gifted painter undone by his own temperament and ambition. Frustrated in his grand dream, deserted by his talent midway in life, he spent the better part of his eighty-seven years ranting bitterly at his country's rejection of his unique gifts.

Born in Lebanon, Connecticut, the youngest son of the governor of the state, Trumbull lost almost all sight in his left eye during his childhood—an accident which was to him no impediment. He was a studious, intelligent boy, whose favorite pastime was drawing. At fifteen, already an accomplished Greek and Latin scholar, he was admitted to the third year at Harvard College.

After his graduation Trumbull had determined to follow

a career in art, but "the low growling of distant thunder" filled him with patriotic fervor. He enlisted in the army, saw action of a sort under General Horatio Gates; became an aide-de-camp to General Washington, who used his talents as a cartographer; and rose to the rank of colonel before his twenty-first birthday. But thin-skinned and haughty, he interpreted a brief delay in his commission as an affront to his honor and in 1777 laid aside his "cockade and sword" and retired from military activity. (He nevertheless accepted and retained the title of colonel for the rest of his life.)

He went directly to Boston, rented Smibert's old studio, and from Smibert's copies of the masters, a few Copley portraits, and several black-and-white engravings, began the arduous task of trying to teach himself the fundamentals of art. The futility of his endeavors was quickly apparent. He returned home and with some difficulty persuaded his father to let him go abroad. In 1780 he left America "for the purpose of studying the fine arts" with Benjamin West.

Shortly after his arrival in England he was arrested by the British "on the suspicion of treason" in retaliation for Major André's execution by Americans. During his confinement, Trumbull occupied himself by painting and studying architecture. Finally, through the combined efforts of West, Copley, and the noted English statesman and author Edmund Burke, he was released and sent back to Connecticut with a warning not to return until the war had ended. At home Trumbull ignored his father's entreaties that he had best abandon a career more suited to the lower classes and become instead a lawyer. Four years later Trumbull was back in London, working "by day at Mr. West's house, and in the evening drawing at the Academy." His style became progressively more fluent, especially after Reynolds criticized one of his portraits as resembling so much bent tin. Yet he never forgave Reynolds and never again showed him a piece of work.

Within a year Trumbull's goal was clearly defined—he

would be *the* painter of the Revolution as well as America's greatest historical artist. He regarded himself as the only living American artist sufficiently gifted to represent the event "with the honor of truth and authenticity." In his mind, Destiny had justly chosen him for this glorious task. His subjects would be twelve decisive occasions in America's struggle for independence, in which he would incorporate the portraits of all living participants.

In 1786 Trumbull completed two of the finest pictures in his epic drama of the American Revolution. *The Death of General Warren at the Battle of Bunker's Hill* and *The Death of General Montgomery in the Attack on Quebec* are brilliantly composed and expertly painted. Trumbull's canvases did not adhere strictly to neoclassic principles. His pictures were based on contemporary events with no reference to antiquity and even included the actual portraits of some of the men involved. He handled his subject with considerable imagination and emotion and used color that was rich and glowing.

John Trumbull: *The Death of General Warren at the Battle of Bunker's Hill* (1786). Courtesy of the Yale University Art Gallery.

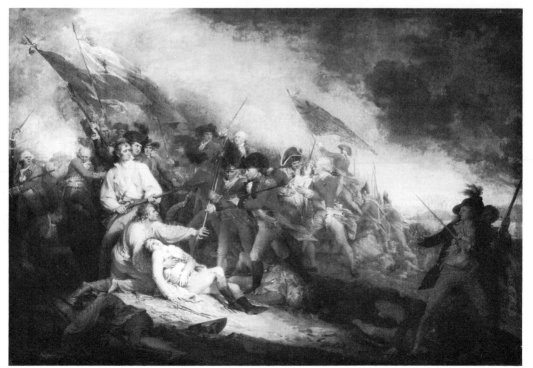

While Trumbull's concept of war was romantic, his paintings are classical in their interpretation of noble, patriotic self-sacrifice. Since David had only the year before established his brand of neoclassicism, it was more natural that Trumbull, working under West, should follow his own teacher's ideas of classicism.

Upon the invitation of his friend Thomas Jefferson, then minister to France, Trumbull visited Paris to gather additional material and to arrange for the engraving of his canvases. Jefferson believed Trumbull ranked just below David as a historical painter. This merely reinforced Trumbull's idea of his own greatness. He decided to return to the United States in 1789 and offer for sale, both to Congress and the general public, engravings of his pictures. "My future movements depend entirely on my reception in America," he wrote Jefferson, "and as that shall be cordial or cold, I am to decide whether to abandon my profession or my country."America, he felt, was morally obliged to support his venture.

In the ensuing four years he traveled through the states, obtaining the portraits necessary to his paintings and selling subscriptions for his engravings. In 1792 the South Carolina legislature commissioned a full-length likeness of President Washington. Though the portrait does not possess the character of Stuart's study of the man, still it is an impressive painting, the best "which exists in [Washington's] military character," as Trumbull granted.

By 1793 interest in Trumbull's "national work" was rapidly declining. The government and the people were enveloped by the problems of economic recovery from the war. Crucial decisions confronted the new nation. The war was still too recent and too fresh in the minds of most men to be viewed in any historical perspective. Consequently, Americans greeted his project with notable lack of enthusiasm. Bitterly wounded by public indifference, Trumbull could only fulminate against

the nation's cultural ignorance. There was no hope for the arts, he despaired, if his own "great enterprise was blighted." As once before he had in injured pride laid down his "cockade and sword," he now abandoned his profession. In 1794 he became secretary to John Jay, the newly appointed envoy to Great Britain.

"My political glory as well as my military has departed, to rise no more," he lamented. He should have wept instead for his artistic ability, which had also departed. In the forty-nine years of life left to him, his work never again showed the skill and romantic fervor of his earlier paintings. His later works were arid, inept shadows of the talent that had once been his.

The diplomatic mission ended, Trumbull returned to New York, where he had to resort to portraiture to earn a living. He sailed back to the Continent in 1808 and, caught there by the War of 1812, did not come home again for seven years. When he did, it was with the idea of giving his countrymen a last chance to support his "great, but long suspended project...."

In 1817, thirty-one years after Trumbull had begun his work on the Revolution, he was authorized by Congress to paint four of the eight panels in the Rotunda of the Capitol building. He was paid $32,000 for the series. It was said that he received the commission not because of his artistic ability but because of his political connection. Trumbull was barely gratified by the appointment. As America's greatest historical painter he was convinced that all eight panels should have gone to him.

The finished murals were static, poorly executed, oversized replicas of his small canvases. The enlargements only betrayed how much his talents had declined. One critic called the pictures "the greatest and most unaccountable failures of the age," and the *Declaration* became known as the "shin piece" for the number of legs in it. The criticism of his murals, unjustified

in his estimation, was yet another blow to his wounded pride. Blinded by egotism, he could only blame an ignorant and insensitive public for dishonoring his valuable gifts.

In 1802 a number af prominent New Yorkers, including DeWitt Clinton, had founded the American Academy of Fine Arts to promote greater public interest in painting and sculpture. The academy provided exhibition space, a collection of pictures, and casts of antique sculptures, which in the early morning hours young students might draw.

Trumbull was the academy's second president, elected in 1817. "An institution," Emerson once said, "is the lengthened shadow of one man." Unfortunately, the academy's shadow was Trumbull's. His autocratic behavior and dictatorial policies, rigidly enforced during the nineteen years of his reign, ultimately alienated almost all of the academy's members. In 1826 the insurgents, led by Samuel Morse, broke away and formed the National Academy of Design, which soon became the most important art school and exhibition center in the United States. Seven years later the National Academy proposed a merger with Trumbull's moribund institution. He was infuriated at the idea of submitting to an "upstart group." He called the merger (the only act that could have saved the American Academy) "unconditional surrender" and refused all compromise. So in 1840 the American Academy closed its doors, sold its collection of paintings and casts, and quietly expired.

Between 1837 and 1840 Trumbull wrote his autobiography, a book that Dunlap called "a defensive, self-justifying document." It is the memoirs of an embittered, arrogant, overly sensitive octogenarian, still racked by the pains of a wounded *amour propre*. The book omits all reference—as if it had never existed—to the American Academy and his connection with it.

In exchange for a yearly stipend of one thousand dollars until his death, Trumbull bequeathed his paintings to Yale University. He designed the building in which they were to

hang and so became both architect and founder of the first college art museum in the United States. His crypt, which lies beneath the gallery, is marked by a marble tablet bearing the inscription: "Colonel John Trumbull, Patriot and Artist, friend and aide of Washington To his country he gave his SWORD and PENCIL."

The contribution made by Trumbull is not inconsiderable. He was every inch a patriot, though his patriotism was sometimes misguided. His paintings give ample evidence of his particular dedication to the cause of American independence. He left a vivid record of the Revolutionary War period and his likenesses of the Revolutionary heroes are of great historical value.

As an artist, before time and disappointment had robbed him of his talent, he was a fine draftsman, with an excellent sense of color and a masterful flair for dramatic composition. His canvases, no matter how small, were conceived with a largeness of vision. His miniatures themselves are notable artistic achievements, rich in characterization, even on so diminutive a scale.

It was Trumbull's misfortune to have been defeated by his times and his talent. He was born too soon to see his dreams realized. Yet in the end he was victorious. Though he was never to know it, he is now *the* painter of the American Revolution.

WASHINGTON ALLSTON

LIKE TRUMBULL, Washington Allston (1779–1843) was infected by noble purpose and sublime dreams. He was determined ". . . if resolution and perseverance will effect it, to be the first painter, at least, from America." And by first, he meant the finest and foremost painter in his country, if not the world.

Allston was the ideal romantic—rich, well-born, well-educa-ted, intelligent, gracious, handsome, a talented writer, and an artist of great promise. With such endowments it was not at all unreasonable for him to anticipate a glorious future. But he was too many men and too much in love with immortality. The phantom of fame pursued, tantalized, and eluded, then finally destroyed him. Allston died a failure in his own eyes and in the eyes of his contemporaries.

The son of a wealthy landowner, Allston was born in South Carolina and educated at one of the best preparatory schools. At seventeen he entered Harvard College, where he dis-tinguished himself scholastically. At his graduation in 1800 he was voted class poet. During these years he counted among his close friends William Ellery Channing, the leader of the Unitarian movement (later his brother-in-law), and the artist Edward Greene Malbone (1777–1807).

Eager to learn whatever he could about art during the time he was at Harvard, Allston took some lessons from Samuel King, a self-taught portrait and house painter. In 1801 Mal-bone and Allston sailed for London, where both entered the Royal Academy. When Allston discovered that drawing was the only course available, he went at once to work with West.

Malbone remained at the Royal Academy for six months. His specialty was miniature paintings of people and land-scapes. Miniatures were done in oils or watercolors on ivory, wood, or metal, and they had for many years a considerable vogue in America because they were both small and cheap. For this type of work Malbone felt he had no need of more thorough training. He returned to a very successful practice in South Carolina, which was cut short by his premature death. Of his charming and delicate portraits Allston said, "He had that happy talent . . . of elevating the character without impairing the likeness"

In 1803 Allston met the American painter John Vanderlyn, an equally romantic idealist, with whom he departed for Paris.

Allston was overwhelmed by the great masterpieces hanging in the Louvre—the spoils of Napoleonic victories. They "enchanted me," he wrote, "for they took away all sense of subject I thought of nothing but the gorgeous concert of colors, or rather the indefinite forms . . . of pleasure with which they filled the imagination."

He spent about a year in Paris and then moved on to Italy, arriving in Rome in 1804. The ancient and eloquent ruins, the beautiful landscape, the sunny climate, and the magnificence of the Renaissance painters intoxicated him. His most intimate companions were Samuel Taylor Coleridge, the noted English poet; the famous American writer Washington Irving, then a fledgling lawyer; and Vanderlyn. In happy camaraderie, Irving wrote, they "pictured forth a scheme of life, all tinted with the rainbow hues of youthful promise."

These were the most fruitful years of Allston's life. Inspired by the Venetian masters, he painted a number of allegories and landscapes using rich and luminous color to convey atmospheric light. *The Rising of a Thunderstorm at Sea*, done in 1804, showing two little boats being tossed about in stormy waters, is a beautifully imaginative conception of the terror and mystery of nature. *Italian Landscape* and *Diana in the Chase*, done in the same period, are serene and glowing fantasies. They were lyrical visions of nature, imbued with a romantic poetry familiar to European painting, but not yet seen in American art.

In 1808 Allston returned to Boston. He had both a fondness and a minor talent for writing, and before too long he was embroiled in the literary life. During these years his painting was limited to portraits of close friends or relatives. But Boston was no Rome, and Allston's creative spirit shriveled in the unromantic artistic climate of New England. He needed a warmer, more congenial atmosphere to inspire him.

Allston fled to London in 1811. There he renewed his friendship with West and Coleridge, and to his list of intimates

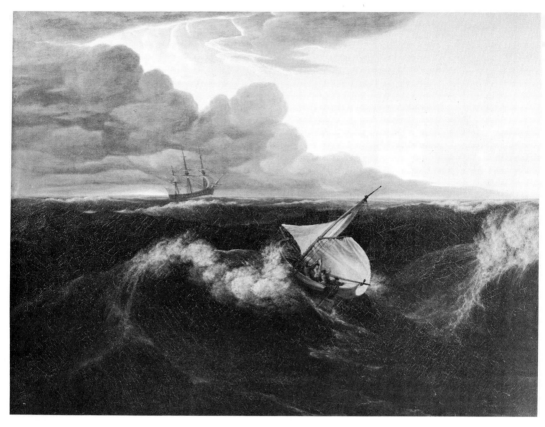

Washington Allston: *The Rising of a Thunderstorm at Sea* (1804).
Courtesy of the Museum of Fine Arts, Boston, Everett Fund.

added the names of Robert Southey and William Wordsworth, who with Coleridge were then the three great men of English poetry. His spirit restored, Allston was now fired by a new theme—the interplay of "mystery and fear in the human relationship"—a darkly romantic theme which increasingly occupied his thoughts. In 1813 he finished work on *The Dead Man Revived in the Tomb by Touching the Bones of the Prophet Elisha*. Based on a Biblical incident, the painting successfully counterpoised the real and the supernatural. The British Institution responded with a remarkable show of neutrality, awarding it a prize even though the United States and England were then at war. At the war's end the Pennsylvania Academy of the Fine Arts bought it for its permanent collection. Fame now seemed surely within his grasp.

Allston plunged into a state of fevered activity, working without rest until he collapsed. When he was on the verge of recovery, his young wife died and the shock sent him into a severe depression. In 1817, his health on the mend, he began working on preliminary sketches of *Belshazzar's Feast*, a canvas that was to embrace "a multitude of figures" uniting "the magnificent and the awful." The picture was a mystical conception of the terror instilled in man by supernatural events. It was to be his crowning achievement and his claim to immortality. It became his nemesis.

The massive canvas—twelve by sixteen feet—was partially complete when Allston decided to return to Boston in 1818. Gilbert Stuart was now an old man, and it seemed logical that Allston's dream of becoming the "first painter" in America was about to be realized. But once again he was diverted by literary affairs.

The inheritance on which Allston had lived was finally exhausted, so he resorted to painting small canvases which he sold for a pittance. *Belshazzar,* meanwhile, remained untouched. In spite of his problems, he managed to create two of his most beautiful and haunting pictures—*Moonlight Landscape* and *The Flight of Florimel*. Both are lyrical visions of nature, touched by the melancholy sweetness of some half-remembered dream.

To free Allston from financial worry and allow him to finish his masterpiece, ten philanthropic Boston merchants contributed one thousand dollars each to "The Allston Trust," thus affirming their belief in his genius. But Allston's original inspiration had vanished. He labored endlessly over the *Belshazzar*. A minor shift in perspective suggested by Stuart (who had no experience with large-scale figure compositions) resulted in "more than twenty thousand chalk-lines in circles and arcs to bring the amended figures into correct drawing," said Allston's biographer, Sweetser.

Persecuted by conscience to repay his benefactors and

driven by desperation to nail down his elusive dream, Allston was a man in torment. He saw the canvas as the decisive painting of his career. So long as it remained unfinished, he could only think of himself as a failure. "I began to look on my picture as something I must finish in order to get so much money . . ." he confessed, "and the spirit of the artist died away within me I was like a bee trying to make honey in a coal hole." In the eyes of his contemporaries he was bankrupt as an artist. The imaginative landscapes exhibited at the inaugural show of the Boston Athenaeum in 1827 were censured as being "too exotic and vague." To the very end Allston wrestled with his monstrous "masterpiece." Only in death, said his brother-in-law, was Allston able to escape from "that terrible vision, the nightmare . . . the tormentor of his life."

Allston died with his hand outstretched, still groping for immortality. Though he and his compatriots were unable to recognize it, he was an artist of unusual imaginative powers and a colorist unequaled in his day. Allston was not the "artistic and poetic genius unsurpassed by any man of his age," as Coleridge believed. But he was the first important romantic painter in American art, the first to create an art from the visions that fill the mind.

JOHN VANDERLYN

THE SAD NEWS of Allston's death awoke bitter memories for John Vanderlyn (1775–1852). "When I look back some five or six and thirty years since," he mourned, "when we were both in Rome together, and . . . in the spring of life, full of enthusiasm for our art, and fancying fair prospects awaiting us in after years, it is painful to reflect how far these hopes have been from being realized."

Like Trumbull and Allston, Vanderlyn was certain that his

was an extraordinary talent, a talent capable of transforming America's provincial tastes in art. But Vanderlyn's paintings held no magic for his countrymen. He was far too "Frenchified" and sophisticated for their liking. Failure was inevitable. He ended his days impoverished, his ability gone, bemoaning the death of his once glorious dream.

The grandson of a Dutch colonial limner, Vanderlyn was born in Kingston, New York. At seventeen he went to work for a New York City firm of print dealers, studying drawing in the evening at the newly founded Columbian Academy of Art. His copy of a Stuart portrait caught the attention of Aaron Burr, then senator from New York and later vice-president under Jefferson. To rescue this "genius from Obscurity," Burr sent him to study with Stuart and, in 1796, to France.

Vanderlyn was the first American to study in Paris. He spent five years at the Ecole des Beaux-Arts learning about composition, anatomy, figure painting, and drawing—laying the foundations of what he expected would be a brilliant career. In 1801 Vanderlyn returned to New York, a finer draftsman with more knowledge of the human figure than any of West's students. When Burr suggested that there might exist a profitable market for such picturesque landmarks, he painted two views of Niagara Falls. He also executed several portrait commissions. But this was for bread and butter. His ambitions were more exalted.

Two years later Vanderlyn was back in Europe, ostensibly to purchase casts of antique statues and copies of the masterpieces for the American Academy. He stayed in Paris just long enough to buy a few casts, then dashed off to London to find engravers for his own pictures. He returned to Paris with Allston, whom he later joined in Rome. The academy then fired him for having failed to live up to his obligations.

In 1807 Vanderlyn painted *Marius Amid the Ruins of Carthage*, the purest example of neoclassicism produced by an American artist. When, the following year, the picture was

shown at the Salon, it was commended for its "impeccable execution" and awarded a gold medal by Napoleon. Vanderlyn saw his star burning brightly. His painting had been singled out for honor. He is supposed to have refused the emperor's offer to buy the canvas for the Louvre, because he wanted to keep it for American exhibition. *Marius* would ensure his glory in his own country as it had in France. The truth of the matter was that Napoleon was hardly a connoisseur of art, and the medal was merely one of many such prizes.

Vanderlyn now laid plans for a new work. "Something in the female," he decided, "to make it more engaging to the American spirit." The "something in the female" was his *Ariadne,* a picture of the daughter of Minos, mythical king of Crete, asleep in a forest. The first full-scale nude to have been painted by an American, it is incontestably Vanderlyn's finest canvas. The beautifully drawn figure possesses a sculptural solidity and sensuous vitality that has seldom been seen in

John Vanderlyn: *Ariadne* (1814).
Courtesy of the Pennsylvania Academy of the Fine Arts.

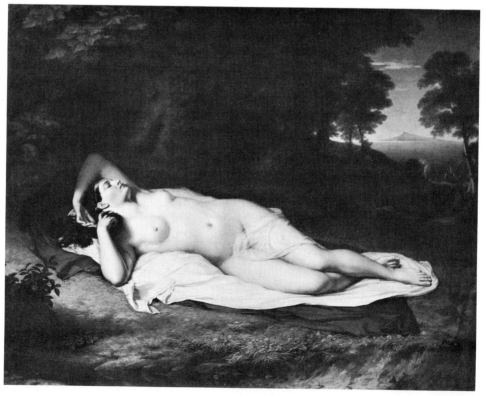

American art, then or now. But if his artistic judgment was acute, his knowledge of the "American spirit" was grievously limited. What was suitable subject matter in France was to prove inadmissible in his native land.

Vanderlyn was forty years old when he returned to New York in 1815. After seventeen years in Europe, America seemed like a cultural backwoods. Neither public taste nor the country's art had made any appreciable headway, it seemed to him. To complicate matters, during Vanderlyn's absence Burr had killed Alexander Hamilton and conspired in treasonable activities. People recalled Vanderlyn's association with Burr. And, innocent as he was of all political intrigue, Vanderlyn was for a time treated with some mistrust.

Neither fame nor fortune greeted Vanderlyn on his arrival. He was reduced to painting portraits, but his snail's pace and his open contempt for this form of work enticed few clients into his studio. When Congress, handing out commissions for the Rotunda murals, bypassed him in favor of Trumbull, he was outraged. Believing himself the finer artist, Vanderlyn engaged in a bitter and unending feud, charging Trumbull with having used unfair means to obtain the assignment.

With money raised by friends, Vanderlyn built his own rotunda to give Americans a full view of his genius. In the circular room, he displayed his panorama of Versailles. In adjacent rooms he hung his copies of the old masters and the only three historical canvases he had produced in his long years abroad—*Jane McCrea, Marius,* and *Ariadne.* But panoramas were out of vogue, and spectators were unmoved by his classical paintings. Only the *Ariadne* attracted attention, and then it inflamed the public with its nakedness.

The puritanical morality of American culture condemned nudity in almost any form as licentious, obscene, and corruptive. Naked little cherubs in a statue by the American sculptor Horatio Greenough "raised an outcry of censure." Plaster casts were draped or strategically covered with fig leaves to conceal

the genitals. The English author Frances Trollope, who in 1832 published her impressions of the United States, complained of the "coarse minded custom" of having men and women enter separately a gallery containing antique casts. Unclothed human models were taboo in American art schools and it was many years before the nude was accepted as a necessary part of art training.

(*Ariadne* was later restored to popular favor through an engraving by the landscape painter, Asher Brown Durand. The black-and-white print was impersonal. The lack of color diminished the illusion of a living figure and did not offend people as the painted figure had.)

The unexpectedly harsh criticism of his work was devastating. Instead of the brilliant career Vanderlyn had envisaged, he was now hopelessly in debt, his morale and his talent undermined. A congressional commission to paint a full-length copy of Stuart's *Washington* did little to dispel his discouragement. "Were I to begin life over again," he said angrily, "I would not hesitate to . . . paint portraits cheap and slight, for the mass of folks can't judge the merits of a well-finished picture." He had much justification for his bitterness.

Belatedly, in 1838, he was asked to do one of the four remaining Rotunda panels, the subject to be *The Landing of Columbus*. Vanderlyn was sixty-three years old when he left for Paris, hoping there to recapture his former ability. He made a few preliminary drawings, but failure had gnawed away the last of his confidence. Unlike Allston, who labored conscientiously, if futilely, to redeem himself, Vanderlyn was said to have hired other hands to complete the work. Rumors of this irregular procedure became widespread and accusations of fraud were hurled at him. Vanderlyn barred his door, leaving the world "to think as they pleased." He was broken, discredited; the lifeblood of his art had run out. It was, he cried, "Too late! Too late!"

The final humiliation came in 1844, when the completed mural was dismissed as nothing but "a spiritless huddle of costumed studio models." The day before he died, Vanderlyn returned to Kingston without so much as a small coin to pay for the transportation of his luggage to a hotel.

Vanderlyn was a splendid draftsman and a truly gifted painter, but not the incomparable genius he thought he was. Perhaps, under other circumstances, he might have become one of America's outstanding artists. Had American morals and the times been otherwise, he could have been a first-rate figure painter, as his *Ariadne* proves. But Vanderlyn was too much imbued with the lofty traditions of European neoclassicism. He was, indeed, too "Frenchified" for the America of his day. Vanderlyn was a victim of mistiming. Like his contemporaries, he had been born too soon.

SAMUEL F. B. MORSE

SAMUEL FINLEY BREESE MORSE (1791–1872) aspired to heights even beyond those of Trumbull, Allston, and Vanderlyn. Describing his emotions in a letter to his father, Morse explained that it was his ambition "to be among those who shall revive the splendor of the fifteenth century; to rival the genius of a Raphael, a Michelangelo, or a Titian . . . to shine not by a light borrowed . . . but to strive to shine the brightest."

It never occurred to Morse that he was not the equal of the Italian masters, or that those times, that country, and those people were far different from his own. The grand irony is that he was the only one of the four who succeeded. He gained everlasting fame as the inventor of the telegraph; as an artist, he too was a failure.

Morse was born in Charlestown, Massachusetts. He was the oldest son of the Reverend Jedidiah Morse, a Congregational

minister and teacher, whose books on the subject were so popular that he was known as "the father of geography." Samuel Morse was educated at Phillips Academy and Yale University, from which he was graduated in 1810.

He had an inventive turn of mind and an interest in chemistry even as a youth. His first study of electrical phenomena was made while he was still at Yale. With his brother's help he later devised a machine for cutting marble and patented a fire-engine pump. But his paramount ambition was to become a painter, to fulfill "the talents which Heaven has given me for the higher branches of art." Despite his father's reluctance, Morse sailed for London with Allston in 1811. There he studied privately with Allston and attended West's classes at the Royal Academy.

It was inevitable that Morse would become a disciple of classicism. "I cannot be happy unless I am pursuing the intellectual branch of art," he declared. "Portraits have none of it; landscape has some of it; but history has it wholly." *The Dying Hercules*, his first historical picture, completed the year of his arrival, was favorably received at the Royal Academy exhibition, and a clay model sculpted for the painting won the student gold medal at the Society of Artists. Another canvas, finished in 1814, *The Judgement of Jupiter*, was good enough to have earned him a prize had he shown it. But his money had run out, and his father demanded his return.

Morse had every expectation of continuing his career as a historical painter when he came back to Boston in 1815. But instead of being hailed as a "rival" of the Italian masters, he was compelled to earn his living at portraiture. Had Morse been realistic, the rejection of his "grand manner" paintings might not have been so painful. He was thirty-five years Trumbull's junior and should have had some awareness of how little excitement Trumbull's historical pictures had generated. Vanderlyn's recent experience should have awakened

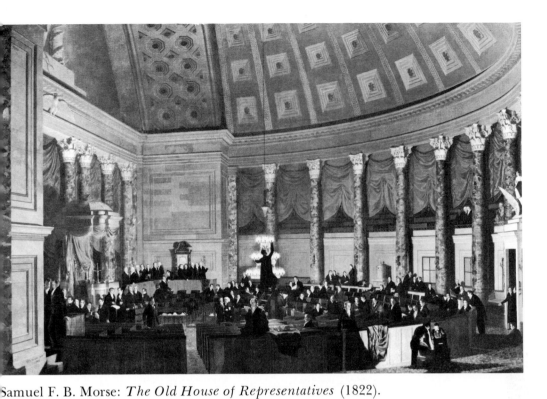

Samuel F. B. Morse: *The Old House of Representatives* (1822).
Courtesy of the Corcoran Gallery of Art.

doubts about his own fate. But Morse, like his compatriots, was blinded by personal ambition.

In 1822 Morse finished *The Old House of Representatives,* a picture he felt certain would win loud approval from his countrymen. Though he had previously adhered to the rules of neoclassicism, in this painting and in a later picture of the Louvre, Morse departed from its principles. Ignoring any allusion to antiquity, he chose as his subject matter the building and the men that, to him, symbolized the ideals of American democracy. The canvas showed the eighty-six legislators at work in the handsome old Hall of Congress. What might have been a dull and ponderous subject, Morse transformed into a colorful, well-integrated, and original composition. But this painting was no more successful than his earlier historical works. The aesthetic merits of a canvas in which a host of figures had been interestingly united with the architectural

background left Americans cold. A petition to have Congress buy the work was bluntly refused.

In 1823 Morse settled in New York, where he eked out a living as a portraitist. Despite his disdain for this type of art, he was a better than average painter. *The Muse, Susan Walker Morse,* is a charming and well-executed likeness of his sixteen-year-old daughter. A full-length portrait of the Marquis de Lafayette, commissioned by the city of New York in 1825, is a powerfully effective character study of the aging French patriot. Though it established Morse's reputation in the city's art circles, it brought him little financial reward.

Morse was dedicated to the "higher" forms of art and would not settle for half measures. In 1829 he went abroad to France and Italy, and three years later he returned with two canvases designed to elevate and educate American taste. *The Chapel of the Virgin at Subiaco* is an agreeable, highly polished landscape, much influenced by the Italian masters. The second canvas, *The Gallery of the Louvre,* was intended to give his fellow Americans their first view of some of the finest of the world's art. A picture of one of the galleries of the great museum, like the earlier *House of Representatives,* it demonstrates his unusual aptitude for composing a unified structure out of diverse elements. It is a remarkable painting in many ways, containing, as it does, over forty faithfully rendered miniature versions of masterpieces, including Veronese's *Wedding Feast,* Titian's *Entombment,* and Leonardo da Vinci's *Mona Lisa.* But the work was a dismal failure. Americans were as bored with his lofty ideals as they were with his art.

Of necessity portraiture became the mainstay of his living. He dabbled in politics, running unsuccessfully for mayor of New York in 1836 and 1841. In 1835 he became a professor of art at New York University, where he taught photography as well as painting. In Paris he had met Louis Jacques Mandé Daguerre, the inventor of the camera. Morse had great ad-

miration for the instrument, which he called "Rembrandt perfected." One of Morse's students, then an aspiring painter, was the famous Civil War photographer Mathew B. Brady.

Morse was painfully poor, sometimes on the edge of starvation. His teaching post was unsalaried, and his portraits brought him minimal recompense. But few suspected or were aware of his desperate circumstances. He made one last attempt in 1835 to save his career, applying for two of the four remaining panels of the Rotunda. Only after his bid had been rejected, did Morse finally devote himself to scientific research. By 1835 he had finished the first model of the telegraph, and in 1844 he tapped out the first message—"What hath God wrought"—to an incredulous world. His invention revolutionized communications and brought him the immortality that he failed to win as an artist.

Morse retained a lifelong interest in the arts. He presented one of Allston's paintings to Yale and was always helpful to aspiring artists. For almost two decades he was president, the first so elected, of the National Academy of Design. In 1845 he resigned his seat, severing his last link to art. "The very name of pictures produces a sadness of heart I cannot describe," he said in his farewell speech. "Painting has been a cruel mistress to many, but she has been a cruel jilt to me. I did not abandon her; she abandoned me"

As if to underline his statement, a cast of *The Dying Hercules* was discovered hidden among the rubbish in the cellar of the Capitol building where he was preparing to demonstrate his invention. The painting of the Louvre had been sold for a pittance to finance his experiments, and *The Old House of Representatives* was found, years later, cracked and begrimed, nailed to the wall of a New York City warehouse. When he died at the age of eighty-one, rich and famous, hardly anyone remembered or even knew that he had ever been an artist.

In 1843 the Apollo Association, an organization founded to

support the work of living American artists and more fully described in Chapter VII, issued the following statement:

> We have no public galleries; our high-ways are ornamented with neither monuments nor statues; the men of wealth and taste among us, who possess works of art, shut them up within the walls of their houses, where they are as much lost to the world as though they had never existed . . . churches now are the last places where an artist would look for encouragement, and the state hardly acknowledges the existence of art

The statement was issued in the year in which both Trumbull and Allston died, nine years before Vanderlyn's tragic end and one year before Morse flashed his telegraphed message to the world. Yet in a nation where much artistic talent survived unknown and unappreciated, or perished "from the neglect of their countrymen" (as one of the neglected charged), Trumbull, Allston, Vanderlyn, and Morse blindly expected, even demanded, public and private support.

Their idealism, however well meant, was ignored by a nation dedicated to advancing its great material wealth. Americans accepted art as a necessary or decorative adjunct of social status, but were not ready to receive it as a meaningful and important part of their culture. In a more receptive atmosphere the four men might have ripened into finer painters. But it was as much due to their own imperfections as to the nation's that they all fell short of their exalted purposes. They were gifted men, but not men of genius. Trumbull, Allston, Vanderlyn, and Morse had tried to shape American tastes. They were pioneers—the first historical and romantic painters in the United States.

V A Passion for Birds:
John James Audubon

O<small>N RARE OCCASIONS</small>, in art as in other endeavors, there appear men who stand alone, apart from all others. They start no fashion; they have no following; they exert no influence; they belong to no definite time. They are *sui generis,* one of a kind. John James Audubon was such a man. An artist of unusual vision and extraordinary talent, he was a painter of rare originality, whose work has no like or equal.

"I have a rival in every bird," Lucy Audubon said. She was not questioning her husband's love, nor was she criticizing his ardent attachment to these feathered vertebrates. She was merely stating a fact.

John James Audubon (1785–1851) had but one passion in life, a passion that amounted almost to monomania—he wanted to paint all the birds of America. He wanted, he said, to "offer to my country a beautiful monument to the varied splendor of American nature, and of my devotion to American ornithology."

Whatever quirk sparked this curious ambition, it resulted in a work that is indeed remarkable. *The Birds of America, from Original Drawings, with 435 Plates Showing 1,065 Figures* is a superb achievement. It is, as one critic declared, ". . . beyond doubt the most magnificent collection on the subject in the world"

Audubon, the natural son of Jeanne Rabin and Captain Jean Audubon, a French seaman, was born in Les Cayes, Santo Domingo (now Haiti), where the captain owned a plantation. Haiti, at that time one of France's most profitable possessions, had a very large population of Negro slaves. In 1791, when the slaves revolted, the captain decided to bring his

children (a girl was also born of this union) back to his home in Nantes, France.

Audubon's preoccupation with birds began in his childhood. By the time he was fifteen, he was already embarked on a series of drawings of the birdlife of France. In 1802 his father sent him to Paris to study with the painter David. This was not because the elder Audubon wanted his son to make a career of art, but simply to help him acquire the cultural graces necessary to a young man of good birth. Since Napoleon was conscripting soldiers for his army, the following year young Audubon was sent to America to manage another of his father's estates, this one in Mill Grove, Pennsylvania.

To Audubon, the New World seemed an ornithologist's paradise, teeming with unusual and exotic specimens. His fascination with birds was ungovernable, and in his absorption with putting down their images, Audubon was oblivious to all else. In 1805 he was either summoned home or went there in hopes of persuading his father to permit him to pursue his dream. Several months later he returned to the States. After an ill-fated business venture, in 1807 he opened a general store in Kentucky. Here he brought his bride, the former Lucy Bakewell, the next year.

The frontier abounded with birds unknown to Audubon. He devoted all his time and energy to tracking down specimens of ordinary as well as unusual birds as models for his growing collection of drawings. He ignored the store; it didn't figure in his dream. Birds were not birds to Audubon. He thought of them as little people with a language and life of their own, both of which he understood.

For the next decade he jumped from one enterprise to another and from one business failure to another. Finally, in 1819, he was unable to meet his debts and was sent to prison. On the day of his release he owned only the clothes on his back, a gun, and his portfolio of drawings of birds. His cred-

itors dismissed his pictures as not worth the paper they were drawn on!

Audubon was then thirty-five years old, without funds or a future, when he conceived of the idea of putting his drawings into book form. He wasn't thinking of the ordinary kind of book, but of a monumental, double-elephant edition, so that his drawings could be life-size. It was a difficult, possibly an unattainable goal even for a man of means. But for a man with no financial resources the notion was unthinkable, even a trifle mad. Lucy Audubon didn't think so. In order that her husband might do what he wanted, she took a job as governess, and for twelve years was the mainstay of the family, which now included two sons.

It took Audubon eighteen years to realize his ambition. He plodded hundreds of miles on foot, living in the backwoods and swamps of the Mississippi and Ohio valleys to observe and draw his birds in their natural habitat. To meet his few needs, he painted portraits, landscapes, and signs; taught drawing and French; and practiced taxidermy. He was often cold, footsore, weary, and despondent, but never did he let himself weaken in purpose.

In hopes of raising money for and to arouse interest in his project, Audubon went to Philadelphia to show his work to the city's most prominent naturalists. (Philadelphia was then the center for the sciences.) Their response was chilling. They were, after all, men of science, not art critics, and they dismissed his work for the inaccuracies he permitted in favor of more dramatic composition. He was advised to go to England where there was a growing interest in natural history. In 1826, with the funds they had managed to scrape together, Audubon and his wife went abroad. His reception was overwhelming. He obtained subscriptions for his work as soon as he arrived in Liverpool. In Edinburgh, he became a friend of the noted Scottish writer Sir Walter Scott, and was elected to the city's

Royal Society. His situation, Audubon declared, bordered
"almost on the miraculous." The British were less concerned
with accuracy than with the astonishing beauty of his draw-
ings.

The years from 1827, when the first of these giant folios was
published, to 1838, when his mammoth work was finally
completed, attest to Audubon's impassioned dedication to his
art. Each painting included in the book was a work of art and
an extraordinary achievement.

Audubon was a perfectionist. He made preliminary studies
and sketches of living birds in the field. Then, having
obtained a freshly killed specimen, he painted the finished pic-
ture in the studio from the model. The bird was mounted on
a board and secured into position by wires while it was still
warm, so that he could catch the full, true color of the feathers
as well as the natural movements of the bird itself. Once he
went to Labrador to get a native bird called a gyrfalcon. So
that he could paint it before the stiffness of rigor mortis set in,
he sat up all through a bitterly cold night on the deck of a
steamer, working by the light of a single, dim lantern.

Audubon drew and redrew any painting that displeased his
critical eye, sometimes reworking whole sections, then pasting
the repairs over the original drawing. (Since they were to be
reproduced as engravings, this was perfectly acceptable.) Any
work that failed to meet his approval was destroyed. To make
as accurate a picture as possible, he used any and all mediums:
pencil, crayon, watercolor, and oil. He had an eye for beauty
and an instinct for grandly dramatic composition. His pictures
of the smaller varieties of birds are handled with a delicate
sensitivity and rhythmic grace that is almost Oriental in feel-
ing; his paintings of the larger birds have a power and
monumentality that is breathtaking.

Audubon supervised each stage of the publication, going
over every plate with his engraver, the Englishman Robert
Havell, Jr., hand-coloring the prints himself. To gain

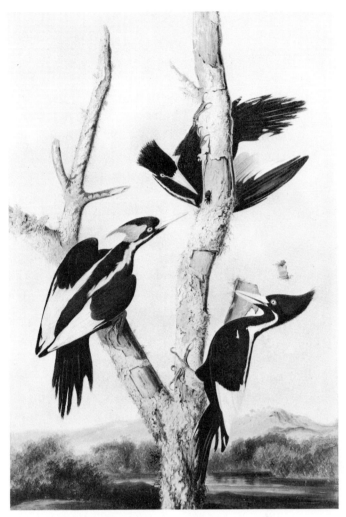

John James Audubon: *Ivory-billed Woodpeckers.*
Courtesy of the Metropolitan Museum of Art,
Rogers Fund, 1941.

American support for his project and to finish his studies of
the birds he wished to include in the book, he journeyed back
and forth across the Atlantic. When his funds ran low, he
painted copies of his pictures for cash. Despite the many pres-
sures under which he labored, he still found time to collaborate
with William MacGillivray in writing the accompanying text
for the five volumes of his *Ornithological Biography*, a Hercu-
lean job in itself.

By the time Audubon returned to the United States in 1839, he was considered the foremost American naturalist. "I have labored like a cart horse for the last thirty years on a single work," he told a friend, and "have been successful almost to a miracle in its publication" He bought a forty-four-acre estate in New York City and settled down to enjoy his good fortune. Formerly a modest and sober man, he became vain and overbearing in manner. He took to dressing with conscious ostentation, appearing either in frontier garb, down to the buckskin jacket and flowing locks, or in elegantly formal attire. (Perhaps he chose his costumes because they symbolized the humble start and successful finale of his career.)

Fame may have turned Audubon's head; it did not affect his work. Immediately after his return from Europe, he brought out another and smaller edition of *Birds of America*. In 1841, collaborating with the Reverend John Bachman on the text, he embarked on another gigantic work, this time on animals—*The Viviporous Quadrupeds of North America*. But the robust energy that had so long sustained him was now depleted. The *Quadrupeds*, which does not approach the aesthetic heights of his first book, is mostly the work of his two sons, John Woodhouse and Victor Gifford Audubon. This final collection of 150 hand-colored lithographs in two volumes was published in the years 1845 and 1846; the three volumes of text appeared between 1846 and 1854. Audubon died three years before its completion.

Audubon could have been a better naturalist had he been a lesser artist. If he exaggerated or distorted anatomical facts, it was not that his eye was faulty but that his artistic intuition demanded that he borrow from Peter to pay Paul. His artistic judgment was infallible. His reputation as a naturalist is sometimes questioned; his reputation as an artist in this his own field stands supreme.

VI Image of America

THE PROBLEMS of government, which Trumbull, Allston, Vanderlyn, and Morse had so casually ignored, occupied the full attention of America's statesmen and citizenry. The Revolution had established the United States as a free and sovereign nation, but the country was still divided by sectional interests. In the twenty-five years between Washington's inauguration and the end of the second war against the British—the War of 1812—the new nation had been beset by rumors and threats of war, by treaties, by embargoes, and finally by actual conflict and invasion. It was out of the War of 1812 that there was born a sense of cohesion and unity, of one people joined under one flag by a common goal into "one nation indivisible." And it was at that point that Americans could at last turn their backs on Europe and devote themselves to the development of their own country.

In the grand American design the nineteenth century was a time of extraordinary growth, a time of rampant individualism and ever-widening vistas. By 1825 there were twenty-four states in the Union; by 1860 there were thirty-three. The population, which in 1790 had numbered just under 4 million, swelled to almost 31½ million before the onset of the Civil War. The country's "growing pains" found relief in westward expansion. The opening of the Erie Canal in 1825 had unlocked the first transcontinental waterway to the West. Within thirty-five years, one could travel by railroad as far west as St. Joseph, Missouri, as far north as Chicago, and as far south as New Orleans. And where just a short while ago there had been only the wilderness, there now stood prosperous and thriving communities. By 1850 all the land from the Atlantic to the Pacific belonged to the United States. And

before the century was done, the Stars and Stripes flew over American territories in the distant reaches of the Caribbean Sea and the Pacific Ocean. In the few short centuries since Columbus' landfall the United States had become a world power.

To foreign eyes America seemed truly a land of hope and promise. For in the United States the common man could be king, and opportunities for advancement were beyond compare. Material success was translated as greatness, and the possession of wealth became in itself a virtue and an ideal—the embodiment of the American dream.

Nineteenth-century American art, which reflected the national mood, also began to push ahead in many directions. It was not, however, an orderly, logical, step-by-step progression, but a spontaneous development on many fronts. It was as if a number of doors in the same room were being opened almost simultaneously, each leading to a different view—one to landscape, one to genre, one to romanticism. Yet, despite this expansion of artistic horizons, during the greater part of the nineteenth century portraiture remained the dominant field in American art. And it remained dominant because it was the most lucrative branch of art.

In the first half of the nineteenth century a "rage for portraits" swept through America. Those citizens who had established themselves financially, having bedecked themselves, their families, and their homes in all the visible aspects of wealth, needed but one more proof of their station—a permanent image of their own importance. Anyone who could paint a passable portrait was assured of an adequate income. For those painters who could enhance the sitters' looks and importance there were greater rewards. Artists who shouted their contempt for portraiture shouted in a vacuum. Likenesses were not bought for aesthetic delight, but as a sign of social position. If one could not afford a first-rate painter, then a second- or even a third-rate artist would do. When finally the

sitter looked at his painted image, he saw not the genius or mediocrity of the work but the eternal and gratifying reflection of his own worldly success.

The standards of portraiture had risen far beyond the primitive conceptions of the early craftsmen and the less-than-expert imitators of Copley. No portrait painter had yet displaced Gilbert Stuart, and his use of clear color and free, rapid brushstrokes was still the ruling style. Though Americans judged portraits, as Mrs. Trollope caustically observed, by the degree of "finish of drapery . . . and, next to this, resemblance" and were ignorant of such refinements as "*drawing* or *composition*," they were nevertheless aware of the technical proficiency of the new generation of American portrait painters.

THE FOLLOWERS OF STUART

CHESTER HARDING (1792–1866) was possibly the most popular of Stuart's disciples. When he settled in Boston, infringing on Stuart's own territory, the clamor for his work was so great that Stuart sarcastically referred to it as "the Harding fever." A portrait by Harding could never be the equal of a Stuart, but sitting for Harding was far pleasanter, and one was rewarded with a dignified and honest likeness.

Harding was a giant of a man, a chairmaker, peddler, woodsman, sign painter, and saloon keeper, who at the age of twenty-four suddenly decided to become an artist. According to Dunlap, Harding's only training came from watching an itinerant artist portray his wife and child. With this handful of information, he confidently embarked on his career, traveling to distant parts of Kentucky and Missouri in search of clients. The sight of some Stuart canvases inspired Harding to make a "pilgrimage" to Boston to learn from the artist himself. And learn he did. So successfully did Harding adopt Stuart's man-

nerisms that at one point his vogue threatened to outstrip the master's.

In 1823 Harding went to London, where his reception was a thundering echo of West's Roman success. The English aristocracy were captivated by the American backwoodsman and competed for the privilege of sitting for him. Harding might have had a substantial future in Britain, but his democratic principles were too deeply ingrained for him to live in a society based on the privilege of birth. So he returned to the simpler ways of Boston.

Harding was a capable painter. He could catch a good likeness, but he rarely probed beneath the surface appearance of his subjects. Of his many portraits, the likenesses of *Mrs. Daniel Webster, Anna Hardaway Bunker,* and *Stephen Van Rensselaer* are worthy of mention for their characterization and pleasing design.

Chester Harding:
Stephen Van Rensselaer
(*c.* 1835-1839).
Courtesy of the
Metropolitan
Museum of Art,
gift of Louisa Robb
Livingston, 1954.

While Samuel Lovett Waldo (1783–1861) and John Wesley Jarvis (1780–1840) didn't enjoy as devoted a patronage as Harding, they were two of the most successful of New York portraitists. Waldo had some training with West and in 1809 opened his own studio in Manhattan. He had a knack for capturing the personality of his subjects, especially those of men. In 1816 he entered into a financially rewarding partnership with William Jewett—a former pupil—and spent the rest of his days grinding out adequate but unremittingly bland likenesses of "distinguished benevolent gentlemen with white hair and white chokers, or of ladies with wonderful eyes and shawls," as Samuel Isham, the art historian, observed.

John Wesley Jarvis never studied with Stuart, but he tried his level best to imitate him. Jarvis was born in England and raised in Philadelphia, where he occasionally assisted the sign and portrait painters, who were, he said, his "introduction to the fine arts and their professors." For some years he was one of the leading portraitists in New York, though his likenesses hardly warranted such a reputation. He was quick to capture a superficial resemblance, and he brushed in his colors rapidly with bold, forceful strokes in hollow imitation of Stuart. Many of the naval and military heroes of the War of 1812, including Commodore Oliver H. Perry, were depicted by his hand.

Jarvis' colorful personality more than compensated for his mediocre talent. He had a taste for the good life. He was a familiar sight to many New Yorkers, strolling through the streets, as one observer recalled, dressed in a "long coat, trimmed with furs like a Russian prince or potentate from the north pole . . . and his two enormous dogs, which accompanied him . . . often carried home his market basket. . . ." His gaiety and wit impressed many of the city's dignitaries, who always had time to "sit an hour or so." But Dunlap was sternly disapproving of Jarvis' fondness for the bottle, and foresaw "a chaos hastening to destruction." Though he ignored the warning, Jarvis fulfilled Dunlap's doleful pre-

diction. Jarvis died a pauper, his ability totally destroyed by drink.

Matthew Harris Jouett (1787–1827) did not anger his father so much as exasperate him by deciding to become a portrait painter. "I sent Matthew to college," the older Jouett protested, "to make a gentleman of him, and he has turned out to be nothing but a damned sign-painter." Years later, after Jouett had earned a reputation, a colleague cheered, "Rembrandt is next to God, and Jouett is next to Rembrandt." It was a touchingly affectionate statement and one that might have delighted Jouett's parent, but it was wildly inaccurate.

Jouett was Stuart's favorite pupil and most devout disciple, reverently recording the master's theories and technique. Although he was credited with being the best portraitist in the Ohio and Mississippi area, Jouett was no more than a mediocre technician—a second-rate copy of a brilliant original.

AN IMPROVED APPEARANCE

THE FOLLOWERS of Stuart were respectable and more or less honest painters, willing to give satisfaction in their merchandise by putting down a truthful likeness. But before the first quarter of the nineteenth century had elapsed, even these small virtues had begun to lose their savor. The man who headed a business, an industry, a bank, a university, or other such important office, was no longer interested in a probing diagnosis of character. Dark business suits did not radiate wealth as did colonial silks and satins. What he now desired was a grand and impressive likeness as befitted his elevated station. He wanted painters with a flattering brush who would show him, not as he was, but as he thought he was. In place of the small-scale likeness, he demanded (perhaps remembering the huge paintings of European royalty) a full-length life-size

or even larger portrait to show how really important he was.
This expansion in the size of the canvas was not accompanied
by an increase in talent. What small vestige of individualism
still clung to American portraiture now gave way to an
all-embracing blandness.

Thomas Sully (1783–1872) more than gratified his custo-
mers' desires. He was convinced that "resemblance in a por-
trait is essential, but no fault will be found with the artist—at
least by the sitter—if he improve the appearance." And no
one did find fault with Sully's improvements. To the contrary,
they submitted only too happily to his physical repairs.

Sully was born in England and brought to Charleston,
South Carolina, at the age of nine. Through his actor parents
he gained an intimate knowledge of the theatrical world,
many of whose luminaries he later portrayed. His first instruc-
tors were his brother and brother-in-law, both miniaturists.
To better prepare himself, Sully was briefly apprenticed to
Jarvis and in 1806 went to study with Stuart. Three years
later he departed for London to work with West and Sir
Thomas Lawrence, the noted English portraitist, to whom
can be credited the fluent elegance and sweet romanticism of
Sully's style. So attractive did Americans find Sully's technique
that it soon became the ultimate in fashionable mid-nine-
tenth-century portraiture.

Sully was essentially a painter of ageless and lovely feminin-
ity, of pearly pink-and-white skin, shining hair, and lustrous
eyes. Employing bold brushwork and clear, luminous color,
he enlarged the eyes to give them special emphasis. He soft-
ened and improved the other features to insure a most pleas-
ing, if superficial, likeness.

Among the best-known canvases of the many social and
theatrical stars he portrayed is the charming portrait of the
famous actress Fanny Kemble and the dashing sketch of an
idealized young Queen Victoria. Sully had difficulty with male
subjects; his portraits of men invariably lacked strength.

Thomas Sully:
Lady with a Harp:
Eliza Ridgely (1818).
Courtesy of the
National Gallery of Art,
Washington, D.C., gift of
Maude Monell Vetlesen, 1945.

While Sully's fame rests on his portraits, he is also known for his historical canvas *Washington at the Passage of the Delaware* (not to be confused with Leutze's more celebrated picture *Washington Crossing the Delaware*). Sully's painting shows Washington on a white horse, standing close to the river's edge, surrounded by a group of mounted soldiers. Despite its excellent composition and skillful execution, the picture has no more depth than Sully's portraits. Far from being the anxious general on whose shoulders rests the fate of a nation, Washington looks like a man in military dress sitting for a likeness.

However, Sully had no grand ambitions to be a historical painter. He continued his career in Philadelphia—where he had settled in 1810—as a highly respected portraitist, turning out almost two-thousand likenesses, genre, and landscape paintings during his lifetime. Dunlap praised him as a man

who "has long stood at the head of his profession as a portrait painter, and whose designs, in fancy subjects, all partake of the elegant correctness of his character" As usual, Dunlap's judgment of artistic merit was influenced by the artist's respectability. And Sully was eminently respectable.

Sully's son-in-law, John Neagle (1796–1865), borrowed his technique from Stuart and his father-in-law. For a time he shared honors with the latter as Philadelphia's leading portraitist. Neagle was born in Boston and began his training as an apprentice to sign and coach painters. He studied at a drawing academy and, for a few months, with Bass Otis, a former scythe maker and one-time partner of Jarvis. In 1825 he visited Stuart, at which time he painted the best-known portrait of the elderly artist. Stuart is said to have been offended by being made to look like a red-nosed dyspeptic, but more probably

John Neagle:
Pat Lyon at the Forge
(1826-1827).
Courtesy of the
Boston Athenaeum,
on deposit at the
Museum of Fine Arts,
Boston.

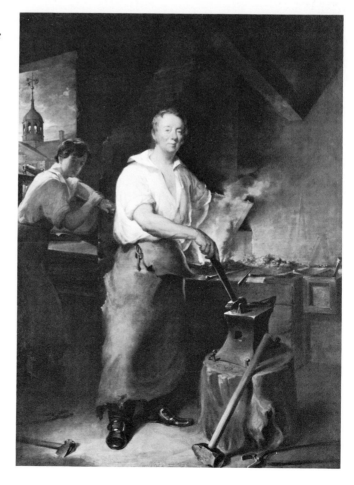

his dislike for the work was sharpened by Neagle's dull hand.

Most of Neagle's work is monotonously sentimental. However, his enormous canvas *Pat Lyon at the Forge* is distinctive as one of the first American pictures to show a workingman at his job. Neagle scored a smashing hit with it when in 1828 it was exhibited and bought by the Boston Athenaeum. After making a copy for Lyon, Neagle went right back to painting innocuous likenesses.

At the age of twenty Charles Cromwell Ingham (1796–1863) arrived in New York from Ireland, already a past master of what one critic called "the most exquisite beauty of finish and delicacy." Trained at the Royal Dublin Society and under several Irish portraitists, he soon honed his technical skills to perfection. His portraits and other painting were distinguished by their high gloss and meticulous, fussy finish. Tuckerman described Ingham's style as "peculiar" and "seldom imitated." Ingham "elaborated his flesh to the verge of hardness, touching and retouching his larger portraits, until the picture had the polish of the finest miniature on ivory."

For almost half a century Ingham enjoyed great esteem, particularly among women who admired his flattering, fashionable brush and his dexterity at rendering sumptuous finery. He was one of the original organizers of the National Academy and an important figure in New York art circles. Ingham was essentially a portrait painter, and his reputation rests in that field. But he also produced several sentimental anecdotal pictures such as *The Black Plume, Young Girl Laughing*, and *Flower Girl*, which were quite popular in their time.

Henry Inman (1801–1846) was born in upstate New York and moved to Manhattan in 1812. At the age of thirteen he was apprentice to Jarvis, who, quick to recognize the youth's skill (he had "the very head of a painter"), had Inman painting the costume and background while he did the head.

Inman began his professional career in 1823 and, like his

teacher, worked with an apprentice. Eight years later Inman
went to Philadelphia, where he partnered a lithography firm
and also painted portraits. He returned to New York
permanently in 1834, where he satisfied many customers with
his prettified likenesses and smooth, shiny brushwork. Inman's
portraits, one critic claimed, "almost always look better than
the originals."

Despite his success Inman thirsted for other laurels. He
painted a number of genre scenes, but aspired to fame as a
historical painter. The "time will come," he predicted, "when
the rage for portraits will give way to a higher and purer
taste." In 1836, almost twenty years after Trumbull had been
awarded four of the Rotunda panels and two years before
Vanderlyn received his commission, Inman was asked to do
one of these highly prized murals. His talents as a historical
painter were never tried. He died before he had completed
more than a preliminary drawing for *The Emigration of
Daniel Boone*. The panel was later given to an Ohio artist
named William H. Powell, whose good fortune it was to have
influential senators as friends. For the Rotunda, Powell
painted *The Discovery of the Mississippi River by De Soto*,
which the art historian E. P. Richardson says, "has not caused
anyone to remember his name."

Only once did Inman digress from the routine amiability of
his work, when, during a demonstration, he rapidly painted
his own portrait. It is his most interesting and least rep-
resentative canvas, handled with unusual freedom.

With Morse and Ingham, he was instrumental in the found-
ing of the National Academy, of which he was elected vice-
president in 1827. When Inman died, one academician
recalled, the line of people (many of them prominent) follow-
ing the bier on foot on a cold winter's evening was two miles
long—an impressive tribute to a successful, but not so impres-
sive talent.

Charles Loring Elliott (1812–1868) stepped right into

Inman's shoes. Born in upper New York State, he came to the city at seventeen and worked briefly with Trumbull and the genre painter John Quidor. Until 1839, when he settled permanently in New York City, he worked as an itinerant portraitist in the state. Somewhere in his travels he managed to exchange one of his portraits for a Stuart, which belonged to a man who was obviously no judge of value. The picture provided the key to his success. Elliott imitated Stuart's manner of giving prominence to the head by placing it against a simple background. But Elliott was an inept draftsman, and his full-length figures are awkwardly constructed. The warmth of Stuart's flesh tones became, in Elliott's portraits, a ruddy glow, which his admirers compared to the flush on "faces around the fireside of home." Unkind critics noted the resemblance to Elliott's own coloring, red from drink. Elliott was, however, less of a panderer to public vanity than his contemporaries. His canvases, painted in a comparatively free

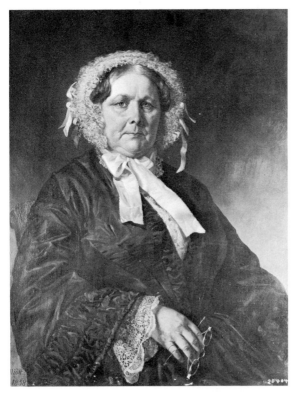

Charles Loring Elliott:
Mrs. Thomas Goulding.
Courtesy of the
National Academy of Design.
Photograph courtesy of the
Frick Art Reference Library.

technique, are more determinedly realistic than was common at the time.

Elliott's florid handling of one sitter's reddish beard caused an enthusiast to liken it to "the splendor of the setting sun." In that age of hirsute adornment, his way with a beard enticed many of New York's male celebrities to his studio. Women found his romantic portraits equally appealing. His popularity remained undimmed almost to the end of his life. During the Civil War, the critic Henry Tuckerman reports, Elliott "dashed off upon canvas, at high prices, the cotton merchants who sat to him, in the hurried intervals of their restless speculations."

George Peter Alexander Healy (1813–1894) was the first American portrait painter to win international acclaim. Warned by Morse that he would not earn "the salt of his porridge at painting," Healy climbed to fame and fortune, a painter of royalty and the social elite of two continents.

The eldest son of a poor Boston-Irish sea captain, Healy displayed a precocious talent for drawing. Though self-taught, he was quite confident of his ability. Encouraged by Sully to seek his fortune as an artist (Sully was a better guesser than Morse), Healy set out on his own at eighteen. A commission from one of Boston's social leaders launched his career. Within three years he had earned the means to study in Europe.

Healy arrived in Paris in 1834 to work under Baron Jean Antoine Gros, a pupil of David and military painter to Napoleon. A portrait commission from King Louis Philippe quickly established Healy's European reputation. By the time he was twenty-six, his fame had spread throughout the Continent, and he was kept busy painting many of the crowned and otherwise renowned heads of Europe.

He returned in 1855 to open a painting "office" in Chicago, from which city he commuted regularly to Europe. He died in Chicago at the age of eighty-one, having led, by his own declaration, a rich, happy, and interesting life.

Healy was a good technician. He had, as a critic said, "a gift for getting resemblance and a certain polish of workmanship," and of course an eye for flattery, qualities that endeared him to the famous in America and Europe. His best work was done during the earlier part of his career. His later canvases were dull, airless, and heavily influenced by photography.

When that remarkable black box called the camera was introduced to the United States in 1839, most artists ignored it. Even those like Morse who professed great admiration for its ability to record an object or person with perfect fidelity saw no threat in the mechanism. Believing that a living man, endowed with a mind and emotions, could bring "something" more to portraiture than the literal image of a photograph, they translated the "something" as flattery. Then, as if superficial banality were not enough, the mid-nineteenth-century portraitists adopted the glossy finish and accurate reproduction of the photograph and began to substitute a photograph of the sitter for the living subject. The painted likeness, once a mirror of humanity in the hands of men like Copley, Stuart, Peale, and even Harding, now became a second-rate and pedestrian rival of the camera. Not until the advent of Whistler, Sargent, and Eakins did portraiture reassert itself as a work of art.

In spite of the preponderance of routine likenesses, portraiture continued to be a most profitable occupation throughout the nineteenth century and even a bit beyond. At the same time, however, the scope of American art had been pushing far beyond its original boundaries. Beginning with the first quarter of the nineteenth century, and increasingly thereafter, a painter could follow his muse in whichever direction she led. No longer would he have to be a "head painter" out of necessity. He could, if he pleased, be a painter of landscape, genre, or fantasy. Henceforth the artist would be criticized not so much for *what* he painted, but *how* he painted.

VII Wooded Temples

LANDSCAPE, GENRE, and romantic painting arose almost simultaneously in nineteenth-century American art. Each was generated by a different impulse, and each developed in its own distinct fashion. The progress of landscape painting, the earliest of these forms to flourish, can best be understood in the light of what was happening in Europe.

In 1824 a not-too-well-known English artist exhibited at the Paris Salon a landscape called *The Hay Wain* that was to change the whole concept of landscape painting. The artist was John Constable, one of the world's greatest landscape painters and the father of modern landscape tradition. Not only was he instrumental in establishing landscape as an art in its own right, but he exerted a profound and liberating influence on mid-nineteenth-century landscape painting.

Landscape painting, as it is practiced today—as the sole subject of a canvas—was at that time almost unknown. In classical tradition it occupied a lowly position, with only genre and still-life painting ranking below. Seventeenth-century Dutch painting had a tradition of landscape, but this was an exception to the general rule.

On occasion, scenes from nature were used as decorations for wall panelings in houses not as works of art, but to enliven the appearance of a room. In the canons of classicism, nature was quite acceptable as a *setting* for historical allegories, but only as a *setting*. Yet even then the laws of classicism demanded that the artist carefully select only the most beautiful aspects of nature, relying on his memory and a few sketches to guide him. The picture itself was always painted indoors, in the studio. In essence, if the proper references to antiquity were made, the work could be more landscape than

allegory. But it was an imaginative, idealized vision of nature, orderly, tasteful, and subdued in color, and nowhere near a picture of nature as it really existed.

Constable defied classical tradition. He had a passionate love for even the most commonplace features of nature. His finished canvases, though done in the studio, were not scenes of an artificially perfected countryside but enlargements of outdoor studies that retained much of their original freedom and freshness. In contrast to the carefully smoothed brushwork and blending of color favored by classicists, Constable applied his paint in bold, visible strokes of clear color that was glowingly alive.

Constable's realistic approach and his personal response to nature affected a group of French landscape painters, known as the Barbizon school because they lived and worked in the village of Barbizon. The Barbizon artists rejected the idea that landscape had value only as background for classical subjects. Like Constable, they believed nature was a vital, vigorous force and important subject matter in its own right. Accordingly, they went outdoors to paint truthful and unprettified scenes of landscape and peasant life. As pioneers in the field of *plein-air* (outdoor) painting, they exercised considerable influence on European and American artists.

Of greater consequence was Constable's effect on the French romanticist Delacroix. Upon seeing Constable's painting, Delacroix revised his own technique and began the investigations into color that were later taken up by the Impressionists—investigations that were in part responsible for the development of modern concepts of color.

While all this was going on in Europe, a number of American artists, the most important of whom were known as the Hudson River school, were independently and more or less simultaneously, discovering the natural beauties of their own country. Although it wasn't long before American painters

began to be influenced by the foreign movements, these artists had no connection with and were mostly unaware of what was happening abroad. In fact, the emergence of this group of landscape painters marked the first truly native development in American art.

Up to this point landscape had even less vogue in the United States than it had in Europe. Certainly Allston had created landscapes, but his were fictional settings for his romantic allegories. Trumbull and Vanderlyn had used nature in the classical manner, as a backdrop for their historical works. In the 1790's four Englishmen tried their hands at American landscape. Of the four, only one, Francis Guy, had some originality. The other three merely remade the New World's wilderness into replicas of the neat English countryside.

As has already been said, landscape was used as decoration, and also as subject matter for topographic renderings describing the American countryside. But landscape as a respectable branch of art was just about nonexistent before the early years of the nineteenth century. For practical reasons American artists didn't venture into landscape painting, even though they might have yearned to do so. There are few men who dare swim against the tides of their times at any point in history. And except in rare instances the artist knew full well that portraiture was the quickest and surest way to financial and artistic success. But America has always been rich in pioneers in art as in other things. And so it was that a few painters began to venture into a field that, as one of them—Alvan Fisher—said, "had not been practiced much, if any, in this country."

The best of the early artists to go beyond the merely decorative and topographical aspects of landscape were Alvan Fisher, Thomas Birch, and Robert Salmon. Fisher was a landscape and portrait painter and is dealt with in another part of the chapter. Birch and Salmon were primarily marine painters. Together with the later artists Fitz Hugh Lane and James

Hamilton, Birch and Salmon were the first to paint American seascapes, an area that had all but been ignored in American art.

Thomas Birch (1779–1851), the son of William Birch, an engraver and miniaturist, came to Philadelphia at the age of fifteen. Here he helped his father publish a series of engraved views, which became quite popular, of the "City of Brotherly Love." But Birch preferred to learn from Nature itself rather than from his father. While still a young man, he painted a view of the ships and wharves in the Schuylkill River as seen from under the famous tree where Penn signed a treaty with the Indians. Birch's first real interest in marine painting was awakened by a trip to the Delaware seacoast in 1807. When a few years later the War of 1812 broke out, the naval encounters between American and British ships provided him with subject matter for a number of paintings through which he established his reputation. One of these pictures, *The Constitution and the Guerrière,* is a dramatically convincing rendition of the sea battle. It shows the *Constitution,* her four identifying American flags waving proudly atop the tall masts, victoriously riding the choppy sea. Beside her lies the battered and beaten hulk of the British vessel.

Birch continued to paint marines for the rest of his days, varying his output with an occasional landscape or a winter scene. For the most part his pictures have a literal simplicity and are painted in thin color with a hard finish. However, he did try to capture the atmospheric effects of light and air and sometimes succeeded in his efforts.

A more competent painter and better colorist was the Scotsman Robert Salmon (c.1785–after 1840). Trained in the English marine tradition, Salmon is supposed to have been a sailor and a practicing marine painter for about thirty years before he arrived in Boston in 1828. He lived in a shack on a South Boston wharf, from which he could readily see the mate-

rial for his art. During the years he spent in America, Salmon produced about five hundred large canvases picturing the sea and the ships and sails that populated Boston's harbor. He also painted a curtain for the Boston Theatre and a panoramic view of the city and its harbor.

Salmon was a meticulous craftsman with a sure hand. The preponderance of his pictures are notable for the mathematical precision with which he designed the horizontal and vertical lines of the ships' masts and rigging. In a few of his canvases, such as *South Sea Whale Fishing*, he caught an unusual clarity of atmosphere and light.

The most interesting of the early marine painters was Fitz Hugh Lane (1804–1865). Born in Gloucester, Massachusetts, to whose harbor came whaling ships and traders, Lane developed an early love of the sea. His predisposition toward marine painting was expressed in youthful renditions of imag-

Fitz Hugh Lane: *Boston Harbor* (1854).
Courtesy of International Business Machines Corporation.

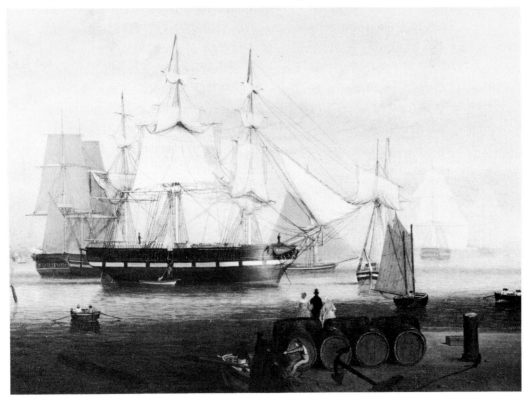

inary shipwrecks, worked in a primitive but compelling style. In 1832 he went to work in a Boston lithography plant, where he soon became an accurate draftsman. Around 1849 Lane returned home. At some point in his life Lane sustained either an injury or an illness, which left him crippled and confined to a wheelchair. Lane did not allow his infirmity to undermine his career. He spent the rest of his years painting views of New England harbors and the Maine seacoast.

Lane seems to have been influenced by Salmon's mathematical design and use of light. Lane's pictures are painted with a hard clarity and great attention to detail. He was particularly interested in the effects of light on water, and his canvases are filled with a calm stillness and an eerie, enchanted luminosity. Among his most impressive pictures is *Owl's Head, Penobscot Bay, Maine,* a view of a schooner and the lighthouse from the headland across the bay. The intense silence and the permeating, almost "magical" quality of the light give this work a genuinely poetic feeling.

With Martin J. Heade, Lane is considered the most prominent of the "luminist" group of nineteenth-century American landscape and marine painters, although E. P. Richardson also includes under this classification James Hamilton, Sanford Gifford, John F. Kensett, and Worthington Whittredge. The term luminist, invented by John I. H. Baur of the Whitney Museum, is applied to those painters who displayed a particular interest in the atmospheric effects of light, especially in the sharp, clear light found along the seacoast where sky, earth, and water meet.

Though a minor member of the luminists, James Hamilton (1819–1878) showed a definite sensitivity to light in his marine paintings. His pictures, like Lane's, are built on a low horizontal that runs across the canvas, creating an effect of calm serenity and giving dominance to the sky. One of Hamilton's canvases, *Seascape,* a view of boats in a harbor, is painted with a hard touch and is overly warm and bright in color. The

picture is not exceptional save for the clear, almost electric quality of his light.

Marine painting continued to gain in favor through the ensuing years. But it was only in the powerful realism of Winslow Homer's sea pictures and the imaginary moonstruck seascapes of Albert Pinkham Ryder that this branch of American art reached its finest and most significant expression. In the interim, Birch, Lane, and the other early pioneers of marine painting were almost forgotten, brushed aside by the sudden and overwhelming popularity of the Hudson River school of artists.

At the same time that Birch and his contemporaries were opening the way for marine painting, other native artists were beginning to find in landscape a new and exciting subject matter. But at this point such subject matter was still not popular with the public. The path for American landscape painting was cleared by the literary figures who set the cultural and intellectual standards of their day. Such writers as Ralph Waldo Emerson, Henry David Thoreau, Washington Irving, and William Cullen Bryant began extolling the unspoiled vistas of nature as the Temple of God. In the past they had ranked poetry as the highest form of art and looked on painting as a pleasing craft—"to the eye what dancing is to the limb," as Emerson put it. But they soon revised their judgment. Painting became "the adornment of civilization" and the artist the instrument whereby God's majestic handiwork could be reproduced.

"Go forth under the open sky, and list to Nature's teachings" counseled Bryant. It was a piece of advice American painters were quick to follow.

Out of pride in the land grew the first real school of American art. Interest in landscape was stimulated by the swift growth of the country. The rapid disappearance of the frontier aroused a wistful nostalgia for what had been and was no more. Surrounded by solid and enduring comforts, Americans could

lean back and enjoy the beauties of the wilderness without being reminded of its harshness. Men of wealth, who sought status by accumulating European pictures (even if they were only copies of the masters), now began to look at paintings of the American landscape with a new and proprietary eye. For in these pleasant bucolic vistas they saw an image of the land that they had helped mold into a great nation.

Landscape painting, as a serious branch of art, began in the early part of the nineteenth century with the Hudson River artists. They introduced a new note of romantic realism to American art. Romantic realism is a term for a painting in which the artist recreates on canvas an accurate, realistic image of his subject matter, in this case landscape. But his picture is not simply a facsimile recording of what he sees. To his work he adds the feelings, the sensations, that the subject awakens in him. The Hudson River painters endowed their faithful copies of the unspoiled wilderness with the spiritual reverence they felt for the land. Toward the middle of the century, as the United States increased in size, power, and wealth, American landscape painters reflected the spirit of their times in mammoth canvases of the natural wonders of the new continent. And in the aftermath of the Civil War, toward the latter part of the century and before it succumbed to European influences, American landscape painting underwent another change. Canvases grew more normal in size; landscape became a more intimate and lyrical vision of the familiar American countryside.

THE HUDSON RIVER SCHOOL

THE HUDSON RIVER painters were given their title by a newspaper critic who seemed to think that these men painted nothing but scenery in that particular locale. Actually, they

worked in various parts of the country, lived at different times, and with a few exceptions had no close ties with one another. Their common bond was an abiding reverence for nature. They painted what they saw in highly polished and minute detail, but they made of their canvases joyous hymns to a sublime creation.

Two of the earliest pioneers in the field of landscape painting were Alvan Fisher and Thomas Doughty. Alvan Fisher (1792–1863) was a minor artist who had little or no influence on his contemporaries. He is worthy of mention, however, because he reveals the growing responsiveness of American artists to their native land. Born in Needham, Massachusetts, he received a little training from a Boston "sign and ornamental" painter. In 1814 he "commenced being an artist," he said, by painting inexpensive likenesses. The following year, before any of the Hudson River painters had come to it, Fisher turned to nature as a subject for his art. He began painting "barnyard scenes," scenes of "rural life, winter pieces, portraits of animals," and views of secluded New England mountain streams. In 1825 he made a tour of the Continent to study the old masters. He returned in a while to continue a fairly successful career.

Fisher had little technical knowledge, and his pictures reflect his ignorance. Though his early work was praised as "promising . . . excellence," he did not live up to such expectations. His canvases are crudely handled and fussily painted. Dunlap found Fisher an admirable man whose "uniform conduct throughout his life has evinced an amiable disposition, and perfect moral worth."

Dunlap had better words for Thomas Doughty (1793–1856). "Mr. Doughty," Dunlap wrote, "has long stood in the first rank as a landscape painter—he was at one time the first and best in the country." A self-taught Philadelphia leather currier, Doughty was one of the first artists of some ability to

unveil the beauty of the American landscape. It was Doughty's ambition, a friend stated, "to appeal to the eye and heart through the medium of canvas and color, by presenting . . . those beautiful scenes with which our country abounds."

With zealous determination Doughty trained himself in the fundamentals of art. In 1822 he exhibited at the Pennsylvania Academy of Fine Arts eight landscapes which were so well received that he decided then and there to devote himself to painting. "My mind was firmly fixed," he declared. "I had acquired a love for the art which no circumstance could unsettle."

Recognition came swiftly. His pictures were bought by Robert Gilmore, a Philadelphia connoisseur and one of the few collectors of American art. Doughty was elected to the Pennsylvania Academy and the National Academy. He made two trips to Europe in 1837 and 1845. Abroad, his canvases won instant approval; at home, his pictures were praised for their spiritual beauty. One critic called him "the all-American Claude Lorrain" in overly lavish comparison with the great French classical landscape painter. His landscapes were reproduced in poetry and guidebooks and widely distributed by the American Art-Union.

In 1838, an engraver named James Herring started a kind of cooperative artistic enterprise in New York City that was both commercial and altruistic in nature. Originally called the Apollo Gallery, then the Apollo Association, it became, in 1844, the American Art-Union, the name by which it is commonly known. The aim of the Art-Union was to "elevate and sustain American art" and to promote the work of living American painters through public subscription. The Art-Union was run as a lottery in which all members participated. Membership was five dollars, for which a subscriber was entitled to an engraving of one of the pictures bought for this purpose and a chance to win the original painting in the annual lottery. In addition he received a pamphlet about

these pictures, the first such bulletin in America devoted exclusively to art.

The huge success of the Art-Union encouraged the growth of similar smaller organizations in other cities. But it also aroused the ill will of a number of artists, most of them members of the National Academy, who felt that the union was undermining the influence of their own institution. The academy brought suit, and in 1852 all the unions were declared illegal and their activities halted. It was an unfortunate decision. In the years of its existence the Art-Union (and its imitators) had been the most effective means of bringing genuine works of art to the people and of creating an interest in contemporary American painting.

For all his acceptance by the Art-Union and by critics, Doughty's popularity began to wane in his later years. The demand was for more brightly colored and exciting scenery, and now his pictures were attacked for their scrupulous finish and bland "tea tray" style. The man whom Dunlap had rated so highly died poor and neglected.

In their day Doughty's tranquil scenes of the Hudson River Valley, the Pennsylvania, Maryland, and New Hampshire regions, were prized for their harmony of color and truthful representation. Unfortunately, Doughty was not the most accomplished of painters. His color is almost uniformly somber, and many of his canvases have identical compositions. Despite these flaws Doughty's faithful renditions of a youthful America are memorable for their deep spiritual kinship with the land. Such pictures as *On the Hudson* and *In the Catskills,* a long view of a forest lake set in the mountains, are imbued with his love for nature's peaceful beauties.

Doughty's pioneer efforts opened the way to American landscape painting. He is sometimes considered one of the fathers of the Hudson River school, along with Thomas Cole and Asher B. Durand. However, the dominant figures and guiding lights of this group were Cole and Cole's follower Durand.

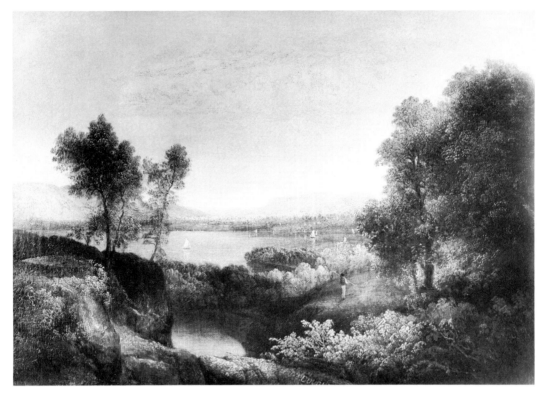

Thomas Doughty: *On the Hudson*. Courtesy of the
Metropolitan Museum of Art, gift of Samuel P. Avery, 1891.

Cole and Durand exerted considerable influence on the direction of landscape painting in America. Thomas Cole established landscape as a major branch of American art. More importantly, he introduced a new quality of romantic realism to American painting, endowing his pictures of nature's wilderness with his own poetic vision. Asher Durand was more realist than romantic. He was one of the first Americans to go outdoors to paint. But even though he took his inspiration from nature as it existed, Durand did not simply copy the scenery. He brought to his work the great reverence he felt for God's wooded temples.

Thomas Cole (1801–1848) believed that the "most lovely and perfect parts of nature may be brought together, and combined in whole [would] surpass in beauty and effect any picture painted from a single view." Taken at face value this statement is close to the classical point of view. But Cole was

no classicist. Only in his allegories did he adopt some of the mannerisms of that movement, and even there his work was too romantic to fall easily into classical categories. He made no attempt to idealize nature as had Allston. Cole worked from pen and ink sketches made outdoors, relying on his remarkable memory to suppy the details. He painted his pictures in the studio, he said, only after time had thrown "a veil over the common details," blocking out all but "the most essential parts."

Cole was the first American "to picture the wilderness with the passion of a poet, and to capture the wild beauty of the continent . . . ," Lloyd Goodrich states. Cole went beyond Doughty's literal transcriptions, bringing to American landscape a fresh, dramatic artistry. He was the best and most fertile member of the Hudson River school. He was both a landscape painter and a painter of romantic fantasies, the latter, with their trite moralizings and operatic staging, somewhat like sermons in paint. To contemporary eyes these earnest canvases seem sadly dated and naive, compelling only in their romantic fervor. His landscapes need no defense. They are lyrical images of a beautiful country.

Cole was born in England and until 1819, when his family emigrated to Philadelphia, was an apprentice engraver in a textile factory. He studied woodcutting and took a few painting lessons. He started his career at the age of twenty-one as an itinerant portraitist, but couldn't make a go of it. For a little while he worked as a designer for his father's wallpaper business in Pittsburgh, but more and more he was drawn to nature. He spent two years at the Pennsylvania Academy, where he saw some landscapes by Birch and Doughty. These so excited him that he soon made his own attempts in that field. But it was not until 1825, after a trip to the Catskills, that his decision to become a landscape painter was firmly resolved.

Three of Cole's canvases, displayed in the window of a New York eating house, caught the eye of Trumbull, Dunlap, and Durand, who promptly bought them and found him other patrons. Bryant's praise of his "scenes of wild grandeur particular to our country" spread his reputation. Within a short time Cole became America's foremost landscape painter.

Cole went abroad twice, in 1829 and in 1841, visiting England, France, and Italy. He departed on his first voyage "like one who is going to his first battle and knows neither his strength nor weakness." When three years later he returned to New York, it was with a confused notion that his strength lay in the "higher" forms of art. From 1833 to his premature death Cole produced in rapid succession, in addition to his landscapes, several series of allegorical fantasies dealing with "the mutation of earthly things." The first of these was *The Course of Empire*, a series of five paintings tracing the growth of the Roman Empire from its primitive stage to its destruction.

The best known of Cole's narrative works is *The Voyage of Life*, a group of four pictures painted in 1839. The voyage begins with *Childhood*, showing a guardian angel leading a baby in a boat out of a flowery cavern into the River of Life. In *Youth* the hero, alone at the helm, guides his vessel toward a heavenly mirage resembling a strange temple, while the angel stands guard on the shore of a luxuriant semitropical landscape. In *Manhood* the boat winds down a river through gloomy gorges and caverns where lurk the demons of lust, intemperance, and suicide. In *Old Age*, the last picture of the series, the angel leads the hero, now old and bent, through the wintry waters to his eternal rest.

Cole's allegories had been commissioned by men of wealth and culture who were not alone in their admiration for this kind of painting. In 1820 Rembrandt Peale's *Court of Death* had played to packed houses. Now Cole's *Voyage of Life* was "standing them in the aisles." Half a million people paid to

see the pictures, and many more bought the engravings published by the Art-Union. Puritan morality was strongly ingrained in the American conscience and seemed to have a pronounced effect on popular artistic taste. Americans considered Allston's romantic visions fanciful daydreaming and Vanderlyn's nudes licentious, but they responded to and admired Peale's and Cole's dramatic moralizations because they were like Sunday church sermons—admonishing, yet uplifting.

Public enthusiasm, however, did not meet Cole's expectations. "Had fortune favored me a little more . . . I would have followed out the principles of beauty and sublimity in my work that have been cast aside because they were not marketable," he charged. Fortunately, Cole's guardian angel ignored these unwarranted complaints and saw to it that he didn't abandon landscape painting.

The *Oxbow of the Connecticut*, one of his finest and most famous pictures, is an example of Cole's ability to unite "the

Thomas Cole: *Oxbow of the Connecticut* (1846). Courtesy of the Metropolitan Museum of Art, gift of Mrs. Russell Sage, 1908.

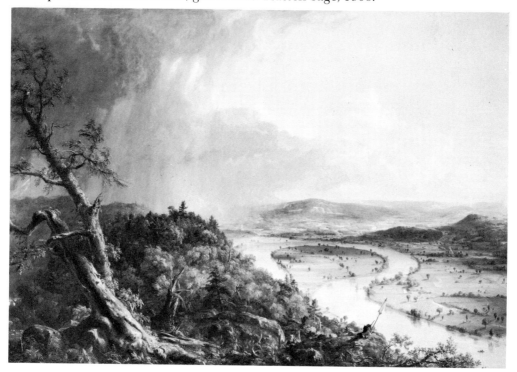

most lovely and perfect parts" into a "beautiful impress of nature." The scene is a dramatic sweep of rolling hills, winding river, distant horizon, and far-ranging sky. Looking closely, one can see the tiny figure of the artist seated high on the hilltop overlooking the valley. Each tree, bush, and leaf, near and far, is worked in meticulous detail. Yet this profusion of minute particulars is so sensitively integrated into the panoramic sweep of the landscape that the details never disturb the massive unity of the painting.

Upon Cole's death, Asher B. Durand (1796–1886) became the country's leading landscape painter. Durand had a less dramatic though a no less impassioned love of nature than Cole. He was a close friend and ardent admirer of Cole, and it was this association that ultimately led Durand to landscape painting. Durand, however, did not share Cole's enthusiasm for the reassembling of "beautiful creation." Landscape painting, Durand said, was "great in proportion as it declares the glory of God and not the works of man." He believed that nature was "fraught with high and holy meaning" and "to imitate her beauties" was sufficient reward for him. His lovely pictures were equally rewarding to his large public. He became one of the most successful landscape painters of his time and one of the most influential figures in the development of landscape painting in American art.

Durand was a fortunate man. He had two careers, both of which he enjoyed and in both of which he was highly esteemed. He was born in New Jersey and learned the art of engraving from his father, a watchmaker and silversmith. After five years as apprentice to an engraver, Durand was asked to become a partner in the firm. At the age of twenty-four he set out on his own, having been commissioned by Trumbull to engrave the *Declaration of Independence*. The reproduction won high praise and established him as the finest engraver in the United States. He did work for many contemporary magazines, gift annuals, and books.

To teach himself drawing, Durand bought Vanderlyn's *Ariadne,* from which he made engravings. (He paid six hundred for the painting and later sold it for five thousand.) The engraved copy heightened Durand's reputation and became a popular version of an unpopular picture. His most ambitious venture was a projected series of engravings entitled *The American Landscape,* after originals by Thomas Cole, Doughty, Durand himself, and others, with text by Bryant. Unfortunately, only one volume was ever published, but the six plates included are vivid proof of his enormous skill in that difficult medium.

To free himself of the niggling style of the engraver, and because he wanted to work in color, Durand began to use oil paints. In 1836—encouraged by Lumen Reed, a rich New York art patron—Durand gave up engraving and became a full-time painter. He began by doing portraits which he thought were "first-rate." His own opinion notwithstanding, Durand's portraits were quite pedestrian. The seminal influence in Durand's career as a landscape painter was his friendship with Thomas Cole. A painting trip with Cole so stimulated Durand's own love of nature that he determined, henceforth, to dedicate himself to the truthful portrayal of her "beauties." He found the scenic beauty he so lovingly "imitated" along the Hudson River, in the Catskill Mountains and in the wooded hillsides of neighboring states.

In 1840 Durand went abroad for a year. Accompanying him were two younger landscape artists, John Frederick Kensett and John W. Casilear, and a genre painter named Thomas P. Rossiter. Durand traveled to London, Paris, Rome, and Florence to see the works of the masters. In England he found "the simple truth and naturalness" of Constable's landscapes much to be admired. But the quantity and magnificence of Europe's art treasures and "the sudden transitions and excitements" of the Continent were almost too much for him. They made him uncertain of his own ability and of landscape painting as he

practiced it. When he returned home, he tried his hand at a few landscapes in which there appeared references to antiquity. But Durand could not long sustain interest in the "grand manner," and soon returned to the more personal joys of pure landscape painting.

A critic once said that Americans were stirred by the "deep thoughtfulness" and "sweet poetic suggestion" they found in Durand's pictures. His canvases are notable for their fidelity to nature. He was particularly skillful at capturing the atmospheric distances of rolling countrysides and misty mountain slopes. As he grew older, his paintings became smaller and more intimate in scope, showing corners of secluded forest groves and woodland streams.

One of Durand's finest and best-known pictures, *Kindred Spirits*, was painted as his tribute to Cole, a year after the latter's death. Two small figures, Cole and William Cullen Bryant, stand on a high cliff overlooking the lush wilderness of the Catskills. Sunlight filters through the woods, bathing the far-off mountainsides in a pearly haze. It is a serene and shining vision of nature in all her unspoiled perfection, set down in minute and loving detail.

Durand lived, said his son, to "an honored, happy and beautiful old age." He was active in New York art circles, was one of the founders of the National Academy, and from 1845 to 1861 served as its second president. His advice to aspiring landscape painters was published serially in the contemporary art magazine *Crayon*. "Go outdoors to paint. Go first to Nature," he urged, much as the Barbizon painters were doing. Imitation, he felt, was preferable to any idealization of nature and simple, familiar scenes were superior to the grandiose aspects of landscape. And many young painters, inspired by his canvases and his words, were inclined to follow his lead.

By the time Cole had died, landscape was firmly entrenched in the public's favor. In fact, during the 1850's and 1860's it had become the most popular form of art, outstripping even

portraiture and genre painting. At this point a new develop-
ment began to be seen in the landscapes of some of the
"second generation" of the Hudson River school. The men
who were followers of Cole, such as Casilear and Jasper Fran-
cis Cropsey, continued to paint naturalistic pictures of the
land. There were other artists who worked in the lyrical
Hudson River style, but they were more interested in explor-
ing the effects of light on natural forms. Their work varies in
style and technique and is similar only in the exploration of
light. Like Lane and Hamilton, they are called "luminists."

Asher B. Durand: *Kindred Spirits* (1849). Courtesy of the New
York Public Library, Astor, Lenox and Tilden Foundations.

"Luminism," explains E. P. Richardson, "grew up within romantic realism, gradually altering it more and more into a style of light." This development, which became apparent about mid-century, was indigenous with American artists and is unrelated to the later French impressionist movement. Among the best-known landscape painters to work in this fashion were John F. Kensett, Sanford Gifford, Worthington Whittredge, and Martin J. Heade.

Both John W. Casilear (1811–1893) and Jasper Francis Cropsey (1823–1900) remained faithful to the tenets of the Hudson River school. Casilear was in his mid-forties before he became a full-time landscape painter. Like Durand, whom he had accompanied to Europe, Casilear 'started out as an engraver. He painted gentle scenes of nature's rural beauties which were praised for their "sweetness of tone" and truthfulness of vision. Cropsey painted pictures of New England woods and mountains. He was an uneven performer, and his canvases are often garish in color. However, many of them became quite popular through lithographic reproduction. Though the fact is little known among New Yorkers, Cropsey designed the quaint kiosks that for many years decorated the city's "elevated" stations.

The leader of the "second generation" of the Hudson River school and a highly successful figure of his time was John Frederick Kensett (1816–1872). His landscapes of New York and New England mountain areas and especially his pictures of the coastal areas of Newport, Rhode Island, are depictions of nature's beauty and harmony. The critic Hilton Kramer calls Kensett "a superb pictorial craftsman who . . . specialized in a kind of Arcadian luminosity that transformed the materials of realism into pure romance."

Born in Connecticut, the son of an English engraver, Kensett stepped into his father's trade at the age of twelve. Kensett was bored by his profession, wanting rather to make his career as a landscape painter. To further his ambition, in 1840 he

sailed to Europe with his friends Casilear and Durand, carrying with him some commissions for engravings. He went to London and Paris, studying the work in the museums and varying his engraving chores with some landscape painting. In 1843 he was called back to London to receive a small legacy, and because of the legal complications involved, he remained in the country for two years. It proved to be a crucial point in his career. "My real life commenced there," he wrote, "in the study of the stately woods of Windsor and . . . Burnham and the lovely and fascinating land that surrounds them."

As soon as his legal affairs were straightened out, Kensett returned to Paris, then continued on to Switzerland and Italy. He spent his time visiting the galleries and sketching and painting the bucolic countryside. Shortly before he returned to New York late in 1847, Kensett sent to the National Academy several of his Italian landscapes which won him instant recognition. Now began what a friend called the "series of noiseless victories" following one upon the other. Within a short time he was one of America's most sought-after artists. His landscapes graced the walls of countless New York homes and galleries and Art-Union reproductions of his work found their way into homes throughout the country. He was elected a National Academician, was appointed to a National Art Commission to help select art works for national buildings, and was both a founder and trustee of the Metropolitan Museum of Art. He was, as well, a member of various clubs and a noted figure in social and artistic circles.

Kensett traveled widely on his painting expeditions, to New York State, New England, the far West, and back to Europe. His pictures were lavishly admired and praised as "poems" of "infinite peace and sweetness." But by the time of his death American tastes had begun to change, and his reputation went into a rapid decline. Recently, in light of the renewed interest in the Hudson River school, Kensett's quiet talents have begun to receive their just due.

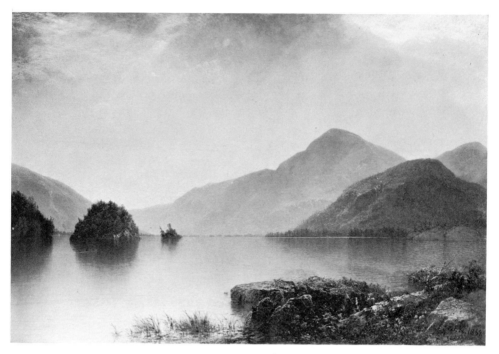

John Frederick Kensett: *Lake George* (1869).
Courtesy of the Metropolitan Museum of Art,
bequest of Maria De Witt Jesup, 1915.

Kensett built his composition on a long, low horizontal,
somewhat in the manner of Lane and Heade. But Kensett
kept his color muted, using subtly graduated tones of silvery
gray to create an illusion of deep aerial space as in his picture
Lake George. Though each form was rendered with careful
precision, his pictures, especially in his later work, were com-
posed with the utmost simplicity. In *Eaton's Neck* all ele-
ments are reduced almost to their bare essentials. The paint-
ing, showing a sandy strip of shore curving into the sea, is
bathed with a delicate radiance and filled with a sense of
profound peace and silence. All is serene in Kensett's world;
the waters are unruffled, the sky is unclouded, and the air is
fresh and clear.

Sanford Gifford (1823–1880), who received some help from
Kensett and whose work resembles Kensett's in its tran-
quillity and handling of light, was born in Hudson, New York,
across the river from Cole's home. While he was an admirer of

Cole and a Hudson River traditionalist, Gifford was particularly interested in "the light giving properties of the sky" to the degree which it affected the forms in nature. He went to Europe in 1855 where he was much impressed by the landscapes of the great English painter William Turner and the Barbizon artists. Yet, like most of the Hudson River painters, Gifford did not approve of their manner of allowing light to diffuse form. In 1868 he made another trip abroad, this time traveling as far as the Middle East. He returned home two years later and devoted himself to painting the more familiar scenery of the American landscape.

Described by a friend as a "serene and placid" man who loved "nature in its most sunny phases," Gifford's pictures reflect his character. *Kauterskill Falls*, a far-ranging view of misted mountains and valleys, is a glowing vision of a peaceful landscape enveloped in the haze of late afternoon sunlight.

In 1865 Gifford and Kensett joined a government expedition to the Rocky Mountains. With them was the Ohio-born landscape painter Worthington Whittredge (1820–1910). His ten years of study in Brussels, Paris, Düsseldorf, and Rome had given him a somewhat freer technique than was customary with the Hudson River painters. On his return from Europe in 1859 Whittredge settled in New York where he quickly gained a reputation as an excellent landscape painter. Elected a member of the National Academy in 1861, he served as its president in 1865 and from 1874 to 1877.

Whittredge too had a reverence for the American countryside, though his pictures are sometimes closer to the spirit of George Inness than to Durand. Yet the sight of one of Durand's landscapes, "so delicate and refined, such a faithful if in some parts sombre delineation of our hills and valleys," could move him to tears. *Camp Meeting*, a picture of a religious gathering in a wooded, parklike setting on a lake, is painted with broad freedom and unusual sensitivity. Sunlight filters through the trees, lighting some areas and throwing other

areas into deep shade, massing distant figures into the landscape and casting a golden radiance over the scene.

The "luminist" painter Martin Johnson Heade (1819–1904) was one of the most individual figures of the "second generation" of American landscape painters and the furthest removed from the pure Hudson River tradition. Heade was born in Pennsylvania, went to Europe while still in his teens, and later wandered through much of the United States and Central and South America in search of subject matter. He settled in New York in 1866, where he stayed for fifteen years. In 1881 he went to live in Florida. Thus removed from New York's active art world, Heade sank into increasing obscurity and was soon forgotten.

Heade saw nature as dominated by light. He painted pictures of salt marshes, Brazilian humming birds, and lush magnolia blossoms with a hard and vivid naturalism. But his most interesting canvases are several seascapes that have a strangely enchanted, almost surrealistic quality. *Approaching Storm: Beach near Newport* is a painting of an area frequented by Kensett. Yet Heade's picture, with its dark sky and water, its brooding eerie light, might have been of another unearthly planet. There is a sense of menace and mystery in Heade's

Martin Johnson Heade: *Approaching Storm: Beach near Newport* (1868). Courtesy of the Museum of Fine Arts, Boston.

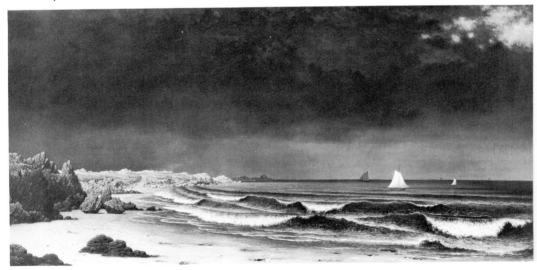

work that is closer to the spirit of Allston than it is to either Kensett or Cole.

PURVEYORS ON THE GRAND SCALE

THE HUDSON RIVER PAINTERS had given Americans a comforting view of a benign and beautiful wilderness, but they had painted only a small portion of a huge country. Though the public loved these gentle scenes, they also wanted to see something grander and more spectacular. In 1840 the United States, in fulfillment of its "manifest destiny to overspread the continent allotted by Providence," began to push its territorial limits over and beyond the seas that bounded the country. And art followed suit. As if to make amends for such earlier artists as Trumbull and his contemporaries, who had been victims of their times, there now came a moment when artists were in perfect harmony with their times. This was the circumstance of Frederick Church, Albert Bierstadt, and Thomas Moran. Like explorers, they brought back dazzling visions of the natural wonders of the North and South American continents. Their giant canvases, scaled to encompass stupendous panoramic vistas, still followed in the traditions of the Hudson River school. Each item, no matter how minute, was finished down to the last detail, so that Americans could see for themselves the incredible marvels of these distant regions. The Civil War, which engulfed the nation, barely touched the lives or careers of these painters. Their passions were excited by America's beauty, not by her problems.

In 1859, the year of abolitionist John Brown's raid on the arsenal at Harpers Ferry, mobs of New Yorkers were elbowing their way into the studio of Frederick E. Church (1826–1900) to see *The Heart of the Andes*. So dense were the crowds outside that police had to handle the flow of traffic. Inside there was scarcely room to stand. Admission fees were

bringing in about six hundred dollars a day. His admirers likened him to "Moses who looked on God unveiled."

With the ingenuity of a born showman, Church had darkened his studio and dramatically focused the light of gas jets onto the huge canvas. Peering through opera glasses or tin tubes, spectators were caught in hushed wonder at the astonishing realism as they roamed through luxuriant jungle growth, scaled the unbelievable heights, and traveled the vast distances of the fabled South American mountains. "This is art's true function," said an awed critic, "not to imitate nature but to rival it."

Frederick Church—the man who could rival the "shining or shadowy sublimities" of nature—was the only son of a wealthy Connecticut family. Because his parents believed in his artistic ability, Church was sent to study with two local painters and, in 1844, to Cole. In the three years he stayed with Cole, Church became a consummate craftsman, far outstripping his master. And by the time he was twenty, he was already known for his colorful renditions of pearly dawns and rosy sunsets in the Catskills.

While he shared Cole's romantic interest in nature, Church had no taste for "grand manner" painting. Nature's magnificence, he felt, was a more sublime subject. A huge picture of Niagara Falls, done in 1857, won him international renown. From then on, he enjoyed a phenomenal success. He traveled throughout the world in search of material: to South America for its mountains, jungles, and volcanoes; to Labrador for the icebergs; to the Middle East in search of exotic subjects; to Greece for its ancient temples. His canvases of mists and rainbows rising over jagged mountain peaks, of fiery volcanoes, roseate sunsets on the Parthenon, and sunlit icebergs in blue and frigid northern waters, sold for huge sums. Rich tapestries, embroidered shawls, foreign carvings, and thick carpets spilled over the walls and floors of his New York studio. On the cliffs of Hudson, New York, overlooking the Catskills, he

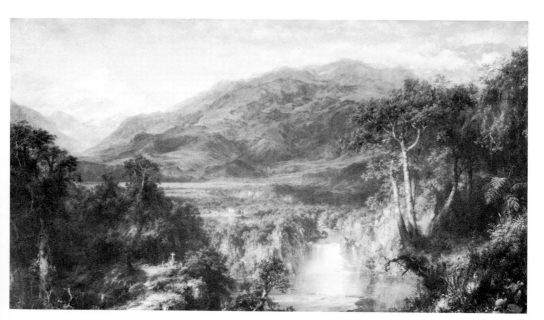

Frederick E. Church: *The Heart of the Andes* (1859).
Courtesy of the Metropolitan Museum of Art,
bequest of Mrs. David Dows, 1909.

built himself a palatial residence in a kind of Persian Victorian architectural style. He called it Olana, the Center of the World.

Church was fifty-one years old when arthritis disabled his right arm. He made valiant but vain attempts to learn to paint with his left hand. His crippling affliction, coupled with Charles Darwin's attack on the divinity of creation, completely undermined Church's universe. The remaining twenty-three years of his life he devoted to furnishing his palatial monument, scouring the four corners of the earth in search of rare and unusual objects.

Church was an extraordinary craftsman, able to render the most minute details with uncanny precision and to capture even the most transitory effects of light and atmosphere. He had a prodigious memory, an exacting eye, and was a most thorough craftsman. Before he embarked on the finished work, he made dozens of preliminary sketches and studies of the subject. His paintings overwhelm by the sheer virtuosity of his

technical prowess. As Henry James once remarked, they "leave criticism speechless."

For all his astounding ability, Church was a man of circumscribed vision. He had a simple imagination and an innocent eye that delighted in massive phenomena, and these he rendered literally in infinitesimal, painstaking detail. His spirit exulted in the grandness of nature, yet, ironically, he was unable to infuse his art with any grand creative passion. As an artist Church was of less than first rank; as a craftsman he had few equals.

Albert Bierstadt (1830–1902), whose career in some ways paralleled Church's, was equally if not more successful. He was showered with awards in America and Europe. His canvases sold for higher prices than any previously paid to an American artist. He built himself a marble and stone mansion overlooking the Hudson in Irvington, New York. It was one of the showplaces of the time. A peak in the Sierra Nevada Mountains bore his name.

Like Church, Bierstadt had a fondness for the spectacular in nature. But the similarity between the two men was superficial. Church was awed by the monumental aspects of nature; Bierstadt saw nature as decor for a dramatic stage set. Church's paintings were almost cosmic vistas of the land; Bierstadt's pictures were no more than extended views of the landscape. Church had an astonishing ability; Bierstadt was, as E. P. Richardson says, "a first-rate second-rate talent."

Bierstadt was born in Germany and brought to Massachusetts during his infancy. He was twenty-three years old when he went back to the land of his forebears, settling in Düsseldorf, where he spent almost three years studying painting. Düsseldorf was a center of European art and was, at this time, becoming a favorite haunt for Americans. Its specialties were landscape, history, and genre painting, sentimentally treated and worked to a high polish.

Before returning to the United States in 1857, Bierstadt

spent several months in Rome with Worthington Whittredge. Then in 1858 Bierstadt traveled out west with a government expedition that was charting an overland route to the Pacific Coast. Bierstadt later made several other trips to California.

From the sketches accumulated during his journeys, Bierstadt evolved the huge paintings of the Rockies, the Sierra Nevadas, Yosemite, and other Western landmarks which brought him fame. He had an eye for topographic accuracy and the dramatic effect of monumental landscape. But his canvases are thinly painted, overly warm in color, and lack sensitivity. *The Rocky Mountains*, done in 1863 and one of the most popular pictures of its time, is worked in a smooth, hard finish and painted in thin, hot color. The mountains, whose pinnacles vanish in misty vapors, are reflected in the glassy waters of a lake. For all that it accurately documents nature, the painting seems to have been contrived in the studio. An encampment of Indians in the foreground (whose sole purpose probably is to contrast the giantism of the mountains by their smallness) seems like an afterthought. The Indians have

Albert Bierstadt: *The Rocky Mountains* (1863). Courtesy of the Metropolitan Museum of Art, Rogers Fund, 1907.

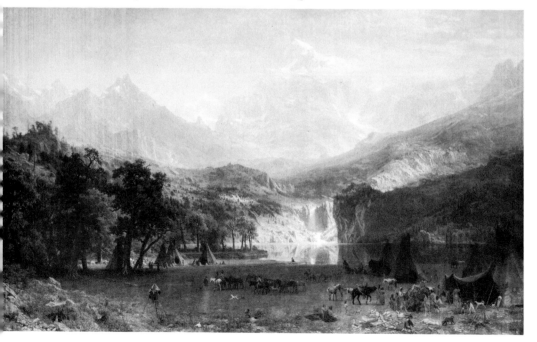

no real relationship to the landscape and look more like a band of picnickers who accidentally stumbled into the wrong picture.

But the very qualities that are now considered its faults were, in Bierstadt's day, considered its virtues. The novelty of the scenery and his overly dramatic and picturesque presentation of it were what made Bierstadt's work so exciting to his contemporaries. Bierstadt, like Church, brought back a vision of the natural wonders of the American land—wonders that were not only new to American art, but new to the eyes of most Americans.

The winds that blow hot one day, blow cold the next. During the last twenty years of his life, Bierstadt's reputation waned. New tastes in art made his work seem old-fashioned and of little value. The greater part of his fortune was gone, and, as if that were not enough, his marble palace was completely destroyed by fire. America's highest paid artist died poor and all but forgotten.

Thomas Moran (1837–1926), who had neither the technical virtuosity of Church nor Bierstadt's dramatic breadth, was nevertheless washed by the waves of their success. "I place no value upon literal transcripts from Nature," he declared. For him the scenery of the American Southwest was "a rainbow land of romantic, miragelike glamor," and to his last days he turned out a constant succession of pretty-colored and immensely popular landscapes of the West. His paintings *The Grand Canyon of the Yellowstone* and *The Chasm of the Colorado*, both of which were bought by Congress, may have led to the passage of the national parks program. Much of Moran's work was widely reproduced as calendar art, for which medium it was eminently suited.

The United States continued on its path of "expansion willed by destiny," and before the end of the century the American flag waved over the Philippines, Puerto Rico, and Cuba. Church, Bierstadt, and Moran had by then been long

forgotten, their huge canvases quietly gathering dust. A new taste in art was developing.

AN INTIMATE LAND

As ARTISTS SOON DISCOVERED, landscape found a ready market. The advances of the Industrial Revolution gave Americans a measure of comfort and security such as their forefathers had never dreamt of. Around 1850 there arose a large, newly-rich urban middle class, who began spending their money on American paintings. They didn't fasten on one particular kind of art, but bought portraits, landscapes, and genre pictures. And if, for one reason or another, they couldn't buy originals, then they bought engravings of such work. Their tastes were unashamedly provincial and American. They had a fondness for carefully painted pictures of simple, sentimental subject matter. For a little while at least, this new breed of art lover bought whatever American artists were painting. Because they found the canvases of the Hudson River school most appealing, landscape painters were among the first American artists other than portraitists to benefit from this affluence.

In 1861 the Civil War—that "uncertain and dreadful dispenser of God's judgements," as the philosopher William James saw it—swept across the nation. The bitter conflict tore the country in two, pitting brother against brother. Before the bloody struggle ended, almost 650,000 had died on the battlefields.

In the long, arduous years of reunification and reconstruction, a new mood filtered into American landscape painting. Perhaps because people now longed for quiet and serenity, the mighty spectacles of Church, Bierstadt, and Moran had begun to pall. Artists were no longer interested in slavishly "imitating" the beauty of an unspoiled wilderness or in picturing nature's monumental grandeur. They now looked on land-

scape as an emotional expression of the artist's personal response to nature.

Beginning in the years after the war, American landscape painting became increasingly subject to developments and movements from abroad. With the manufacture of new and brighter pigments, pictures took on a richer glow. Stimulated by the canvases of the Barbizon school, Americans became more concerned with the effects of outdoor light on nature than with verisimilitude. Their landscapes grew smaller and more intimate, more compelling visions of a corner of the American soil. And in the latter years of the nineteenth century there began to be seen the first signs of the brilliant, pure colors, the small, broken brushstrokes, and the vagueness of forms employed by the French impressionists to convey the effect of natural light. Of all European movements, impressionism was to exert the most considerable influence on late nineteenth- and early twentieth-century American landscape painting.

George Inness (1825–1894), America's finest landscape painter, was a strangely paradoxical human being. This painter of tender, peaceful landscapes was a man of stormy, capricious, and obstinate temperament. Determined to become an artist, he was intractable in the face of his family's efforts to make a merchant of him. He was an ardent abolitionist, and unlike most of his fellow artists, he volunteered his services at the onset of the Civil War. (He was an epileptic and therefore rejected.) He spent years searching for a religious faith, running the gamut of beliefs and finally coming to rest in the mysticism of Swedenborgianism.

His methods of painting were erratic. When seized by inspiration, he worked as many as sixteen hours in a state close to frenzy, oblivious to hunger or fatigue. He had a strange compulsion for revision and frequently altered his pictures in midstream. Paintings that started out as evening scenes ended

as pictures of sunrise; snowstorms became views of peaceful meadows. It was not unusual for him to repaint a canvas as many as six times. He had none of the ordinary qualms about touching another man's work and, because of this scandalous habit, was forbidden to enter the studio of his friend Alexander Wyant.

Yet, in stark contrast to his volatile character, his canvases are tranquil, poetic declarations of his abiding love for the American soil.

Inness was born in Newburgh, New York, the son of a retired merchant who moved his family to Newark, New Jersey, in 1829. He was a sickly child, pale, nervous, and strong-willed, whose education was cut short by illness and a stubborn resistance to authority. He refused to run the grocery his father had bought him and was so insistent on becoming an artist that his family finally capitulated. He studied with a local artist and for a brief period worked with Régis Gignoux, a French landscape painter then living in New York. Inness was otherwise self-taught.

At the age of twenty Inness moved to New York and began his own course of instruction. He worked directly from nature and made an intensive study of the Hudson River painters, particularly of Cole and Durand. Though his intention was to depict nature "grand instead of being belittled by trifling detail and puny execution," his early canvases were tightly rendered and crammed with detail.

Inness' landscapes received little notice. He rarely sold a picture and then for not more than a few dollars. It was Ogden Haggerty, a dry-goods auctioneer, who furnished the necessary moral and financial support, and who underwrote the expenses for two of Inness' trips to Europe. Inness first traveled to Europe in 1847. When he returned, his paintings showed some of the impress that the French and Italians had made on him. Now he began to "see" landscapes as a unified

relationship of earth and sky. He made three other trips to Italy and France, in 1851, 1854, and 1870–1874, all of which added to his growth as a painter.

In 1859, at Haggerty's suggestion, Inness moved to Medfield, Massachusetts, a suburb of Boston, in the hopes that New England would provide a more receptive audience for his landscapes. But Bostonians showed no particular liking for them. His work lacked the picturesque qualities that pleased popular taste, and he was incapable of painting for mass appeal. The years in Medfield were hardly prosperous and by 1864 Inness was back in New Jersey.

Despite his financial problems, Inness produced many of his finest canvases during this, his middle, period. He had outgrown the "puny execution" of his early style. His landscapes were now handled with a greater freedom of brushwork and were rich and glowing in color. Such pictures as *Delaware Water Gap*, the large and now-famous *Peace and Plenty*, and *Hackensack Meadows* are luminous and lyrical visions of a bountiful land.

Inness' reputation had been growing steadily if not spectacularly. In 1868 he was elected a full member of the National Academy. The prestige accorded an artist by the initials N. A. appended to his name most always meant a rise in income. But Inness, said one critic, was too "capricious, headlong, impulsive." He needlessly offended and lost potential customers. He detested bargaining, criticism, or suggestions of any kind, and after such encounters with clients would obstinately refuse all offers, even when his needs were most pressing.

To stimulate sales, his dealers offered to subsidize a European trip so that he could paint the foreign views so much in demand. Inness was outraged. "Nothing is good without a foreign name on it," he railed. "Why, when one of our biggest dealers on Fifth Avenue was asked to procure for a gentleman two American pictures for one thousand dollars each, he said he could not take the order because there was not a picture

produced in America worth one thousand dollars." Despite his displeasure with art dealers' tactics, Inness departed for Europe in 1870. He spent four years in Rome and Paris, where he was particularly affected by the Barbizon painters' emotional yet truthful interpretations of nature.

The trip Inness had been so reluctant to make proved to be the turning point in his career. He came back to the United States, settled in Montclair, New Jersey, and began painting the pictures of his third, or final, period, the paintings that won him instant recognition as America's ranking landscape painter.

Inness' late period was marked by a new development in style. His canvases, smaller in size and more limited in scope, were handled with a greater freedom and feeling. His palette grew brighter and more vivid, his forms vaguer and diffused with light, in the manner of the impressionists. In his picture *Indian Summer,* painted in 1894, Inness transformed a prosaic subject matter into a moving and mystical experience. The

George Inness: *Niagara* (1889). Courtesy of the
National Collection of Fine Arts, Smithsonian Institution.

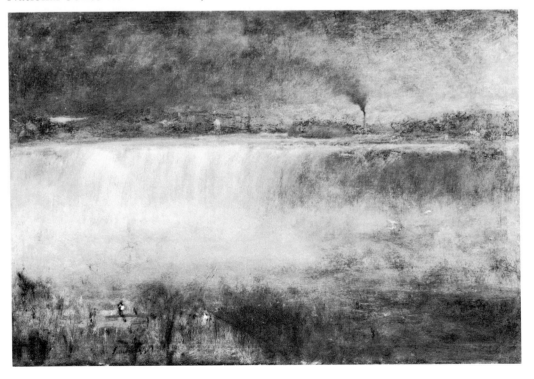

canvas is an eloquent vision of twilight serenity, in which trees, earth, and sky blend into a shimmering pattern of light and shade. His painting *Niagara* is a beautifully impressionistic treatment of the famous waterfalls, in which light, air, and water merge into a radiant, silvery mist.

During the last quarter of the nineteenth century American taste had begun to change. The younger generation of American artists had seen the emotional approach of the Barbizon painters and the impressionists' use of broken color to convey light. These developments were modern and much to be admired, the opposite of the niggling, antiquated realism so esteemed by the National Academy. To the young artists, Inness seemed the hero of the new movement. However, Inness had arrived at his treatment of light in his own fashion. He angrily denied any connection with impressionism. But with characteristic contrariness, he insisted that the "purpose of the painter is simply to reproduce in other minds the impression which a scene has made on him."

Inness was an uneven painter, and even after his "breakthrough" he would revert to the tight little mannerisms of his early years. Occasionally his sense of color would play him false. Yet the whole of Inness' work is greater than the parts. As Tuckerman said, Inness was "unequal in his artistic efforts, but he is also unequalled." Inness brought to American landscape painting a style that was new and intensely personal— a style rooted in Hudson River realism, but arising from his own independent vision. It was a more romantic approach to nature, an art that spoke almost entirely through the feelings.

It was the sight of one of Inness' canvases that made Alexander Helwig Wyant (1836–1892) decide to become a painter of landscapes. He left his job as apprentice to a harness maker and came East to study. At an exhibition he chanced on a picture by a Norwegian landscape artist named Hans Gude. Gude's landscapes were handled with the meticulous precision and smooth finish typical of the Düsseldorf school, but his can-

vases were charged with a Gothic sense of menace not uncommon in North European landscapes of that period. Wyant was so impressed that he hurried off to Karlsruhe, Germany, where Gude was teaching.

The Mohawk Valley, done in 1866, shortly after his return from Germany, established Wyant in the front ranks of American landscape painters. As in most of his early canvases, the picture combines Düsseldorf polish, Gothic portent and Hudson River realism. The canvas depicts a view of a river meandering through rocks and trees to lose itself in the distant hills. Yet Wyant had become so steeped in the Gothic idiom that he managed to convert the bucolic American scenery into a harsh and alien landscape.

In 1873 Wyant joined a government expedition to New Mexico and Arizona to paint its scenery. The rigors of camp life proved too much for him, and he suffered a stroke which paralyzed his right side. Another man might have resigned himself to the half-life of an invalid, but not Wyant. Painfully and with almost superhuman effort, he taught himself to paint with his left hand. The shift from one hand to another was accompanied by a complete transformation of style. Possibly because he could exercise less control with his left hand, Wyant's canvases became softer and gentler.

After his illness Wyant began to show the influence of Inness. Wyant's late works were small and intimate glimpses of nature blurred in a haze of light. His production was severely limited by his ailment and further reduced by his wife. When he died, out of respect to his memory Mrs. Wyant systematically destroyed all the canvases she deemed inferior. Fortunately, she did not destroy *Moonlight and Frost,* a painting endowed with a tender and melancholy poetry.

The artistic vision of Homer Dodge Martin (1836–1897), a contemporary of Wyant, came sharply into focus as he neared the end of his life. "If I were completely blind now and knew where the colors were on my palette, I could

express myself," Martin declared. The grand irony was that he was almost completely blind at the time he said this. In the last ten years of his life, his eyesight failing, Martin produced his most lyrical and memorable work. Though few of his fellow artists recognized it, he was a sensitive and genuinely gifted painter and one of the pioneers of American impressionism.

Martin was born in Albany, New York, and at the age of sixteen began his career as a painter with Hudson River tendencies. He attempted to imitate the style of Kensett's simple and harmonious landscapes, but Martin had none of Kensett's tranquillity. There was "an austerity," his wife said, "a remoteness, a certain savagery in even the sunniest and most peaceful of his landscapes—a quality his countrymen found repellent."

The work of Jean Baptiste Camille Corot, one of the great nineteenth-century French painters, was just becoming known in the United States. Having seen some of Corot's landscapes, Martin felt that he had to go to Europe to see for himself what was happening in French art. In 1876 he went to France and returned there three years later for a prolonged stay. Much of the time he lived in the coastal villages of Normandy and Brittany. Here he came under the influence of the impressionists, many of whom painted in the area. Martin adopted their method of applying pigment in small dabs of color and blurring the edges of objects. However, he didn't care for their vivid color, preferring for his own use a paler, more subdued palette.

When Martin returned home in 1887, he had at last found his direction. Two years before he died, he completed *The Harp of the Winds*, one of the most widely reproduced pictures of its time. It is a view of the low-lying French countryside dominated by a row of tall, slender poplars, their delicate, harplike image reflected in the shimmering waters of a nearby

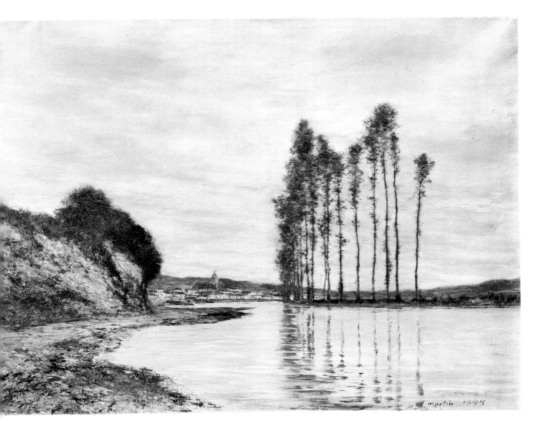

Homer Dodge Martin: *The Harp of the Winds* (1895).
Courtesy of the Metropolitan Museum of Art, gift of several gentlemen, 1897.

stream. The painting is one of the most sensitive and evocative of American impressionist landscapes and the picture by which Martin is best known.

If the appetite for likenesses seemed never-ending, the interest in landscape painting was almost as great. Landscape had opened American's eyes to a new awareness of nature, especially to the beauties of their own, their native land. Though Copley probably would not have considered it the most discriminating kind of appreciation, he would surely have been heartened by the knowledge that Americans were increasingly displaying a "taste for painting." For in the creative climate of the nineteenth century the horizon of American art was growing ever wider.

VIII Buffaloes and Ballots

> We cross the prairie as of old
> The pilgrims crossed the sea,
> To make the West, as they the East,
> The homestead of the free!

So RAN THE WORDS of an old American marching song
designed to buoy up a flagging spirit or a timorous heart. For
the West was a bloody arena, won by force and violence. Like
the pilgrims of whom they sang, these later pioneers had to be
made of stern stuff to carve a future in this new wilderness.

Ever since the colonies had been planted, the march was to
the West. In the nineteenth century what had started as a
trickle swelled to a continuous flood of settlers pouring into
the frontier. Swiftly they transformed the wilderness into
thriving communities and productive farmsteads. Land was
plentiful, cheap, and fertile, and this new breed of native- and
foreign-born pioneers were as hardy, intrepid, and determined
as the original colonists. Carrying their household possessions
and even their livestock, they came by overland routes on foot,
on horseback, and in "prairie schooners," as covered wag-
ons were called, or they paddled down the winding river-
ways on homemade rafts or flatboats. For safety they carried
their guns and traveled in groups that sometimes stretched for
miles. Whatever their means of transportation, the journey
was long, exhausting, and hazardous, plagued by illness and
the ever-present danger of Indian attacks. When at last the dif-
ficult trek was done, each step of the way was marked by the
graves of those who had died of disease or been killed in the
savage struggle to wrest the land from the Indian.

From the time the first white man set foot on American soil,

140

the Indian had been slowly, but relentlessly, uprooted from his ground. These pioneers who sang of freedom meant freedom only for their own kind. To secure the land, they had to dispossess the "savage" by one means or another, fair or foul. And the means were mostly foul.

It was an unequal contest. Outnumbered, outmaneuvered, poorly armed, the red man waged a hopeless battle against the white. By the time the West was won and a peaceful solution arranged, the Indian was all but decimated. The few survivors of the race, scattered and dispirited, became one of America's forgotten peoples.

Before the first quarter of the nineteenth century the only artists who entered the frontier regions were those employed on government expeditions. Most artists never even thought of the Indian or the Western settler as a subject for art. Several authors had written stories or plays about the Indian, and in 1826 James Fenimore Cooper published *The Last of the Mohicans,* a novel about "nature's noblemen," which made Cooper famous. In mid-century Bierstadt and Moran were painting the West. But almost all their canvases were concerned with the West's grandeur, not with its inhabitants.

There weren't many artists willing to venture into Western territory. Reputations and money were made in the East, so they had little reason to exchange their cushioned comforts for the barbaric crudity and dangers of the frontier. America's artists do not value "our incomparable material . . . ," Emerson once declared. ". . . our log rolling, our stumps and their politics, our . . . Indians . . . are yet unsung."

Emerson was addressing himself to literary men. But there were painters, two in particular—George Catlin and George Caleb Bingham—who were singing these "songs." Both were pioneers, "adventurers in the brush line," to borrow a phrase from Samuel Morse. Catlin was a painter of Indians, the first to depict America's truly native sons as they really were. Bingham chronicled the life and people of the West. He was the

first American artist to paint the common man against the background of his everyday life.

SAVIOR OF A NOBLE RACE: GEORGE CATLIN

ONE ARTIST HAD the purpose, resolution, and boldness to carry him where others feared to tread. George Catlin (1796–1872) was a man with a mission. Deeply moved by the plight of the Indian, he resolved that nothing short of death would stop him from becoming their historian. He left his family, gave up a promising career, and went to live with Indian tribes so that he would really know them. "I have flown to their rescue," he wrote, "not of their lives or of their race (for they are 'doomed' and must perish), but to the rescue of their looks and their modes . . ." so that "phoenix-like they may rise from the 'stain on a painter's palette,' and live again upon canvas . . . the living monument of a noble race." His portraits, drawings, and written records are "a living monument"—a graphic and lasting document of the life and customs of the American Indian.

Many of the residents of Wilkes-Barre, Pennsylvania, the town where Catlin was born, were survivors of Indian raids. His mother never tired of telling of her childhood rescue from a band of savages. Soldiers, hunters, and frontiersmen who frequented the area boasted of their victorious encounters with the red man. On Catlin's cheek, like a mystic portent of his future, lay the scar of a tomahawk wound accidentally inflicted by a playmate. Yet even during these early years, Catlin had more compassion for than fear or dread of the Indian.

Catlin was at first a lawyer. The profession bored him, and by 1823 he decided he'd had enough. He sold his books, his furniture, and his almost nonexistent practice (he had only one case on record) for some "paint pots and brushes" and set

himself up as a painter of portraits and miniatures in Philadelphia. Notwithstanding his complete lack of training, he was elected to the Pennsylvania Academy the following year. He also won a prize and membership in the National Academy for a classical painting, commissioned for the opening of the Erie Canal.

Though Dunlap rejected Catlin's likeness of De Witt Clinton as "utterly incompetent," there was enough demand for portraits (even inferior ones) to insure Catlin of a fair livelihood. But Catlin needed a *raison d'être*, a justification for his life and his art. He found it one day when he happened to see a visiting delegation of American Indians. Then and there he came to a decision: He would rescue these "lords of the forest" from "oblivion," and to promote their cause and his, he would found an Indian museum, along the lines of Peale's institution. In 1830 he bade his family good-bye and departed for St. Louis to begin his life's work.

With a minimum of painting equipment strapped to his back, Catlin spent six years traveling through the wilderness to what are now the states of South Dakota, Oklahoma, Missouri, Minnesota, Iowa, Louisiana, and Florida. In Catlin's time this was largely unexplored territory, known only to the Indians, a few fur traders, and the soldiers who manned army outposts. He visited countless tribes such as the Mandans, the Comanches, the Sauks, the Sioux, the Osages, the Choctaws, the Ojibwas, and the Seminoles, never knowing whether he would encounter friend or foe. Imbued as he was with the spirit of brotherly love, he was generally on the friendliest terms with the Indians. He lived with them, learned their customs, and was invited to witness secret tribal rituals and torture rites, an invitation rarely extended to a white man. He portrayed every facet of their existence: their looks, their dress, their habits, their abodes, their land.

The Indians, who knew little about the white man's art, were a superstitious people and sometimes suspected Catlin of

George Catlin:
One Horn
(1832).
Courtesy of the
Field Museum of
Natural History,
Chicago.

possessing occult powers. His portrait of a Dakota chieftain, *One Horn*, alarmed even the staunchest warriors. The medicine men accused Catlin of having condemned their leader to a horrible and premature death. He had imprisoned One Horn's soul in the canvas and fixed his eyes open for all eternity. Feelings against Catlin rose to such heights that only One Horn's intercession saved him from bodily harm. But once Catlin's innocence was established and his intentions made clear, the whole village offered to sit for him.

To paint the many portraits, speed was essential. In dealing with the various tribes, tact and diplomacy were indispensable. The members of a tribe had to be taken in correct order, the most important first, the least important last, and males before females. If he tried to change this order, particularly when he was more interested in painting one of the women, he had to use all the arts of persuasion, and then he wasn't always successful.

Once, and unwittingly, Catlin precipitated violence. He was painting the profile portrait of a brave. A rival of another tribe taunted the brave, saying he had only half a face and was thus only half a man. The infuriated sitter demanded a duel, in the course of which he was mortally wounded—he was shot on the side of the head absent in the portrait! His relatives immediately swore vengeance. Catlin, fearing for his life, took off with unceremonious haste. Later he learned that the rival had been killed and that his own head was sought. Fortunately, incidents of this kind were very rare.

In 1837 Catlin came east to open his Indian Gallery. Included were several hundred pictures—portraits, landscapes, and scenes of daily life—as well as real wigwams, tribal outfits, scalps, and a variety of artifacts. In addition, Catlin, dressed in Indian regalia, delivered a lecture on the red man's customs. His descriptions of tribal ceremonies, especially the Mandan torture rites, were regarded as out-and-out fabrication. On top of this, his violent denunciations of the fur companies' and the federal government's cynical treatment of the Indian convinced his listeners that he was nothing more than a publicity-minded crank. Catlin oversold his cause. His too ardent espousal made him seem suspect.

Catlin offered the government a chance to buy his collection. It was refused (fortunately, since the Smithsonian Institution, the national museum in which it would have been housed, was completely destroyed by fire in 1865). In 1839 he took his gallery on a successful tour of Europe's capitals. He had added a band of gaudily bedecked, whooping Indians, which brought in money, but lent the exhibition an air of sensationalism. Then, through a series of bad investments, he lost his money and the entire collection. (Years later, in 1879, it was discovered blackened and begrimed in a Philadelphia warehouse and donated to the rebuilt Smithsonian.) Undaunted by his misfortunes, Catlin traveled to North America's western coast, the Aleutian Islands, and Siberia to complete

his studies of Indian civilizations. Then he settled in Brussels to organize his material.

At the age of seventy-four, after an absence of thirty-one years, Catlin returned to the United States with his new Indian Gallery. It was five years since the last gun of the Civil War had been fired and the country was enmeshed in the problems of reconstruction. Catlin tried to revive interest in the Indian and once again offered his work to the government. He was ignored on both counts. A year before he died, he was still hoping that Americans would "find enough of historical interest excited by faithful resemblance to the physiognomy and customs of these people, to compensate what might be deficient in them as works of art."

Though Catlin was a better reporter than artist, he was entirely too humble about his work. His lack of training and the enormous pressure under which he worked (he produced as many as eight canvases a day) account in part for his faults. His color may be thin and garish, his drawing often inaccurate, but his faithful documentation, his attention to detail, and his ability to portray character outweigh these faults. His Indians are never colorfully costumed models, but strong and dignified flesh-and-blood men and women. Catlin responded with greater sensitivity to pencil and watercolor. His landscapes, scenes of buffalo hunts, and figure drawings in these mediums have a delicacy and refinement that is truly delightful.

Catlin had the bad luck to have picked a lost cause. In the day when most Americans felt that "the only good Indian is a dead Indian," he had the audacity to preach peace and freedom for the red man. His aims were to achieve amicable relations between the Indian and the white man; to have the government establish a national park along the length of the Rocky Mountains as a permanent homesite for the Indian peoples; and to have the government purchase his collection

as the nucleus of a national Indian museum. He was not destined to see his dreams come true, but much of the assistance later granted the Indian was due to his untiring efforts on their behalf. His writings, notably *The Manners, Customs and Conditions of the North American Indians*, published in 1841 at his own expense, have added immeasurably to the knowledge and understanding of these original inhabitants of the New World. But it is through "the stain" on Catlin's palette that the Indian lives.

INDIANS . . .

CATLIN WAS NOT the only man to paint the Indian. A number of artists followed in his wake, some of whom were better painters, better draftsmen, and better colorists. But none of them was a Catlin. They had none of the dedication, the insight, and the love that endowed Catlin's pictures with the unmistakable ring of truth. Nevertheless, their work has importance, not so much for its aesthetic merits but as visual documentation of a time and a people that are now a part of American history.

In 1829, a year before Catlin set out on his great adventure, Seth Eastman (1808–1875) was painting pictures of the frontier. Eastman was a curious amalgam—a military man and professional artist, who managed to combine both careers in happy union. He was born in Brunswick, Maine, graduated from West Point, and did several tours of duty at army outposts in western territory. At one time he was assistant professor of drawing at the military academy, and his *Treatise on Topographical Drawing* was adopted as their first textbook on the subject. He saw service during the Civil War and rose to the rank of brevet brigadier general. As testimony of his artistic ability, he was elected Honorary Member, Amateur, of

the National Academy—*honorary* because he lived outside the one-hundred-mile radius of New York; *amateur* because he was a soldier by profession.

Eastman's interest in the Indian was kindled during his years of service as a frontier officer. He painted many pictures of the Sioux, Chippewa, and Seminole tribes, as well as views of army installations and landscapes of the frontier, most of which were very well received by contemporary critics. He illustrated a number of his wife's books about Indian life. And he was selected by Congress to illustrate the five volumes of Henry Rowe Schoolcraft's *The American Indian,* an assignment of considerable importance, which for some reason Catlin had refused.

Eastman was, a friend said, "a most efficient frontier officer." He was calm, courteous, and understanding in his dealings with the Indians, but he never relaxed his authority or let them forget his superiority as a white man and as an officer of the United States Army. He did not look on the red man as one of "nature's noblemen," as did Catlin, but considered them childishly superstitious pagans full of "ungoverned passions." Eastman's pictures are objective reports, competent but undistinguished. The Indian and his country intrigued Eastman's eye, but never snared his emotions.

It was chance rather than compulsion that led Alfred Jacob Miller (1810–1874) to the American frontier. The son of a prosperous Baltimore grocer, Miller first studied with Thomas Sully, then went off to Paris with hopes of becoming a historical painter. Like other such dreamers he found little market in America for the grand style, and with a minimum of fuss and complaint he adjusted himself to a future as an itinerant portraitist.

In New Orleans, Miller became acquainted with Captain William Stewart, an adventurous Scottish nobleman on his way into Indian country. Stewart was looking for an artist to make sketches of the West which could later be enlarged into

murals for his castle. He offered the job to Miller, who eagerly accepted it. Allowed a free hand in his choice of subject matter, Miller painted almost everything in sight. His watercolors of fur trappers, buffalo hunts, Indian encampments, and the Western landscape have a vigorous realism. In his pictures of Indian maidens and Indian courtships, however, Miller had a tendency to become rather tritely sentimental. When he completed his assignment (including the murals), he returned to a less eventful existence in Baltimore, painting dull portraits and re-creating his earlier Indian pictures.

Karl Bodmer (1809–1893), born in Switzerland, came all the way to the United States in 1832 to gather material on the American Indian. His pictures on this subject provided the illustrations for a book by the German naturalist Maximilian, prince of Wied-Neuwied, entitled *Travels in the Interior of North America*. Bodmer visited a number of Indian settlements along the Missouri River, taking the same route Catlin had a short while earlier. He returned to Europe in 1834 and, after finishing his job, went to live in Barbizon, France, where he became fairly well known for his etchings of animals.

Bodmer was the most competent and sophisticated painter of the frontier. His pictures were skillfully composed, his color was cool and harmonious, and his drawing impeccable. But the true character of the red man escaped his learned foreign eye. Bodmer was a classicist, and his figures were modeled after antique Greek sculpture. His Indians are beautiful, but unreal—they are mythological warriors inhabiting an American Olympus.

William T. Ranney (1813–1857), a self-taught portrait painter, became enamored of the Southwest when he was posted there during the Mexican War. Arriving after the fighting was over, he spent his time sketching and making notes of the area, which he brought back to his New Jersey studio. From then on he painted nothing but pictures of hunters, trappers, Indian scouts, and occasional illustrations of early

pioneer life. He was a mediocre draftsman and had little eye for color, but his canvases have a certain power and vitality. Ranney's best-known work, *The Trapper's Last Shot*, portrays a lone horseman fording a stream, his whole being alert to the danger of Indian attack. The painting was reproduced through engraving and became enormously popular.

John Mix Stanley (1814–1872), a Detroit portraitist, made several excursions into Indian country. To record his impressions, he brought along not only a sketchbook, but also a camera which must have been one of the earliest models. Like Ranney, Stanley created his pictures in his studio. He was not very sympathetic to the Indian and generally portrayed them as savage brutes torturing innocent white women. Fortunately or unfortunately—it is hard to say which—most of his work was lost in the Smithsonian fire of 1865. Stanley's few existing canvases are competently rendered, but have the hard, glossy finish of a photograph.

A visit to Catlin's Indian Gallery inspired Philadelphia-born Charles Deas, pronounced Days (1818–1867), "to taste the wild excitement" of the West. From 1840 to 1847 he lived in St. Louis, from which point he made forays through the Mississippi Valley and the prairie country. His pictures of trappers and hunters and his other scenes of frontier life became quite popular as engravings.

The last eighteen years of Deas's life were spent in an insane asylum, from whose dark confines he sporadically sent paintings (which have all disappeared) to the National Academy shows. Tuckerman describes one "representing a black sea, over which a figure was suspended by a ring, while from the waves a monster was springing, which was so horrible that a sensitive artist fainted at the sight."

Deas's known canvases were studio-fabricated scenes charged with a sense of violence and impending disaster—terrified settlers desperately trying to outride the encroaching flames of a prairie fire; a white man and an Indian, both on horseback,

locked in mortal combat as they plunge down a yawning abyss.

As time went on, the image of the red man was drowned in a sea of mawkish sentimentality, and only Catlin's objective pictures have served to rescue the true image of the Indian from oblivion. It is one of the bitter paradoxes in American history that no sooner had the Indian been vanquished than he became a shining symbol of bravery and nobility. The living Indian was ignored; he no longer existed as a threat to the white man's progress.

. . . AND COWBOYS

By THE LATTER PART of the nineteenth century the vanishing frontier had vanished. The Old West was gone. On yesterday's hunting grounds there were homes and ranches, and the air was filled with the peaceful lowing of huge herds of cattle.

Now the West had a new hero. The cowboy, cowpuncher, vaquero, buckaroo, waddie, or broncobuster as he was called, depending on the locale in which he worked, emerged as the most colorful and romantic figure of the new West. Artists and writers alike were intrigued by his picturesque qualities. He galloped through countless pictures and pages of print and onto motion picture and television screens to become one of the most universally admired characters. Even today, when the frontier has long since given way to a landscape of super-highways, motels, hamburger stands, and drive-in theaters, the cowboy retains his luster as an image of American enterprise and individuality.

It was only natural that Frederic Remington (1861–1909) should have been attracted to the cowboy. An ardent sports-man, a skilled rider and outdoor enthusiast, he loved the raw excitement of the West. Remington was born in Canton, New York, attended a military school, and in 1878 entered the Yale School of Fine Arts. During his year and a half at Yale (his

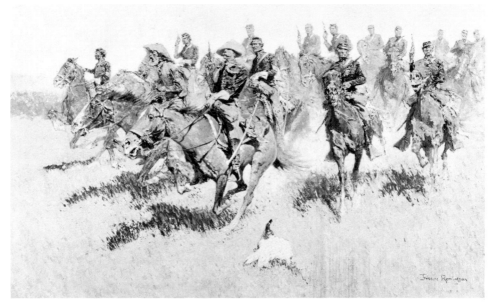

Frederic Remington: *Cavalry Charge on the Southern Plains* (1907).
Courtesy of the Metropolitan Museum of Art, gift of several gentlemen, 1911.

father's death precluded any further study), he gained a con-
siderable reputation as a boxer and football player.

In 1883 Remington bought himself a sheep ranch in
Kansas, where he learned to ride like an expert and handle a
lasso with a cowboy's dexterity. But he soon discovered that he
preferred to paint the frontier rather than work it. He sold his
property and headed for Texas, New Mexico, and Arizona,
filling his notebooks with drawings of cowboys, Indians, sol-
diers, and prospectors. He returned to New York City, where
he soon became the foremost illustrator of the West.

Remington loved horses. He would have been proud, a
friend said, "to have carved on his tombstone the simple sen-
tence 'HE KNEW THE HORSE.'" That Remington knew the
horse is self-evident. He knew the cowboy and the cavalryman
equally well. His much-admired paintings, sculptures, illustra-
tions, books, and stories of frontier life are filled with swift-
paced action and the sureness of first-hand knowledge. He was,
however, more of an illustrator than an artist. His accurate

reporter's eye could highlight an incident and capture its excitement. But his paintings lacked imagination and fire. He did not have that indefinable spark of creative vision that makes for a work of art. It was in his sculpture that Remington was able to capture that elusive element. No one has better translated the Western scene into bronze. His statues of cowboys or Indians and their horses are welded together in an incarnation of animal energy that is the essence of the rough-riding West.

When Remington died, Charles Schreyvogel (1861–1912) became America's most popular interpreter of the Old West. He was born on Manhattan's Lower East Side and in 1887 left for three-years study in Munich, a city that was now replacing Düsseldorf as a center for American artists in Germany. He returned to Hoboken, New Jersey, where he started his career as an illustrator. In 1893 he indulged a long-repressed desire to see the West, spending part of the summer at an Indian reservation in Colorado and the remainder in Arizona. He made one other trip West, this time to the Dakotas during the summer of 1900.

That same year he reluctantly sent his painting *My Bunkie* to the National Academy exhibition, where it won first prize. The picture, showing a trooper galloping to the aid of a wounded comrade while fellow soldiers hold off a band of Indians, became an overnight sensation and launched him on a highly successful career. Critics were divided in opinion about his work. Some thought him better than Remington, others not as good. Remington himself, perhaps resenting Schreyvogel's popularity, called his pictures "half-baked stuff." But it didn't matter. Schreyvogel's work had sufficient appeal and gained a wide audience through photographic reproduction. "Buffalo Bill" Cody, the famous United States cavalry scout and self-proclaimed "King of the Cowboys," bought many of Schreyvogel's canvases for his collection of Western art. Theodore Roosevelt, another of the artist's admirers, gave

him presidential carte blanche to visit all government military posts and Indian reservations.

Schreyvogel's pictures were mostly of cavalrymen engaged in fierce encounter with the Indians. As with Remington, he had a better knack for telling a story than creating a work of art.

Like many young American boys Charles M. Russell (1864—1926) was bedazzled by the color and excitement of the West. At the age of sixteen he settled in Montana, determined to become the best chronicler of the West. Russell was not a man to waste a moment. He carried his paints and modeling clay with him at all times. Sometimes, when he was visiting and couldn't use his paints, he would sit talking, his fingers busily working his clay.

Russell was self-trained and had disciplined himself into becoming an able draftsman. He was a competent technician, but had a weak sense of color and a prosaic eye. His pictures of cowboy life are matter-of-fact representations of what he saw. Like Remington, he was also a sculptor and writer. His work in these two fields is no more exciting than his canvases. All the same, Russell had quite a successful career.

Americans, particularly men, enjoyed pictures of frontier life. They weren't seeking an aesthetic experience. What they found in these paintings was vicarious pleasure. Without leaving their armchairs, they could thrill to the dangers and excitement of the rugged West. This, as much as anything, accounts for the immense popularity of these pictures.

PAINTER AND POLITICIAN: GEORGE CALEB BINGHAM

WITH THE EXCEPTION of Catlin, the men who painted the wilderness were, almost to a man, capable but undistinguished craftsmen. They were all strangers to the West, foreigners,

whether American or European, in alien territory. To them the West was interesting mainly because it provided a colorful and dramatic type of subject matter.

There was one man other than Catlin—a man named George Caleb Bingham—who knew the West as well as he knew his own face. He was, in addition, a genuinely gifted painter. His canvases were bought by the Art-Union, and he became nationally known through reproductions of his pictures. But because he was a Westerner and his work was deemed "vulgar," Bingham was almost completely ignored by the important art circles of the East. Yet his contemporaries Eastman, Ranney, and Deas, who were neither as talented or perceptive, were well regarded in these same circles. Only after his death did Bingham gain the full recognition he so richly deserved.

Bingham was a man pulled in two directions. He was by vocation an artist. He was also a political man, a passionate and pugnacious champion of the common man's struggle against injustice. His political achievements, however commendable, left no lasting impression. It is as an artist that Bingham is remembered. He knew the brawling, roistering rivermen; the hardy, shrewd fur trappers; the log-rolling, stumping politicians. And he painted them with the vigor and vitality indigenous to the frontier. He is the painter of the West, the first to see it as part of the American scene.

George Caleb Bingham (1811–1879) was born in Virginia. When he was eight years old, his family moved to Franklin, Missouri, a thriving, bustling frontier community. Franklin was a hub for the rivermen who manned the boats of the Western waterways. Here Bingham came to know by heart the day-by-day frontier life that was to be the lifeblood of his art.

Though he wanted to study painting, the untimely death of his father sent him into the world to earn a living. He worked in a tobacco factory rolling cigars, was apprenticed to a cabinetmaker, toyed with the idea of entering the ministry or

studying law, before he finally decided to become a professional painter. At the age of twenty he set himself up as a portraitist in Franklin and later moved to St. Louis. For several years he worked in Washington, D.C., painting the likenesses of the political figures of the day. Except for a brief period of study at the Pennsylvania Academy, Bingham was self-taught. He learned his craft by watching itinerant artists and, as he said, "by means of his own unassisted application. . . ." He was fairly adept at catching a surface resemblance, but his portraits were woodenly stiff, and his technique was hard and tight. Nevertheless, his reputation was growing, and he might have found himself a comfortable berth in that field. But Bingham was restless. Like Catlin, he was seeking an art form that held more meaning for him.

The turning point in Bingham's career came in 1844, when he went back to Missouri. Here he began to paint the "social and political characteristics" of the people he knew so well. He portrayed in all their various guises the hard-working, hard-playing, rowdy boatmen who plied the great Western rivers. The workings of democracy in frontier country also stimulated his imagination. With vivid realism he showed politicians making the rounds stumping for votes. He depicted the final moments of a political contest when the results of the balloting are announced to the local electorate.

From these commonplace, everyday activities of the ordinary man, Bingham created a grand and lasting image of the American frontier. Despite his lack of training and a certain harsh rigidity in his drawing, he was an artist of unusual sensibility and originality. His canvases, some of which are quite small, have a monumental simplicity and a largeness of design. Some of his political pictures are intricate arrangements of architectural backgrounds and multitudes of figures. All of his characters are drawn from life, each man a recognizable type.

One of the finest and most famous of Bingham's paintings of

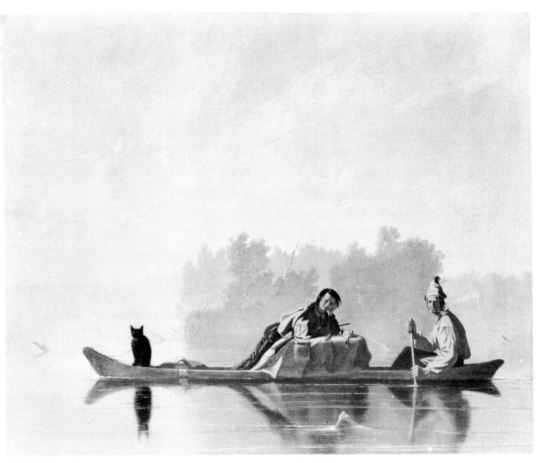

George Caleb Bingham: *Fur Traders Descending the Missouri* (1845).
Courtesy of the Metropolitan Museum of Art, Morris K. Jesup Fund, 1933.

the rivermen is *Fur Traders Descending the Missouri*. It
depicts a boatman and a young boy in a dugout canoe, gliding
silently over the glassy surface of the river. The background is
a shimmering haze of light, revealing only the slightest hint of
the wilderness beyond. The picture depicts a commonplace
aspect of frontier life at that time. But Bingham endowed it
with a lyric majesty that makes this little canvas an impressive
work of art.

Bingham's pictures became enormously popular through
Art-Union engravings. Yet, despite his success, Bingham was

not highly regarded by Eastern art circles. In their estimation he was no more than an "untutored" and tasteless painter. To acquire the polish so esteemed in the East, Bingham went to Europe in 1856. He spent three years on the Continent, mostly in Düsseldorf. Unfortunately, he succumbed to the same ailment that afflicted many self-taught American painters when they tried to adopt a foreign veneer. His Düsseldorf experience robbed him of his innate artistry and individualism.

Though Bingham continued to paint pictures of Western life, his finest and most important work lay behind him. More and more of his time and energy were now diverted to political ends. When he returned home in 1859, the issue of slavery had bitterly divided the nation, and Bingham immediately jumped into the fray, aligning himself on the Union side. For many years he had worked for local political parties, painting posters and banners, campaigning for legislative measures, and in 1848 he had sat in the Missouri House of Representatives. In 1874 he was appointed commissioner of the Kansas City Police Department and a short while later was named adjutant general of Missouri. Bingham was an honest and fearless public servant and an enemy of tyranny. One of his last acts as adjutant general was to break up the Missouri branch of the Ku Klux Klan and imprison its leaders for their criminal treatment of the Negro.

In 1863, Bingham became embroiled in a macabre battle in which he used his art as a political weapon. The painting he did was to be his last. To halt the bloody raids along the Kansas-Missouri border by bands loyal either to the Union or to the Confederacy, Union General Thomas Ewing issued an order demanding the evacuation of all residents of the area. The wake of looting, pillage, and murder that followed the issuance of "Order Number 11," as it was called, enraged Bingham. When Ewing refused to withdraw his authorization, Bingham vowed vengeance. He painted *Order No. 11* to

expose "the character of military rule which oppressed and impoverished huge numbers of the best citizens of our state. . . ." His strategy succeeded; Ewing was transferred to another post. The picture was an effective piece of propaganda. As a painting it had little merit.

When in the aftermath of war Ewing was being mentioned as possible presidential timber, Bingham renewed his attack. Bingham died soon afterward, but a posthumous letter published in the newspapers under the heading "A Voice from the Tomb," wrecked Ewing's career. As in death Bingham triumphed in his fight against injustice, so did he later win recognition as one of the finest painters of the West. His scenes of the frontier are filled with an unabashed enthusiasm for a subject matter that is uniquely American. But beyond this, Bingham brought to his pictures a compelling artistry. His canvases are timeless portraits of a vanished era in American life.

IX What the People Want

MEN, WOMEN, and children by the thousands descended on the nation's capital to witness the inauguration of their hero, Major General Andrew Jackson, as seventh President of the United States. They watched him take the oath of office and listened raptly to his speech. When they saw him mount his horse and ride off to the White House, they dashed madly after him, not willing to miss a moment of the glorious event that had taken place on this day, the fourth of March in the year 1829.

Farmers, ditchdiggers, woodsmen, tradesmen, millers—the American "people"—overflowed the presidential mansion, trampling dirt under foot, standing on damask chairs with their muddy boots, spilling punch onto the carpets, breaking glass and china in the crush to be among those to shake Jackson's hand. Shocked conservatives viewed the scene with horror, seeing the demonstration as the first manifestation of mob rule. But they need not have been so concerned. Jacksonian Democracy, as his "reign" was called, was neither revolutionary nor anarchic in character. It was, however, the beginning of a new brand of democracy in American government, an assertion of the "people's right to govern themselves." And it marked the start of the common man's rise to political power.

Andrew Jackson was the first President to have come from the people. He was born on the frontier, had a limited education, little experience in government, and was without social pretension. "Old Hickory," as he was called by the press, "King Andrew I" or "King Demos" (King of the Mob) as his enemies called him, was the epitome of the self-made man. Jackson was hardly "the champion of the poor, or even the

'common man,' " says the historian Samuel Morison, but the people "loved him because he proved that a man born in a log cabin could become rich, win battles and be elected President of the United States."

Jackson's accomplishment was indeed something to make a man hold his head high. Americans had begun to take pride in the beauty of their land. They also began to take pleasure in looking at pictures that reflected their daily lives. Newspapers and magazines, directed to a mass audience, started printing illustrations of everyday activities. As a form of advertising (whose popularity has lasted to this day), business firms distributed calendars containing sentimental or humorous scenes of commonplace incidents, a different one for each month. Currier and Ives began publishing their now famous lithographs of familiar pursuits and topical events.

Genre painting—the term used to describe pictures of anecdotes or scenes from ordinary, everyday life—started at almost the same time as landscape painting, shortly after the first quarter of the nineteenth century. When Ralph Waldo Emerson declared "We do not, with sufficient plainness, or sufficient profoundness, address ourselves [to the] times and social circumstances," he obviously had not heard of Bingham. Just as he was unaware of the men who were painting the Indian, so was he unaware of the men who were addressing themselves to the "times and social circumstances."

There were reasons why genre painting did not develop sooner that it did. Genre was a natural extension of the field of portrait painting. But portraiture rarely included more than one figure on a canvas, and that was most often painted in bust size or half-length. The "conversation piece," which did include several figures, was an uncommon assignment, and here, as in a single portrait, the overriding concern of the artist was in catching the sitters' likeness.

Genre painting generally involved many figures, whose very movements and gestures had to "tell a story." There weren't

too many American painters capable of handling the figure in a variety of poses. At that time what art schools there were in the United States didn't offer classes in human anatomy or life drawing (drawing from the living nude model). These courses were essential to the understanding of the human body. Yet students were expected to pick up such information by drawing from antique casts or by copying engravings of the old masters. Figure painting was taught in European art schools, but only those artists with sufficient means could afford to stay long enough to acquire such knowledge. Artists interested in figure painting, who were lucky enough to have studied abroad, usually became converts of the "grand manner"; they regarded genre as a vulgar and inferior branch of the arts. Finally, and perhaps more important, there was no particular demand for such paintings. Neither church, state, nor private patron showed any pronounced interest in figure painting and especially not in figure painting of any kind by American artists.

That genre painting should have begun to flourish at this particular moment in American history is understandable. The notion that genre was an inferior art form was a foreign concept and one that could not long exist in a nation dedicated to the equality of men. The further away Americans grew from their humble roots, the more they discovered a nostalgic tie to their past. And in this era of Jacksonian Democracy, when each man was as good as his neighbor (provided he was born white and free), the "common" man was delighted to see his ordinary activities pictured on canvas, whether these activities were portrayed seriously, humorously, or satirically. It gave him an importance he hadn't known before. Now it wasn't only a face or the land or the inhabitants of the wilderness that excited artists but *his* life and *his* workaday pursuits.

Once American painters discovered how rich a vein of material there was to be found in the life around them, they

learned somehow to draw the figure. Some struggled at home by themselves or in the best art school they could find. Others went abroad for their education, the majority heading for Düsseldorf, Germany, which became a center for American art students in the mid-nineteenth century. The Düsseldorf Academy specialized in highly finished, minutely detailed, sentimental or melodramatic narrative paintings, the subjects generally derived from history or literature. It was a style a number of American genre painters adapted to their own needs, and one that became very popular during the 1860's. In fact, it was so popular that a number of New York galleries would handle nothing else.

As in the case of landscape, as soon as there was a demand for genre, more and more artists began depicting American life. Some of their work was mediocre, some of it was sentimentally banal. But there were painters who brought to genre an originality, a freshness, and a vigor that was "as American as apple pie."

NOT FOR THE FEW

ALTHOUGH BINGHAM WAS a pioneer of American genre painting, he lived and worked on the frontier. He had no influence in the East, where the new developments in American art originated. Therefore it is William Sidney Mount (1807–1868) who is considered the father of American genre painting. Mount was the first native artist to gain recognition in this field, and it was his success that helped make genre a respectable and legitimate branch of American art.

Mount was a singularly happy man, delighted by his lot, his work, and his country. He had no grandiose ambitions. "Paint pictures that will take with the public—never paint for the few, but the many," was his motto. No restless urge to better himself by study abroad disturbed Mount's dreams. He

turned down an offer that would have paid all expenses for a year in Paris, because he knew that the things he wanted to paint lay under his nose in America and not in European museums.

Mount was born in Setauket, Long Island. In 1814, after his father's death, he moved to the nearby town of Stony Brook and there spent the better part of his life. He was the youngest of four sons, two of whom also became artists—Henry, who was a highly successful sign painter, and Shepard Alonzo, who was a moderately well-known portraitist. At the age of seventeen William came to New York as an apprentice to his brother Henry, and in 1826 he entered the newly opened National Academy. Within a few years he began his career as a painter of mediocre historical scenes and portraits.

Forced by illness to return to Stony Brook, Mount suddenly discovered the key to his art in the familiar aspects of country life. One of his first genre pieces, *The Rustic Dance*, painted in 1830, was singled out for enthusiastic attention. From then on, it was all uphill. Almost overnight he became the leading man in his field, acclaimed by public and critic alike. His name became nationally known through countless reproductions of his pictures. Toward the last decade of his life his powers began to fade, but his reputation remained undimmed.

Mount's output was not large. He was a slow and methodical worker. For many years he had suffered ill health, and the death of his brother Henry in 1841 awoke fears of his own mortality and further reduced his production. But he had too much zest for life to succumb to infirmity. He was active in local politics and loved to sail and hunt. When he wasn't painting or sketching, he worked on inventions. He built a machine to increase the speed of steamboats and made a violin called the Cradle of Harmony, which had a concave back and used a key instead of the normal bow. A friend affectionately described him as "the laughter-loving and incomparable

genius . . . a first rate fisherman and a most pathetic player on the violin."

Mount painted daily, commonplace events: farmers nonchalantly whittling while they bargain for a horse; men talking around the stove in a country store; foolish swains courting bashful maidens; a perceptive friend appreciating an artist's pleasure in his picture; a Negro farmhand standing outside a barn enjoying the music a fiddler plays for the two white men inside. One of Mount's finest pictures, *Eel Spearing at Setauket*, painted in 1845, shows a white boy, a dog, and a Negro woman in a rowboat. The boy is paddling and the woman standing with a long rake poised for the catch. Behind them the sunny green landscape lies in peaceful silence, its serenity mirrored in the quiet waters. Here is a moment of life

William Sidney Mount: *Eel Spearing at Setauket* (1845).
Courtesy of the New York State Historical Association, Cooperstown.

suspended in time; man and nature are united in perfect harmony.

Mount had a relish for life's simple pleasures and a sympathetic affection for all humanity. He was an able draftsman and knew how to make his figures come alive, both physically and emotionally. His pictures are composed with a large simplicity and filled with the warmth of summer sunshine. Mount didn't see anything wrong with the world. He never attempted any social comment, nor did he probe too deeply beneath the surface of his characters. Nevertheless, they seem real. Their faults and virtues are viewed with genial and honest amusement. His people, black or white, are never burlesqued or sentimentalized. They accept their places in Mount's world, each his own, but are joined together by love and understanding in sharing the small, simple pleasures of life.

Where Americans might chuckle at Mount's canvases, they snickered at the sly pokes delivered by the brothers James Henry Beard (1812–1893) and William Holbrook Beard (1824–1900). Like the internationally popular English artist Sir Edwin Landseer, they gave animals human characteristics and set them in human situations. James used dogs and William used bears as the protagonists in sentimental and farcical dramas that parodied social conventions. But it was all in fun, no offense intended.

The brothers were raised in the backwoods of Painesville, Ohio, and eventually settled in New York. Both were essentially self-taught (James was William's instructor) despite the fact that they spent some time in Europe. Though study improved William's technique to a certain degree, it never erased James's hard-edged provincialism. James's pictures were maudlin anecdotes—a female dog weeping over her dead husband's collar; a bitch, surrounded by her sleeping pups, coldly eyeing her husband, bruised, bandaged, and penitent after a gay night out. William was slightly more gifted and imagina-

tive. His characters were wild animals, and he specialized in
bears that mimicked the antics of the American male.

The growing appetite for gentle jokes accounted for the
enormous success of Richard Caton Woodville (1825–1856).
Yet, strangely, his sentimentally humorous canvases didn't at
all jibe with the darkly romantic bent of his own character.
He was the son of a wealthy, educated Baltimore merchant, at
whose insistence he entered the University of Maryland Medi-
cal School. But Woodville wanted to be an artist, not a doctor,
and against his father's wishes he became a student at Robert
Gilmore's painting academy. At twenty he married a rich
young lady of proper background. All was forgiven, and he
was allowed to go abroad to study art. He went to Düsseldorf,
where in five years he acquired a polished competence. He
also acquired the affections of another young woman, with
whom he fled to Paris. In that City of Love, he died of an
overdose of morphine, accidentally or deliberately.

Woodville was a soundly realistic painter with an ability to
see humor in the most trivial of situations. His comments on
life were so mild and good-naturedly amusing that it is hard to
believe the pictures were created by a man driven by a desper-
ate wish for self-destruction. In one canvas, *The Sailor's Wed-
ding,* a group of relatives, anxious to get a young sailor and his
blushing fiancée married, interrupt the lunch of an irritated
justice of the peace; in another a number of people fight their
way past each other to read a Mexican War bulletin; in a third,
two men sit in an oyster house discussing politics, one excited
by his own rhetoric, the other bored and impervious to all
arguments.

Woodville's canvases were aimed at an American audience.
The people were dressed in American costume and set in
American environments, but his characters and their situa-
tions were broadly universal. Woodville lived abroad, yet he
was astute enough and knew his countrymen well enough to
know what they liked. His paintings, which were shipped

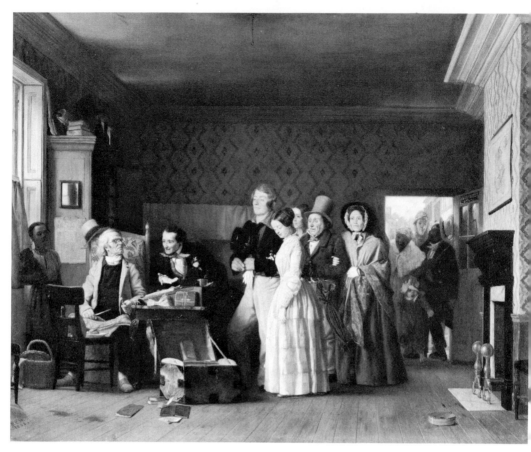

Richard Caton Woodville: *The Sailor's Wedding* (1852).
Courtesy of Walters Art Gallery.

directly to New York, were snapped up for reproduction by
the Art-Union and the engraving firm of Goupil and Com-
pany. Shortly after Woodville's death the National Academy
bought *War News from Mexico* for their permanent collec-
tion, and Woodville's work became more popular than ever.

Mount's humor was well meaning and good natured. The
Beards, Woodville, and the majority of genre painters pre-
ferred to keep their laughter within proper bounds. John
Quidor (1801–1881) did not. He bellowed with loud Gargan-
tuan glee as he mocked the fatuous conceits of his fellow
Americans. Taking his characters from Washington Irving's
genial tales of old New York, he enlarged on them, concocting

his own witches' brew of spindle-shanked, hook-nosed, pot-bel-
lied burghers and their apple-cheeked dames. In mad frenzy
they prance and whirl through canvases that are the products
of an original but undisciplined talent.

At the age of ten Quidor was taken by his schoolteacher
father from his home in Tappan, New York, to New York
City, where he was apprenticed to Jarvis. Quidor learned little
from his master, and his technical ignorance resulted in the
eventual blackening of many of his later works. It may have
been Quidor's ineptitude, his indifference to social niceties, or
his quick temper; whatever the cause, the apprenticeship
ended in a lawsuit. Quidor's principal employment thereafter
was painting banners and decorating the panels of fire
engines.

Quidor's draftsmanship, color, and technique were negligi-
ble. He knew almost nothing about anatomy, and his figures
were distorted to the point of caricature. His color was arbi-
trary—white for light, black for shadow, and browns or greens
for middle tones. But all these technical inadequacies pale
before Quidor's unique imagination. He portrayed his coun-
trymen—rich and poor, important and unimportant—with
trenchant wit. Their costumes were just props. Nothing was
sacred in his eyes. Life, death, and human pretension—all
were subject to the ribald thrust of his brush. Robbers digging
for buried treasure are not terrorized by a supernatural vision.
They are just plain scared out of their wits by a bogey man
who happens to be a nightshirted farmer. A dying man is
quickly revived by the news of unexpected riches. The Devil
who converses with old decrepit Tom Walker is not the suave
and elegant creature we know, but a burly, heavy-set savage
with a wicked glint in his eye and a self-satisfied smirk on his
face.

Quidor's canvas *The Wall Street Gate* is particularly
strange. At first glance the picture shows a roistering group of
people within the city gates being watched from a distance by

young Rip Van Winkle. A closer look and the background hills
become the figure of a recumbent giant, his gun and dog by
his side. Then the objects in the foreground assume the shape
of another huge figure, this one asleep. In this curious paint-
ing Quidor synthesized the story of Rip's twenty-year sleep
and his puzzled astonishment on awakening.

Toward the latter part of his life Quidor fell into obscurity.
It was mostly his own fault. He had a certain following, exhibi-
tion privileges at the National Academy, offers to illustrate
books, and pupils who came to study with him. But he fought
with the Academy and, with rare exceptions, refused to let them
or anyone else show his work; he knew nothing about engraving
pictures for illustration and would not learn how to work in
that medium or even how to make a working drawing; he was
too bored or too drunk to bother teaching. When he moved to
New Jersey in 1868, he might have been living on another
planet. Sixty years after he died, he was given his first one-man
show. Quidor would certainly have found something funny in
that.

David Gilmor Blythe (1815–1865) was not as original a
painter as Quidor, but he too made no effort to spare his coun-
trymen's sensitivities. He looked on mankind with bitter
amusement, finding little that commended itself to his jaun-
diced eye. He sneered at human greed and pomposity, while
the silent sufferings of the underprivileged roused in him a
mixture of pity and contempt. Anticipating twentieth-century
protest painting by some seventy years, he depicted the "dog
eat dog" morality in canvases that are vivid commentaries on
his time.

Born in an Ohio log cabin, in his sixteenth year Blythe
went to Pittsburgh and became apprenticed to a woodcarver.
At the age of nineteen he opened his own carpentry shop, but
that didn't hold his interest for long. He spent three years in
the navy and then became an itinerant portraitist, wandering

through Ohio and Pennsylvania executing crude likenesses. About 1846 he married and settled down in Uniontown, Pennsylvania. His happiness ended with his wife's premature death. He eased his sorrow with alcohol and as a result was unable to complete assignments, became impossibly belligerent, and in 1851 just up and disappeared.

Half-demented, he wandered aimlessly searching for some utopia "where man and man might dwell together in unity." A year before the financial panic of 1857 hit the nation, he turned up in Pittsburgh and once again began painting. His pictures were not likenesses now, but bitter commentaries on the American scene. In acid caricature he flayed the brutality of horse traders bartering for a horse that is no more than skin and bones. In a more realistic manner he portrayed the hopeless ineffectuality of a ragged, unemployed woodsman sharpening his ax, and of Civil War heroes ending their days in the dungeons of Libby Prison. Blythe's pictures, which he displayed in the window of a local art-supply store, attracted many customers. But he was totally indifferent. He died a few years later from malnutrition, the result of his drinking.

Eastman Johnson (1824–1906) was the best trained and probably the most gifted of the early genre painters. Unfortunately he never quite lived up to his potential. Floundering from one style to another, he sometimes produced remarkably impressive canvases. But he also painted pictures that were cloyingly sentimental—pictures that would upset no one and that would "take" with the "many."

Like Woodville, Johnson had little touch with the common people. He was the son of a prosperous Maine politician, with homes in that state and in the nation's capital. Johnson began his career as if he had been born in colonial times. At seventeen he served as an apprentice in Bufford's lithography shop in Boston and a year or two later set himself up as a portraitist, executing likenesses in crayon. He worked in Maine,

Boston, and Washington, D.C., where because of his connections many of the day's famous personalities patronized his pencil.

But Johnson had neither the stamina of his forebears nor the desire to remain a provincial head painter. In 1849 he went to Düsseldorf to learn the fundamentals of his craft. Two years later he was in The Hague and was so smitten with the technical mastery of Rembrandt, Vermeer, and the Dutch genre painters that he remained there for another three years. His next stop was Paris, where in two months he picked up the freedom of brushwork and sharp contrast of tone emphasized by the French portrait and history painter, Thomas Couture. Johnson returned home in 1855, not because he wanted to, but because his mother was dying.

Not sure of what he wished to do, Johnson made two short trips to the Northwest Territory, in 1856 and 1857, to sketch the "picturesque" Indians. But the Indians failed to inspire him. In 1859, seven years after the publication of *Uncle Tom's Cabin*, he painted *Negro Life in the South* as though slavery was an idyll rather than the festering shame that had roused the sympathy and sometimes angry concern of many Americans. The picture, later called *Old Kentucky Home*, presents a group of raggedly dressed Negroes singing, talking, playing with a child, strumming on a banjo, lazy and happy. Two young white girls (perhaps the master's daughters) peer curiously from a doorway, which separates the slave quarters from their stately home.

The canvas was painted in the manner of Düsseldorf realism—each thing put down with fussy exactitude and coated with a layer of sugary sentiment. The painting struck just the right note. Southerners liked the picture because it showed the "unalloyed contentment and happiness among the slaves," as a Virginia congressman said. Northerners liked it because it showed the degradation and poverty of the Negro slave. The

United States government thought enough of the painting to send it to the Paris Fair in 1867—two short years after the end of the Civil War—as representative of American art, and in 1876 the government included it in the art section of the Philadelphia Centennial.

Johnson also painted some war pictures. He took no stand, portraying maudlin subjects that incurred no one's displeasure. As a contemporary critic said, Johnson "preached no ugly doctrine of discontent."

Every once in a while Johnson stepped outside the polished artificiality of his Düsseldorf style to create a work that shows him to have been an artist of impressive powers. One of the best of his pictures is *Not at Home.* In this painting the eye first looks into a spacious parlor flooded by sunlight from a hidden window, then slowly wanders to the figure of a woman going up a staircase on one side of a darkened hallway. The work is boldly conceived and painted with great freedom and a knowing assurance. What story there is is subtly suggested by the motion of the figure and the title. It is a canvas that needs no "story" to stand on its own merits as a painting.

In the 1870's, during summers spent in Maine and Nantucket, Johnson veered in a new direction. Instead of picturing pretty young girls nursing handsome wounded soldiers or cute little country lads mischievously scampering around an abandoned coach, he concentrated on painting what he actually saw as it appeared before him. He studied the effect of sunlight on the natural world in a vein reminiscent of Winslow Homer, the great American painter of the outdoors. Johnson's brilliant little canvases of berry pickers, people working at a maple sugar camp or shucking corn, and other such subjects are handled with a slashing authority and genuine artistic sensibility. They have a sparkling clarity and an honesty of vision that is a far cry from the mawkish sentimentality of his overfinished anecdotes. With one exception, John-

Eastman Johnson: *Not at Home* (*c.* 1870–1880).
Courtesy of the Brooklyn Museum.

son never produced large-scale works of this quality. Having waited vainly for commissions to enlarge these little pictures, after 1880 he painted nothing but portraits.

For the most part Johnson's likenesses were bland representations. He had earlier painted a "conversation piece" family group that was notable mainly because it contained fifteen figures, from infants up to grandparents. But in his portrait *Two Men*, done in 1881, Johnson produced a powerful and strikingly original canvas. It is a penetrating study of male

character, handled with imagination and feeling. Two figures are seated in chairs in the gloom of a Victorian parlor. The man on the left, his face half lost in deep shadow, is speaking to his companion. Johnson focused attention on the heads and hands, highlighting facial expression and gesture to pin down the men's personalities.

Had Johnson produced nothing but his outdoor sketches and the portrait of *Two Men,* he would have been an artist to reckon with. The pity of it is that with so much talent he could not have done more. Unhappily he lacked direction and a compelling theme. Johnson was a good painter, occasionally a brilliant painter, but never as brilliant as he should have been.

Emanuel Leutze (1816–1868), with whom Johnson shared a studio during his student days in Düsseldorf, is the author of *Washington Crossing the Delaware,* one of the most celebrated American paintings. Seen by generations of schoolchildren and adults in reproduction, it has become so closely identified with American history as to be almost inseparable from it. Whenever we think of the event, we see it as Leutze painted it.

Leutze came to Philadelphia from Württemberg, Germany, when he was nine years old. He studied painting with a local practitioner and at twenty started a career as a portraitist. Aspiring to greater heights, he entered Düsseldorf's Royal Academy and later became one of its favorite teachers. He also spent some time in Munich and in Italy, absorbing what would best suit his style. Leutze wasn't interested in the amusing aspects of ordinary life, but rather in portraying events from history as if they were anecdotes, to be easily understood and universally admired. His meticulously finished historical pictures became enormously popular in Germany as well as the United States.

Leutze's first version of *Washington Crossing the Delaware,* which remained in Germany, was destroyed during World War II. For the larger (21′ 7″ x 12′ 5″), more famous canvas,

painted in 1851 while he was still abroad, Leutze employed only Americans, many of them fellow artists, as models for the life-size figures. To add authenticity, he dressed them in genuine Revolutionary costume. The picture was promptly bought for six thousand dollars by the engraving firm of Goupil and Company (who knew a winner when they saw one) and shown throughout the United States.

Thousands of engravings were sold, and the canvas was hailed by one critic as "the most majestic, and most effective painting ever exhibited in America." Despite these claims the picture is full of historical inaccuracies and artistic flaws. Yet, to give credit where credit is due, the painting does convey a quality of noble heroism. Though Washington and his ragged band of revolutionaries never looked like Leutze's clean-shaven, warmly clothed, well-fed heroes, perhaps in their hearts they felt like them.

Assured of success, Leutze returned to the United States in 1851. During the rest of his life, however, he made periodic trips back to the Continent. In 1860 Congress commissioned Leutze to paint *Westward the Course of Empire Takes Its Way*

Emanuel Leutze: *Washington Crossing the Delaware* (1852).
Courtesy of the Metropolitan Museum of Art, gift of John S. Kennedy, 1897.

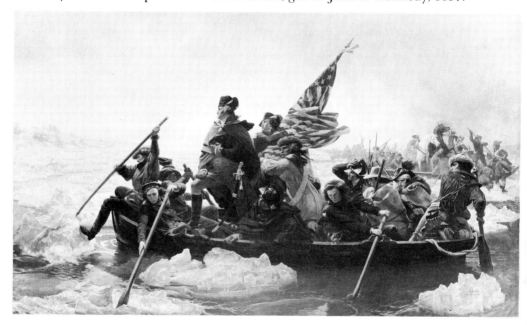

for the national capitol. To familiarize himself with the scenery, Leutze visited the Rocky Mountains and then went back to Germany to learn how to paint on plaster walls. Yet all this careful preparation resulted in a poorly conceived, badly executed melange of artistic clichés that covers many square feet of the Capitol's walls. It is a mural in which, as a fellow painter scathingly commented, "Confusion reigns paramount."

Genre painting would come to its full maturity in the work of Winslow Homer and Thomas Eakins. But they were individualists, bucking the tide of conformity, and their work is in a class of its own. The preponderance of anecdotal painting, like portraiture was soon infected with a saccharine banality. Genre painting surfaced briefly during the latter part of the nineteenth century in the imaginative canvases of Harnett and Peto, both of whom brought a fresh viewpoint to narrative by using still life to relate simple little stories.

THE DECEIVERS

HAD WILLIAM MICHAEL HARNETT (1848–1892) not been so honest, he could have been a superb counterfeiter. His rendition of a five-dollar bill looked so much like the real thing that a government agent thought it barely escaped being a forgery. Harnett could paint a nail, a cupboard, a book, or the hot coals in a pipe bowl with such absolute naturalism that they appeared to exist "real as life." His paintings are superb examples of *trompe l'oeil*, canvases which are intended to fool the eye. A writing table, an old book, papers, and a quill pen; a violin, a bow, and sheet music—humble, time-worn bits of Americana, which aroused tender affection and happy memories, served as the "living" models for Harnett's stories.

Born in Ireland, Harnett was raised in Philadelphia, where he became an engraver of silverware. He studied evenings at

the Pennsylvania Academy and later in New York at the National Academy and at Cooper Union. By 1879, four years after he started his career as a still-life painter, he had earned enough money to spend six years in Europe, most of it in Munich. He returned to New York, where he remained for the rest of his days.

Harnett was well rewarded for his technical wizardry. He was, however, more than an astounding magician. His pictures were composed with great ingenuity. He had an extraordinary

William Michael Harnett: *My Gems* (1888).
Courtesy of the National Gallery of Art, Washington, D.C.,
gift of the Avalon Foundation, 1957.

ability at painting solid objects standing in space, and his color harmonies were handled with consummate skill. But the illusion of three-dimensional reality was so overpowering that it was often hard to see the fine artistry beneath the "living" surface.

Some sixty years after Harnett's death, in doing research for a study on the painter's work, the art historian Alfred Frankenstein uncovered some puzzling discrepancies. Harnett seemed to have worked in two distinctly different styles—a "hard" finish in which forms were clearly defined, and a "soft" style in which the edges of the forms were blurred and in which the color had greater luminosity. Moreover, some of Harnett's canvases were posthumously dated! The two different kinds of pictures were so similar in most other respects that the technical variations were undetectable by all but the most observant eye. After a lengthy investigation, Frankenstein concluded that some of Harnett's canvases were actually forgeries. The painter of the "soft" style was an unknown artist named Peto. Forgers, seizing the opportunity to cash in on Harnett's popularity, had acquired a number of Peto's pictures after the latter's death and simply endorsed them with Harnett's signature. It was Peto's only stroke of luck. Had there been no forgeries, he might well have remained unknown and unsung.

John F. Peto (1854–1907), a fellow Philadelphian, was such an ardent admirer of Harnett's work that he fashioned his own style directly after it. Yet while Harnett commanded large sums for his pictures, Peto could barely give his away. He desperately wanted to study abroad, but could not abandon the two maiden aunts who were totally dependent on his support. Robbed of this dream, he retired to a small town on the New Jersey coast, where he gradually sank into oblivion.

Peto was rankled by poverty and saddened by neglect, and his paintings are imbued with a tender, wistful poetry. He possessed considerable talent, but his work was uneven and not

quite the equal of Harnett's. Peto's best paintings are luminous and appealing arrangements of familiar objects, in which, Frankenstein said, Peto saw the "fantasticality of the commonplace and the pathos of the discarded."

The most adroit and skillful illusionist was Connecticut-born John Haberle (1856–1933). He became noted for his extraordinary renditions of paper money, bits of newsprint, and other scraps of paper put together to tell a story. With such dexterity at his command, he did not hesitate to accept a commission to paint—large and real as life—a picture of an entire farmhouse wall. The enormous canvas (8′ x 5½′), called *Grandma's Hearthstone*, contained a fireplace complete with burning logs and boiling kettles as well as a litter of bric-a-brac on the mantel. This remarkable *tour de force* took him all of two years to finish.

Haberle may have been the best magician. However, in the art of *trompe l'oeil* Harnett was the master poet.

While the public found such deceptions delightful, *trompe l'oeil* even in combination with anecdote, was never quite accepted in the art circles of that day. Most artists regarded it as an inferior form of painting, a clever trick with eye appeal. It was all right for the average citizen who knew nothing about art and was awed by the artist's ability to make real things look even realer. But *trompe l'oeil* paintings had none of the higher refinements sought by the connoisseur. Because it was held in such low esteem, this kind of painting soon became outmoded and was rarely seen again.

X A Grander Vision

IN THE fifteen years following the end of the Civil War, the United States made a vital and irreversible change from a predominantly agrarian to a predominantly industrial and urban society. It was a period of great excitement, adventure, and growth; of daring exploit, keen competition, and ever-expanding horizons—a "riot of individualistic materialism," as Theodore Roosevelt aptly put it, which was revolutionizing the American way of life.

American painters, who were usually carried along on the tide of the times, were beginning to swim against the current. The movement known as romanticism, which began more or less concurrently with landscape and genre painting, came into full flower during the latter half of the nineteenth century. At least in part, romanticism was a psychological reaction to the Industrial Revolution—a creative balance against the ever-growing complexity of a mechanized technological society dedicated to the accumulation of material wealth. But of more significance in the movement was the artist's own deep-rooted need for self-expression.

The spirit and indeed the very essence of art lies in its creativity. Each work of art is an expression of the artist's personal ideas and emotions. But only too often in the history of art, American or otherwise, the quickest path to success has been to follow along the lines of popular tastes. And even in those cases where a maverick painter achieved fame, he generally had to wait a long time—sometimes a lifetime, sometimes longer—until he was accepted.

Individualism in art has rarely been greeted by instant public acclaim, not in Europe and especially not in the United States. In colonial America Copley had bemoaned the

fact that he could only paint likenesses. Vanderlyn, Trumbull, and Morse discovered that their countrymen were not interested in their historical or imaginative canvases. Allston's romanticism was accepted mainly because his important literary friends approved of his art. But Allston was an exception, not the rule. It was only as American art expanded that artists began to work in a more personal manner in line with the dictates of their own emotions. Yet even as late as the twentieth century, American painters who refused to bow to convention were almost always confronted by hostile resistance.

Of all the movements in art, romanticism—which originated in France during the early part of the nineteenth century as a revolt against neoclassicism—is the hardest to define. Not only did it follow no particular style, but the very qualities inherent to romanticism are present to some degree in all works of art. For example, the landscapes of the Hudson River school, though realistically truthful "imitations" of nature, were imbued with the artists' reverent love for the beauty of the land. They were, thus, romantic expressions of nature.

The term *romanticism* is derived from literature, where highly popular "romances"—stories of love, adventure, or extraordinary events—stressed imagination and feeling. In romantic painting, the qualities of emotion, imagination, and individualism are valued above all else. Romanticism is an art that speaks from the heart, not from the mind.

European romanticism began in opposition to the severe, ordered concepts of classicism, and found its expression in vividly colored, turbulent, and wildly impassioned visions of supernatural, fantastic, mystical, and exotic subject matter. Romanticism appeared in the United States when European romanticism was already being displaced by a new movement called realism. In America, where there was as yet little tra-

dition to break, romanticism took the form of a mildly poetic and moody idealism.

DARK FORESTS OF THE MIND

WILLIAM RIMMER (1816–1879) was one of the most original voices in American romanticism. A man of strange complexity and singular talents, he created his own world of imaginative and haunting fantasy.

William was two years old when his family left Liverpool, England, to come to Nova Scotia. Eight years later the Rimmers moved to Boston, settling in one of the city's slum areas. They made no friends, welcomed no one to their home. Yet behind their shuttered windows Thomas Rimmer, a poor cobbler, and his wife, an Irish servant girl, raised their children as if they were royalty, teaching them Latin, Greek, Hebrew, history, mathematics, music, and other such gentlemanly subjects. The children were brought up in this manner because their father believed himself to be the lost dauphin, son of Louis XVI, king of France, beheaded during the French Revolution. Thomas saw enemies in every darkened corner and lived in psychopathic terror of assassination. Yet whatever doubts the other members of the family may have entertained, William never once questioned that his father was the rightful heir to the French throne.

Physician, sculptor, painter, and anatomist, William Rimmer was self-taught in all his professions and gifted in each. At the age of fourteen he went out into the world to help support his parents, working as a sign painter, draftsman, typesetter, soap maker, cobbler, and lithographer. After his marriage in 1840 he became an itinerant portraitist, doubling as a cobbler when commissions were scarce. In 1845 he undertook the study of

medicine in his spare hours and ten years later was granted a license to practice.

With his medical background Rimmer knew far more than his contemporaries about human and animal anatomy. He was also a fine draftsman and sculptor. A small carving entitled *Despair,* modeled when he was fifteen years old, is one of the earliest male nudes in American sculpture. Except for those in his anatomical drawings, Rimmer's figures were invariably male, though depicted without genitalia. Two of his sculptures, *Falling Gladiator* (a male figure) and *Dying Centaur* (an animal), are remarkable for the emotional power of the figures and for their dynamic sense of movement. When the *Falling Gladiator* was exhibited at the 1862 Paris Salon, Frenchman refused to believe that the sculpture had not been cast directly from the human body because it was so uncannily accurate.

Rimmer struggled with his sculpture in the spare moments when he was not practicing medicine. A perceptive neighbor persuaded him to exhibit some of his pieces in a gallery. The public knew little about sculpture, having seen only casts of antique statues and some smoothly rounded, inoffensive white marble figures of ladylike godesses. To them, Rimmer's work looked like an "exhibition of muscles" done by an amateur. To those more informed, it was obvious that Rimmer knew a great deal about the human figure.

In 1861 Rimmer was asked to start an anatomy class for artists, and his lectures became so popular that he added a special class for women. Rimmer saw nothing wrong in disseminating knowledge of the human body to females. "Art," he declared, "is as independent of sex as thought itself." He did not use live models. He talked about the body and illustrated his lectures with blackboard drawings of the muscles, the bone structure, and the figure. Sometimes he was so carried away by his own enthusiasm that the blackboard

became filled with pictures of angels and devils doing battle. Among his many students were the painters John La Farge and William Morris Hunt.

From 1866 to 1870 Rimmer was director of the art school at Cooper Union in New York City, where oddly enough the moral codes were stricter than in Boston. The trustees of the school found Rimmer's ideas too advanced and his intransigence insufferable. When Rimmer demanded that women be allowed to study anatomy, he was asked to leave. (Thomas Eakins was to feel the brunt of such repressive measures even more painfully for daring to introduce nude models in a class for women.) Hurt by his rejection as a sculptor and teacher, Rimmer was delighted by William Morris Hunt's invitation to collaborate on a mural for the State Capitol in Albany. But Rimmer insisted on having his own way, and his ideas were so outrageous that Hunt paid him one hundred dollars to leave. Rimmer returned to Boston, withdrawing into a private world to paint the strange visions that invaded his mind. Some former students, wishing to preserve his masterful anatomical drawings, persuaded the doctor to have them printed. *Art Anatomy*, published in 1876, is still one of the finest books on the subject by an American.

A year after Rimmer's death, the Boston Museum of Fine Arts held a comprehensive showing of all his work. Only then was it discovered that Rimmer had also been a painter. His canvases had made even less of an impression on his contemporaries than his sculpture, and during the years many had been either lost or destroyed.

Rimmer's paintings are thoroughly romantic in conception. They are intensely emotional fantasies filled with anguish, terror, and mysterious meaning. His magnificently drawn winged male nude, *Evening: The Fall of Day,* is arched in mortal agony, dragging a lingering foot as he slowly sinks beneath the horizon. *Flight and Pursuit* is almost surrealistic

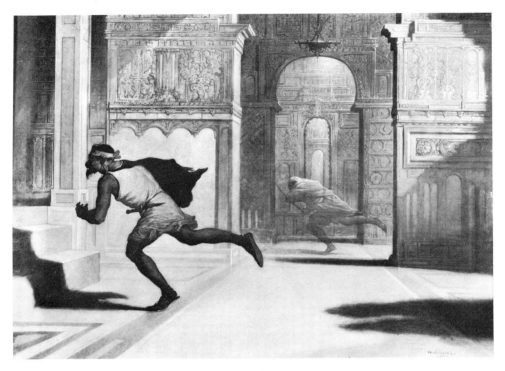

William Rimmer: *Flight and Pursuit* (1872).
Courtesy of the Museum of Fine Arts, Boston, Miss Edith Nichols Fund.

in its eerie imagery. The picture shows two running male figures dressed in short, togalike costumes being pursued down endless corridors by a two-headed shadow and evokes a feeling that is at once mysterious and frightening.

Rimmer had few admirers in his time because his sculptures were too unconventional and his paintings too strange and baffling for the average taste. He was also ignorant of the rudiments of his craft. His sculptures give little outward evidence of his appalling lack of knowledge, but he was completely unversed in the most elementary procedures of modeling. He knew little about oil painting, and his color and technique are only a cut above an amateur's. Rimmer was one of the casualties of American art. He was among the finest of American draftsmen and sculptors in his day and a painter of unusual imaginative power. With such formidable gifts and good training, he might have become one of the masters of American art. "The poor long-suffering doctor," commented

his former student, the American sculptor Daniel Chester French, ". . . he just missed being great."

Elihu Vedder (1836–1923) had none of Rimmer's startling originality. Vedder's work was typical of its time in its literary derivation and academic style. Had he painted only in this fashion, he would justly have been forgotten. But he also possessed an unusual imagination, and the best of his fantasies have the brooding, haunting quality of a disturbing dream.

The descendent of early Dutch settlers, Vedder was born in New York City, where he first began to study art. In 1856 he went abroad for additional learning, spent a year in Paris, then left for Florence, Italy. When he returned home in 1861, he found a country on the verge of civil war. To earn a living, he painted comic valentines, did illustrations for magazines, and picked up anything else that came his way. He couldn't find a buyer for his serious work, even though he was elected a full member of the National Academy. Shortly after the war ended, in 1866, Vedder returned to Europe. The next year he settled permanently in Rome among the ruins he so admired.

Some of Vedder's most haunting fantasies were products of the few years he spent in America. They are strange pictures,

Elihu Vedder: *The Lair of the Sea Serpent* (1864).
Courtesy of the Museum of Fine Arts, Boston.

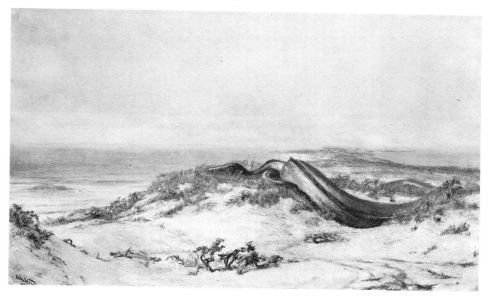

strangely titled, and, like Rimmer's, they fit into no precise category. *The Questioner of the Sphinx, The Lost Mind, The Lair of the Sea Serpent*, are visions of evil portent, of mysterious forces inimical to man. The latter canvas is a seascape showing a strip of beach under a lowering sky. Then one becomes aware of the evil and watchful eyes of a hideous serpent coiled up on a dune. And the picture, which at first glance seemed a pleasant vista of the sea, suddenly takes on the quality of a nightmare.

Vedder's style was peculiarly his own. He used a muted palette and painted in a traditionally academic manner. He accentuated movement by a series of curving lines of strong and well-defined character that followed the action of the figure and the contour of the landscape. As he grew older, his style became coldly mannered, overly intricate in design, and his color became pale and chalky. He painted a number of murals for Bowdoin College and the Library of Congress in the nation's capital. Perhaps because they better suited his abilities, his illustrations for the *Rubáiyát of Omar Khayyám* are the finest realizations of his later years.

Rimmer and Vedder were unusual painters, endowed with uncommon imaginations. Their works, filled with somber and intense emotion, were unique in American painting of that period, but did not alter the course of American art. Like other individualists, they were out of joint with their times. Their sculptures and paintings were too unsettling for a generation that preferred an art that was simpler, pleasanter, and formulated from more conventional recipes.

There were additional artists who painted in a darkly romantic vein. But their canvases contained none of the sinister intensity and mysticism characteristic of Rimmer's and Vedder's works. These other artists drew their inspiration from the world about them, from people and from the landscape, endowing their images with a moody, poetic sentiment.

George Fuller (1822–1884), who began his career as an

itinerant portraitist, polished his technique abroad. He worked as a farmer by day; the long, quiet hours of the night were devoted to art. Fuller loved the deep tonalities of the old masters with which he shrouded his landscape and figure paintings. Fuller was no master, old or new, but his landscapes have a certain dreamlike quality, and his dark, brooding pictures of country girls a sensuality that is not displeasing. In 1875, pressed for money, he sent a number of his canvases for exhibition in Boston. Their enthusiastic reception assured him of clients for the nine remaining years of his life.

Robert Loftin Newman (1827–1912) had studied with the French painter Jean François Millet and first came to public notice at the age of seventy. Newman was slightly more gifted than Fuller. Newman painted pictures of biblical and legendary subjects and of young women, their figures half-merged in background gloom. He worked with the heavily loaded brush and rich color of the Barbizon school, and his often unrealized and fragmentary imagery is tinged with a melancholy, yet appealing, romanticism.

The most interesting of these minor romanticists was Ralph Albert Blakelock (1847–1919). He was a self-taught artist who in 1869 spent a few months in the West gathering material for his canvases. Blakelock's career was one of bitter failure. He was barely able to sell a picture for more than a few dollars to feed his impoverished family, and the last twenty years of his life were spent in an asylum. Ironically, as soon as he was committed, his fame spread, and his pictures began selling for high prices. Unfortunately, not a penny of this money ever reached poor Blakelock or the members of his family.

Blakelock painted Indian encampments bathed in sunset's ruddy light and landscapes which are sometimes imitative of Albert Ryder's luminous fantasies. But Blakelock was particularly obsessed by the eerie enchantment of twilit forests, and painted picture after picture of trees blackly sil-

houetted in an intricate network of lacy foliage against the luminous green of the evening sky. These pictures are rather like a somber dream-vision that presents itself with startling clarity.

A PERSONAL SONG

FULLER, NEWMAN, AND BLAKELOCK created a moody, dream-like vision of nature. Rimmer and Vedder created an art born of their own personal fantasies. William Page, William Morris Hunt, and John La Farge, who were contemporaries of all these painters, took their incentive from the European masters: Page from the Italian Renaissance painters, Hunt from the modern French artists, and La Farge from both sources. Using the art of the Old World as a basis, they altered it to suit their own visions and brought to American painting a new and subjective poetry.

Page, Hunt, and La Farge were romantic idealists. They believed that all art was an emotional expression of individual experience, and that the artist must be free to follow his own truths and his own feelings. "Through this following and pursuit of the fact that each artist sees in his own way . . ." said La Farge, "we shall come to perceive, perhaps, why it is that this faceting of truth . . . sings for each of us a new personal song. . . ."

It was a siren song, luring them into false security and expectations. Page, Hunt, and La Farge were men of culture and intelligence who wanted to bridge the gap between European and American art. But like some of their unhappy predecessors they ignored public taste, and Americans were less than grateful for their efforts. Though they rarely received more than whispers of praise from their contemporaries, the three painters helped raise American art to a new level of sophistication. And at the same time they made

American painters aware of the overwhelming need for a universal language of art.

William Page (1811–1885) was one of the most daring and complex personalities of his time. A gifted painter, a confirmed individualist—egotistical, intelligent, impulsive, emotional—he was a constant source of controversy, praised by some and castigated by others. His unconventional behavior (he married three times) violated social standards. Yet he numbered among his friends and admirers the famous English poets Elizabeth and Robert Browning and the American James Russell Lowell. His paintings of nudes, alone or in embrace, were attacked as shockingly sensuous and lewd, and they were banned in London, Paris, and Boston. Still, some foreign critics hailed him as a genius, and Boston intellectuals, while they never quite forgave his many marriages, crowned him with Allston's laurels as "the American Titian." He was elected president of the National Academy, but condemned by members for his experimental theories, his Italianate leanings, and his immorality. In the eyes of his contemporaries he was a ridiculous failure. They were wrong. Page was one of the first genuinely romantic visionaries and experimental painters in American art.

When he was nine, Page moved from his birthplace in Albany to New York City. He was a precocious youth. At fifteen he entered the National Academy for two years of training under Samuel Morse, who thought Page showed "talents of uncommon strength." Before he turned twenty, Page had already studied religion and the law and had tasted the delights of marriage. By the time he reached his twenty-first birthday, he had decided to follow a career in art and set himself up as a portrait painter. Three years later he was elected an associate of the National Academy. He was then twenty-four.

Page was an uncommon man, a nonconformist with a lively intelligence, who wanted to be in the thick of intellectual life.

He found the city dull and his fellow artists too timidly conservative. His compatriots, in turn, thought his theories, his romantic approach to art, and his interest in the color of the Venetian masters (which harked back to Allston) ridiculously outdated.

In 1840, while on vacation in Boston, he met the American poet James Russell Lowell and other of the city's eminent writers, who shared his excitement in exploring "the profoundest questions of art, philosophy and society." He was so delighted that in 1844 he removed himself to Boston. It was almost inevitable that the Boston intelligentsia would regard Page as Allston's logical successor. In Page the artist, the intellectual, and the theoretician, they thought they saw the makings of genius. The poet James Russell Lowell, in his book *A Fable for Critics,* wrote:

> Be true to yourselves and the new nineteenth age,
> As a statue by Powers, or a picture by Page.

Things didn't work out as well as Page had hoped. He received few portrait commissions (he was an unconscionably slow worker), and his romantic canvases were considered too scandalous to be shown. His theories also irritated many of his fellow painters, who thought him more disposed to talk about art than work at it. Page went back to New York in 1847. Two years later, after having obtained several commissions for copies of Titian's paintings, he sailed to Italy, and there spent the next eleven years. By the time he returned to the United States, artistic fashions had changed. Page's canvases seemed outdated, and his reputation went rapidly downhill.

Page had an inordinate estimation of his own talents. He felt that he had done "more for art than any man . . . since Titian," casually ignoring such men as Rembrandt, Rubens, El Greco, Vermeer, to name only a few of the world's greatest artists. In his painting, he was like a square peg in a round hole, refusing to make any concessions to current styles. He

painted mythological allegories when such subject matter was not especially favored. He used a rich, dark palette reminiscent of the old masters when fashion dictated a brighter palette. And he insisted on painting sensuous nudes at a time when Victorian prudery was rampant.

His technical theories were just as contrary, sometimes even absurd. He built his flesh tones from the inside out, starting with a white ground and adding layer upon layer of thin color glazes to simulate the complexion of skin. There was nothing new or startling about this; Stuart had worked that way and so had other artists. But Page went at it as if he were creating a live human being. For example, he never painted a blue vein blue, but would start with a red line—the blood flowing in the vein—then cover the line with successive films of transparent color until it took on a blue coloration. His mathematical proportions for the perfect figure were formulated from a quotation in the Bible. He experimented with an endless variety of technical procedures which only too often ended in some of his pictures turning black or red, developing spots, or flaking off the canvas.

Despite these eccentricities Page was an impressive painter. His pictures had a grave, monumental strength and a dreamlike sensuality, qualities that were, unfortunately for him, far in advance of the times. His portraits were perceptive studies of human character, painted in a dark, moody, and massively simple style. He believed that portraits should be thought of as paintings and judged on their merits as integrated works of art, not on whether or not they were polished and presentable likenesses—an idea later taken up and enlarged by the artist James McNeill Whistler.

Page's allegorical canvases were too recklessly romantic and sensual for nineteenth-century America. *Cupid and Psyche*, painted in 1843, is a rear view of the upper half of Psyche's nude body being embraced by Cupid. The slight suggestion of erotic passion created an immediate scandal. The picture was

rejected by the National Academy as licentious. Page was not
a man to kowtow to public opinion, and he provoked even
angrier comments with his depiction of Venus, the goddess of
love, whom he considered the incarnation of "health and
nature." To think of her in any other way, he insisted, was
"either grossly ignorant or vulgarly and morbidly corrupt."
His personal notions of Venus did not change things. The pic-
ture was banned in the United States and Europe as well.

Like Vanderlyn almost a half-century earlier, Page was
damned for daring to paint an unclothed female. The fact that
the subjects were drawn from mythology and had been pic-
tured nude by the world's greatest masters made no difference.
Nakedness, and especially female nakedness, was taboo. So
deeply ingrained was the puritan ethic in America that, try as
they would, American painters could never quite escape its
inhibiting effects. Even Thomas Eakins, who was a superlative
figure painter, was destroyed by the country's narrow moral-

William Page: *Cupid and Psyche* (1843).
Courtesy of Kennedy Galleries, Inc.

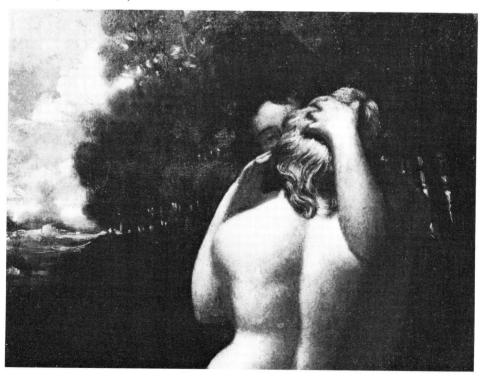

ity. The penalty was heavy. There are few memorable pictures of the nude in American art.

"I might have painted if I had lived in an atmosphere of art," said William Morris Hunt (1824–1879), "but in America everything resolves itself into the getting of money and selling a poor article instead of a good one." He had no need to sell a "poor article." A man of independent means, intelligent, well-born, well-educated, successful, he had lived in Italy, Germany, and France. But, all too humanly, he deluded himself, blaming circumstances rather than himself for his not being a better painter than he was.

Hunt is less important as an artist than as a teacher and cultural arbiter. As a disciple and champion of the Barbizon school, he introduced the work of these radical French painters in America even before they had been accepted in their own country. He was one of the first American painters to recognize the importance of the revolutionary developments taking place in France. And it was he who began urging American students to go to Paris rather than Italy or Germany for their study.

Hunt was born in Vermont in a family sympathetic to the arts. He was a good student and at nineteen entered Harvard. In 1846 his widowed mother, concerned about William's health, withdrew him and took him and his younger brother Richard to Rome. (Richard Hunt became one of the most successful and fashionable architects of his time, designing ornate French chateaus for American millionaires.) Having decided to become a sculptor, William went off to Düsseldorf for his training. But he found the stolid temper of its schools boring and left for Paris. One day he happened to see a picture by the French artist Thomas Couture, and at that moment made up his mind to become a painter.

In the Salon exhibition of 1850 Hunt came upon a canvas of laboring peasants painted by Jean François Millet, the leader of the Barbizon school. Hunt was so excited by the

emotional depth of the work that he bought the picture and took himself off to Barbizon to become the master's devoted disciple. He adopted Millet's technique, using a warm, muted palette and heavy brushwork and blurring the outlines of objects. In 1855 Hunt returned to the United States, settling first in Newport, Rhode Island, then seven years later in Boston. He married one of the city's socialites and, through his wife's and brother's connections, became one of Boston's most prominent and fashionable portraitists. He also taught private classes in painting, and his pupils included such later famous men as the artist John La Farge, the philosopher William James and his brother, the novelist Henry James.

Hunt bowed to the inevitable demand for portraits. The preponderance of his work is likenesses, many of them full-length figures. They are emotionally powerful and perceptive studies of character, sometimes too honest for his sitters' tastes. Among the best of these are his portraits of Lemuel Shaw, chief justice of Massachusetts, and the intemperate abolitionist, Senator Charles Sumner of Massachusetts.

Hunt's imaginative pictures lacked the strength of his portraits. He produced a number of canvases reminiscent of his days in France as well as landscapes and figure compositions of rural American activities, such as boys swimming and playing ball. They are well-painted and charming pictures, but show clearly how much he was under the influence of Millet. Hunt was an obedient disciple, with nothing of his own to say. Unfortunately, many of his paintings and several canvases of Millet's, which Hunt owned, were destroyed in the Boston fire of 1872.

Hunt's most important commission came in 1875, when he was invited to paint two murals for the new Capitol in Albany, New York. He selected an allegorical subject based on a Persian poem that symbolized the flight of ignorance before the forces of enlightenment. Of the two murals he produced, *The Flight of Night* was superior. The color had a rich lumi-

nosity; the composition was broadly conceived and full of movement. It was his most successful attempt at creating a purely imaginative work and the only instance in which he showed none of Millet's influence.

Because of some miscalculation by the builders, Hunt was given six months in which to complete the assignment. The enormous pressure under which he labored and the lurking dread of failure were too much for him. He collapsed under the strain, and even though his murals won extensive praise, he could not resume painting. The following summer, while recuperating at a friend's home, he was found floating face down in a pond under circumstances which hinted at suicide. A short time afterward his murals were ruined by damp seeping into the stone. All that remains of his best effort are the preliminary sketches and a bronze of the central figures.

John La Farge (1835–1910), a pupil of Hunt's, is perhaps the one man who best expressed the yearning for Old World culture felt by many upper-class Americans during the latter part of the nineteenth century. La Farge was a man of great intellectual refinement and cosmopolitan tastes and probably one of the most artistically knowledgeable painters of his time. One of the first Americans to recognize Japanese art, he wrote a study of the master Hokusai and published, as well, several books on the European masters.

La Farge was born in New York City, the son of French emigrés. He received his first lessons in art from his maternal grandfather, a painter of miniatures. He spent some time in law school after graduating from college, and in his twenty-first year was sent abroad to meet his relatives and broaden his background. He worked for a few weeks with Couture and then wandered through the museums and galleries of Europe, studying the masterworks. It was not until after he returned to the United States and went to study with Hunt that La Farge decided to follow a career in art.

In 1870 the American architect H. H. Richardson persua-

ded La Farge to turn his talents to mural paintings. Because he drifted into this field at an early stage of his career, La Farge's output of easel paintings is fairly limited in number. From the very start La Farge showed strong naturalistic tendencies and a preoccupation with color and light. In Europe he had become interested in the science of color as set forth by the French chemist Michel Eugène Chevreul, whose theories were to play a role in the development of impressionism. La Farge's first paintings were faithful reproductions of nature, re-markably advanced in their handling of light. His later work, particularly his studies of flowers, were luminous, romantic conceptions. *Greek Love Token,* a painting of a

John La Farge: *Halt of the Wise Men* (1868).
Courtesy of the Museum of Fine Arts, Boston.

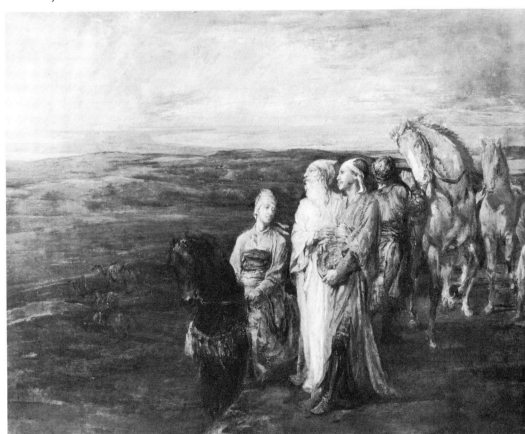

wreath of flowers hanging on an old Roman wall, is imbued with a tender poetry evocative of the Renaissance masters. In 1890 La Farge spent a year in the South Sea Islands (he went to Samoa, and was in Tahiti just before Gauguin) and there painted a number of oils and watercolors that are notable for their almost impressionistic use of vivid color and their handling of radiant light.

La Farge was an able painter with a splendid eye for color and a romantic imagination, but his canvases often seem over-refined and overly cultured. Yet La Farge was not just a follower of various masters. Though he borrowed freely from the art of all ages, his work bears the imprint of his own ideas and his own feelings. It was as a muralist and designer of stained-glass windows that La Farge achieved a well-merited international reputation. His glowing wall decorations of scenes from the Bible and from Greek or Roman literature were beautifully integrated with their surroundings. He revived the art of stained glass, for which he invented an opalescent material that allowed him to attain the full radiance of a given color. His windows are an artistic achievement without parallel in America.

Henry Ossawa Tanner (1859–1937), who was somewhat younger than La Farge, evolved a romantically sympathetic vision of the real world. But in addition to the usual problems that beset romantic individualists, Tanner discovered that the fact that he was a Negro was a definite hindrance to his career. Americans had little interest in Negro art, good or, bad. However, Tanner was a dedicated painter who by his talents managed to achieve some recognition. Sadly enough, few other Negroes were able to study art and surmount the barriers of racial prejudice.

Tanner was born in Pittsburgh, the son of a Methodist bishop, writer, and editor of a religious journal. He studied at the Pennsylvania Academy, where he received a thorough grounding in realism under Thomas Eakins. After his school-

ing, Tanner began painting landscapes, genre scenes, and occasional portraits which reveal an ability to read human character. One of his early pictures, *The Banjo Lesson*, is a well-executed and compassionate study of an elderly black man's loving patience as he teaches a little boy how to play the instrument.

Tanner was unable to support himself through his painting. He worked as a photographer, but found it impossible to earn an adequate living. In 1891 Tanner decided that he could no longer sustain what seemed an impossible struggle. So that he could be free to paint and forget the color of his skin, Tanner left the United States and settled permanently in Paris. Here he studied for a time with several French academicians. Moved by a desire to paint religious works, he made a trip to Jerusalem and the Holy Land, and soon established a reputation in that field. Tanner painted solidly academic canvases of Breton peasant life. But his religious pictures are imbued with a genuine religious eloquence.

Ten years before he died, Tanner was elected a member of the National Academy, despite his foreign residence. It was as much a tribute to the man as to his art.

Of all the romantic painters in the latter half of the nineteenth century, Page, Hunt, and La Farge were the most influential. They were idealistic individuals and men of great artistic insight and sensitivity. All had been to Europe, had sat at the feet of its masters, and unlike many other well-educated Americans, had returned home to give their countrymen the benefit of their learning. They were, however, a little premature. Although the scope of American painting had broadened considerably, American art was still governed by and dependent on public taste. And the public had not developed any fondness for a European type of romantic idealism. George Sala, a contemporary English journalist who made an extensive tour of the country, commented pointedly on what

he had seen. He found Americans an astonishing people with an "uncultivated taste for the pathetic" in the arts.

Page, Hunt, La Farge, and Tanner never caught the public's fancy as did the more sentimental genre painters. As Vanderlyn had been too "Frenchified" for American palates, so Page and Hunt were, to all but a few, "too Italianate," while Hunt was clearly too "modern" and the expatriate Tanner was of interest mainly to his fellow artists. None of the four men was either rebel or genius, but they were all gifted painters who brought to American art a new and more personal vision. They were also instrumental in directing the attention of American painters to the revolutionary developments in French art.

XI The New Expatriates

WHILE nineteenth-century American painting moved with slow and measured tread, two steps forward and one step back, French art progressed with dizzying speed, whirling from revolution to revolution. The battle against romanticism had been launched in 1855 by Gustave Courbet, a bitter opponent of classicism, romanticism, and all idealization in art. A fiery and outspoken champion of the workingman and peasant, Courbet proclaimed that everyday realism was the only democratic form of art. Because of his political beliefs he was violently attacked for the "socialistic" content of his work. And the upholders of academic tradition counted among their forces not only the romanticists but the still powerful classicists.

In 1855 several of Courbet's works were denied entrance to an international exposition of art being held in Paris. As a challenge to the academicians who had juried the show and to display his rejected work, Courbet erected on grounds near the exposition a building which he called the Pavilion of Realism. By exhibiting his work outside official circles, he set another precedent in the continuing battle for artistic freedom. Both Courbet's form of realism and his defiance of the authorities profoundly influenced the rising generation of painters.

In 1863 the French Academy, in an excess of conservative zeal, rejected four thousand canvases from its annual Salon exhibition. It was an act that spelled the eventual doom of the academy. Because the number of rejections was so unprecedentedly large, Emperor Napoleon III was forced to order a separate showing of the rejected paintings under the title

Salon des Refusés. It was the sole such exhibition ever held. Nevertheless it underscored the need for art to liberate itself from strangulating academic rule and reinforced the belief that artists must be free to work in whatever manner they wished. After 1863 those who disagreed with official taste organized their own salons.

The hero and most reviled painter in the *Salon des Refusés* was Édouard Manet, the precursor of impressionism. Manet was a realist. But he believed that the function of art was not to imitate nature. A picture, he felt, was an arrangement of areas of paint on canvas that showed the artist's direct response to his subject matter. The rounded modeling of classical tradition demanded the intervention of a gray half-shadow between light and dark. Instead, Manet laid down adjacent sections of light and dark, giving to his work a vivid sense of immediacy, as in a snapshot. His forms were painted in large areas of flat color, much in the manner of a Japanese woodcut. After 1870 he adopted the bright palette and free handling of the impressionists, though he was never one of their group.

In 1874 a group of thirty French artists, taking their cue from Courbet and Manet, held in a small Paris studio an exhibition that was to mark the beginning of the modern movement. Derisively labeled "impressionists" by an outraged critic who had seen Claude Monet's *Impression—Sunrise*, the name became synonymous with the most important artistic movement of the nineteenth century.

The impressionist aim was to achieve greater naturalism by painting directly from nature and recording the artist's spontaneous response to the whole of what he saw. This was contradictory to the traditional custom of putting down on canvas a preconceived idea of what a thing looked like. Whether he painted a still life or a landscape, the traditional artist did not depend solely on his eye and paint an object exactly as he saw it. Instead, he relied almost as much on his memory and

knowledge of the object to supply all the details his eye could not see.

For instance, when a traditionalist worked on a landscape, he painted the farthest tree a little smaller and in more muted color, but almost as solidly and clearly defined as a tree in the foreground. Since the human eye is incapable of seeing distant objects clearly, the artist was painting it not as he saw it, but as he knew it to be. The impressionists, on the other hand, were aware of the fact that light diffuses form. They saw the farthest tree as a blur and painted it as a blur.

The impressionists thought in terms of light rather than form. The human eye does not actually see an object, but rather the light reflected from it. A room without light becomes a dark void where all objects disappear. Because pictorial light can best be expressed in color, the impressionists used the vibrant colors of the spectrum to simulate the play of light upon the surface of an object. Instead of mixing their color on the palette to match the colors in nature, as tradition dictated, they laid their pigment directly on the canvas in adjacent dabs of pure, vivid color allowing the viewer's eye to mix them. Their forms lacked firm outlines, the edges blending into the surrounding atmosphere. All solid form was thus shattered into countless multicolored flecks of reflected light. This too was antithetical to tradition, which held that all objects were solids encased in well-defined linear borders.

The intense color, the "sketchy" technique, and the fuzzy shapes alienated the public and enraged academicians. But by the time the impressionists disbanded in 1886, they had gained their objective. Though they continued to be attacked by conservatives, the movement itself had begun to have a profound and far-reaching effect, the results of which would eventually change the entire concept of art throughout the world.

Into this arena of conflict came three Americans—James McNeill Whistler, John Singer Sargent, and Mary Cassatt. The

three artists were contemporaries of such men as Harnett, Vedder, Johnson, and Hunt. But time is a relative thing. The paintings of Harnett, Vedder, Johnson, and Hunt belong to the second half of nineteenth-century American art. Whistler, Sargent, and Cassatt, by virtue of their interests, their lives abroad, and their work, were painters whose influence reached beyond the nineteenth century and into the twentieth.

James McNeill Whistler, John Singer Sargent, and Mary Cassatt came to Paris, not for the joy of participating in rebellion, but to study painting. Like many Americans, Whistler and Mary Cassatt were virtually compelled to seek their training abroad because of the inadequacy of mid-nineteenth-century American art schools. Sargent, who was born in Europe, naturally gravitated to Paris, since it provided the best training. Whistler and Sargent were but marginally affected by the upheavals in French art. Only Mary Cassatt aligned herself with the impressionists but more particularly with the famous French painter Edgar Degas. She was, in fact, the only American to have been intimately involved with the impressionist group and exhibited with them from 1879 until they disbanded.

The three artists were as disparate in their life styles as in their styles of painting. Though acquainted, they had little taste for each other's company and were barely tolerant of each other's ideas or work. Their bonds were purely coincidental: Each maintained a peculiar loyalty to America; all were expatriates who lived and died abroad; all were destined to leave their mark, both in the United States and in Europe, as artists of considerable stature.

Sargent created the first new style in American portraiture since the days of Stuart and Sully, and early in his career he became the toast of two continents. Whistler's reputation rose toward the end of his life, but never as high as Sargent's. Whistler's work had a minimal influence on American painting. It was in his battle for artistic freedom that the full measure of

his weight was felt. Mary Cassatt was virtually unknown to most of her compatriots during her lifetime. Not until the twentieth century was she finally accorded her rightful position in American art.

Ironically, with the sudden reversals that often accompany changing fashions, Sargent's reputation slid abruptly downhill after his death. As much maligned then as in his lifetime he had been lauded, he fell into disrepute, scornfully dismissed as a flashy, superficial painter, an opinion that has only recently been revised. By contrast, Whistler and Cassatt gradually rose into prominence and are now considered among the finest of American artists.

ART FOR ART'S SAKE: JAMES McNEILL WHISTLER

"I AM THE QUIXOTE in the battle fought by the painters," James McNeill Whistler (1834–1903) once said. To a public hugely amused by his antics, he did indeed seem to be foolishly tilting at paper windmills. But he was in deadly earnest. Under the banner of "Art for Art's Sake," he rode forth not to jostle tradition, but to rid art of the outmoded restrictions, suffocating banalities, and pretentious claptrap that he felt weighed heavily upon it. As an English historian wrote, in Whistler's concept of art "a painting was no longer to be a moral exercise, or an anecdote, or an unimaginative illustration, but a free expression of the eye's true seeing."

The most flamboyant figure of his day, Whistler was a brilliant performer, a dandy, a clown, eccentric, witty, and arrogant. He delighted in shocking the prim and the pompous and in attacking the mediocre. Born in America, trained in France, by choice a resident of England, he painted English subjects in the French manner with a Japanese feeling. His

work belongs to no country, to no school, to no movement. As in his life style, so in his art Whistler was a law unto himself.

With customary insouciance, Whistler brushed aside the fact that his birthplace was Lowell, Massachusetts, declaring, "I will be born when and where I choose." The son of a military engineer, he was taken in 1843 to St. Petersburg, Russia, where his father supervised the construction of a railroad for the Tsar. Six years later, when the elder Whistler died, the family returned to Stonington, Connecticut. Following in his father's footsteps, Whistler entered West Point, but was dismissed in his junior year for having failed in chemistry. "Had silicon been a gas," he joked, "I would have been a major-general." He spent a year in Washington, D.C., as a map engraver, and in 1855, the year Courbet issued his manifesto on realism, Whistler came to Paris to study art.

Through his friendship with the French painters Henri Fantin-Latour and Courbet (whom he met in 1858) Whistler soon began to formulate his own ideas on art. His early work showed the influence of Courbet's solid realism, his somber palette and heavy brushwork. *At the Piano*, a picture of Whistler's sister and niece, is imitative of Courbet, but already reflects Whistler's growing taste for artful composition and subtle color harmonies.

Though he knew the members of the literary and artistic avant-garde and was considerably influenced by their ideas, Whistler was never a member of their inner circles. In 1859, having heard that the market for paintings was prospering in England, he went to London. Within a short time he was a familiar figure in the literary and art circles of that city. But he remained uncommitted to any one movement. Though neither a follower nor a member, he was an aloof associate of the Pre-Raphaelite Brotherhood, a little community of independent English artists and writers who believed in the greatness of those Italian painters who preceded Raphael. Bound

together by a vague aesthetic adulation for the Middle Ages, the brotherhood was championed and popularized by the famous English critic John Ruskin.

In 1863 Whistler sent *Symphony in White No. 1: The White Girl* to the Paris Salon. The first of his works to bear a musical title, it had already been rejected by London's Royal Academy as "too odd" and was now similarly dismissed in France. Along with the pictures of Manet and of many other later-celebrated painters, it was shown in the *Salon des Refusés*.

The White Girl was a daring picture for its time. In contrast to the overworked and polished naturalism of academic tradition, it was painted in subtle variations of color, with the emphasis on design. His portraits and landscapes were realistic, but he had moved toward a more abstract style of composition, which was prophetic of the direction in which art was heading. He believed that line, color, and form were the essentials in a work of art, not just the means one used to copy nature or tell a story. Adapting the simplified design of Japanese art, he created harmonious "arrangements" of delicately attuned tonalities of color. To stress the importance of these abstract values, he gave his pictures musical titles.

"Why should I not call my works 'symphonies,' 'arrangements,' 'harmonies,' and 'nocturnes'?" he demanded. "My picture of a *Harmony in Grey and Gold* is an illustration of my meaning—a snow scene with a single black figure and a lighted tavern. I care nothing for the . . . black figure, placed there because black was wanted at that spot. All I know is that my combination of grey and gold is the basis of the picture."

His experiments came to their fullest expression after 1870. Despite the continued indifference of the Royal Academy, Whistler's reputation had grown, and he received many commissions from fashionable Londoners. If he was not considered an artist of great stature by his contemporaries, he was grudgingly accepted as a meritorious, though annoyingly rebellious, painter. During the three decades after 1870 he

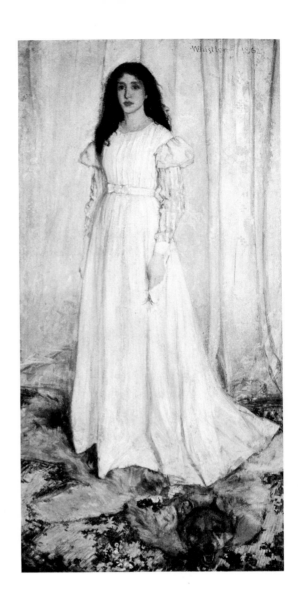

James McNeill Whistler:
The White Girl
(1862).
Courtesy of the
National Gallery of Art,
Washington, D.C.,
Harris Whittemore
Collection.

produced some of his finest etchings and oils, among them
Harmony in Grey and Green: Miss Cicely Alexander, a remark-
ably sensitive portrait of a young girl; the famous picture of
his mother; and his luminously beautiful "nocturnes."

Constantly and consciously seeking the limelight and always
ready for a good fight in support of his principles, Whistler
was handed the opportunity to give the greatest performance
of his career by Ruskin. Now old, cantankerous, and filled
with unreasoning dislike for modern art, Ruskin was roused
to fury by the sight of Whistler's canvas *The Falling Rocket:*

Nocturne in Black and Gold, a picture of a nighttime display of fireworks over an amusement park as seen from across the Thames River. The bright flecks of color and the vague illuminated shapes would hardly anger anyone today, but the painting set Ruskin's teeth on edge. Furiously denouncing it as "willful imposture," Ruskin declared "I have seen and heard much of cockney impudence before now; but never expected to hear a coxcomb ask two hundred guineas for flinging a pot of paint in the public's face." Whistler sued for libel. The stakes were high, but Whistler was willing to risk his career in defense of his art.

The trial took place in November 1878. Whistler was a dazzling performer. A crisp military moustache and goatee, eyes that flashed scornfully from under heavy brows, a monocle screwed into his right eye, and a flamboyant lock of white hair (which he claimed had been touched by the Devil) accentuated his Satanic appearance. This "minor Mephistopheles," as Oscar Wilde once called him, parried each thrust of Ruskin's attorney with diabolic wit, defending his right to paint, not a literal transcription of nature, but his own interpretation of nature in an "artistic arrangement." For his "unfinished" canvasses (as the prosecution called them) he demanded payment not on the rate of hourly production, but for the "knowledge of a lifetime."

The jury found Ruskin guilty and awarded Whistler one farthing (a half-penny) with court costs to be shared by both parties. It was a hollow victory. The decision showed all too clearly the conservatives' contempt for artistic originality. The cost of the trial forced Whistler into bankruptcy. If before he had been a deliberate Bohemian, scoffing at Victorian standards, he now declared war on the Philistines, and indeed fought with anyone who disagreed with his ideas.

In 1879 Whistler left for Italy, where he produced a number of etchings and watercolors that were remarkable for their skill and delicacy of tone. When he returned to London

two years later, the climate had changed somewhat. The progressive Society of British Artists elected him their president. American collectors began to buy his work; a Scottish corporation purchased his portrait of Thomas Carlyle, and in 1891 France acquired *The Artist's Mother* for the Luxembourg Palace collection. Yet when the Carlyle portrait, honored in Paris, Brussels, and Munich, was shown at London's Victorian Exhibition, it was hung high on the wall almost out of sight. "Could anything be more perfect—as a résumé of all the past!—Was ever revenge more complete!" Whistler wrote in a letter to his friend G. N. Smalley. "One work received with high honour in the Luxembourg . . . at the *very moment* that another is hoist with equally high disrespect. . . ." In academic circles he was still persona non grata.

Controversy nipped at his heels like a hungry dog. Though he helped establish more enlightened standards in English art, his high-handed methods irritated the members of the Society of British Artists to such a degree that they demanded his resignation. He quarreled with the New English Art Club, the one group that was making any serious attempt to liberalize academic rule. Imperiously, he laid down his principles of art as universal standards in a public lecture—called the "Ten O'Clock" for the hour it was held—which ended in an unpleasant three-sided argument with the poet Algernon Swinburne and the playwright Oscar Wilde, two of England's outstanding literary lights. In 1890 Whistler published *The Gentle Art of Making Enemies*, a collection of critical comments on art and people, dedicated to "the rare Few, who, early in Life have rid Themselves of the Friendship of the Many. . . ." A butterfly with a long, forked barb—an emblem he evolved from his initials—danced through the pages, enjoying its own revenge.

In 1892 Whistler returned to Paris, to be where the "new" art was developing. But he was now a complete outsider. The avant-garde had no use for him, and his former friends ignored him. He was too much of a performer for their tastes.

"My dear Whistler," Degas scolded, "you have too much talent to behave the way you do." The last few years of his life were spent alternately in France and England. When he died in London, only a few relatives and a scattering of friends attended the funeral. He was no longer news.

Whistler was just a shade too conscious an aesthete. He sought perfection and made a cult of beauty. And beauty, in his case, became an exaggerated delicacy of style. This deliberate insistence on elegance and on exquisite refinement robbed some of his work of its vitality. He explored contemporary movements in art, but never with any profound conviction or dedication.

For all his weaknesses, Whistler was an extremely complex man and a gifted and original artist. His skillful portraits, though termed "arrangements," were nonetheless observant studies of character. He was one of the best etchers of his time, bringing to this difficult medium a new depth of sensitivity and warmth. His "nocturnes" are lyrical visions of twilight landscapes. He was an innovator, anticipating the ornamental design and flowing line of a style that would become known as *art nouveau*—literally new art. And he was prophetic of a much later kind of simplified abstraction. He was a devotee of Japanese art, owned a large collection of Oriental porcelain, and was instrumental in establishing a taste for both in England.

The sum of the man was more than all his self-conscious posturings and willful performances. He was a stimulating and perturbing spirit, a fine artist and an audacious fighter in the battle for freedom of expression.

THE VIRTUOSO: JOHN SINGER SARGENT

"JOHN SINGER SARGENT [1856–1925]," said his close friend and admirer Henry James, "offers the slightly uncanny spectacle of

a talent which on the very threshold of its career has nothing more to learn." Sargent was a man, to quote Shakespeare, "framed in the prodigality of nature." He was an imposing figure, tall, distinguished, and urbane. A brilliantly accomplished painter, he became the darling of society and an international celebrity by the time he was thirty, and a likeness by Sargent became the hallmark of fashionable elegance and worldly success. Honored by kings and governments, he was termed "the most conspicuous of living portraitists" by a respected American critic; he was deemed England's greatest living portrait painter and offered a knighthood, which, as an American citizen, he declined. He was the only living artist of his time (and an American at that) to have his work in England's National Gallery.

Success came, perhaps, too easily and quickly. Midway through his career Sargent found himself mortally tired of the routine of portrait painting. Desperate to rid himself of this lodestone, he dashed off too many canvases, substituting facility for effort and appearance for substance, thus contributing to his later reputation as a glittering virtuoso.

He was actually a great deal more. Though he insisted his was a dispassionate approach—"I chronicle, I do not judge" —his portraits, particularly those of his earlier period, are vivid images of the *haut monde*. Like no other painter, he captured the very essence of wealth. The rich loved him, said the noted English writer Sir Osbert Sitwell, "because with all his merits, he showed them to be rich: looking at his portraits, they understood at last *how* rich they really were."

Sargent was not only a social chronicler. His early oils, his sparkling watercolors and impressionist canvases are works of genuine artistic power.

Sargent was the son of an eminent Philadelphia surgeon and a woman of independent means. His mother had an unquenchable thirst for European living and finally persuaded her husband to retire to Florence, Italy, where Sargent

was born. Because of Mrs. Sargent's incurable wanderlust, he became, even as a child, a proficient linguist, at home in most countries. His mother attended to his cultural education, giving him lessons in music and art, and when he was fourteen, she saw to it that he entered the Accademia delle Belle Arti in Florence. In 1874, the year of the first impressionist exhibition, Sargent arrived in Paris to begin his training at the Ecole des Beaux-Arts under the portraitist Carolus-Duran. Three years later Sargent had far outstripped his master.

After a trip to Holland and Spain in 1880 he returned to Paris and in 1882 completed two of the most striking of his early canvases. Sargent was twenty-six when he painted *El Jaleo,* which showed a Spanish dancer accompanied by several guitarists performing for an audience in a café. The picture revealed his incredible mastery at handling pigment. The canvas was painted with a bold and sure brush and caught, with dramatic vividness, the dancer's explosive movement. More penetrating was *The Daughters of Edward D. Boit.* It was a daring composition, asymmetrical in balance with its four figures emerging from various parts of the canvas, and brilliantly handled in its counterplay of light and shade. Criticized as "four corners and a void" when it was shown in the Salon of 1883, it won unstinting admiration from his fellow artists for its remarkable skill and originality.

In 1884 Sargent sent to the Salon a portrait of Madame Pierre Gautreau, one of the most fashionable of Parisian beauties. The likeness, which emphasized her statuesque elegance, was extremely simple. Sargent painted her in a low-cut evening dress, her head turned in cameo profile and her pale skin gleaming against the somber background. The canvas raised a storm of protest. Madame Gautreau, her family, the critics, and the public reviled the work for its shocking décolletage and for revealing the lady's inordinate vanity. The offending portrait was immediately removed from the exhibition and never again shown during Sargent's lifetime. When the Metro-

politan Museum purchased the picture in 1916, Sargent stipu-
lated that the title be changed to *Madame X,* the name by
which it is now known.

To escape the unpleasant aftermath, Sargent moved to Eng-
land. British art circles at first regarded him with suspicion
and distrust. Like Whistler, he was an American trained in
France. Henry James, himself an expatriate, long an admirer
and now a close friend, introduced Sargent to London's liter-
ary and social circles. Within a few years, Sargent had become
the most sought-after painter in the world.

He grew wearied and bored by the overwhelming demand

John Singer Sargent:
Madame X
(1884).
Courtesy of the
Metropolitan Museum of Art,
Arthur H. Hearn Fund, 1916.

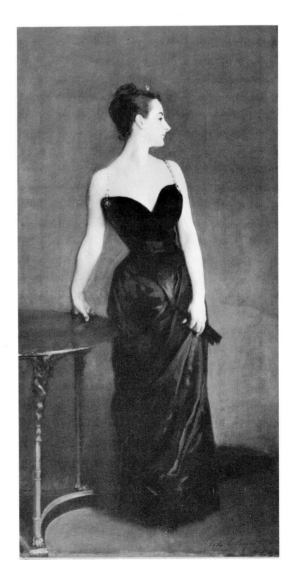

for his services, and his work became superficial. He tried to limit his commissions, raised his prices, but to no avail. His clients continued to clamor for his brush. If he would not paint a full-length portrait for them, then a head would do; if he said no to an oil, then a charcoal sketch was satisfactory— anything at all, so long as it was by his hand.

Periodically over the years, to escape the pressures of his commitments, or, as he put it, "to regain my manhood," Sargent fled to the Continent. There, revived by the knowledge that he had no one but himself to please, he devoted himself to the painting of watercolors. Sargent had no interest in the picturesque. He painted what he saw before him, putting down his observations in crisp, bold strokes of glowing transparent color. His eye, though detached, was nevertheless extremely selective. He never painted landscapes, but brilliant and vivid impressions of a doorway, part of a building, a gushing fountain, a woman swathed in voluminous draperies giving a painting lesson to two girls. Of all Sargent's work, his watercolors are the most intimate expressions of his extraordinary virtuosity.

In 1890 Sargent was commissioned to paint murals for the newly completed Boston Public Library. He chose as his theme a religious subject and traveled to the Middle East to authenticate his material. In 1916, the year his library murals were completed, he was invited to decorate the rotunda of the Boston Museum of Fine Arts, a project finished shortly before his death. He also painted two murals for the Widener Library at Harvard University. Sargent's murals are period pieces, handsomely executed wall decorations.

In 1910, at the height of his fame, he finally refused to paint any more portraits. During World War I he did accept a few such commissions as part of the war effort, but turned his fees over to the Red Cross. He went to France at the behest of the British government to do a series of commemorative war

paintings. When he returned to London, he was offered, but declined, the presidency of the Royal Academy.

Sargent's reputation plummeted almost immediately upon his death. By 1925 modern art was already firmly entrenched, and to the younger generation he was already *démodé*, a thing of the past. Whether his career would have taken another turn had he remained in Paris is questionable. He was essentially a traditionalist and a portrait painter at heart. Even though he produced a number of splendid impressionist landscapes, it was Monet's influence and vision rather than his own conviction that guided Sargent. He was not unaware of the revolution then going on in art, but showed no inclination to join it or be other than he was—a superbly gifted painter with a bold, spontaneously fresh, and sometimes most perceptive approach. Oddly enough, the technical virtuosity for which he was later so roundly condemned became the goal of American portraitists, and his style one that is to this day prevalent in academic circles.

A PHILADELPHIA LADY: MARY CASSATT

IN 1879, hanging in the impressionist exhibition among the works of such now famous painters as Degas, Monet, Renoir, and Pissarro, were two pictures by a wealthy Philadelphia society lady named Mary Cassatt (1844–1926). That she should be a participant in such a show was astonishing. By all odds, she should have been sitting in her parlor, a dignified matron pouring the tea out of heirloom silver, engaging in the kind of polite conversation proper to her background and her position as sister of the president of the Pennsylvania Railroad. Instead she was unmarried, a painter living in Paris, and an ardent supporter of the most revolutionary artistic movement of her time.

Mary Cassatt, daughter of a stockbroker of French descent, was born in Allegheny City (now Pittsburgh), Pennsylvania. She was taken to Paris when she was seven, just in time to witness the transformation of the Second Republic to the Second Empire under Napoleon III. She returned to Philadelphia at the age of fourteen. At twenty when, instead of making feverish preparations for her debut like most of her friends, she announced her firm intention of becoming an artist, it was as if she had committed a sinful act. "I would almost rather see you dead," was her father's horrified response. In that mid-nineteenth-century era of rigid convention, dabbling in watercolors or painting on china was an approved cultural hobby for women. But a career in art was out of the question.

With the iron-willed determination and independence of spirit that marked all her actions, she nagged at her parents until finally in 1864 she was permitted to attend the Pennsylvania Academy of the Fine Arts in Philadelphia. Two years and many arguments later she left for Europe, settling in Paris, where she was joined by her parents and sister. With the exceptions of summers at her country home and a few trips to the United States, she remained in France the rest of her long life.

Mary Cassatt was an extraordinary woman. To become a painter, she defied her parents, disregarded convention, and gave up all hope of marriage and a family of her own. "There are two ways for a painter," she once said, "the broad and easy one or the narrow and hard one." It did not matter that her road might be even harder because of her sex. Art was all-important, and for art she was willing to make any sacrifice.

Instead of following the usual path to the Beaux-Arts, she went to Italy to study the masters, particularly Correggio, and then to Spain to learn from Velázquez and the great Flemish painter Peter Paul Rubens. Returning to Paris in 1873, she worked briefly in the studio of the academician Charles Chaplin. Searching for a more meaningful direction in art, she

stumbled across some of Degas' paintings in the window of a picture dealer. "I used to go and flatten my nose against that window and absorb all I could of his art," she recalled. "It changed my life. I saw art then as I wanted to see it." When in 1877 Degas, who had seen and admired her work in the Salon exhibitions, invited her to join the impressionists, she needed no persuasion. "I began to live," she said.

While she knew all the impressionists, Degas was her only intimate friend. Theirs was a long, devoted, and sometimes stormy relationship based on their common interests in art and their respect for each other's talents. There was no room for romantic attachment.

Mary Cassatt was neither an imitator nor an awed disciple of Degas. She absorbed all she could from him and from Japanese art, then sifted her learning and adapted it to her own style. She possessed a fine sense of design and was an uncommonly good draftsman—so good that Degas once infuriated her by refusing to believe that one of her prints had been done by a woman. To improve her drawing, she became an etcher, working on her copper plates in the evening and painting during the day. Her etchings are remarkable for their purity and crispness of line, richness of tone, and originality of composition. Her etchings, both in black and white and in color, are genuine works of art and among the finest individual expressions in the medium.

There was nothing feminine or weak about her work. She used the high-keyed impressionist palette, but never adopted their dissolution of form. No matter how boldly free her technique, her figures were always solidly drawn. Most of her canvases are of women and children, though she did not limit herself to this theme. Perhaps a frustrated yearning for such a relationship found expression through art. Her mothers and children are treated with an honesty of vision and a tender, yet penetrating insight that is totally devoid of sentimentality. Like Degas, she saw her subjects as human beings whose very

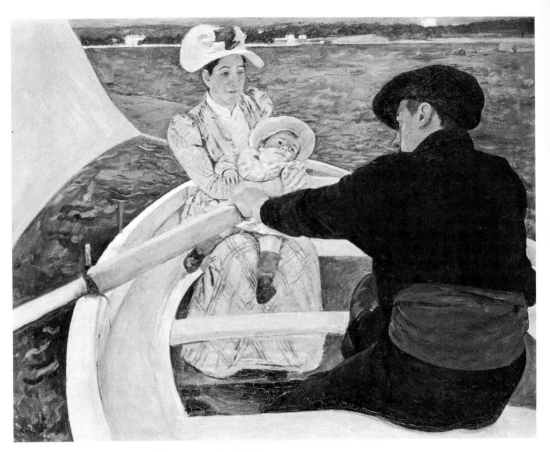

Mary Cassatt: *The Boating Party* (*c.* 1893).
Courtesy of the National Gallery of Art, Washington, D.C.,
Chester Dale Collection.

commonplace qualities were in themselves beautiful and endearing.

Long absent and so closely identified with Degas and the impressionists as to be regarded a French painter, she was virtually unknown in her own country. When in 1900 she arrived in the United States on her first visit in more than thirty years, the announcement in her hometown paper, the Philadelphia *Public Ledger*, read simply: "Mary Cassatt, sister of Mr. Cassatt, President of the Pennsylvania Railroad, returned from Europe yesterday. She has been studying painting in France and owns the smallest Pekingese dog in the world." Mary Cassatt was then at the peak of her career.

During her stay she went the rounds of the art museums and was appalled by the poverty of the collections. She was determined to do something about it, and as her biographer Frederick A. Sweet says, she "exercised a stronger influence on American art collecting than any other individual of her day." Mary Cassatt had an infallible eye and an unerring instinct for great art. She was one of the first to recognize the importance of the Spanish master El Greco, when her contemporaries considered him an oddity. While the impressionists were being reviled in their own country, she persuaded her brother to buy the works of Monet and Pissarro. For her friend Louisine Havemeyer, the wife of the American sugar magnate, she helped build one of the world's greatest collections of old master and impressionist paintings, now in the Metropolitan Museum. And to many more of her wealthy friends, who were beginning to invest their money in art, she gave unsparingly of her time and her invaluable assistance.

Mary Cassatt was every inch the cultivated American gentlewoman. Conventionality, which she detested in art, was the standard that regulated her personal life. Except for her art, she might just as well have been living in Philadelphia as in Paris. "We . . . make no acquaintances among the Americans who form the colony," her mother wrote, "for as a rule they are people one wouldn't want to know at home." Apart from the family, the Cassatts entertained sparingly, and then only a few of the more distinguished statesmen and intellectuals of the time. Mary was an intelligent woman interested in politics and literature as well as art. But she drew a sharp line between her art and her private life, allowing neither to impinge on the other.

During the latter part of her life her work became increasingly coarse. Her eyesight, which had been rapidly failing, became so poor that etching or painting was no longer possible. Her parents and sister, with whom she had lived and who had frequently served as her models, were long gone. Degas

and many of her fellow impressionists, now accepted as masters, had breathed their last. The world she had known and loved had disappeared in 1914 in the flames of war.

Defeated by blindness, she grew more peppery and opinionated with age, a "vinegary old maid" as someone called her. She was opposed to the Versailles Treaty and vehemently denounced the principles of Woodrow Wilson and her old friend Georges Clemenceau. She disliked Sargent for a "dreadful" portrait he had done of her brother. For Whistler she had no use; his behavior was much too unconventional and shocking. Monet was lacking in intelligence; Renoir was too "animal." Matisse's work was "extremely feeble in execution and very commonplace in vision." Invited once to Gertrude Stein's home, where the most advanced writers and artists met, she left almost immediately, declaring she had never seen "so many dreadful paintings in one place" and "so many dreadful people gathered together." For young American art students she had only one piece of advice: ignoring her own rich experience, she bade them stay home. This was a new century, inhabited by a new breed of artists, whose aims were incomprehensible to her. The principles and traditions on which she had been nurtured had vanished.

Mary Cassatt once said that she had failed in her duty as a woman by not marrying and bearing children. If she failed in that sense, she more than compensated for it in her creative life. She was a significant artist in her own right, regardless of her sex or subject matter. "There is an inner conviction about her work," says Sweet, "which asserts itself over and above any specific limitations of time or place."

XII Americans Abroad

Whistler and Mary Cassatt were, of course, not the only American artists to go abroad to study. Other painters felt the need for a sounder training than that provided by American art schools. Ever since the days of Benjamin West, there had been a steady flow of Americans going to Europe for their learning. But, most often, these were men who had already had some experience working at their profession. They were abroad to gain polish and a greater knowledge of their craft.

Beginning with the 1870's, what with the comparative ease and speed of travel, the flow of American artists going abroad swelled to a torrent. But these were a new generation. Like Whistler and Cassatt, who preceded them, they were young students aspiring to be painters, traveling to Europe to obtain training *in preparation* for a career. In Europe there were the schools, the teachers, the museums and masterpieces, from which they could learn. They descended on the various art centers—Florence, Venice, London, The Hague, Rome, Antwerp, Munich, Paris—with Munich and Paris as the leading attractions.

Unlike Whistler and Cassatt, most of the painters who went abroad during these years returned to the United States as soon as their schooling was done. Many of them then became teachers as well as practicing artists. In this double-vantaged position, they carried great weight, especially with the younger artists. Not only did they possess a thorough knowledge of their craft, but—and perhaps more important—they were aware of the latest European trends, even though they frequently didn't fully understand them. Consequently, by the time the twentieth century arrived, American art schools

could, for the first time, take pride in the large number of well-trained and talented artists who manned their staffs.

In the 1880's Paris became the Mecca of art. A decade earlier the favorite haunt of young Americans was Munich, the capital city of Bavaria, Germany. Here aspiring painters could work at the conservatively oriented academy and, if they were so inclined, could also study privately with a number of artists who lived in the city. One of the most popular and esteemed of these artists was Wilhelm Leibl, a man whose ideas and style of painting had great impact on his American students. Leibl was opposed to the romantic idealism then prevalent in German art. He had been trained in Paris, where he came under the influence of the great French realist Gustave Courbet. Leibl painted portraits and scenes of everyday life in a broad, dashing style, which had its origins in the brushwork of Hals and Rubens. Leibl gained a reputation for his forceful draftsmanship and his bold, sure touch. He is known as the leader of modern German realism.

The "Munich style," as it came to be called in the United States, emphasized a romanticized, yet vigorous, form of realism. Students were taught to paint *alla prima*—that is, directly on the canvas without any preliminary drawing. They learned to apply a heavily loaded brush with rapid, slashing strokes, enveloping their forms in atmospherically deep shadows. The "Munich style," with its warm, dark tonalities and virtuoso technique had a surface brilliance that impressed even the most artistically ignorant spectator. It took the American public by storm.

THE BROAD BRUSH

OF THE MANY MEN who brought back the "Munich style," Frank Duveneck and William Merritt Chase were the most gifted. Both were extremely successful painters and highly re-

spected teachers and, with the exception of Sargent, exerted the greatest influence on the younger generation of American artists.

Frank Duveneck (1848–1919), the son of German immigrants, was born in Covington, Kentucky, a town near Cincinnati, Ohio. Duveneck was a remarkably facile painter even in his youth. While still in his teens, he quit school and went to work as a painter, gilder, and carver for the local Catholic churches. At the age of twenty-two he arrived in Munich and quickly adopted the mannerisms of its schools. He was an especially apt student and within three years had developed a kind of dark, boldly brushed style, which seemed like an up-to-date version of the old masters.

Duveneck returned to Cincinnati in 1873 to paint portraits that attracted little notice. Two years later, at the Boston Art Club, he exhibited five canvases which sent his reputation skyrocketing. The dashing fluency of his brushwork, his deep, resonant color, and his bold division of light and shadow to create mood drew swarms of admirers. Overnight he became one of the leading figures in American art, but the attraction of Europe was overpowering. In 1875 he went back to Munich where he started his own school (it was later moved to Florence), dividing his time between teaching and painting. The many young American artists who came to study with him were later known as "the Duveneck boys" for their faithful imitation of his mannerisms. In 1889, when his wife died, Duveneck returned to Cincinnati, where he spent the rest of his life as dean of the city's art academy.

Duveneck was a sound craftsman and a talented, pleasing painter, who took genuine delight in the manipulation of pigment. Too frequently, however, he was carried away by his own dexterity. With excessive modesty, in view of his own incredible skill, Sargent is said to have called Duveneck "the greatest brush of his generation." Perhaps Sargent was being less humble than acutely perceptive. In the final analysis,

Duveneck was a bravura performer whose work had little substance.

When a group of bountiful businessmen asked William Merritt Chase (1849–1916) if he wanted to study abroad, the talented twenty-three-year-old Indiana artist replied, "My God, I'd rather go to Europe than go to heaven." A fellow student in Munich and later a pupil of Duveneck's, Chase became one of the dominant figures in late-nineteenth- and early-twentieth-century American art. He had some training with local painters and studied for a while at the National Academy before he went to Munich in 1872. Five years later he was offered but declined a professorship at London's Royal Academy of Arts. By the time he returned to America in 1878, he had earned such a fine reputation that he was immediately invited to join the staff of the recently established Art Students League in New York. His popularity as a painter and teacher continued to grow and, after a few years, he founded his own school. There he taught for the rest of his life.

Chase was an unerringly confident craftsman with a reverence for brilliant painting as an end in itself. He employed the dashing mannerisms and sooty tonalities of the Munich school. In the 1880's he adopted the brighter palette of the impressionists and the spirited, sweeping brushstroke of Sargent. His painting *In the Studio* is a charming example of his versatile brush. Chase had "a juggler's skill of copying things," as Robert Henri, another notable teacher put it, and Chase's style is sometimes imitative. His full-length portrait of Whistler, for example, is most adroit in its deliberate duplication of Whistler's mannerisms. Chase's fame was based on the elegant portraits and pearly still lifes of fish and onions, which were painted with spectacular fluency and speed. "His big broadly handled brush stroke," a critic stated, "his glistening highlights and dark shadows, created an impression of dazzling virtuosity" which inspired his students and excited his clients.

Chase had a hedonist's delight in the good life. He dressed with impeccable care; his daughters were dressed like Spanish princesses. His studio on West Tenth Street, which can be seen in the reproduction, was crowded with gleaming copper urns, lustrous silks, thick carpets, beautiful tapestries, and other opulent objets d'art. And his Saturday "at homes" were eagerly attended by most of New York's art world.

Chase's was a "painter's painting," said the critic Royal Cortissoz admiringly. It was an estimable but superficial talent. However, Chase was an exciting and enormously popular teacher, and by 1900, under his influence, the bravura handling and bright impressionist palette had become the stylistic hallmark of American painting. "The long quivering brushstroke was what we were after" his pupil, the well-known artist Charles Sheeler, said. "The statement was of little or no importance—the word never entered our vocabulary. The

William Merritt Chase: *In the Studio* (*c.* 1880).
Courtesy of the Brooklyn Museum.

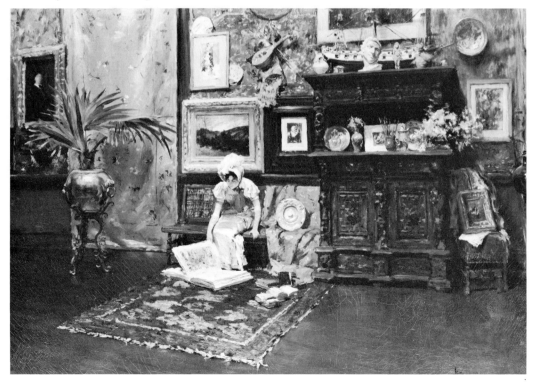

mechanics of painting was what mattered—brilliance, fluency."

In his younger days Chase had been a forward-looking paint-er, alert to the latest developments in European art. A year after his return to New York he was elected president of the Society of American Artists, a progressive organization formed in 1877 to counteract the restrictive policies of the National Academy. But Chase was no rebellious hero; he was much too jealous of his reputation and his enviable income to jeopardize his position. In the ten years of his administration he became increasingly conservative and, in large measure, was respon-sible for the society's ultimate absorption into the enemy camp. Soon another and more potent uprising against the National Academy would erupt, but it would be organized by and would affect a later generation of American artists.

THE LITTLE IMPRESSIONISTS

IN THE LAST two decades of the nineteenth century echoes of the new ideas that were revolutionizing French art began to reach the United States. Now, instead of going to one or an-other of the cities on the Continent for their learning, Ameri-cans, as well as Europeans of all nationalities, began flocking to Paris. Until the outbreak of World War II, Paris would be the international capital of the art world, and what happened there would affect the entire course of art, particularly in the United States.

In 1898 John Twachtman, Childe Hassam, Edmund C. Tarbell, Frank W. Benson, Willard L. Metcalf, Edward Sim-mons, Robert Reid, Joseph de Camp, Thomas W. Dewing, and J. Alden Weir founded a group which they called Ten American Painters. Almost all French trained, they held one of the first exhibitions of American impressionism. Appearing in the United States more than twenty years after the original movement was established in France and when many of its

adherents had already moved on to even more radical concepts, American impressionism was actually no more than a historical addendum. American painters were foreigners, shut off from the mainstream of developments in French art and they never fully grasped the fundamental principles of impressionism. In theory the French thought of light as the principal subject of a picture, but Americans saw it, as Homer Martin explained, as a new and interesting method of laying down "little bits of paint alongside each other to make them twinkle." The American artists borrowed the impressionist's bright palette and flicking technique and used them as a kind of embroidery for their realism. And where the French fragmented all forms into splinters of light, the Americans rendered their shapes a little more vaguely, only a little less solidly then in the past. Of all the men who worked in this style, Theodore Robinson, J. Alden Weir, Childe Hassam, and John Twachtman are considered the pioneers of American impressionism.

In the brief span of his lifetime Theodore Robinson (1852–1896) traveled a long circuitous route to impressionism. He had done accurate little crayon portraits in Wisconsin, and in 1877 he went to Munich, where he adjusted himself to the dark palette and solid drawing of that school; then in Paris he acquired the polished style taught in conservative ateliers.

During the years when Robinson and other young Americans were gathering in Paris, the French Academy was still dominated by conservatism. The most successful and reputable French artists of that period were painting sentimental pictures based on events in history, the Bible, and on "Oriental," that is to say Near Eastern, subject matter in a style that was almost photographically naturalistic. This was the style being taught in the ateliers and the style that most American artists first encountered on their arrival in Paris.

Not until the last twelve years of his life did Robinson work in the impressionist manner. In 1884 he had discovered the

canvases of the famous French impressionist Claude Monet.
Just as Hunt had followed Millet to Barbizon, so Robinson
went to Giverny to study with Monet. But Robinson could
not quite fathom Monet's principles, and Robinson's hand
could not quite detach itself from the realism of his earlier
training. The sharp division of light and shade and the
solidity of Robinson's forms as seen in his landscapes show
little real understanding of the underlying concepts of
impressionism.

Robinson's contemporary, J. Alden Weir (1852–1919), the
youngest of the sixteen children of Robert W. Weir, was born
in West Point, New York. Alden's father, a portrait and histori-
cal painter, was professor of drawing at West Point in the days
when Whistler attended the military academy. And Alden's
brother, John Ferguson Weir, a well-known academic painter,
became the director of Yale University's art school.

Alden Weir studied at the National Academy and in 1873
went to Paris. After his return to the United States he helped
found the Society of American Artists and "The Ten," and
from 1915 to 1917 served as president of the National Acad-
emy.

In Paris Weir had learned to conceal his innate con-
servatism with little strokes of silvery color. Yet no more than
Robinson was he able to bridge the gap between academic
realism and impressionism. Weir struggled valiantly to speak
in a modern idiom, but his landscapes and figure paintings
have a gentle, turn-of-the-century quality, which one critic
described as a "reticent idealism."

Childe Hassam (1859–1935) was more successful in adapt-
ing the atmospheric effects of impressionism to his own style.
He had been trained in Boston, where he became a fairly
popular magazine illustrator. In 1883 he went abroad to study
in Munich and Paris and returned five years later to continue
his careers as an illustrator and painter. Though his training
in France was academic, Hassam was enchanted by the

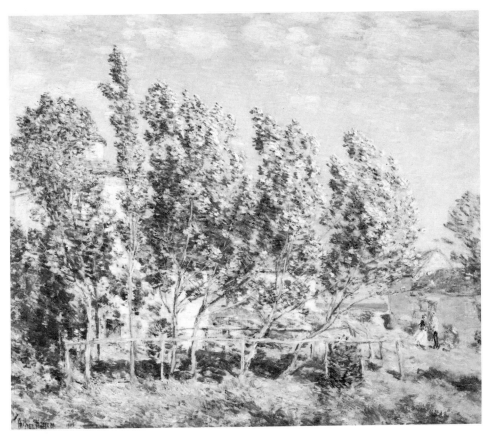

Childe Hassam: *The Southwest Wind* (1905).
Courtesy of the Worcester Art Museum.

impressionists' color and technique. Using both to suit his own ends, Hassam evolved a pleasing style that was a fairly close approximation of orthodox methods. He worked in little strokes of bright pigment, but his forms were much more solidly realistic than those of the French impressionists. Hassam's early canvases of New York, France, and London have a vitality and sparkle that make his later pink and lavender portraits of New England churches seem comparatively pallid.

John Twachtman (1853–1902) began to hate the "brown sauce" of his well-saturated Munich palette as soon as he came to Paris. Born in Cincinnati, Ohio, he painted window-shade decorations for a living and studied art with Duveneck at Cincinnati's School of Design. In 1875 Twachtman accompanied

Duveneck to Munich and in a short while joined Chase as a
student in Duveneck's European school. Twachtman spent
eight years, on and off, traveling in Italy, England, Holland,
and Munich. In 1883 he finally went to Paris and there
became a convert to impressionism.

Returning to New York in 1884, Twachtman shipped
ahead all of his European canvases, including those he had
painted in the new manner. They were all lost at sea. During
the next five years he supported himself by giving art lessons
and working on a new group of paintings. For the last thirteen
years of his life he was an instructor at the Art Students
League, where as one of the first teachers to promote impres-
sionism he built up a considerable following.

Influenced as much by Whistler's delicate tonalities as by
Monet, Twachtman gradually developed a style that was more

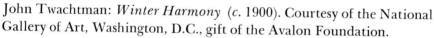

John Twachtman: *Winter Harmony* (*c*. 1900). Courtesy of the National
Gallery of Art, Washington, D.C., gift of the Avalon Foundation.

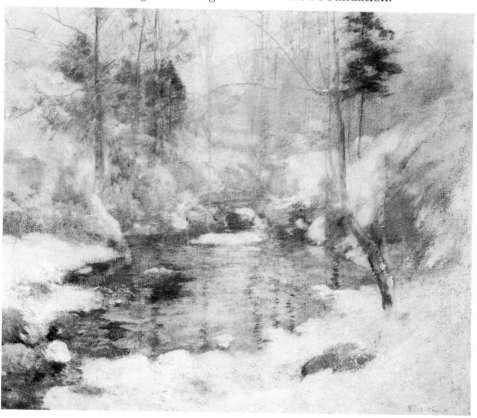

sensitive and less naturalistic than that of his American colleagues. In small rhythmical strokes of pastel color, he painted fragile and lyrical scenes of intimate landscapes—the flow of a little brook under winter snow, a quiet meadow in spring bloom, a peaceful farmhouse and field in the early morning sun—veiled in a haze of pale luminosity that all but obliterated form. Twachtman had a feel for paint and a fine sense of design. Notwithstanding their vagueness, his forms assert themselves with subtle clarity and strength. Of the four pioneer American impressionists, Twachtman created a personal and distinctive expression.

Impressionism was accepted a little more readily in the United States than it had been in France. Nevertheless, the heightened color and blurred forms offended the sensibilities of a public accustomed to darkly romanticized reflections of nature. What Americans wanted was an art that was familiar—an art in which all objects were clearly defined and recognizable and one that mirrored the most agreeable aspects of life. This they found in paeans to upper- and middle-class American womanhood, which became enormously popular during the late nineteenth and early twentieth century. In line with the moral idealism of the time, the American female was enshrined as a creature of the utmost purity and spiritual beauty. She became the subject matter for a number of painters who portrayed her saintly qualities on canvas after canvas.

George de Forest Brush portrayed chastely beautiful Madonnas and children with an Italianate perfection borrowed from the Renaissance masters. Nimble young maidens of incorruptible innocence sprinted through Abbott Thayer's canvases. Kenyon Cox's listless goddesses and Edwin Blashfield's unsullied virgins displayed their classic virtues on the walls of public buildings. Edmund C. Tarbell depicted more prosaic young matrons, embodiments of the good wife and wonderful mother. And Thomas Wilmer Dewing evoked a wan poetry in

his thinly brushed renderings of wraithlike gentlewomen, as in his painting *The Letter*.

Brush, Tarbell, Dewing, and the many others who painted like them were at one with their times. Even more than Duveneck and Chase (who were more gifted to start with and at least presented a surface truth), these painters used what skill they possessed to give the public nicely packaged platitudes. They skimmed the surface of American life, ignoring all that was vital, unpleasant, or simply not pretty or picturesque. And the National Academy, which had become the bastion of conservatism, stood solid and unmoving, its halls filled with the well-painted banalities that at this point dominated American art.

Thomas Wilmer Dewing: *The Letter.* Courtesy of the Metropolitan Museum of Art, Rogers Fund, 1910.

XIII America's Old Masters

By the end of the nineteenth century, American painting was mired in a bog of academic mediocrity. Most artists routinely followed the paths laid out for them. There were, however, three men who believed so strongly in their own visions that they could walk no road other than the one they themselves hewed. It was fortunate that they did so. They were to be America's old masters.

In the progress of American art, the battle against academic conformity was not won by organized rebellion, but by solitary individuals who pitted themselves against the entrenched authorities. Winslow Homer, Thomas Eakins, and Albert Pinkham Ryder were such men. Yet neither their honesty nor their extraordinary talents were greeted with tumultuous acclaim. For adhering to their ideals, they were forced to travel a lonely and sometimes impossible road. But they never compromised their principles. Out of their personal experiences they fashioned an art that was the most profoundly independent and original statement of nineteenth-century American painting. From man's relationship to nature Homer derived a boldly masculine poetry; Eakins painted the most searching and perceptive portrait of the urban middle-class American; and Ryder re-created the haunted, night-scented fantasies that originated in his mind.

Isolated from the mainstream of American art and untouched by foreign mannerisms, Homer, Eakins, and Ryder created no school or movement in their own time. It was not until the next century that the full weight of their influence became apparent. More than any other native painters, Homer and Eakins gave shape and meaning to American realism. They portrayed the world as it was, not as they wished it

235

to be or thought it should be. Though their work marked the end of the nineteenth century in American art, it provided nourishment for new generations of independent realists. Ryder spanned the centuries. In the monumental forms and stormy rhythms of his imagery, the later abstract expressionists found a source of contemporary inspiration.

YANKEE INDIVIDUALIST: WINSLOW HOMER

WINSLOW HOMER (1836–1910), a descendent of a long line of Boston merchants, was once called a "Yankee of Yankees." Sparse in speech, uncommunicative in matters purely personal, he had a New Englander's straightforward honesty, spirited independence, and fierce love of individual liberty. Early in life he determined "I have had no master and shall never have any." As the art historian Lloyd Goodrich said, "Homer looked more at nature than at other art and painted by eye rather than tradition." And in a style that perfectly expressed his subject matter, Homer created a vision of nature that was monumental, original, and vividly alive.

Homer had no formal training. He had a gift for drawing that he perfected during his years as an illustrator. He spent two years as an apprentice in a Boston lithography shop, leaving it as soon as he turned twenty-one to become a free-lance illustrator for *Ballou's Monthly* and *Harper's Weekly*, the two most popular magazines of the day. In 1859 he moved to New York and for the next seventeen years was one of the city's leading illustrators. During the Civil War he served as artist-correspondent for *Harper's*, recording graphic impressions of the conflict.

In 1866 Homer showed *Prisoners from the Front*, one of his early oils, at the National Academy where it won immediate attention. The contrast between the well-dressed dignity of the Union officer and the shabby abjection of the Confederate

captives succinctly summarized the injustices of war. The pic-
ture was the strongest statement on the war to have been made
by any artist, and it established Homer as painter of conse-
quence. Thereafter, though he was frequently rebuked for his
lack of refinement, he was never out of the public eye.

The following year he spent a few months in Paris. If he
saw anything save a few pictures in the Louvre, he had,
characteristically, nothing to say about them. After his return
he began producing the genre scenes of resort and country life
that are such engaging records of the American past. The can-
vases of bathers, children, schoolmarms, farm girls—beaches,
meadows, and "pie nurtured maidens," as Henry James called
them, held in an "envelope of air"—were painted with a
joyous tenderness that was totally unsentimental. His treat-
ment of outdoor light had a clarity not previously seen in
American painting. Such a canvas as *Long Branch, New
Jersey,* with the sunlight sparkling on strollers along the wind-
swept bluffs, is close to Monet's early impressionism in its

Winslow Homer: *Prisoners from the Front* (1866).
Courtesy of the Metropolitan Museum of Art, gift of Mrs. Frank B. Porter, 1922.

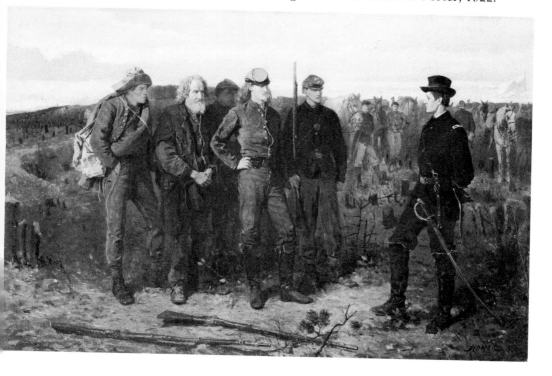

fresh color and economical technique. Yet it is unlikely that Homer ever saw any of Monet's work.

Homer was thirty-seven years old before he began painting in watercolor, a medium in which he was to become one of America's masters. He had a natural talent for watercolor and handled it with extraordinary fluency and authority. Up to this point watercolor had been used as an opaque medium which could be overpainted. Since watercolor is transparent, such treatment most often resulted in dull, muddy color. Homer rescued the art of watercolor painting from its lowly rank as "colored drawing," raising it to the highest levels of artistic expression. His color was clear, fresh, and of a sparkling transparency. He worked swiftly, putting down his observations of nature exactly as he saw it, with a sure hand and an unerring eye for what was right.

Homer's watercolors sold well from the first. His oils, however, were considered radical, unrefined, and lacking in finish. They sold well enough, but for moderate sums. He was in his mid-forties, a respected member of the National Academy, his fame growing, yet he had little in the way of financial success to show for it. A love affair is supposed to have ended unhappily because he was unable to support a wife. (His withdrawal from society is thought to have been a direct result of this experience.) For too many years "the press has called me 'a promising artist,' and I am tired of it," he complained. Homer was a hardheaded Yankee. He felt no need to starve for art.

In 1881 Homer took himself off to Tynemouth, a bleak little fishing village on the north coast of England. It was a move that was vital to his later development. Here he began his first studies of the sea and the men and women who wrested their living from it. He spent two seasons in Tynemouth, working mainly in watercolor. A year after his return he left New York and settled permanently at Prout's Neck, Maine. He lived by himself in a studio overlooking the Atlantic Ocean.

Here he painted the pictures of the forest and the sea that are without equal in American art.

The country urchins and genre maidens had vanished. His pictures were now concerned with a grander vision of untamed nature—the drama of man's struggle with his environment. His art grew in emotional depth. Humanity all but disappeared from his canvases. When it was present, it was subordinate to his central theme—the sea in all its moods. Periodically Homer made trips to Florida, the Bahamas, and the Adirondacks. His watercolors of clear mountain streams, deep green forests, brilliant tropical waters, and the sun-drenched, brown bodies of Negroes are graphic examples of his extraordinary control of the medium.

By the time he was sixty, Homer ranked among the foremost American painters. Yet even at this point he was attacked for what the public thought was ugly subject matter and slipshod technique. His canvases were sought by museums and collectors, but they fetched nowhere near the sums paid for a Church or a Bierstadt. The older Homer grew, the more antisocial he became. He rarely appeared in public. He allowed only a very few friends and no strangers into his home. But whatever aspect he presented to the outside world, he was known by his neighbors at Prout's Neck as an unfailingly kind and generous man. He was his own man, "perfectly happy and contented" in the life he had chosen.

In one of the rare instances when he talked about his work, Homer said, "When I have selected the thing carefully, I paint it exactly as it appears." He built himself a portable studio, so that he could work from nature no matter what the weather. And in one known instance he waited two years for the right atmospheric conditions to finish a painting. But Homer was not a copyist; he coupled nature with art. His eye was direct and honest, but unerringly selective. His paintings have no clutter of detail or belabored technique. Whether he worked

in oil or watercolor, he was interested only in the larger essentials.

His canvas *The Fox Hunt* shows only a flat expanse of barren winter landscape, a flock of crows descending into the picture to attack a fox. The composition is almost stark in its simplicity, yet expresses a profound understanding of nature's own brutal logic in the struggle for existence.

With the possible exception of Courbet, whose marines are preponderantly romantic, no other artist has painted as compelling and vividly naturalistic seascapes as Homer. Homer did not care for a quiet sea and rarely painted it that way. He painted the sea as he knew it and loved it best—as an elemental force, dangerous, powerful, and monumentally beautiful.

Eight Bells, painted in 1886, is one of Homer's best-known works. It shows two sailors dressed in oilskins as protection against the heavy seas as they read a sextant to determine their

Winslow Homer: *Maine Coast* (1895). Courtesy of the Metropolitan Museum of Art, gift of George A. Hearn in memory of Arthur Hoppock Hearn, 1911.

position. The picture has a sense of man's loneliness and smallness in relation to the forbidding immensity of the ocean. The canvas called *Weatherbeaten, or Stormbeaten,* which Homer painted in his fifty-eighth year, contains no human element. It is a picture of the eternally ebbing and flowing sea that sends wave after wave crashing against the rocks with relentless energy.

Homer was the last artist of major stature to paint an America unchanged by man. "He was," as Lloyd Goodrich said, "our greatest pictorial poet of the sea and the wilderness and the pioneer spirit that had explored and settled a continent."

THE TRESPASSER: THOMAS EAKINS

"IF AMERICA IS to produce great painters," Thomas Eakins (1844–1916) once told his pupils, "and if young art students wish to assume a place in the history of the art of their country, their first desire should be to remain in America, to peer deeper into the heart of American life." Eakins followed his own advice. He probed deeper and more extensively into the "heart of American life" than any other American painter. He became a great artist, one of the greatest of his century.

It was Eakins' triumph and his tragedy that he peered too deeply into the human soul. His implacable honesty violated the canons and alarmed the guardians of prim Victorian morality. In an era in which, as a contemporary critic declared, it was the "business of art to afford joyance," Eakins stated his truths too baldly. His relentless candor trespassed on people's complacency. Had he learned to compromise his principles, he might have spared himself much suffering and defeat. But integrity and truth were the cornerstones of his ethic and he could no more live a lie than paint one. So while lesser men were revered for their artful blandishments, Eakins

was reviled for his probity, denounced as a "butcher" and a "brutal artist," and his masterpiece *The Gross Clinic* was damned as "a degradation of Art." He was ostracized by his fellow painters and shunned by clients—an outcast, condemned to obscurity. When he died, few mourned his passing. Many people had never even heard of him.

The lifeblood of Eakins' art was drawn from middle-class city life. His subjects were people, ordinary men and women engaged in ordinary human activities: his father playing chess; his wife and their dog; an elderly man at the cello, a middle-aged woman at the piano, and a plain-faced lady singing a pathetic song; men of science and literature; a male friend lost in thoughtful speculation; men rowing, sailing, wrestling, and boxing. With but one exception, he never painted a landscape.

Whatever he painted was set down with the utmost regard for the truth. His portraits—and all his paintings are essentially portraits—are intensely searching studies of character. But Eakins had an abiding love for mankind, and his subjects are rendered all the more human for their frailties.

Eakins suffered from his rejection. He was a masterful figure painter and might have become one of the greatest had his efforts not been stifled by American prudery. Some of his later canvases have a certain harshness; his portraits reflect a sense of defeat that was undoubtedly the result of his bitter frustration. The wonder of it is that neither his morale nor his genius were completely destroyed. He worked in a void, painting only for himself and the very few friends loyal enough to stand by him. He did not lie back and lick his wounds in self-pity, but, proud and sternly independent, held to his principles to the very end. "Eakins," said his friend the American poet Walt Whitman, "is not a painter, he is a force."

Mathematician, linguist, anatomist, teacher, and painter, Eakins was an extraordinary man and one of the most knowledgeable artists of his time. He was born, lived, and died in Philadelphia. He enrolled at the Pennsylvania Academy

where little but drawing from plaster casts was taught. The rare times a live model did appear (masked if female), it was only for purposes of drawing. There were no classes in painting. To supplement his study of the figure, Eakins attended classes in anatomy at Jefferson Medical College, where he underwent the same rigorous training as the regular medical students.

After five years of intensive work, Eakins came to the reluctant conclusion that only in Europe could he receive a thorough grounding in his craft. In 1866 he arrived in Paris and began his studies at the Beaux-Arts under the foremost French academician, Jean Léon Gérôme. Eakins continued his anatomical research in the Paris hospitals and took a course in sculpture to round out his knowledge of art. In 1870 he returned to Philadelphia.

Eakins believed in academic tradition. The controversy fomented by Courbet and Manet left him indifferent. In Spain, which he visited in 1869, it was only in the sober naturalism of Velázquez and Ribera that he discovered a strength and purity of spirit that moved him. Titian he ignored, Goya he didn't care for, and Rubens he thought a "most vulgar noisy painter." Eakins was a realist, an ardent believer in nature's supremacy. "The big artist," he wrote, "does not . . . copy. . . . he keeps a sharp eye on Nature and steals her tools. He learns what she does with light, the big tool, and then color, then form, and appropriates them to his own use."

Eakins' interest in science was second only to his interest in art. He was a fine mathematician and urged his pupils to its study because it was "so much like painting." He was also an expert photographer and collaborated with Eadweard Muybridge, one of the pioneers in that field, on a series of investigations for the University of Pennsylvania on human and animal locomotion. Not content with Muybridge's methods, Eakins invented a camera that recorded the continuous movement of a single action—essentially the principle on which the

motion picture camera is based. The results of his experiments, which he believed were also relevant to art, were published in 1894 by a scientific society.

The substance of his painting, its solidity, its truth to nature, were of greater importance to Eakins than style or technique. He believed that a picture was constructed like a building. Starting with a thin coat broadly brushed in, he built up his forms in consecutive layers of overpainting and glazes. His colors were dark, somber, and resonant. His technique varied; he painted broadly and simply at times, and with almost photographic precision at others.

All his knowledge was applied to achieve the truth as he knew it to be. He made preliminary oil sketches (even for his watercolors!) before he embarked on the finished canvas. His rowing pictures were guided by his studies of light and perspective. He made small models of the boat and figures and set them in the sunlight so that he could "get the true tones." His signature was inscribed in perspective so that the illusion of depth remained unbroken. In *The Concert Singer*, his model, the singer Weda Cook, began each session with a song so that he could observe the action of the throat muscles. Each figure in his medical pictures, including those in the background, was done from life. When he painted *The Crucifixion*, he induced a friend to strap himself on a cross so that he could see the downward pull of the body and the tension of the muscles.

In the hands of a lesser artist all this dedication to fact would have resulted in mere photographic imitation. But Eakins never let his desire to capture a truthful image of his subject override his artistic instincts. Science and knowledge were handmaids to his art—the means to understanding the nature of a thing, not the ruling factors. Despite his avowed concern for objectivity, he regarded painting as a profound emotional exploration of the reality hidden under the surface. In *Max Schmitt in a Single Scull*, the most famous of his

Thomas Eakins:
The Concert Singer
(1892).
Courtesy of the
Philadelphia Museum
of Art.
Photograph by
A. J. Wyatt,
staff photographer.

rowing pictures, one can almost smell the fresh spring breeze that whisks feathery clouds across the clear blue sky; in *The Concert Singer* one can almost hear the voice of Weda Cook.

It was for the Philadelphia Centennial Exhibition of 1876, in celebration of one hundred years of American independence, that Eakins painted his first important and ambitious canvas. He had resumed his study of anatomy at Jefferson Medical College soon after his return from Europe, and during the course of his investigations he was struck by the heroic battle being waged by modern medicine. *The Gross Clinic* was Eakins' salute to science. The focal point of the painting is a magnificent and penetrating portrait of Dr. Samuel Gross, Philadelphia's leading surgeon. Scalpel in hand, fresh blood dripping from his fingers, he is shown lecturing to his students

during the performance of an operation. The picture is com-
plex in structure, containing many life-size figures and, despite
an uncomfortable imbalance in the overly dramatic pose of
the patient's mother (relatives were evidently permitted in
the audience), it is a most impressive and realistic portrayal of
medical procedure. Even now, almost a century later, it is still
remarkable for the piercing honesty of Eakins' vision.

For an age that indulged itself in sugar-coated generalities,
Eakins' candor was revolting. Prior to submitting *The Gross
Clinic* to the Centennial, he showed it at a private gallery,
where it was subjected to much abuse. Indignantly rejected by
the Centennial art jury, it was allowed to hang in the medical
section only after considerable wrangling. When three years
later the Society of American Artists and the Pennsylvania
Academy reluctantly allowed the canvas to be shown, the reac-
tion was even more hostile. The critics were almost unani-
mous in their condemnation. The canvas was denounced as a
brutal debasement of art, a "morbid exhibition" and Eakins
was criticized violently for having painted the doctor with
blood on his hands. The "scene is so real," one critic fumed,
"that [spectators] might as well go to a dissecting-room and
have done with it. . . ." Another stated that "if the innate
delicacy of our people continues to assert itself, there is no
fear that it can be injured by an occasional display of the hor-
rible in art, or that our painters will create many such works."
When, eventually, the picture was bought by Jefferson Medi-
cal College, the purchase price was two hundred dollars.

It was in keeping with Eakins' character that he should
want to be a teacher. He had an encompassing knowledge of
art, a profound desire to improve the standards of American
art schools, and a genuine affection for young people. In 1876,
the year the Pennsylvania Academy opened its new building,
he volunteered his services without pay as instructor in the
life class. Three years later he became a member of the staff
and in 1882 was appointed director of the school.

Eakins' teaching, like his life, was guided by his conscience. He set about reorganizing and revitalizing the curriculum, instituting a series of reforms that were completely radical for their times. The basis of American art education had always been the study of the antique. Eakins' approach was founded on a thorough study of the nude human body. "Anatomy is the grammar of art," was his firm conviction. Students were taught human and animal anatomy, attended lectures on the subject given by a surgeon, and were expected to work in the dissecting room. So that they could better understand the roundness, solidity, and weight of the human figure, a class in sculpture was started. A course in perspective, designed to help students learn how to handle distance, was added to the curriculum. And since nature was not black and white, students began painting with brush and pigment without long months of preparatory drawing.

Eakins was an outstanding teacher. "It was an excitement to hear his pupils talk of him. They believed in him as a great master, and there were stories of . . . his unwavering adherence to his ideals, his willingness to give, to help" said Robert Henri. Eakins considered the human figure to be nature's most beautiful creation and saw nothing wrong in allowing male and female students to work from the nude. "Respectability in art" appalled him. The school's board of directors, however, were scandalized by his "advanced" ideas. When, finally, he removed the loin cloth from a male model before a class of women, the directors demanded that he alter his views or resign. Eakins resigned. As a measure of their loyalty, most of his pupils went with him to form the Art Students League of Philadelphia. In the six years of the league's duration, Eakins taught all classes without remuneration. His father had left him a small income, and it was enough for Eakins to be of service to future artists.

In 1889 he received one of his rare commissions. The students at the University of Pennsylvania's medical school

wished to present Dr. D. Hayes Agnew with a portrait upon
his retirement. Instead of the customary full-length, Eakins
painted a composition similar to that of *The Gross Clinic*.
The Agnew Clinic showed the surgeon in the operating thea-
ter lecturing to his students. It was a brilliant and incisive
portrait. More factual and less dramatic than its predecessor,
it suffers somewhat from the obtrusive variety of postures of
the figures in the background.

The Agnew Clinic was *The Gross Clinic* all over again.
The truth was no more palatable now than it had been four-
teen years earlier. Dr. Agnew was not pleased at being por-
trayed with blood on his hands. Philadelphians repeated their
indignant cries of "butcher." The canvas was banned by the
directors of the Pennsylvania Academy and turned down by
the Society of American Artists for its "neglect of the beauties
and graces of painting." His rejection by the single art organi-
zation of which he was a member deeply offended Eakins. In a
letter severing his connection with the society, he accused
them of hanging much that was "frivolous and superficial," yet
dismissing the Agnew portrait, "a composition more impor-
tant than any I have ever seen upon your walls!"

For many years Eakins had worked almost completely out-
side of official art circles. Now, having severed his last ties, he
fell into increasing obscurity. In his long career he suffered
only defeat for adhering to his ideals. He had been pilloried
by the "respectable" art world, dismissed from the academy,
and labeled a "butcher." No man could fail to be shaken by
such an agonizing series of failures, and Eakins was no excep-
tion. Though he did not withdraw into himself, the broad
artistic vision of his youth had steadily narrowed. He no
longer painted many genre or figure pieces, but confined him-
self almost exclusively to portraiture.

Even in this field he had little worldly success. Commissions
were few and very far between, and the finished likeness was
often refused. Occasionally a portrait was accepted, but later

destroyed or hidden from sight because of its too-honest revelation of character. Eakins drew his models from his family, his friends, and those who had no fear of being exposed. He especially liked to paint elderly people for the marks of character the years had etched on their personalities.

Eakins' genius lay in his ability to penetrate the psychological depths of the human soul. Despising flattery as a lie, he painted the unadorned truth with unswerving honesty. No countenance was ever enhanced by his brush, and sometimes his brush could be brutally frank, especially with men. His portraits are unfailingly alive and full of feeling. Standing in front of any of his likenesses, one cannot help but know what kind of person each was and what he stood for. Sargent had turned the sanest of heads with dazzlingly elegant portraits; Eakins' likenesses were of men and women whose reality can never be doubted.

His painting of *Mrs. William D. Frishmuth* is a superb example of Eakins' unique ability to create a profound and compassionate portrait of human nature. With masterful power Eakins pictured her sitting in the gloom, surrounded by the musical instruments she collected. Mrs. Frishmuth is no fashionable middle-aged dowager, but a large, heavy woman of monumental dignity. The light, which is focused on her stubby, plump, powerful hands and her blunt and aging features, pinpoints the vibrant expression of her sharp intelligence and the forceful mettle of her character.

In the long, bitter years of his exile, Eakins was never tempted to compromise his principles. His output during this time was twice that of his earlier days. He had always been interested in sculpture and had done some reliefs for his own amusement and assisted a former student with the figures on a Philadelphia building. In the early 1890's, on a commission obtained through the efforts of the same student, Eakins modeled the horses for the equestrian statues of Lincoln and Grant on the Memorial Arch in Brooklyn. The figures on the Tren-

ton Battle Monument were his last in this medium. His sculptures have the same authoritative knowledge, skill, and power that was the signature of all his work.

In the late 1890's Eakins became interested in prizefighting—a subject then considered vulgar and not worthy of exploration by "respectable" painters. But Eakins found the almost nude human body in motion a thing of surpassing beauty. To gain his knowledge firsthand, he attended the fights several nights a week and became a most enthusiastic fight fan. His three canvases on the subject—*Salutat, Taking the Count*, and *Between Rounds*—are among his finest pictures. His fighters belong in the ring. They stand with the panther grace of their profession, waiting for the clang of the bell before moving in on their opponents.

Eakins was a master interpreter of the figure—at rest or in motion—and without counterpart in America. Even in repose his figures have a sense of impending movement, which makes their quiescence seem temporary. He could give free rein to his love for the male figure in pictures of sports. But he rarely found an opportunity to paint the female nude. In real life women wore clothes, and Eakins was an implacable realist. He would not create fantasy merely to indulge his love of the figure.

One of the few times he painted a nude female was in his canvas in homage to the pioneer American sculptor William Rush, painted in 1877. It shows a naked young woman, chaperoned by an elderly female, posing for the sculptor. Both Rush and the young woman had scandalized all proper Philadelphians, and the subject had strong overtones of Eakins' own unhappy experience. The figure stands in graceful repose. A warm light, reminiscent of the Venetian masters, issues from the studio's dim interior and bathes the model's flesh with a golden glow. It was one of Eakins' most beautiful and romantic expressions. Several years before he died, Eakins painted three new versions of the picture. But time and defeat

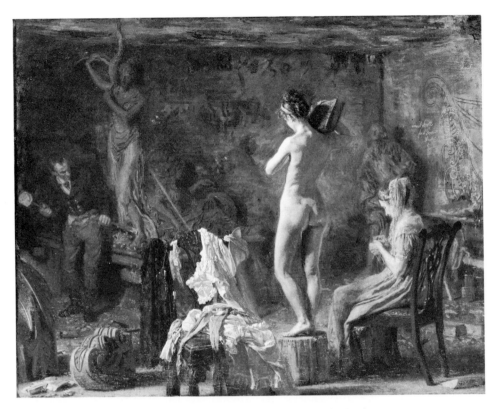

Thomas Eakins: *William Rush Carving His Allegorical Figure of the Schuylkill River* (1877). Courtesy of the Philadelphia Museum of Art. Photograph by A. J. Wyatt, staff photographer.

had taken their toll. None of the later paintings equals his earlier work.

Eakins received a modicum of recognition, but it was not until after his death that he began to emerge as the monumental painter he really was. "In Eakins," Robert Henri once said, "you will find . . . a man who was a man, strong, profound, and honest, and above all, one who had attained the reality of beauty in matter as it is"

MOONSTRUCK VISIONARY: ALBERT PINKHAM RYDER

THERE WERE THOSE FEW American painters who heard an inner music, which the poet Shelley described as "voices which

vibrate in the memory." They were romantics in a class with Washington Allston, artists whose work was imbued with the moody poetry of some half-real, half-remembered dream. Their romanticism was not the wildly spirited romanticism of the European school, but an introspective, intensely personal, imaginative statement.

The most eloquent and enduring of the romantic visionaries was Albert Pinkham Ryder (1847–1917). Like Homer and Eakins he was a man independent of his time. But Ryder was no rebel at odds with convention. His individuality flowered from a purity of vision and expanded in the snug security of his innocence. Worldly fame and fortune had no meaning for him. "The artist," he once said, "needs but a roof, a crust of bread and his easel, and all the rest God gives him in abundance." And Ryder believed what he said. His studio, squalid and disordered, was his palace; his art was his "abundance." Living and working in the midst of Manhattan's strident hubbub, he went his own way, deaf to all but the whisper of his mystical dreams.

Ryder was born in the picturesque old whaling town of New Bedford, Massachusetts. Here he first saw the romantic beauty of moonlit waters that would later figure so largely in his work. At the age of twenty-one he moved to New York. Too idiosyncratic to submit to traditional discipline, he became his own teacher. He went out into the fields to paint directly from the land. He struggled painfully, putting down each leaf, each blade of grass, trying vainly to create a vision of nature that would spring "into life upon my dead canvas." Then one memorable day he made the discovery that provided the foundation for his future greatness. Nature suddenly presented itself in "three solid masses of form and color—sky, foliage, and earth—the whole bathed in an atmosphere of golden luminosity." Exultantly, Ryder said, he "raced around the fields like a colt . . . and literally bellowed for joy."

Ryder's early canvases were mostly landscapes containing

figures or animals, several of which he first showed at the National Academy in 1873. With Chase he was one of the founding members of the Society of American Artists, and had it not been for this organization, a friend said, "such an unmistakably genuine painter" as Ryder might never have had his work hung. His notices, on the rare occasions when he was mentioned, were generally unsympathetic, his work criticized for its "slovenly execution" and "poor drawing." However, Ryder was immune to criticism, both good and bad. An artist "must live to paint, and not paint to live" was his credo. Fortunately, he was befriended by the picture dealer Daniel Cottier, who exhibited Ryder's canvases and persuaded several collectors to buy them.

Ryder made four trips to the Continent, but remained a most indifferent sightseer. His greatest pleasure during these voyages lay in "soaking in the moonlight" that played on the dark, deep waters. Other lands and other men's art left him cold. Literature, music, the murmur of the nocturnal sea provided the inspiration for the sea and landscapes of his mind. Nature was the foundation of his art, but nature bent and transformed to his will. He worked his pigment almost as if it were clay, putting layer upon layer on his canvas, blending color into color until it attained the translucent radiance of a jewel. He balanced light against dark in rhythmical patterns, combining the whole into a grand emotional design.

Ryder's seas were not Homer's seas. Homer painted the actuality, the living waters. Ryder painted dream-haunted visions of a sea that dwelt in his imagination. *Moonlight Marine* and *Toilers of the Sea* are two examples of his unique talent. Using a few simple shapes—clouds in a night sky, a boat sailing on glowing, moonlit waters—he created a world of lyrical enchantment. The seed of Ryder's inspiration sprang from a variety of sources. But whatever its source, the flowering of his ideas took place in his mind. Each picture had its own mood, created its own universe. "The moonlight in his

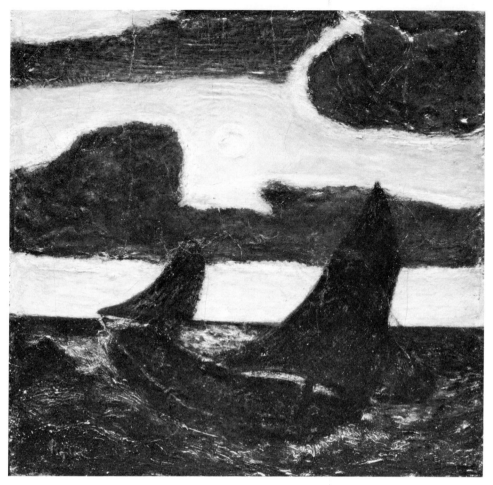

Albert Pinkham Ryder: *Moonlight Marine*. Courtesy of
the Metropolitan Museum of Art, Samuel D. Lee Fund, 1934.

Temple of the Mind," says the art historian Oliver Larkin,
"was not so much described as felt, something to be absorbed
by one's senses as though the painting had generated its own
light." And so it is with *Macbeth and the Witches*. The drama
here is not "described," but unfolds slowly into a vision of
dark and brooding mystery.

In contrast to the huge pictures that were so popular in
those days, Ryder's canvases were extremely small, sometimes
as tiny as a cigar box. His output was comparatively sparse.
During his lifetime he produced only about one hundred and

fifty paintings. He was a slow worker, inching his way, painting and repainting a canvas sometimes for years on end, until he captured the rich perfection of his mind's image. When he reached his early fifty's, the wellsprings of his creative genius ran dry, and he took to reworking his old pictures.

His ignorance of the oil medium was colossal. Because of his poverty, he used the cheapest colors available. With supreme disregard for consequences, he would varnish a freshly painted canvas so that he could work on it the following morning. His method of cleaning a dusty picture was to wash it with soap and water! As a result of his carelessness, many of his finest pictures have cracked, blistered, or blackened beyond recognition, and others have darkened so drastically that only a faint hint of their original gemlike radiance remains.

Ryder had been gaining in importance during the latter part of his life. Within a decade after his death he had become one of the great men of American art. The enormous demand for his paintings sent their prices soaring, and the market soon became flooded with spurious Ryders. At one time there were five times as many counterfeit Ryders in existence as genuine. Ironically, it was Ryder's own ignorance that provided the key to separating the true from the false. Forgers might imitate the external appearance of his pictures, but they could never duplicate his appalling technique—or the inspired workings of his mind.

Homer, Eakins, and Ryder are known as America's "old masters" because their work belongs to the nineteenth century. The three men were painters of extraordinary talent who brought American art to new and important levels of achievement.

The nineteenth century had seen an enormous broadening of artistic viewpoints and goals. But the nineteenth century was done. A new age and a new century was at hand.

XIV A Blow for Independence

THE TWENTIETH CENTURY began on a note of grand optimism. In the hundred and twenty-five years after the first guns of the Revolution had been fired, America had become one of the richest nations on earth, and the day was rapidly approaching when it would be the greatest of world powers.

Millions of immigrants, dewy-eyed with dreams of freedom and prosperity, spilled into newly risen cities which sprouted like mushrooms throughout the land. That the great bulk of the wealth lay in the hands of the few was of little consequence to the immigrant. The possibilities of striking it rich seemed within the reach of all men—upper-class or peasant, educated or illiterate. Some of the people did rise by dint of their own efforts from "rags to riches," but they were a minority. The average workingman lived in dank, dark, overcrowded tenements, toiling long and grueling hours for a wage barely above subsistence level. Dissatisfied with his lot, the industrial worker began to swell the ranks of organizations dedicated to the improvement of the human condition. The labor movement, born soon after the Civil War, now became a potent force in the fight for shorter hours, higher pay, and better living conditions.

The beginning of the twentieth century saw also an atmosphere charged with resurgent liberalism. Freudian psychoanalysts, delving into the subconscious, were discovering sex as the motivating force of human behavior. "Lucy Stoners" and girls in bloomers paraded the streets, demanding equal rights and the vote for women. The "muckrakers," a term taken from *Pilgrim's Progress* and applied to reform-minded writers, attacked political, industrial, and social corruption.

Radical political philosophies of European origin fright-

ened the rich and entranced the poor with visions of egalitarian utopias. But few Americans paid much heed in 1905 to an aborted revolt against the Tsar by Russian workers—a revolt that presaged the Bolshevik Revolution and the establishment of the world's first Communist government. That same year saw the publication by a twenty-six-year-old German-Jewish physicist named Albert Einstein of a paper on the theory of relativity which unlocked the secrets of atomic energy. In the United States the status quo was scarcely affected. The American dream remained intact, its symbol John D. Rockefeller, a self-made man, the richest man in the world, and every American's hero.

Art too was changing, especially in France. Revolutionary movements were succeeding each other, altering the look and the course of art almost from moment to moment. In the nineteenth century the rebels had begun to question the function of representational art. Now twentieth-century rebels were rejecting the entire concept of art as a mirror of the visible world.

The impressionists had pointed the way for modern art, but it was that extraordinary genius Paul Cézanne who actually fathered the modern movement. He laid the foundations for cubism and provided the key to later forms of abstraction. Cézanne disliked the vague shapes of the impressionists. He "wanted to make of impressionism something solid and durable like the art of the museums." He did not want "to reproduce nature"; he wanted rather "to recreate it." His aim was to analyze an object, to express its essential qualities without destroying its reality.

Cézanne believed that nature could be interpreted "in terms of the cylinder, the sphere, the cone . . . everything in perspective, so that each side of an object, of a plane, receded toward a central point." In his paintings mountains assumed the shape of cones; houses were rectangular cubes; tree trunks were constructed as cylinders; and the foliage was treated as a

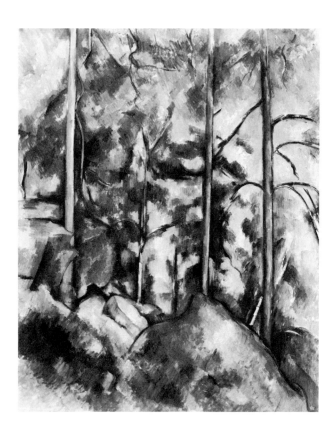

Paul Cézanne:
Pines and Rocks
(1895-1900).
Courtesy of the
Museum of Modern Art,
New York,
Lillie P. Bliss Collection.

mass of varying planes. Using subtle variations of color, he modeled his forms in a series of planes, each plane represented by a change of color. Warm colors (those containing a preponderance of red or yellow) were used to make a plane come forward in the picture; cold colors (those containing a preponderance of blue) were used to make a plane recede; and combinations of both kinds of colors were used to make a plane occupy an intermediate space. To emphasize perspective and lead the viewer's eye where the artist wanted it to be led, objects were deliberately distorted. In his pictures each form was interrelated with and exerted pressure on all the others.

Cézanne created a new geometric vision of nature. More important, he insisted on the artist's right to "recreate nature" by altering its visible appearance in whatever manner he saw fit. These principles were to provide the basic concepts for all modern art.

It remained for the cubists to pick up where Cézanne left off. Meanwhile in 1905 Henri Matisse, the most dominant figure of Fauvism, launched the first significant revolt against impressionism and cut still another tie with the past. "Les Fauves" (the wild beasts), derived their title from a critic who was horrified by their use of pure, brilliant color and extreme distortion. Instead of employing conventionally harmonious tones of light and shade in imitation of nature, the Fauves explored the properties inherent in pure color. Dispensing with traditional light and shade, they used violently clashing warm and cold colors to create depth and movement as well as to express emotion. Though the Fauves based their ideas on the abstract properties of color and willfully simplified and distorted objects, their pictures still contained recognizable subject matter. Four years after the Fauves' revolt, Pablo Picasso and Georges Braque invented cubism and opened the way toward total abstraction.

In opposition to the amorphous shapes and the preoccupa-

Pablo Picasso: *"Ma Jolie"*;
Woman with a Zither or Guitar
(1911–1912).
Courtesy of the
Museum of Modern Art,
New York,
Lillie P. Bliss Bequest.

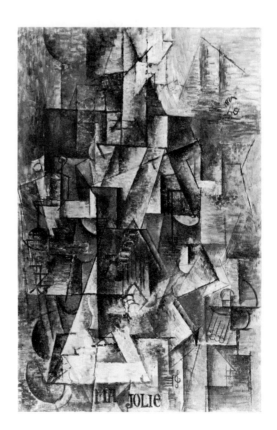

tion with surface appearance of the impressionists, the cubists created a more intellectual and abstract approach to painting based on Cézanne's theories of volume (solid objects) and space (the air surrounding the object). They deliberately gave up representing objects as they appeared to the naked eye, instead showing the whole of the object as the mind knew it to be. They painted the object in the position it occupied in space so that all sides could be seen simultaneously. For instance, the cubists would not paint a bottle in the traditional manner as a transparent object seen from a single frontal view. Since one cannot walk around an object that is painted on a flat canvas, the cubists took the bottle and broke it into fragments, reassembling it in overlapping geometric shapes that showed the bottle from several viewpoints at once. In this manner they created a new, abstract conception of the object, which was barely suggestive of its derivation in nature.

In contrast to the revolutionary developments taking place in France, painting in the United States was at a standstill. The National Academy was still the taste maker, and its galleries were lined with innocuous traditional pictures which offended no one's sensibilities. "Art in America of that era was merely an adjunct of plush and cut glass" said Everett Shinn, a member of the Ash Can group. "It lockstepped in monotonous parade in a deadly unbroken circle Art galleries of that time were more like funeral parlors wherein the cadavers were displayed in their sumptuous coffins."

Men of wealth plowed through European markets, shedding their dollars like a rain of autumn leaves, garnering antiquities (sometimes by the carload) to enhance their prestige and their Italian marble mansions. American culture had become synonymous with anti-American snobbery. "Elegantly Europeanized" women in "discreetly lighted and luxurious drawing-rooms associate art with Florentine frames, matinee hats, distant museums, and clever talk full of allusions to the dead," the British writer Arnold Bennett reported. Now and

then American collectors and an American museum would buy the work of a living American artist. But it was almost always a canvas by a successful academy member, not an independent outsider.

For American painters, as for the French, the way to success and recognition was through the auspices of the academy. The National Academy was the single most important art institution in the United States and admission to its membership and its exhibitions were highly prized. The academy's standards, like those of its French counterpart, were rigidly conservative; its requirements were technical dexterity as well as a willingness to paint traditional and agreeably attractive subject matter. Unvarnished naturalism, as portrayed by Homer and particularly by Eakins, was considered ugly, unrefined, and was rarely tolerated; modern art was unhealthy and smacked too much of European radicalism.

The half-hearted challenge once voiced by the Society of American Artists was resolved by 1906. But a deep-seated resentment against academic despotism still boiled beneath the surface. Within two years it erupted into a full-scale rebellion.

The battle against the academy was spearheaded by two men—Robert Henri and Alfred Stieglitz—working from opposite positions. Henri was a member of the academy, a realist painter in the Eakins' tradition. He instigated a successful revolt, on academy grounds, against official taste. Stieglitz was a prophet of revolution. He fought his war outside conservative strongholds, battling for the acceptance of the new forms, and presaged the modern movement in American art.

THE BLACK GANG: THE EIGHT

IN 1908 New York was witness to the first genuine rebellion against the National Academy in an exhibition of "Eight

American Painters." Though few people then realized it, the event was to lead to the decline of that institution.

"The rebels are in arms, their brushes bristling with fight, and the conservatives stand in a solid phalanx to resist the onslaught of radicalism," a New York newspaper reported. "The question as stated by the radicals is, Shall there be an American art—an art that dares paint . . . the streets and people . . . rather than the dikes and wooden-shoed peasants and Venetian sailboats of the older school?"

The critics, almost to a man, aligned themselves in defense of the "older school." They called the Eight, as the group was known, a "revolutionary black gang," and an "outlaw salon." They attacked the eight painters for their lack of "aesthetic merit," their "vulgarity," and their "preoccupation with the merely sordid and ugly." Had the critics foreseen the effect their printed insults would have, they would undoubtedly have been more circumspect. The exhibition, which might otherwise have languished, enjoyed a thumping success because of the lurid publicity. The Eight, who never again joined forces, had struck the first resounding blow in the American battle for artistic independence.

The Eight were united only in their opposition to the academy's power. They had otherwise nothing much in common. Henri and his disciples—George Luks, William Glackens, Everett Shinn, and John Sloan—became known as the Ash Can school for their depiction of lower- and middle-class city life. They were the dominant members of the Eight and the prime movers against the academy. Ernest Lawson was an impressionist landscape painter, Arthur B. Davies was a painter of romantic allegories, and Maurice Prendergast was a pioneer modernist. Though the critics hardly cared for the work of Lawson, Davies, or Prendergast, they were genuinely outraged by the "vulgarity" of the Ash Can "gang." To their way of thinking, Henri and his group were nothing but "apostles of ugliness."

The Ash Can painters were realists in the tradition of Eakins. Luks, Glackens, Shinn, and Sloan had earned their living as newspaper illustrators before turning to fine arts, and they brought to their work the immediacy of pictorial reporting. They painted broadly brushed representational scenes of New York's people: its teeming streets, its tenement slums, its rich, its poor, working girls on their days off, people in restaurants, children playing in the park. Henri, Luks, and Sloan found their material in the life of the lower classes, Shinn in the theater, and Glackens in the life of New York's more affluent citizens.

It is difficult today to understand why these pictures should have been found so offensive. But at that time the prevailing tastes, as regulated by the academy, were rigidly conservative and ran to shiny still lifes, innocuous portraits which made the sitter look better than he really was, and picturesque scenes of foreign landmarks (Dutch dikes, Venetian sailboats, etc.), all painted in the dark tonalities of the old masters. Pictures served as decorations for the well-appointed home and were meant to conjure up pleasant vistas and pleasing emotions. The seamy side of life, as portrayed by the Ash Can school, was not considered an appropriate subject for art. "Is it fine art to exhibit our sores?" The answer in academic circles was a loud and firm *"No!"*

Were the Ash Can painters radicals? Not really, at least not in the same sense as Cézanne, Matisse, or Picasso. Of the Eight, only Prendergast and Lawson, who showed modern tendencies in their work, and Davies, who was soon to be involved in the modern movement, could be so tagged, and then only provisionally. The Ash Can painters were homegrown realists. They found their inspiration not in Courbet's realism, but in Eakins' American vision. Theirs was not a revolt against tradition, but a battle over subject matter. They wanted the academy to adopt more lenient policies and to judge a work on its artistic merit, not on its content. They

won their battle and are important because they helped liberate American art from the musty gentility of the past.

The guiding spirit of the Ash Can school and the central figure of the rebellion against the academy was Robert Henri (1865–1929), born Robert Henry Cozad in Cincinnati, Ohio. Artist, teacher, crusader, Henri was a passionate believer, as Sloan declared, in "the importance of *Life* as the primary motive in art" and in the right of the artist to the free expression of his personal vision. "A man must be master of himself . . ." he said, "to achieve the full realization of himself as an artist." And in defiance of all academic standards, he urged his students to depict the truth no matter how ugly; to portray, not popular romantic subject matter, but the hard realities of life; and to be independent in thought as well as action.

Henri studied at the Pennsylvania Academy under Thomas Anshutz, a devoted disciple of Eakins. In 1888 Henri went to Paris to continue his schooling. What he saw there of the new movements left him indifferent or bewildered. Henri had no real affinity for modern art, then or later. His principal interest was in the vigorous realism of Hals and Manet. The justification of art was in the truthful portrait of humanity. "Stop studying water pitchers and bananas," he told his students, "and paint everyday life."

Henri was twenty-six when he came back to Philadelphia to begin his long career as a teacher. During the open-house sessions he started in 1893, he met John Sloan, William Glackens, George Luks, and Everett Shinn, all of whom knew each other through their jobs on the Philadelphia *Press,* and who later formed the nucleus of the Ash Can school. After 1901 Henri taught at William Chase's New York School of Art, and in 1908 he founded the Henri School of Art on Broadway, close to where Lincoln Center now stands.

Henri was a dynamic and inspiring teacher. *The Art Spirit,* a collection of his lectures, theories, and ideas is still one of

the most enlightened and knowledgeable books on the fundamentals of art. He imbued his students with his own passionate excitement and awakened them to the world of ideas, to life, and to their individual potentials. "No other American painter," said the writer Forbes Watson, "drew unto himself such a large, ardently personal group of followers" most of whom joined him in the battle against the National Academy. Though Henri was a member of that institution, he was unalterably opposed to its reactionary standards and fought for equal rights for all artists, progressive or conservative. In his dual role as leader of the Independents and teacher, Henri became one of the most influential figures in the art circles of the day. It was largely due to his efforts that the academy's hold was finally broken and American artists began to enjoy the freedom of expression that today is so much taken for granted.

There is, however, great divergence between Henri's artistic philosophy and his art. He brought a spontaneity and vigor to his landscapes, portraits, and street scenes, but they are wanting in emotional depth and insight. Too often, as in the Halsian *Laughing Girl*, he was no more than a bold manipulator of paint. Only in his teaching did Henri emerge as the "searching, daring . . . creature" he believed an artist must be.

George Luks (1867–1933), nicknamed "Lusty Luks," was drawn to Ash Can realism like a moth to flame. He had an omnivorous appetite for living, a hearty contempt for virtuousness, and a strong dislike of aesthetic pretension. "Art, my slats!" he boasted, "I can paint with a shoestring dipped in lard!"

Before coming to Henri, he had studied at the Pennsylvania Academy and in Paris and Düsseldorf. In those days newspapers had not yet begun to use photographs, and artists were employed to illustrate news stories. As well as being an artist-correspondent for the Philadelphia *Press,* Luks created a comic strip for the New York *World.*

In 1896 Luks moved to New York and in the city's slums found the subject matter for his art. His identification with the lower classes was not a matter of social conviction but an overweening desire to flout convention. In the poverty of these depressed areas, he saw neither degradation nor misery, just an innocent, happy acceptance of life's condition.

For all his bragging, Luks canvases have little more than their vigor to recommend them. He was an indifferent workman, depending too much on the ardor of his spirit and his slapdash technique. Only in rare instances, as in his portrait of the actor Otis Skinner, did Luks go beyond the picturesque externals to reveal some insight into character.

The lower classes provided William Glackens (1870–1938) with material for his newspaper illustrations, but he was himself a detached and amused observer of the poor. More to his taste was the pleasanter image of middle-class life that centered about Central Park. Glackens attended the Pennsylvania Academy and in 1895 spent the obligatory year in Paris. After his return he settled in New York, where for several years he continued to work as a newspaper and magazine illustrator.

Glackens' early canvases are lively comments on the city scene. *Chez Mouquin,* which was the name of a restaurant popular with Glackens and other painters, shows the restaurant owner and a female companion seated at a table. It is a handsome, impressive picture, painted with the rapid brushwork and bright colors reminiscent of Manet's style. Yet when the canvas was shown at the Independents' exhibit, it was criticized for its "ugliness." It was bad enough that the painting lacked the proper careful finish, but it also portrayed people in a restaurant. And according to academic tenets, this was too coarse a subject for art.

About 1910 Glackens began to imitate the work of Auguste Renoir, the famous French figure painter and member of the impressionist group. In Glackens' hands Renoir's sunny pal-

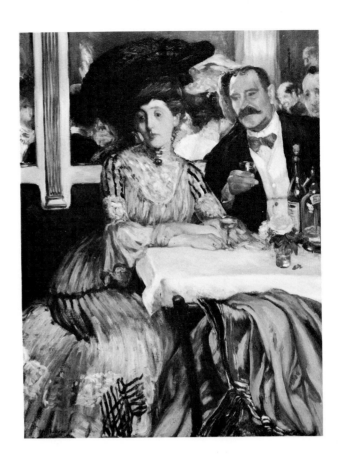

William Glackens:
Chez Mouquin
(1905).
Courtesy of the
Art Institute of Chicago.

ette turned garish, and Renoir's sensuality was transformed
into a wan and listless frailty.

Everett Shinn (1876–1953), educated at the Pennsylvania
Academy and in Europe, began his career as an Ash Can realist.
His association with the group was short lived. A bon vivant,
Shinn sought his company and his subject matter in the
glittering circles of the theater and society. A jack of many
trades, he was not quite master of any. He was an inconse-
quential playwright; a mediocre portraitist of celebrated
figures; a creator of gaudy murals for plush theatres, hotels,
and millionaires' mansions; and, finally, art director for sev-
eral motion picture companies. His theatrical canvases have a
vivacity that skims across the surface illusions of that world.
During his stay abroad Shinn fell under the spell of Degas.
Shinn should never have tried to imitate Degas. His talent was
too slender.

The last of the group to be recognized, John Sloan (1871–
1951) was the most significant of the Ash Can realists.
Sloan created an enduring image of the urban American life
of his day. A critic once called him "the American Hogarth"
for his ability to portray the incidental humor and pulsing
vitality of the lower classes. But Sloan was less of a humorist
than a humanist with a great affection for people. The only
member of the Eight who did not seek his training abroad, a
teacher as well as painter, he was the closest to Henri in spirit.
"An artist is a spectator who not only sees, but interprets," he
once said. And Sloan was both sharp-eyed observer and com-
passionate interpreter of the "maze of living incident" he
found in the city's streets.

Had it not been for Henri, Sloan might have remained an
illustrator all his days. His closest friend and "father in art,"
Henri introduced Sloan to the work of Daumier and Goya
and encouraged his "creative spirit." Sloan began painting in
1897 at the time he shared a studio with Henri, and in 1905 he
moved to New York. Sloan was forty-two years old when he
sold his first canvas. Until 1916, when he began to teach at the
Art Students League, he supported himself as a commercial
artist.

"We came to realism," Sloan said of the Ash Can group, "as
a revolt against sentimentality and artificial subject matter
and the cult of 'art for art's sake'." Sloan's realism, though
more sentient than his colleagues', is nonetheless colored by
the buoyant optimism so characteristic of the times. He saw
neither cynicism nor despair in the "drab, shabby, happy, sad"
mass of the city's lower classes, but rather a vital manifestation
of the human comedy. He found bright-eyed beauty in work-
ing girls drying their hair on a sunlit roof, in cheery house-
wives hanging their wash on a web of clothesline in the rear of
dank tenement buildings, and robust animation in crowds
elbowing their way through a narrow maze of pushcarts and
people. *Sixth Avenue Elevated at Third Street* captures the

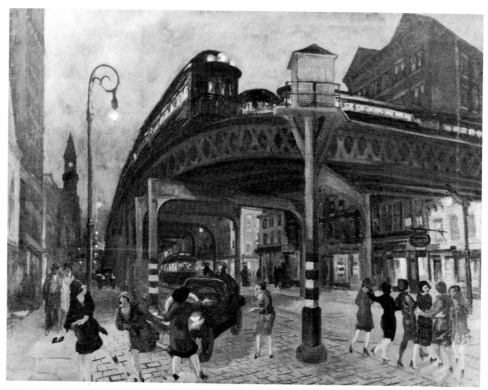

John Sloan: *Sixth Avenue Elevated at Third Street* (1928).
Courtesy of the Whitney Museum of American Art, New York.

animation of twilight in the city. Their days work finished, people walk home cheerfully anticipating the pleasures of the evening. And the brightly lit trains rattling round the corner add an additional note of gaiety to the scene.

The Wake of the Ferry, one of his finest pictures, with its lone passenger watching the tugboats churning through the slate-gray, wintry waters of the city's harbor, is filled with a powerful, brooding romanticism. But this canvas was an exception. Sloan was a painter of life, rarely of mood.

Because he was deeply moved by the plight of the underprivileged, Sloan became politically active. He joined the Socialist party, was a frequent contributor to its newspaper *The Call*, then became a staff member of *The Masses*, a left-wing literary journal. He twice ran unsuccessfully for state assemblyman. He resigned from *The Masses* in 1914 because of a

growing disagreement with its militant policies and that same year left the Socialist party. But he never resigned his interest in humanity.

Like many of his contemporaries, Sloan was profoundly affected by the "ultra-modern" work displayed in the Armory Show—an important exhibition of current movements in American and European painting held in 1913 which changed the direction of American art. Sloan discovered in modernism "a medicine for the disease of imitating appearances" and "a return to the root principles of Art." He did not abandon realism. But increasingly, he began using a brighter palette and a more finished technique. He became less interested in the *what* of his painting and more interested in the *how*.

The effect of the Armory Show on Sloan was to make him turn to the old masters to learn the "root principles of Art." Teaching had also renewed his interest in the figure, and he attempted to create a modern version of classical figure painting. The results of these experiments became suddenly apparent when Sloan was nearing sixty. His style was utterly transformed, and his subject matter became almost exclusively the nude. His forms were rounded and clearly defined along the lines of classical tradition. Then, in deference to the new styles, they were overlaid with a web of brightly colored thin lines to emphasize their solidity. Like other American painters of the time, Sloan was smitten by the surface aspects of European modernism and didn't really understand its basic principles. His attempts to fuse the old with the new never quite jelled, and these latter canvases are stiff and self-conscious. They lack the insight and individuality that made his earlier observations of city life so convincingly alive.

In 1933 Sloan sent a letter to the most important American museums offering them any or all of his canvases at half price. He was then sixty-two years old and almost 90 percent of his work was still unsold. He made exactly one sale through this

most unusual procedure. Yet these same museums were avidly buying the paintings of George Bellows (1882–1925), who had died eight years before.

One of the last men to paint in the pure tradition of Ash Can realism, Bellows suffered none of the indignities heaped on the other members of the school. On the contrary, his rise was meteoric and his talents amply rewarded.

Honest, idealistic, a firm believer in the virtues of home and family, Bellows was a model red-blooded, clean-cut American youth. He was born in Ohio, where he attended the state university. He was an excellent athlete and for a time toyed with the idea of accepting an offer to play professional baseball. In 1904 he came to New York to study with Henri. Three years later, in the same exhibition of the National Academy that had rejected the works of Luks, Glackens, and Sloan, a picture by Bellows called *42 Kids* won overwhelming praise. He was then twenty-five years old. A series of paintings of prizefights which followed shot his reputation sky high. At the age of twenty-seven he became an associate of the National Academy; at twenty-eight he was invited to teach at the Art Students League. When he was thirty-one, he was elected a full member of the academy, one of the youngest men to be so honored.

Bellows became one of the most popular and esteemed painters of his time. His canvases won awards with almost monotonous regularity and were eagerly sought by museums and collectors. In 1916 he had taken up lithography, and he became almost as well-known in that field as in painting. He was one of the strongest of the Ash Can painters, and his influence continued to be felt in the painting of the 1930's.

Bellows' pictures, especially those dealing with the city and with sporting events, generate energy. He worked broadly, wielding a fluid brush with the robust gusto that was so much a part of his nature. His boys move with the rawboned vigor of youth; his dock workers are thick-ribbed and brawny. His

prizefight pictures convey the furious action of the ring, and his canvases of the banks along the Hudson River have a massive vitality. Bellows had a relish for painting and a bold technical facility for picturing the world about him. But for all their show of dashing brushwork, Bellows' pictures display little insight or sensitivity. Sloan portrayed living human beings; Bellows' characters seem like vigorous puppets. Sloan's city scenes are teeming with life; Bellows' cityscapes have a surface excitement.

Bellows, too, was thrown off course by the modern art he saw in the Armory Show and wound up a disciple of "dynamic symmetry"—a method of organizing a composition according to geometrical lines of force. This prefabricated formula was thoroughly incompatible with the natural spontaneity of his realism, and the net result was a confusion of styles and techniques that is rigidly mechanical. Perhaps, given time, he might have ripened into a more sensitive artist. But he died suddenly at the age of forty-two, midway in his career.

The fact that Bellows was a phenomenal success at the same time that Sloan was a near failure is not easily explained. Bellows was, like Sloan, an Ash Can realist, a friend of the Eight, and one of the Independents who helped organize the Armory Show. He was in no way the kind of conservative who fitted neatly into academic patterns. *Stag at Sharkey's*, one of his best and most famous pictures, was of a prizefight, for which subject Eakins had been violently attacked. Bellows' *42 Kids*, showing a crowd of playfully squirming, naked young boys swimming off a city pier, was as boldly realistic and "ugly" as anything Sloan had ever attempted. Yet the stigma of "radicalism" and "vulgarity," which still clung to the Ash Can members of the Eight, never attached itself to Bellows.

Perhaps because he wasn't a member of the Eight, and had not himself openly fought the academy, academicians and critics saw him in a different light. Perhaps it was his personal charm, his youthful vitality, and his dashing technical dexter-

ity that made Bellows the "fair-haired boy" of the Ash Can realists. Or perhaps it was a combination of all these things plus the fact that the Independents were, finally, victorious.

Lawson, Davies, and Prendergast were associated with Henri and the Eight solely in the fight for artistic freedom. Their aims, in all other respects, were totally divergent from those of the Ash Can school. Ernest Lawson (1873–1939) was a painter of introspective impressionist landscapes of suburban New York. From his studies with Twachtman and what he saw in Paris, Lawson developed his own version of impressionist technique. His canvases, painted in thick, glowing globs of color laid on with a palette knife, have greater range from light to dark and more solidity than was customary among American converts of the movement.

Slender nudes float in a pale, dreamlike procession through the moody allegorical landscapes of Arthur B. Davies (1862–1928). In spite of the somewhat "old-fashioned" romanticism of his style, he was thoroughly liberal in outlook. He had aligned himself with the Eight in their war on the academy

Ernest Lawson: *Winter* (1914). Courtesy of the Metropolitan Museum of Art, George A. Hearn Fund, 1915.

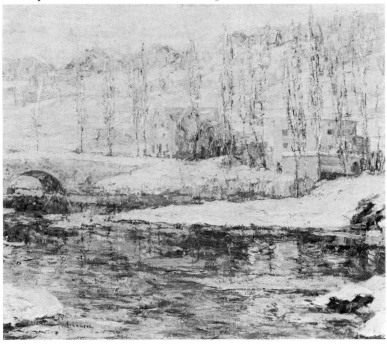

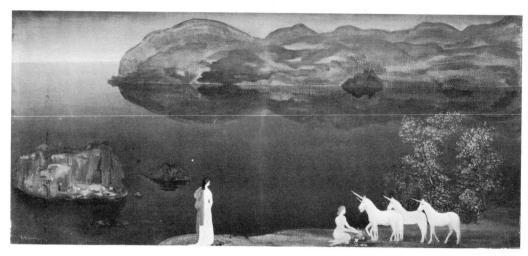

Arthur B. Davies: *Unicorns* (1906). Courtesy of the
Metropolitan Museum of Art, bequest of Lizzie P. Bliss, 1931.

and played a major role in the organization of the Armory
Show. Davies had spent some time in Europe and there gained
a firsthand knowledge of the latest European trends, to which
he was unusually sympathetic. It was only natural that he
should have been affected by the new art. Unfortunately, his
acquaintance with the modern movement gave him no special
insights into its radical theories. His experiments ended in an
odd combination of styles. Toward the latter part of his life he
started designing tapestries, a medium better suited to the
wistful poetry of his idylls.

More than a decade before the Armory Show touched off a
revolution in American art, Maurice Prendergast (1859–
1924) had begun to distill his own unique brand of mod-
ernism. The oldest member of the Eight, he was one of the
most advanced painters in American art in his time. Prender-
gast grew up in Boston, where he eked out a living lettering
showcards and helping his brother make picture frames. He
made several trips to Europe, the first during the 1880's, to
study in Paris, and in 1914 he settled in New York.

During his years abroad Prendergast became aware of the
new forms of art, and under the influence of Cézanne and
impressionism, he arrived at a totally independent and origi-

nal style. His subject matter was similar to that of the Ash Can school—crowds at the beach, strolling along city streets, walking and riding in the park. But Prendergast had no interest in people as people. He saw them as two-dimensional elements integrated with their environment into flat patterns of light, motion, and color. He built his compositions on a horizontal plane, much like friezes, using such natural objects as trees to create a cross-current of vertical movement. His pigment was laid down in small, thick dabs of color, as in a richly glowing mosaic. Prendergast was also a gifted watercolorist, and some of his most striking impressions were done in this medium.

Prendergast lived in obscurity most of his life and had shown little of his work. When some of his canvases appeared at the Armory Show, they were so violently attacked that they attracted considerable attention, and he began to gain a reputation that has grown steadily throughout the years.

Prendergast was a "loner." He had no following; he started no trends. But he now occupies a secure niche as one of the pioneers of the new art in America. He was the first, says

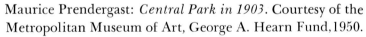

Maurice Prendergast: *Central Park in 1903*. Courtesy of the Metropolitan Museum of Art, George A. Hearn Fund,1950.

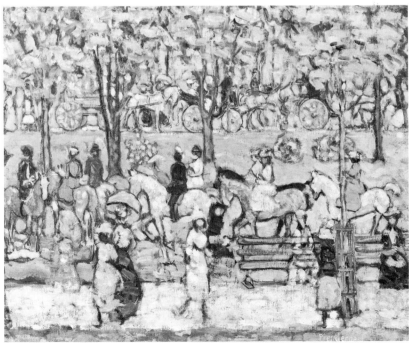

Lloyd Goodrich, "to see the picture as a physical object having its own harmony and order—a concept which has governed modern art for the past half-century."

Prendergast was not alone in his vision of a new art. There were other pioneer modernists at work. The spirited realism of the Ash Can school hardly had time to assert itself, when it was swept aside by a wave of radical art that made it as passé as last year's hat. Ash Can realism marked the end of an era in American life and American art—an era of middle-class virtues and provincial innocence that would be seen no more.

BRAVE NEW WORLD

IN 1905, three years before the exhibition of Eight American Painters and the same year Parisians hurled epithets at the Fauves, a small gallery housed in three rooms of a brownstone at 291 Fifth Avenue, New York, opened its doors to the public. The Little Gallery of the Photo-Secession (later rechristened "291" for its address) started out as a showcase for camera art and soon became the center for avante-garde painting. The formation of the gallery was the single most important step in the course of art that had as yet been taken in the United States. The "largest small room of its kind in the world" as one of its members, Marsden Hartley, described it, " '291' left a lasting impression in the development of American art"

The man behind it all was the photographer Alfred Stieglitz. He was the single individual most responsible for the introduction and growth of modern art in the United States. His personal devotion and financial assistance sustained the first American modernists at a time when no other self-respecting gallery would give them an inch of space. He was the buffer who stood between his artists and the outside world, encouraging and educating them to the full realization of

their talents. And his magazine, *Camera Work*, founded in 1903, was the first publication dedicated to the advancement of the new art.

Henri had demanded greater freedom of choice for the artist, but his ideas about subject matter and style were still within conventional bounds. Stieglitz, on the other hand, was dedicated to the introduction and acceptance of the kind of modern art that was revolutionizing European painting. Henri took exception to the "look" of American art; Stieglitz challenged the concepts on which it was based. Stieglitz not only demanded the artist's right to express himself in completely new ways, but insisted on it.

Stieglitz's gallery, as a friend put it, was "a laboratory where experiments [were] conducted in order to find out something." Until 1917, when "291" was closed by the war, it was host to the most progressive art on both sides of the Atlantic, most of which had never before been seen in the United States. It included the works of Cézanne, Matisse, Picasso, Braque, and other European radicals, and the Americans—Maurer, Dove, Weber, Hartley, Marin, O'Keeffe, and Walkowitz, among others. In 1925 Stieglitz opened the Intimate Gallery and four years later moved to larger quarters which he called An American Place.

But contemporary Americans had little liking for the incomprehensible, unpretty forms of the new European art or the "experimental" American paintings. The average man and the majority of the critics were decidedly hostile toward modernism of any kind. Stieglitz's advocates, though loyal, were small in number. But these few were enlightened men who saw in these strange visions a brave new world of art.

Of the many painters who exhibited with Stieglitz, the most significant were Alfred Maurer, Arthur Dove, Max Weber, Marsden Hartley, and John Marin. Though all were influenced by European movements, some more than others, each man evolved a distinctly personal style. Except for

Marin, whose original and boldly simple watercolors had some effect on the younger generation, none of these pioneers had any particular following, nor did they start a school. They are important to the development of art in the United States because they laid the foundations of American modernism.

The battle between the supporters of the old versus the new art, which engaged the passions of so many American artists of that time, became a bitter personal problem for Alfred Maurer (1868–1932). A student of William Chase, Maurer was one of the first Americans to adopt the mannerisms of modern art. Maurer's father was a successful commercial artist and academic genre painter who hated all manifestations of modern painting. The young Maurer believed that art must differ from nature or the artist would lose all justification for painting. Torn between divided loyalties—to his father and to himself—Maurer was trapped in a vain, lifelong struggle for acceptance, a struggle that ended in defeat and tragedy.

To escape his traditional background and his father's contemptuous eye, Maurer went to Paris in 1897 to study the modern movements. Beginning with impressionism, he worked his way through to Fauvism and cubism. In 1914, with the outbreak of war, Maurer reluctantly returned to his father's house in New York. Maurer began exhibiting at "291" in 1909, but his work was too distinctly foreign for prevailing academic tastes and was poorly received. When he was in his fifties, Maurer produced the series of canvases of cubist-styled female heads for which he is best known. Painted in thin, flat tones of muted color, these attenuated, large-eyed portraits seem to split into two separate haunting likenesses, as if Maurer's own inner conflict had surfaced on the canvas.

While Maurer remained unrecognized, the object of his father's scorn, the elder Maurer, aged ninety-nine, was given a one-man show. To celebrate the event, Maurer painted a head of George Washington with black streaks across the face like a canceled stamp. The following year the elder Maurer died.

Sixteen days after his father's death, exactly eighteen years after his return home, Maurer committed suicide.

Maurer was an underrated painter. His double images are haunting, but too intensely personal. The most interesting of his works are those which reflect his grasp of the new styles of painting. In his landscapes Maurer's color has the expressive and emotional qualities inherent in Fauvism. But it is in his cubist still-lifes that Maurer is most authoritative. These pictures, of fragmented and well-organized geometric forms, are handled with a power and assurance not too common in modern American art of that day.

Maurer's friend, the illustrator Arthur Dove (1880–1946), whom Maurer introduced to the new movements when they were both in Paris in 1907, was the first American painter to speak in abstract terms. With the staunch support of Stieglitz, whom he met soon after his return to the United States in 1909, Dove arrived at a personal idiom of abstraction, which he described as "extractions" of nature. His art was a romantic, rather than an intellectual, response of his "inner consciousness" to the "sensation" of reality.

Dove had a reverence as deep as any of the Hudson River painters for nature, which he saw in a symbolic sense. In simple, rhythmical patterns and richly subdued color he painted shapes that heave, swell, or undulate—visual conceptions of the ideas of light, sound, movement, and emotion. The mournful bleat of a foghorn swells in volume through concentric arcs of somber color; the thrust and pull of a team of horses are translated into a pattern of rounded and jagged shapes. A contemporary critic, commenting on an exhibition of Dove's canvases, made the following amusing as well as acute observation of the painter's works:

> ... Mr. Dove is far too keen
> To let a single bird be seen;
> To show the pigeons would not do
> And so he simply paints the coo.

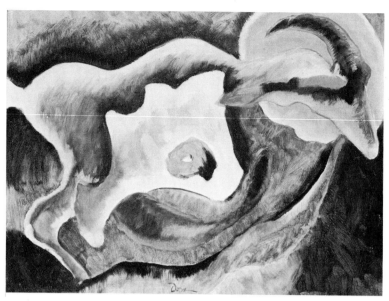

Arthur Dove: *Goat* (1935). Courtesy of the Metropolitan
Museum of Art, the Alfred Stieglitz Collection, 1949.

Dove also experimented with collage, a medium he
employed with wit and grace. Some of his collages are por-
traits, "extractions" of the essence of the person, constructed
into abstract arrangements from odds and ends of material.

Dove was a painter of limited range, and many of his
abstractions are simply stylized rhythmic designs. Dove's was
not a bold, inventive mind. But his symbolic, poetic interpre-
tations of nature were both interesting and, sometimes, far
advanced for their time.

Max Weber (1881–1961) was one of the few Americans who
really understood the principles of the new European move-
ments. Yet in his case it was more a hindrance than a help.
Weber was the son of a Russian-Jewish tailor who brought his
family to New York in 1891. Weber was seventeen when he
entered Pratt Institute to study art. One of his teachers there
was Arthur Wesley Dow, a champion of the new art, who
introduced Weber to the paintings of the French modernists.
Weber was so taken by their work that he went to Paris to
learn about modernism for himself. He could not have picked
a moment more appropriate to his purpose. He arrived in

1905 in time to see a large showing of Cézanne's paintings and the historic Fauve exhibition in the Autumn Salon. Three years later he was one of a handful of Americans to work in Matisse's private class, where he gained a deeper insight into the concepts of modernism.

Shortly after Weber returned to New York in 1909, he met Stieglitz. He became one of the regular exhibitors at "291," and because he had no money, he lived at the gallery for a brief period. Weber's sophisticated interpretations of the latest European movements were often attacked for their "grotesqueries" and their "brutal, vulgar and unnecessary display of art license." During the late 1930's he gained a considerable reputation, which began to fall off at the onset of the abstract-expressionist movement.

Weber was a gifted painter with an intelligent grasp of modern art. But his individuality was not strong enough to surmount his knowledge. Weber was not so much an imitator as a collector of other men's styles. Some of his work is heavily influenced by Matisse's vivid color and sensuous line, some by Cézanne's architectural construction. Other paintings bear the unmistakable imprint of Picasso's cubist angularities, and still others combine cubist concepts with futurism's fragmented color explosions.

Between 1915 and 1919 Weber's ideas seemed to take on a more definite personal form. He produced a number of energetic abstractions based on city life, in which he used a kind of kaleidoscopic pattern of intermingling, differently colored, and variously textured shapes. One of the best-known of these works is the cubist-futurist inspired the *Chinese Restaurant*. Though the picture is full of "glaring, stylistic inconsistencies," says the art historian Sam Hunter, "it is nevertheless a remarkable and convincing demonstration of a vital native application of Parisian esthetics."

During these same years Weber also produced a series of small sculptures that were among the first purely abstract

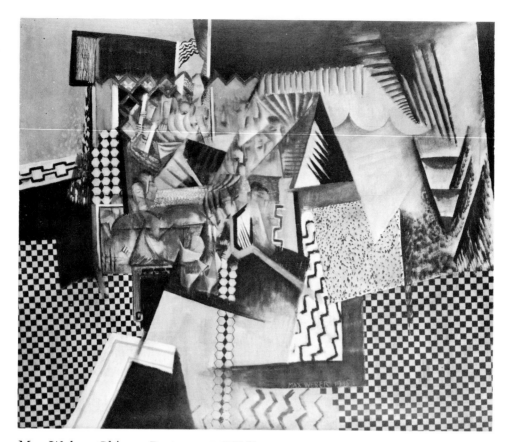

Max Weber: *Chinese Restaurant* (1915).
Courtesy of the Whitney Museum of American Art, New York.

works in that medium. Around 1920 he returned to a more naturalistic treatment of subject matter in his paintings, with occasional forays into modernism. In the 1940's Weber began painting religious fantasies of Talmudic scholars dancing or arguing. The figures are pulled and twisted into strange, elongated shapes, painted in thin, transparent washes of vibrant color, and encased in a network of thready black lines. In *Guitar Player,* one of his later canvases, Weber combined an expressionistic freedom in his handling of pigment with a linear definition of form. The picture, which is painted in muted tones of gray, has a plastic solidity. The two figures— one standing, the other seated—are rendered with a knowing, sensitive hand.

Marsden Hartley (1877–1943) began his restless pursuit of a personal expression in his native state of Maine. Then for almost twenty years this "gnarled New England spinster man," as a friend described him, roamed through Europe, Bermuda, Nova Scotia, and the United States, shuttling from one country to another and one style to another in persistent search of himself. At one point, early in the journey, he seemed to have found his destination in German expressionism. But it was only a temporary, if impressive, diversion. His search finally came to an end where it had begun. In the last years of his life Hartley found the full measure of his individuality and talents in the people, the sea, and the landscape of his native state.

Hartley studied at the Chase School and the Art Students League and, through Stieglitz, first became aware of modern European painting. In 1909 he had his first one-man show at "291." The paintings of that period were dark and brooding "black mountain" landscapes, which had some of the romantic qualities of Ryder's canvases. Three years later Hartley was in Paris, producing impressionist pictures that were "stitched" with bright colors. He also did several paintings in the cubist style. In 1914 Hartley arrived in Berlin. Here he came under the influence of the expressionism of the Blue Rider, a group of European painters led by Wassily Kandinsky.

It was Kandinsky who jumped the final hurdle into total abstraction. Kandinsky believed that a picture's expressive qualities came from color and line, not from its subject matter. Consequently, the artist was free to "improvise" forms without any reference to nature. To emphasize his total separation from subject matter, Kandinsky numbered or dated his nonobjective paintings, a practice Jackson Pollock would later follow.

In German expressionism, Hartley seemed to find for the first time a viable personal style. In *Portrait of a General*, done in 1914, he grouped German military insignia and geometric patterns into a vigorous abstract arrangement. The

canvas was not violently radical or even terribly original by European standards, but it was one of the most advanced works that had, as yet, been conceived by an American artist.

Hartley's preoccupation with abstraction lasted only a short while after his return to the United States in 1915. Until the late 1930's he tried to formulate a more personal idiom, one that was expressive in content and modern in concept. He experimented with a simplified form of geometric cubism, "trying to take up where Cézanne left off." But it wasn't until he returned to Maine that his powers coalesced to reveal the full force of his vision.

Hartley was never a facile craftsman. His paintings have an oppressively heavy and harsh quality about them. But it was a quality that was in perfect harmony with his images of Maine. These canvases have a raw strength, as if their stark forms had been hewn out of solid blocks of granite. Using vivid color and a style that was crudely primitive, he created a monumen-

Marsden Hartley: *Mt. Katahdin, Autumn, No. 1* (c. 1942).
Courtesy of the University of Nebraska Art Galleries, F. M. Hall Collection.

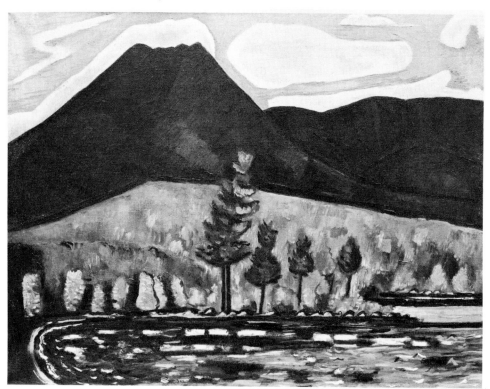

tal vision of the land and its people which is almost brutally direct and simple. Log jams, whipped by froth-edged waves, settle into "jack straw patterns," diagonals battling against horizontals; volcanic rocks rise like monstrous black whales to rest against the gaunt, pine-ribbed shore; a fisherman's family eat their last supper, saying grimly, as Hartley wrote, "nothing at all / violently." In *Mt. Katahdin, Autumn,* No. 1, small pines stand sturdily erect against the russet hills that rise above the clear blue waters of a lake. And clouds that seem carved of ice drape their chill forms over the blackness of a massive mountain.

John Marin (1870–1953) also painted the Maine coast, but his vision was as different from Hartley's as if they had worked on separate planets. Marin did not spend years searching for himself, but ambled casually through life, evolving in a comparatively short time, one of the most original and outstanding expressions in modern American art. In 1936 he was given a large retrospective show by New York's Museum of Modern Art, an institution devoted to the most revered international revolutionary masters. The show was, indeed, a rare tribute to a living American artist. Yet by all conventional standards, up to the age of forty Marin had been a dismal failure.

Born and raised in New Jersey, Marin had spent a year studying engineering, and from time to time worked as a draftsman. In 1893 he set himself up as an architect, producing more drawings of bunnies than blueprints. At twenty-nine he entered the Pennsylvania Academy, where he passed two years grumbling about regulations, Later he worked for a few months at the Art Students League. He was just about thirty-five when he went abroad. Though he stayed mostly in Paris, he was completely oblivious to the artistic revolutions that were erupting under his nose. When he returned home in 1910, his total production amounted to a handful of Whistlerian etchings and a number of delicately sensitive watercolors.

The photographer Edward Steichen, an associate of Stieg-

litz, had seen some of Marin's watercolors in Europe and was so impressed with them that he sent them along for exhibition at "291." Thus began the long and close friendship between Marin and Stieglitz, which proved a turning point in the artist's career. Stieglitz introduced Marin to the work of Cézanne and the French cubists and provided the spark that fused the loose ends of Marin's talents.

Marin's style is as strikingly original as it is visually exciting. He is the only American artist of any consequence to have worked almost entirely in watercolor. His pictures were suggestive rather than literal, set down in a kind of visual shorthand of symbols. Like Cézanne, he used the white of the paper as a color and focused his image toward the center, creating an effect of airy buoyancy. The restless energy, so much a part of all his painting, is conveyed by a series of diagonal and curved lines, which shift the movement from one plane to another. He patterned his line, not on the shapes he saw, but on the rhythms the shapes inspired. As a balance, "to keep the picture from sliding off the edge," he used a "frame"—several slanting lines around the edges of his image —a device that served to unite the "warring" elements.

Marin's early pictures were mainly of New York City, which he saw as a "battle of the buildings." Giant, tilting skyscrapers, plunging bridges, hurtling "el" trains—"warring, pushing, pulling forces" explode into fragmented bits of realistic and abstract forms. From 1914 onward, after he discovered Maine, Marin's style became increasingly abstract. In *Pertaining to Stonington, Maine,* he dispensed with perspective, allowing opposing colors in juxtaposition to create the illusion of depth. Movement is projected in the counterplay of tensions, of slashing curves pitted against vigorous diagonal lines. Yet, as abstract as he got, Marin never wholly retreated from nature. "The sea I paint may not be *THE* sea," he said, "but it is *A* sea, not an abstraction."

During the late 1930's Marin began experimenting with oils

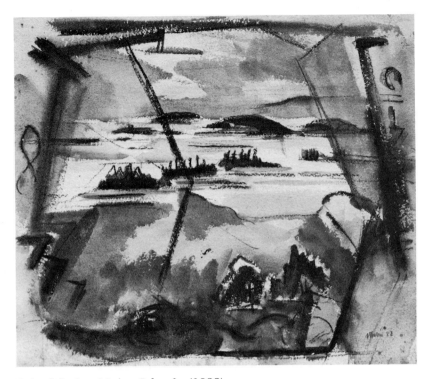

John Marin: *Maine Islands* (1922).
Courtesy of the Phillips Collection, Washington, D.C.

to "show paint as paint," as an entity in itself. He tried to duplicate the spontaneity of his watercolors in a medium unsuited to such spirited expression, and many of his canvases are heavy in feeling and murky in color. Occasionally, as in *Off Cape Split*, he achieved a vitality and power reminiscent of his watercolors.

In 1916, Stieglitz saw some drawings by an artist named Georgia O'Keeffe (1887–) and instantly recognized their unusual quality. A relative latecomer to the group around Stieglitz, Georgia O'Keeffe became, with Dove, Marin, Hartley, and Weber, one of the prominent pioneer American modernists.

Georgia O'Keeffe was born in Sun Prairie, Wisconsin, and trained at Chicago's Art Institute, at the Art Students League in New York and with Arthur Wesley Dow, then an instructor at Teachers College, Columbia University. From 1912 to 1918 she was a teacher and a supervisor of art in Texas. It was during this time that she began developing the style for which she

would later be known. "I decided . . . to at least paint as I wanted to and say what I wanted to when I painted" she wrote. By the time she married Stieglitz in 1924, she was well on her way to becoming one of the outstanding new painters. In the late 1920's she began to paint in New Mexico, finding in the striking Southwestern landscape new inspiration for her art.

Because of the clear-cut precision of her technique and her interest in architectural subject matter, O'Keeffe's work is sometimes grouped with the "immaculate" painters Charles Sheeler and Charles Demuth. Sheeler and Demuth created a pristine, cooly impersonal image. O'Keeffe evolved a glowing, carefully designed and executed imagery of crystal clear forms, through which runs an undercurrent of vibrant sensuality. Like Dove, whose work she greatly admired, O'Keeffe's art is rooted in nature. But hers is not a purely abstract concept of nature. With the exception of some paintings done in 1910, there is always a tangible evidence of nature's forms in her canvases. Her pictures of voluptuous magnified flower forms, buildings, and the dry Southwestern landscape have an austere, intensely individual poetry. The very whiteness of a sun-bleached cow's skull heightens the radiance of the flowers on it, and the sky seen through the openings of an animal's pelvic bones seems more vividly clear and blue. There is in O'Keeffe's canvases, as a critic said, an admirable wedding of the "chaste" and the "passionate."

The artists grouped around Stieglitz created, each in his own way, a distinctive artistic statement in twentieth-century terms. They were pioneers heralding the way for the new art. If modern American painting was still derivative of foreign concepts, it would not be so for long. The time was not far off when Americans would become leaders of an international revolution.

Meanwhile, Henri and Stieglitz had set the stage for revolt, and the curtain was rising on a drama that would shake the very foundations of American art.

XV Cataclysm in Manhattan

O_N the night of February 17, 1913, critics, reporters, dignitaries, and other invited guests began filing into the Sixty-ninth Regiment Armory at Lexington Avenue and Twenty-sixth Street for the gala preview of the International Exhibition of Modern Art. A band was playing lively tunes; art students were handing out buttons and catalogues imprinted with the pine-tree symbol of Revolutionary days and bearing the slogan "The New Spirit." The cavernous hall was attractively decorated and crammed with paintings and sculptures by American and European artists. The atmosphere was noisy, buzzing with an undercurrent of excitement and anticipation. Though few then knew it, Americans were witnessing the single most significant event in their country's artistic development. Before the Armory Show (as it became known) had closed, the National Academy's authority had been dealt a blow from which it never recovered. The public had gotten its first good look at modern art. "American art will never be the same," said a foresighted *Globe* reporter. He was right.

It all began innocently enough as a protest against the academy. The Independents had decided to stage a comprehensive showing of contemporary American painting on their own terms, and had decided to include a token display of European art. To this end, twenty-five painters of more or less liberal tendency (including Bellows and all of the Eight except Shinn) organized the Association of American Painters and Sculptors in 1911. From the very outset there were indications of the rupture that would afterward divide American artists. The association had barely begun to function when its president, J. Alden Weir, tendered his resignation because of

289

his loyalty to the National Academy. His replacement was Arthur B. Davies.

With the election of Davies, the entire complexion of the show changed. Believing there was only one way to break through the barriers of American provincialism, he proposed an all-inclusive exhibition of the most advanced European and American art. In cooperation with the American painters Walt Kuhn (the association's secretary) and Walter Pach, Davies assembled about thirteen hundred paintings and sculptures. Approximately a third of the work was foreign. The show represented a thorough and serious study of the development of modern art, from its beginnings in nineteenth-century romanticism to the latest and most revolutionary examples. The paintings ranged from the work of Ingres, Delacroix, Corot, and Courbet to the impressionists and postimpressionists and included the modern masters Cézanne, Van Gogh, Gauguin, Kandinsky, Matisse, Picasso, and Duchamp, among others. Except for a few examples previously shown by Stieglitz, none of these European paintings had ever before been seen in the United States.

The Armory Show exploded like a bombshell on an unsuspecting populace. To traditionalists, professionals and laymen alike, the new art seemed like a horrendous monster which threatened the very foundations of the American way of life and art. Frightened and angered by its "unnatural" appearance, they unloosed a stream of invective against the foreign ogre in newspapers and magazines, hoping thus to destroy it. They damned the paintings and sculptures as the work of degenerates, madmen, anarchists, bolshevists, and, for good measure, called them unprincipled dissolutes. Never before had Americans responded with such savagery to art.

Royal Cortissoz, dean of American art critics and an arch conservative, saw modernism as the tool of "terrorists" determined to "turn the world upside down." Kenyon Cox, an academic painter, believed cubism was a sickening manifestation

of social disorder. Newspaper reporters called the movement morally dangerous, labeling it "European intellectual degeneracy carried to its lowest depths." A *New York Times* editorial warned Americans that modernism was "part of the general movement, discernible all over the world, to disrupt and degrade, if not destroy, not only art, but literature and society, too." Theodore Roosevelt, recently defeated in his bid for a third term as President, called modern art the work of a "lunatic fringe," especially "the Cubists, and the Futurists, or the Near-Impressionists" (whatever he may have meant by the latter term).

Art schools and art societies staged burlesques of the exhibition. Poems and parodies lampooned modern art, and caricatures drawn in the style of, and mocking, cubism became almost as popular as comic strips. Newspapers gleefully printed the inevitable story of one highly esteemed painting that had been done by a donkey swishing its tail and another of a picture that had unwittingly been hung upside down. The room in which the cubists were hung was christened the "Chamber of Horrors." Cézanne, Van Gogh, and Gauguin were written off as inept amateurs, Picasso was labeled a clever impostor, and Matisse was denounced as a fraud and a scoundrel interested only in turning a dollar. Even Marin was hit by a stray shaft. His picture of the Woolworth Building was likened to "a clam with a bent neck."

Piqued by the reams of daily publicity, seventy-five thousand people eventually paid their way to see for themselves the degenerate art. "The crowds piled in and out day after day," a painter recalled, "some hilarious—some furious—none indifferent." The *succès de scandale* was the French artist Marcel Duchamp's *Nude Descending a Staircase*, a cubist picture depicting, through a series of interlocking and overlapping planes, the successive movements of a figure walking down a flight of stairs.

To the uninitiated the picture was the incarnation of mod-

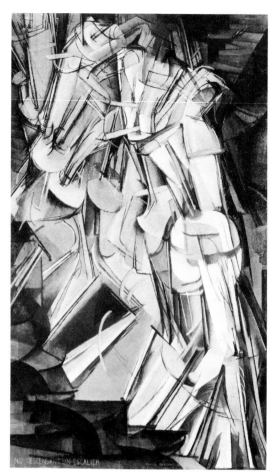

Marcel Duchamp:
Nude Descending a Staircase,
No. 2 (1912).
Courtesy of the
Philadelphia Museum of Art,
Louise and Walter Arensberg
Collection.

ernist lunacy. Newspapers ran cartoons imitating the picture, one of which was titled *The Rude Descending the Staircase (Rush Hour at the Subway)*. The painting was ridiculed as "an assortment of half-made leather saddles," a "pack of brown cards in a nightmare," and, more famously, as "an explosion in a shingle factory." Hordes of people, who came to jeer and jibe, pushed, shoved, and frequently became so violent that a guard rail had to be erected to protect the canvas. Before the exhibition closed, the *Nude* was bought sight unseen by a collector who, without knowing it then, had acquired one of the classics of modern art.

After its run in New York, the Armory Show went on to Chicago, where it incited more violence. Chicagoans de-

nounced it as a circus of European immorality, a "pollu-
tion" and "an insult to the great self-respecting public." A leg-
islative committee investigating vice demanded its suppression
on the grounds of obscenity. As a fitting climax, students at
the Art Institute burned Matisse in effigy and were com-
mended by the school authorities for their sensible attitude
toward modern art. Bostonians, who saw a curtailed version of
the exhibition, ignored the whole affair in well-bred silence.

The aftereffects of the Armory Show were astounding. A
good many of the entries had been sold, most of them, ironi-
cally, foreign works, especially those paintings and sculptures
that had been singled out for attack. Bought by wealthy Amer-
icans and connoisseurs of art, many of the works are among
the masterpieces of modern art, and now form the nucleus of
some of the finest collections in the nation's museums. Art
dealers, sensitive to the sudden shift in taste, went along with
the trend. And a raft of new galleries opened, which catered to
this specific demand.

Modernism split the American art world into two hostile
camps, creating a breach between conservatives and radicals,
which even time has not fully healed. The National Academy
became the last stronghold of reaction. Though it remained in
operation, it lost much of its former power. But its collapse
was not immediate. For many years the academy continued its
assault on modern art, but it was fighting a losing battle. Ulti-
mately, the forces of progress were victorious.

The Armory Show changed the course of American art.
Direct confrontation with the experimental forms had
shocked Americans, and particularly artists, into an awareness
that an aesthetic revolution had occurred of which they had
little or no knowledge. In juxtaposing American and Euro-
pean painting, the Armory Show had clearly and cruelly
revealed how retarded the native product was.

In Europe modern art had evolved slowly and logically,
progressing step by step toward nonrepresentational form. In

the United States the new art had arrived without warning, finished and fully grown. The jump from traditionalism to abstraction was too abrupt and too great for Americans to be able to hurdle in one big leap. But the Armory Show had injected a new vitality into American art and had pushed it into the mainstream of world art. For the next few years, until reaction set in, there was an exhilarating scent of freedom and daring in the air.

Galleries and museums, which a little while earlier would not have given American modernists an inch of space, were emboldened by this new spirit and started showing their canvases. Just a few months after the Armory Show, New Yorkers saw their first synchromist paintings. Synchromism, which the Americans Stanton Macdonald-Wright and Morgan Russell founded in Paris, was the first American contribution to abstract art. Synchromism was the American equivalent of orphism, a movement led by the French painter Robert Delaunay in opposition to cubism's static qualities and dull colors. A heated controversy, which was never resolved, arose between the American synchromists and the French orphists, each side taking credit for having originated the style. Whether the synchromists first conceived the idea or not, they went beyond the orphists in their use of pure color to create movement, space, and form. The synchromists enjoyed a brief period of importance in America, influencing a number of native artists.

Synchromism was based on the premise that pure color was the "generating function" of art, serving both as form and subject matter. The synchromists painted whirling discs and broken prisms of brilliant complementary colors that produced vigorous forward and backward movements across the picture surface. Russell created arrangements of broad, flat, adjacent areas of vivid color, either angular or circular in shape. Macdonald-Wright painted in planes and arcs of intense, transparent colors, which blazed into light and then

faded into the surrounding area. His compositions are more emotional and more rhythmically structured than Russell's.

At approximately the same time that the synchromists made their debut, Max Weber was given a one-man show by the Newark Museum. It was the first instance of an American museum opening its doors to a modern American painter. In 1914 the National Arts Club, no standard bearer of progress, included the work of some of America's avant-garde painters in their exhibition. That same year Gertrude Vanderbilt Whitney founded the Whitney Studio, which soon became the center for independent artists and out of which grew the Whitney Museum of American Art. And Congress, by lifting the import duty on foreign art, touched off an influx of the latest styles in European painting.

One of the most significant artistic events of the year 1916 was the Forum Exhibition of Modern American Painters. Organized by Willard H. Wright, author, art critic, and brother of Macdonald-Wright, in cooperation with Stieglitz and other forward-looking men, the Forum Exhibition focused attention on the American experimentalists instead of their European counterparts. The exhibition, devoted to the work of seventeen modernists, was, as a critic called it, "the first thorough cross-section of the newer American endeavor."

In 1917 the Independents, under the leadership of John Sloan, founded the Society of Independent Artists, renewing their pledge to keep "an open door in American art." The society's first and most notable show was a huge affair (twenty-five hundred works by thirteen hundred artists), nonjuried and representative of all styles from the most conservative to the most advanced. Whatever impact the show might have had was lost in the rush of history. On April sixth, three days before the exhibition was scheduled to open, the United States declared war on Germany. Americans hurried forward to "save the world for democracy," and for the duration art was forgotten.

XVI Future Shadows

The war ended in 1918. Europe was left staggering under a load of economic burdens, ravaged by poverty, hunger, and disease and racked by violent political dissension. By the time the Treaty of Versailles was signed in 1919, the seeds of future conflict had already been sown.

In contrast to the suffering and devastation in Europe, the United States emerged from the war as the richest, most powerful nation on earth. The decade from the boom days of 1919 to the "big bust" of 1929 was known as the "roaring twenties" or the "jazz age." It was a time of unabated prosperity and extreme change, characterized by excessive extravagance, organized corruption, a reevalution of moral codes, and the thumping syncopation of jazz. It was a time of materialistic "get rich quick" philosophy, of enormous technological strides forward, and of artistic compromise.

Disenchanted by the state of the world, American writers examined their own consciences and expressed their concerns in literary works that were deeply probing and boldly original. American painters, who had often before followed the lead of their literary brothers, seemed indifferent to all that was going on. American painting of the twenties reflected none of the moral disillusion of the period. "Nothing," said the author Alfred Kazin, "was so dead in 1920 as the crusading spirit of 1910." The advances that had been made before the war had come almost to a full stop. The modernist "kick" touched off by the Armory Show had subsided, and most painters had returned to conventional formulas. Those with a modicum of daring made a halfhearted accommodation with the modern viewpoint, updating traditional styles with a few cubist-type angles.

There were, however, several painters who persisted along modernist paths. Charles Sheeler, Charles Demuth, Joseph Stella, and Stuart Davis formulated a modernism that was wedded to the American scene. They sought a subject matter that would have the look and feel of the twentieth century. They found it in the steely sharp planes and angles of machinery, in the rib-roofed factories and soaring smokestacks of America's vast industrial landscape, and in the throbbing energy of twentieth-century America.

Industry had rarely been, in any country, a theme for art. In the nineteenth century, John F. Weir and Thomas Anshutz were two of the few Americans who had made use of such subject matter. In Weir's canvas *Forging the Shaft*, a scene in a gun foundry becomes a picturesque genre painting. Weir seemed more interested in depicting the radiant glow of hot steel than concerned with the actual functions of a munitions plant. And Anshutz's *Steel Workers, Noontime* could just as easily have represented, even with the backdrop of the mill, a group of men warming up for an athletic event.

Oddly enough, artists in France and Italy, where technology was hardly as advanced, were the first to recognize the contemporaneity of industrial and mechanical forms. The surrealists Marcel Duchamp and Francis Picabia, who had some influence on later American painters, devised a weird, inhuman machine-image, while the cubist Fernand Léger created robots with human characteristics. Futurism, a literary and artistic movement, which originated in Italy in 1909, also had some effect on American artists. The futurists rejected the past and glorified the present. They exalted speed and deified the machine, taking their inspiration from the furious motion of mechanized equipment—the automobile, the airplane, the railroad, or other such objects that threw "an iron network of speed" around the earth. They painted objects "according to the *lines of force* which characterize them," using raylike lines and multiple images to emphasize the dynamic force of speed.

In the United States the precisionists—also called cubist-realists and immaculates—Charles Sheeler and Charles Demuth created a sharp, clean geometrical imagery, which combined literal representation with cubism. Theirs was a landscape of iron and concrete—an image of America that was cold, brittle, and devoid of humanity. Joseph Stella applied futurist dynamics to visions of steel and electricity that were hymns to American progress.

But of the few painters of that time who continued to work in the modern idiom, Stuart Davis created the most original, the most abstract, and the most contemporary expression. And he found his inspiration not only in technology's mechanical forms but also in the pulsating rhythms of the whole of the American scene.

MACHINES WITHOUT MEN

"I FAVOR THE PICTURE which arrives at its destination without the evidence of a tiring journey," said Charles Sheeler (1883–1965) "rather than the one which shows the marks of battle." And Sheeler's cool, objective canvases are indeed innocent of all "marks of battle." They are clean, smooth, hard, and airless, like objects under a glass bell. No figure, no movement, disturbs the sterile silence, the austerity of his mechanical landscapes.

Sheeler spent nine years trying to divest himself of an academic background. Born in Philadelphia, he had been so well coached in the academic manner by William Chase that he could never make the final break. He arrived at a compromise after a third trip to Paris in 1909—a compromise well suited to his dry, factual interpretations of a mechanized America. Sheeler was also a professional photographer, a sideline he pursued for a living, and his canvases bear the static, impersonal imprint of this medium.

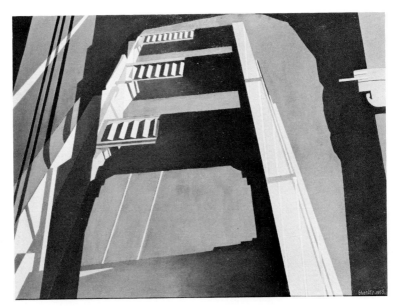

Charles Sheeler: *Golden Gate* (1955). Courtesy of the Metropolitan Museum of Art, George A. Hearn Fund, 1955.

"I sought," Sheeler explained, "to reduce natural forms to the borderline of abstraction, retaining only those forms which I believed to be indispensable to the design of the picture." He honed his subject matter into flat, sharp-edged, rectangular planes of light and shadow without losing any of its natural appearance. His Pennsylvania barns, city skyscrapers, factory smokestacks, and steel machines are dustless, germ-free descriptions of technological order, and as precisely designed and integrated as the cogs and wheels of a machine.

Charles Demuth (1883–1935) also found contemporary beauty in mechanical and architectural forms. He was aloof and fastidious by nature, and his paintings have a detached, glacial, and brittle elegance. Like Sheeler, Demuth received his training at the Pennsylvania Academy and spent several years in Paris. Though the last fifteen years of his life were plagued by illness, he produced many of his best works during that period.

Demuth found his modernism in the crisp, clean lines of machinery and buildings, and he too developed a style that

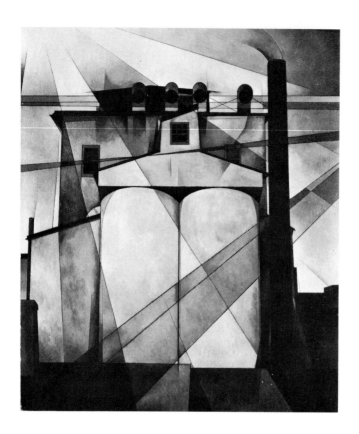

Charles Demuth:
My Egypt
(1927).
Courtesy of the
Whitney Museum
of American Art,
New York.

was in part traditional, in part avant-garde. In *My Egypt* he simplified his subject matter into geometric cubist angularities and further abstracted his images by the use of futurist ray lines. Though his work was more abstract than Sheeler's, it still retained its connection with visible reality.

Some of Demuth's paintings, particularly those in which he used ray lines, have a superficial stylistic resemblance to the work of Lyonel Feininger, an American painter of cubist and futurist tendencies, who was a member of the Blue Rider group. Feininger was also an instructor in Germany's famous art school the Bauhaus, which, after its founding at the end of World War I, exerted an enormous influence in the fields of American architecture and design. He left the United States in 1887 and returned half a century later in 1937, when the Nazis came to power, and is therefore more properly associated with the German modernists. Feininger used a prismatic division of color to convey the mystical poetry of light.

He broke his forms into sharp planes of transparent colors and extended the range of his forms by the use of ray lines. Demuth adopted or arrived at a simplified version of Feininger's technique, but did not share Feininger's interest in light. The use of geometric forms and ray lines were for Demuth a convenient means of dividing his composition into modern angularities.

Demuth's best-known oil, *I Saw the Figure 5 in Gold,* is a "literary" picture based on a poem by his friend the American author William Carlos Williams. An arrangement of numbers, letters, signs, and architectural structures, the whole is integrated into an arresting pattern of flat planes and lines. Like a picture within a picture, the numeral 5, set against planes of bright red, is repeated three times, growing larger and insistently bolder to approximate the "gong clangs" and "siren howls" of the firetruck in Williams' poem.

Demuth had an affinity for watercolor, which he handled with extraordinary delicacy. His book illustrations and his circus and theater drawings in this medium are among his most original and perceptive achievements. Only in these pictures does he use the human figure, which he employs less for narrative purposes than to stress the rhythmic, flowing lines of his compositions. His later watercolors of still life and buildings, greatly influenced by Cézanne, are painted in thin washes of transparent color and have the translucency and delicate fragility of exquisite china.

The response of Joseph Stella (1877–1946) to the machine age was directly opposite to the emotional objectivity of Sheeler and Demuth and closer in spirit to that of Marin. Stella was thrilled by the dynamism of twentieth-century America, finding it rich with "new motives to be translated into a new art." His subject was New York City, "a monstrous steely bar elevated by a modern Cyclops to defy the Gods"; his style was a personal and rather heavy-handed adaptation of futurism.

Stella was born in Italy and therefore felt himself related by

birth, if not by blood, to the futurists. He came to New York at the age of twenty-one and in 1897 entered the Art Students League. In 1898 he began several years of study under William Chase. Stella was twenty-eight when he started his career as a magazine illustrator, painting in his spare hours. He had already drawn the slag heaps of Pittsburgh with simple and impressive monumentality before he went to France and Italy in 1909 to be indoctrinated by cubism and futurism.

In the decade following his return in 1913, Stella began painting his futurist tributes to the metropolis—a series of five large canvases like stained-glass windows entitled *New York Interpreted*. Stella was not so much moved by the speed of the city as by the sum of its qualities—the steel webs of bridges,

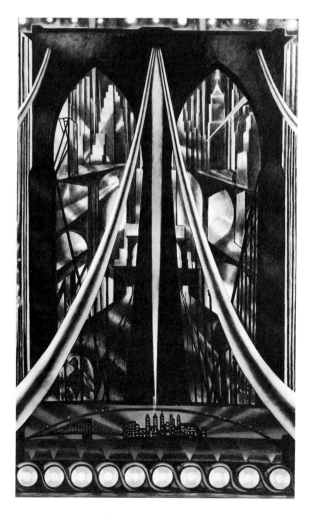

Joseph Stella:
*The Brooklyn Bridge:
Variation on an Old Theme*
(1939).
Courtesy of the
Whitney Museum of
American Art, New York.

the rumbling subways, the whirling electric blaze of amusement parks, the spastic dance of traffic lights and winking signs, the deafening vibrato of city sounds and sights. By the time he finished these celebrations of "electric and steel," Stella had little left to say. During the last thirty-five years of his life Stella traveled extensively in search of new themes. But the impetus of his former vision was gone. His later canvases of swanlike birds and attenuated ladies reclining in gaudily colored, exotic landscapes were painted in a hard, meticulous technique. More to his credit are the sensitively composed collages and drawings he produced during the same period.

BOOGIE-WOOGIE MODERN: STUART DAVIS

STUART DAVIS (1894–1964) would have been a modernist under almost any circumstances. It was in his blood. The Armory Show proved to him that he could follow no other path. At the time of this historic exhibition, to which he sent several watercolors, Davis was nineteen years old. The show, he stated later, was "the greatest single influence I have experienced in my work. All my immediately subsequent efforts went toward incorporating Armory Show ideas into my work." And for more than ten years he hammered away at his goal. He emerged with a style as fresh and contemporary as the jazz he loved and as native as the bits and pieces of Americana that enliven his art.

Davis got his first lessons in art from his father, art editor of the Philadelphia *Press* and friend and employer of the Ash Can realists. When he was sixteen, Davis began three years of study with Henri, and two years later, on Sloan's invitation, he joined the staff of *The Masses*, to which he contributed drawings until 1916.

Davis had begun the journey into modern art while the Armory Show was still fresh in his mind. He learned "to think

of color more or less objectively," so that he could paint "a green tree red without batting an eyelash." Having mastered that, he went on to see "color as an interval of space—not as red or blue." Color became the means of making his forms bounce, jump, advance, or recede. From there he moved on to cubism. He made use of such popular, everyday objects as a saltshaker, a bathroom fixture, and a cigarette package, as did the later pop artists. But Davis fragmented his forms, creating a series of semiabstract compositions of bold, spare, geometric design.

Davis now felt that his next step was to see and think modern at one and the same time. "The 'Abstract' kick was on," he said. In 1927 he set to work. He nailed an electric fan, a rubber glove, and an eggbeater to a table and for the next year used it as his exclusive subject matter. Viewing these objects as a series of integrated shapes rather than as specific objects, he invented geometric forms that took impulse from his ideas rather than from his subject matter. He simplified and reshaped his forms, ironing them into flat planes of color that shifted restlessly from one dimension to another. To record his progress, he identified these pictures by number. By the end of the year Davis felt he had attained his goal. He could now call himself a modern artist.

In 1928 Davis spent a year in Paris, where he painted a number of flat, decorative street scenes, then returned to New York two months before the stock market crashed. In the Great Depression years of 1933 to 1936 he worked (as did many outstanding American artists) on the Federal Arts Project, a nationwide program providing relief and work for writers, painters, and musicians. For this program he painted three murals. One of these, done for New York's municipal radio station at a cost to the city of $90, was reevaluated in 1965 as worth $100,000.

Like Sloan, Bellows, and other painters of the time, Davis was seriously concerned about the economic status of the artist

and his role in society. He believed that the artist, as a responsible citizen, must involve himself in political action, both in national and world affairs. Davis joined the Artists Union, contributed to its magazine, *Art Front,* and was founder and national chairman of the American Artists Congress, an organization formed by artists to oppose war and fascism. In 1940 he resigned his position because of the Congress' left-wing policies. And during all these years, when most artists had returned to traditional modes, he was a constant and vociferous champion of modern art.

As he grew older, Davis' art grew increasingly abstract. His pictures were no longer simplified geometric divisions of cubist derivation. Now areas of pure, vivid color and boldly aggressive, interlocked forms danced across the canvas with a restless, jazzy bounce. Abstract shapes, segments of signs, way-

Stuart Davis:
Owh! In San Pao
(1951).
Courtesy of the
Whitney Museum of
American Art,
New York. Photograph
by Geoffrey Clements.

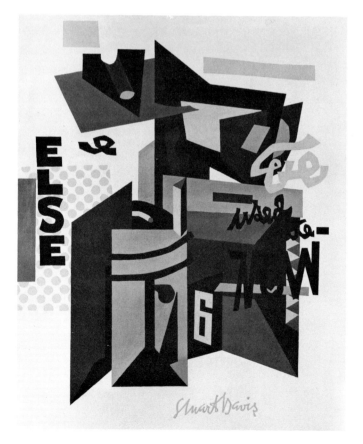

ward letters, gas pumps, houses—the components of an urbanized America, which everywhere "bombarded" the eyes—became the components of his art. Words, which were to him "as real as any shape of a face or a tree," were incorporated into the composition. Even the writhing trail of his signature was integrated into the design of the picture. His titles, many of which stemmed from the jazz idiom, were as lively and spirited as his paintings. With humorous playfulness he used such names as *Owh! In San Pao, Rapt at Rappaport's,* and *Hot Still-Scape for Six Colors.*

Davis' art had an amused detachment. Technique and emotion were subordinate to the more important elements in his paintings—color, movement, and design. The gaiety and wit that pervade his canvases arose from an intellectual reaction to his subject matter rather than from his feelings about it. Nevertheless, there was always in Davis' pictures a personal response to American life that was as native and fresh in its own way as that of the Ash Can painters. ". . . I have enjoyed the dynamics of the American scene for many years," Davis once declared, "and all my pictures . . . are referential to it. They all have their originating impulse in the impact of the contemporary American environment."

Davis was one of the most stimulating of the early pioneers of American abstract art. His never-ending search for artistic truths provided nourishment for two generations of American modern artists. "The act of painting is not a duplication of experience," Davis explained, "but the extension of experience on the plane of formal invention." For his contemporaries he supplied a clarification of the complexities of the new movements. He showed them that instead of merely imitating the styles and methods of modern French painting, these ideas could be applied inventively to native subject matter. And when in the 1930's reaction to modernism set in, he symbolized for that generation's avant-garde the necessity to continue searching for new meanings in art.

XVII The Age of Anxiety

On October 24, 1929, a day known to history as "Black Thursday," the stock market crashed, bringing down with it the whole of the American economy. "In Wall Street," a reporter said, "every wall is wet with tears." Bankers, brokers, and businessmen, big and little, were bankrupted. Factories shut down, throwing millions of men and women out of work. The rich were poor and the poor were paupers. The Great Depression, the most severe economic disaster in American history, affected countries throughout the world. It began in 1929, reached its lowest point in 1933, and lasted until 1939.

When Franklin D. Roosevelt became President in 1933, there were more than twelve million jobless Americans. To "provide enough for those who have too little," and to bolster the morale of the great mass of unemployed, he immediately created an "alphabet soup" of federal agencies to make use of people's particular abilities. One of these agencies, founded in 1933 as the Public Works of Art Project, hired painters and sculptors to provide works of art for public buildings. In 1935 the agency was reorganized as the Federal Arts Project within the Works Progress Administration, or WPA as it was commonly called. Under the direction of the noted collector Holger Cahill, artists on the project produced posters; researched and published *The Index of American Design*, a comprehensive study of native skills; painted pictures and murals and performed other tasks involving arts and crafts. For the many artists so employed, a number of whom later rose to prominence, the project provided both moral and financial encouragement during these difficult, lean years.

Perhaps in part because of the depression, the decade beginning with 1930 was marked by an almost complete rever-

sal in the styles of American art. During these years modern-
ism lost many of its former converts and American painters
turned back to realism in reaction to foreign *isms*. They re-
verted to conventional representation, portraying American
life in the Ash Can tradition, but with a more penetrating eye
and an honesty that exposes all its sores. They saw a world cold
and cheerless, of middle-class drabness, of poverty, and of neg-
lect. They painted the "hundred cities" and "thousand towns"
so movingly described in Pare Lorentz' documentary film *The
River*. Theirs was not a pretty picture of America, but it was
born of affection and hope.

A HUNDRED CITIES
AND A THOUSAND TOWNS

"IT IS IMPOSSIBLE for me to imagine anything better or more
beautiful than this world," Charles Burchfield (1893–1967)
once said. Yet there is no vestige of ordinary beauty in Burch-
field's art. His kind of beauty lay in imaginative Gothic fan-
tasy and in the real world of ugly fact. He was one of the first
of the new generation of realists to paint a truthful portrait of
the decay and dry rot of rural America—the kind Sherwood
Anderson was then writing about.

Burchfield was born in Ohio, attended the Cleveland
School of Art, and in 1916, armed with a National Academy
scholarship, left for New York. The huge city frightened him,
the academy depressed him, so he returned home. He took a
job and painted Sundays and evenings. Between then and 1918,
when he joined the army, he turned out a series of eerie
imaginative landscapes.

Delving into childhood memories, he "tried to recreate such
moods as fear of the dark, the feelings of flowers before a
storm, and even visualize the songs of insects and other
sounds." Desolate houses become menacing, their windows

Charles E. Burchfield: *November Evening* (1934). Courtesy of the
Metropolitan Museum of Art, George A. Hearn Fund, 1934.

like ghostly eyes in the night. Gaunt, withered trees lift claw-
like branches to the sky. Yet Burchfield's imagery is not com-
pletely convincing. Where Dove could visualize the melan-
choly loneliness in the sound of a foghorn, Burchfield's
fantasies are arch and forced.

In 1921 Burchfield became a permanent resident of Buffalo,
New York, working as a designer of wallpaper until 1929,
when he was finally able to support himself as a full-time paint-
er. Between 1920 and 1940 he produced the watercolors of
dreary, dilapidated towns that the critic Henry McBride
called "Songs of Hate." Dismal Victorian homes like mourn-
ful relics, pinch-penny drab storefronts, shabby little wooden
houses, crumbling farm buildings, stand as symbols of the
death of the American pioneer spirit—garish, crude, and
unlovely in their decay. His watercolors of the provincial
backwaters of America were painted with an honest and literal
eye. His technique was minimal, his color dull and drab. He
wanted to put down what he saw, "not invent a quasi poetry
and try to fit the facts of nature about it."

In the 1940's Burchfield turned back to his "first imaginative and romantic outlook," reworking many of his earlier pictures. These later paintings are sometimes overdecorative. But, as the critic John Canaday wrote, they are a fresh and "poetic vision of sunlight (or moonlight) skies, wind and flowers (or winter trees)."

The most distinguished and enduring of the new realists was Edward Hopper (1882–1967). A painter who started no movements, who had no following, who resisted all trends and all *isms*, Hopper created a profound and personal vision of America, which is as convincing today as it was in the past.

Hopper was fifty-one years old before he achieved major recognition. He had begun his career when Ash Can realism was dominant and when, soon afterward, the revolutionary styles of the new French art were making many American converts. But Hopper succumbed to neither influence. Even though he knew it meant that his work might be overlooked, he preferred to follow his own vision. When he died at the age of eighty-five, he had become the "grand old man" of American art, John Canaday said, a painter "whose work had distilled from the confusion of the 20th century an expression of modern America that put [him] in generational sequence with Homer and Eakins."

Hopper was born in Nyack, New York, and in 1900 settled permanently in New York City. That year he spent a few months studying commercial illustration, then entered the New York School of Art. For five years he worked under Henri and Kenneth Hayes Miller, a painter of city life. Hopper went abroad for four years, staying mostly in France and Spain. Though he showed some interest in Cézanne and the impressionists, he remained, like Eakins, immune to the lure of all the new movements.

When Hopper returned to the United States in 1910, Ash Can realism was in its heyday. Receiving no encouragement for his quiet, more objective realism, he supported himself

through commercial art and diverted his talents to etching, in which field he rapidly made a name for himself. His etchings are delicate and sensitive studies, which, like his oils, are bathed in sunlight and silence. In 1923 the Brooklyn Museum purchased one of his paintings, the second he had ever sold, and his reputation began the slow climb to its present eminence.

A "nation's art is greatest when it most reflects the character of its people" Hopper once said. "The domination of France . . . has been almost complete for the past thirty years or more in this country. If an apprenticeship to a master has been necessary, I think we have served it." Like Eakins, Hopper found his material in the everyday America of his time—apartment dwellers, usherettes in a movie house, people sitting on the sun deck of their house, the tops of tenements seen from a subway crossing a bridge, people in an all-night diner. Eakins' pictures sometimes reflect sadness or suffering;

Edward Hopper: *Rooms by the Sea* (1951). Courtesy of the Yale University Art Gallery, bequest of Stephen Carlton Clark, BA 1903.

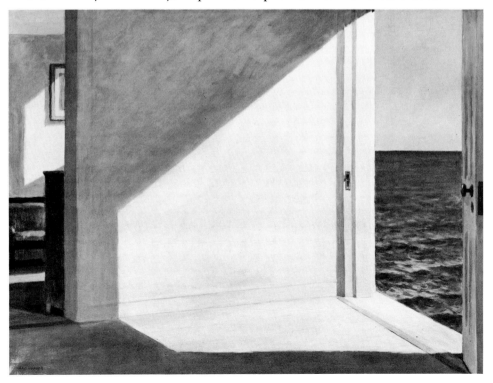

Hopper's paintings always convey feelings of inner privacy and loneliness. He was, in fact, known as "the painter of loneliness." His cityscapes, landscapes, and interiors have a sense of hushed seclusion; the people in his canvases are wrapped in solitary isolation even when sharing the same room or sitting next to each other.

Hopper's aim had "always been the most exact transcriptions of my most intimate impressions of nature." His objectivity was nonetheless touched by a melancholy poetry that ran through all his work, both early and late. The morning freshness of the air, the crystal clear light, the peaceful, yet haunting, quiet that washes the shop fronts and windows of a row of two-story buildings in his 1930 *Early Sunday Morning,* are but slightly altered in *Rooms by the Sea,* painted in 1951. His palette had grown brighter, his composition almost abstractly simple, his light more sparkling. But the qualities of impenetrable silence and inexpressible loneliness that mark his work remained timeless and unchanged.

The best-known painters of the 1930's were the Midwestern "regionalists" John Steuart Curry, Grant Wood, and Thomas Hart Benton. Regionalism was a literary and artistic movement which celebrated life in particular sections of the country and especially in the Midwest. The movement reached its height during the years of the depression and expired in 1940 with the onset of prosperity. It was a form of expression that, interestingly enough, took on the political coloring of its locale. In the large cities, regionalist art tended to be traditional in technique and had vague Marxist implications in its depiction of "proletarian" life. In the rural agrarian areas of the Midwest, it developed as a strongly conservative reaction against all foreign *isms*—especially European modern art— and a return to a subject matter that was thoroughly American in content and treatment. No "art can come to those who do not live an American life," Benton claimed, "who do not have an

American psychology and who cannot find in America justification of their lives."

The term *regionalism* became particularly identified with Wood, Curry, and Benton because of their artistic chauvinism. The champion and defender of the regionalists was Kansas-born Thomas Craven, a writer and art critic. He abominated modern art, looking on it as a dangerous and destructive weapon of foreign revolutionaries. Craven believed that the regionalists were America's best painters. Wood, he declared, was a better portraitist than Copley; Benton had originated the "outstanding style in American painting" and was far greater than Eakins. Craven's claims were inordinate. The Midwestern regionalists were capable artists, but of circumscribed abilities.

Curry and Wood were painters first; their interest in the Midwest was secondary and reflected not so much their patriotic fervor as their familiarity with the native scene. John Steuart Curry (1897–1946) "never forgot that his folks were plain Kansas folks," Benton once said. Actually, Curry did his best to try to forget his plain Kansas background. He studied at the Kansas City and the Chicago Art Institutes and worked as a free-lance illustrator to earn the wherewithal for a year's stay in Paris. He returned to the United States in 1927 and, instead of heading for home, settled in New York, where he taught at Cooper Union and the Art Students League. In 1936 he went back to the Midwest, this time to Wisconsin, where he became artist-in-residence at the state university.

Unfortunately, Curry was a man of second-rate talents. He was unable to invest his work with any depth or feeling. He had been raised on the prairie, yet his pictures of the Iowa wheatlands, of animals threatened by the elements, of the gigantic torso of a wild-eyed, wind-blown John Brown, are no more than overscaled, melodramatic illustrations of Midwestern themes. His best canvas, *Baptism in Kansas*, is more origi-

nal in choice of subject matter. Yet even in this instance Curry did no more than record the event. What he could not convey was the religious fervor that was so much a part of this ceremony.

Grant Wood (1892–1942) was, perhaps, more desperate in his desire to escape the provinciality of his Iowa youth. Wherever and whenever possible he studied painting and, by scrimping and saving, finally got himself to Paris in 1923. His first act after setting foot on French soil was to divest himself of his American identity. He bought a smock, a flowing tie, and a beret, raised a beard, and began to paint like an impressionist, or at least tried to. But his Midwestern conscience and training couldn't be downed so easily. Reluctantly he came to the conclusion that he could work better while "milking a cow" in Iowa than sitting in the Louvre copying other men's art. So he shaved his beard, removed his smock, threw away his beret, and took the next boat home. In 1928 he was commissioned to do a window for the Iowa American Legion and went to Munich to study the technique of working in stained glass. There he discovered the Flemish and German primitives in whose meticulously rendered pictures he recognized the images of some of his American neighbors.

Wood became an overnight sensation in 1930 with *American Gothic*, a portrait of a farmer and his wife, done in the careful, precise technique of the Flemish style. The couple are the embodiments of the hard-working, grim, pious men and women who settled in the prairie country. The picture has been so widely reproduced that it has become one of the best-known American paintings. *Daughters of the Revolution*, painted two years later, mildly disparages the bigotry and snobbism of the organization in its portrayal of three prim, square-jawed, tea-drinking matrons. Wood's reputation rests on these canvases. His later pictures of historical events are smooth and artificial.

The most belligerent, biased, and vocal of the regionalists

was Thomas Hart Benton (1889–), who had neither poverty nor provinciality to overcome. The son of a Missouri family long prominent in politics, he spent more of his youth living in Washington, D.C., than in his native state. After a year at the Chicago Art Institute he went to Paris in 1908 and immediately became a disciple of the new art. When he returned to New York in 1912, he was still experimenting with cubism, synchromism, and other modern styles.

The first indications of his violent antipathy toward modern art appeared suddenly in 1918, while he was serving in the navy. He became aggressively chauvinistic and rabid in his opposition to all forms of modernism, denouncing them as "political and aesthetic doctrines drawn from middle European philosophizing." Stieglitz he attacked as the incarnation of foreign decadence, and those painters whose views he so recently had shared he called "an intellectually diseased lot, victims of sickly rationalizations." He complained that he had "wallowed in every cockeyed ism that came along and it took me ten years to get all that modernist dirt out of my system," as if it had all been forced on him.

From 1924 to 1934 Benton wandered through the South and the Midwest, gathering material for a national art that was to have "unmistakably American meanings" for all Americans. He planned a grandiose, sixty-four-panel pictorial history of the United States, only sixteen of which were ever completed. In 1935 he went back to Kansas City, where for the next six years he taught at the Art Institute. Ironically, Benton's reputation was made in the "hothouse atmosphere" of the East, against which he had so much railed. He won popular recognition for his easel paintings, but is best known for the murals he painted for the New York School for Social Research, the Whitney Museum, and the Missouri State Capitol.

Benton's mannered figures, elongated and writhing in the style of the Spanish master El Greco, have a certain rhythmic

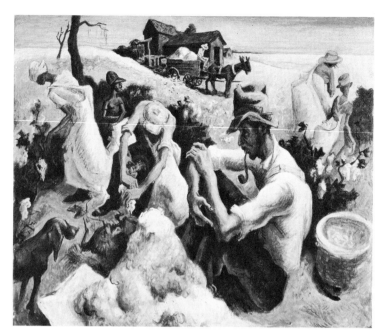

Thomas Hart Benton: *Cotton Pickers, Georgia* (*c.* 1932).
Courtesy of the Metropolitan Museum of Art,
George A. Hearn Fund, 1933.

originality. But his pictures of the Dustbowl, of impoverished
farmers and emaciated sharecroppers, painted in chalky color,
are not emotionally convincing. Like his fellow regionalists,
Benton's talent would carry him just so far and no further. He
tried to create a national epic out of Midwestern life and came
up with a fancily staged, provincial drama.

NEW YORK, NEW YORK

As THE OPPOSITION to modernism grew more widespread, a
milder and less obstreperous form of regionalism became
popular among New York's artists during the 1930's. They
created a period portrait of New York life in styles that were
less traditional, but more or less representational. A number
of these painters became identified with the depression, not
because they created an incisive study of that era, but because
for the most part they found their subject matter in the city's

poor and its "proletariat." Most of them were students of Kenneth Hayes Miller, a follower of Ash Can realism, but otherwise they had little in common.

Two of Miller's students, Isabel Bishop (1902–) and Guy Pène du Bois (1884–1958) did not wholeheartedly share Miller's enthusiastic observation that Fourteenth Street was "the greatest landscape in the world." Isabel Bishop painted New York shopgirls and housewives, but gained a reputation for her Rubenesque nudes. Pène du Bois preferred more affluent circles, using his pictures to make mild satiric comments on the behavior of capitalists. His canvases are painted in sharply contrasted lights and darks, and rigidly stylized in the manner of Bellows' late works.

Raphael Soyer (1899–) is the one painter who most reflects the depression period. One of three sons—all of them painters—of a Russian-Jewish tailor, Raphael grew up in the poverty of New York's Lower East Side. He studied art at the National Academy, Cooper Union, and the Art Students League, where he was a pupil of Pène du Bois.

Soyer believed that art "must describe and express people, their lives and their times." And in Degas' pictures of the Parisian working class Soyer found the key to his art. He was a sensitive and tender painter, a capable, if not distinguished, craftsman. Sometimes sentimental, sometimes gently poetic, always somber, his canvases are filled with a muted sadness. His subjects—workers, relatives, or professional models—are forlorn little people, defeated by a world they never made.

The most exuberant and most gifted figure of this group was Reginald Marsh (1898–1954). A man of seemingly limitless energy, he was, at one time or another, cartoonist, book and magazine illustrator, mural painter, teacher, as well as artist. He studied painting at Yale University, and with Sloan, Luks, and Miller at the Art Students League. He learned anatomy at a medical school and also took private lessons in fresco painting, sculpture, and etching. Beginning in 1935 and

for a number of years thereafter he taught at the Art Students League and during World War II was artist-correspondent for *Life* magazine.

Marsh was captivated by the vigor and vulgarity of the lower classes. "Well-bred people are no fun to paint," he declared, and was dubbed the "Hogarth of New York" for his animated scenes of its teeming masses. Crowds of seedy-looking bums mill aimlessly in front of Bowery flophouses beneath the Third Avenue "El"; burlesque queens prance before an eager audience; gay sailors and their girls sway to the rhythm of a carousel; and thousands of half-naked, squirming bodies spill over Coney Island's beach. In *Human Pool Tables* people sprawl and spin on a whirling disk in Luna Park's funhouse.

Marsh was an excellent draftsman, and his figures have a Renaissance-like solidity and roundness. His pictures, which are actually colored drawings, were worked directly on the canvas in pen. He drew his figures in inked lines, then

Reginald Marsh: *Human Pool Tables* (1938).
Courtesy of the Whitney Museum of American Art, New York,
gift of Mrs. Reginald Marsh and William Benton.

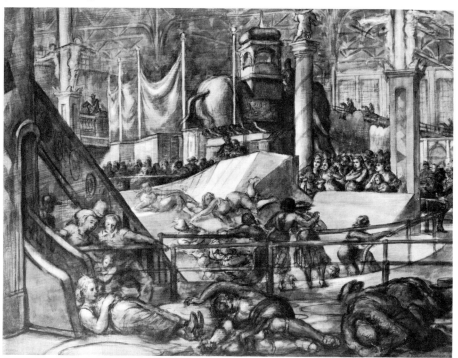

rounded them out with thin, transparent layers of brownish earth colors. Marsh's portrait of the city was drawn with humor, insight, and affection. Of all the painters of New York, with the possible exception of Sloan, he came closest to capturing its essential vitality.

MEN OF CONSCIENCE

For some American painters, art could not be separated from conscience. Unlike many of their contemporaries, they found it impossible to ignore the tragic effects of the depression or the savagery of war. The Ash Can view that the poor, notwithstanding their unhappy lot, were filled with a bounding joy in life—even Marsh's more cynical, yet equally exuberant, portrait of the urban poor—seemed naive and irrelevant in a harsh and ugly real world,

These painters believed that moral and social injustice threatened the libertarian principles of American life. They were men of conscience, who believed that artists bore a special responsibility to society in that their art could be used as a weapon with which to fight these injustices. So that their message would be instantly intelligible to all, they painted in realistic, recognizable forms. They were not salesmen of revolution, but compassionate, idealistic men who used their talents to try to build a better, more humane world.

"The artist," said Jack Levine (1915–) "must sit in judgement and intelligently evaluate . . . the world he deals with." Wagging a moral finger, Levine exposes some of the more obvious ills that afflict American society. His targets are gangsters, big business, war profiteers, those who grow rich and powerful by feeding on their fellow men—the standard figures of corruption. But his indictment is the more pointed for its contrastingly sensitive style and fluent technique.

Squat, ugly figures, loose-jowled and cold-eyed, are painted as
if seen through small sections of delicately tinted glass.

Civil rights became an issue of national importance some
thirty years after Jacob Lawrence (1917–) first made his
reputation with his pictures of Northern Negro life. Raised in
Harlem's ghetto, he taught himself, as well as he could, the
fundamentals of art. He painted in flat, angular, modern pat-
terns, relying on "a pantomime of gesture" to convey the pov-
erty, the emptiness, and the hopelessness of Negro life. While
employed on the Federal Arts Project, he produced *Firewood*,
an impressive, cubist-inspired painting of a woman gathering
kindling into a cart. Style seems to have been of primary
importance to Lawrence. He is an able and interesting paint-
er, but one could have wished for a more passionate state-
ment in his art.

Lawrence's friend Romare Bearden (1914–) also draws
his inspiration from Negro life in America. Born in Charlotte,
North Carolina, he was raised and educated in New York. In
1937 he worked at the Art Students League under the noted

Jacob Lawrence: *War Series: Another Patrol* (1947).
Courtesy of the Whitney Museum of American Art, New York.

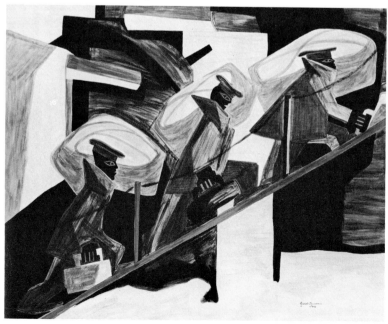

artist George Grosz, who urged Bearden into serious painting.

In 1945 following his discharge from the army he went to Paris. Returning to New York, Bearden took a studio directly above Harlem's famed Apollo Theatre, the home of many of the great jazz musicians. Inspired by these surroundings, he turned to song writing, but soon went back to his art. He works in collage, experimenting "with flat painting, shallow space, Byzantine stylization, and African design." His collages are made of torn or cut pieces of newspaper and magazine photographs as well as painted areas. They are constructed in cubist planes. Figures are distorted to heighten mood; faces are cut, split, and reassembled into austerely dignified visages that remind one of African masks.

Bearden paints the life of his people, in his own description, "as passionately and dispassionately as Brueghel painted the life of the Flemish people of his day." Bearden's works are free of social comment. They are powerful and boldly original statements.

Peter Blume (1906–) used a surrealistic image and the glowing colors and meticulous rendering of the Flemish masters to carry a contemporary social message. He burst on the scene at the age of twenty-six with *South of Scranton*, an enigmatic composite of coal heaps, quarries, house fronts, boat decks, and athletes hurtling through space. Lavishly admired by the art world as much for its craftsmanship as for its content, the picture was denounced by Pennsylvania businessmen, clergymen, and politicians for its "offensive" pro-Roosevelt, socialist, and modernist tendencies.

Blume's reputation rose even higher with his canvas *The Eternal City*, a "painted essay" attacking Italian fascism. Completed in the mid-1930's, when Mussolini was at the height of his power, it portrayed "Il Duce" as an evil, glowering, green Jack-in-the-box inflicting suffering on his country and his people. The painting was acclaimed by liberals of all persuasions for its indictment of fascism and praised by the general

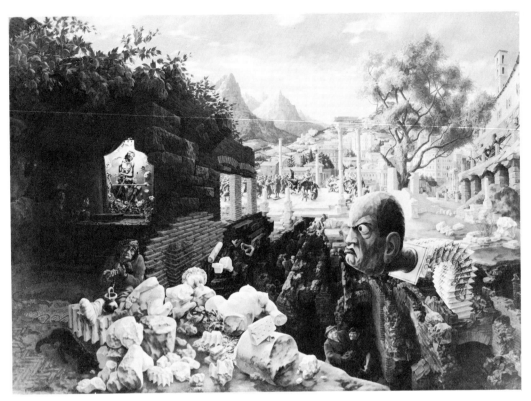

Peter Blume: *The Eternal City* (1937). Courtesy of the
Museum of Modern Art, New York, Mrs. Simon Guggenheim Fund.

public for the gemlike brilliance of its technique. Blume's
later pseudosocial messages are skillful renderings manufac-
tured for popular appeal.

Other men might try to imagine life under the heel of
a dictator, but George Grosz (1893–1959) was personally
acquainted with its terrors. Born in Germany, he had served
in World War I, and it left him with such a loathing that
he dedicated his art to opening men's eyes to the horrors
of war. He was a member of the German Dadaists, an antiwar
artists group, and was one of the country's outstanding politi-
cal cartoonists. In 1932, just before Hitler came to power, he
fled to the United States.

Like Levine, but with a ferocity unknown to the American
painter, Grosz deliberately played technique against subject
matter to hammer home his message. With a delicate, razor-

edged line, he drew some of the most incisive and bitter portraits of the widespread corruption and depravity in postwar Germany. His watercolors of bloated profiteers, brutal army officers, fawning flunkies, empty-faced prostitutes, deformed war-crippled beggars, and starving children seem even more horrendous in contrast to the glowing radiance of his color and his sensitive artistry.

Grosz enjoyed a fairly successful career in the United States and in 1938 became a citizen. But his entire outlook, his life, and his art had been conditioned by a land he could not wholly erase from his memory. His satirical watercolors of smugly prosperous New Yorkers had some of the old sting, but it was a sting drawn from a bitter past. When peace finally came to Europe, he returned, like so many other disoriented and haunted wanderers, to Berlin to die among the bombed-out ruins.

Ben Shahn (1898–1969) also wanted to see a better world. "I hate injustice . . ." he said, "and I hope to go on hating it all my life." Shahn's hatred was not the searing emotion that ravaged Grosz, but an emotion that arose from a deep-seated love for humanity. Shahn was the best known of the social realists. His canvases have a savage, yet lyrical poetry that expressed an enduring concern for his fellow man.

Born in Lithuania, Shahn was brought to New York in 1906, when his family, like thousands of other Russian-Jewish immigrants, fled from the poverty of the ghettos and the terrors of Tsarist pogroms. While he was still in his teens, he went to work for a lithographer, supporting himself at this trade until 1930. He continued his schooling at night, and spent a few years in college with the idea of becoming a biologist. In 1922 he began studying art at the National Academy and at the Art Students League. Three years later he made his first trip to Europe.

Shahn came into the public eye in 1932 with a trenchant series of canvases on the Sacco-Vanzetti case. This was a famous

murder trial of two alien anarchists—Nicola Sacco and Barto-
lomeo Vanzetti—accused in 1920 of killing a paymaster in
Massachusetts. Though the two men maintained their inno-
cence to the last, both were finally executed in 1927. The case
roused a fury of public controversy, with some people insist-
ing that the accused had been fairly tried, others claiming that
the men had been railroaded to their death because they were
foreign radicals. The trial became an international *cause célè-
bre* for liberals. Shahn believed the men were innocent vic-
tims of injustice, and his pictures reflect his feelings.

Shortly after the Sacco-Vanzetti paintings, Shahn produced
several canvases sympathetic to Tom Mooney, an imprisoned
labor leader and another subject of widespread controversy.

In 1933 Shahn became an assistant to the well-known Mexi-
can artist Diego Rivera, who was painting a fresco for Rocke-
feller Center. Rivera was then greatly esteemed in art circles,
despite his avowed Marxist beliefs. However, when Rivera
included a portrait of Lenin in the fresco, the owners felt he
had gone too far. Rivera was dismissed, and the offending
mural, unfortunately, was scraped off the wall. Though Shahn
didn't agree with Rivera's politics, he did feel that the Mexi-
can artist had a perfect right to express his political beliefs in
his art. The association with Rivera proved a valuable experi-
ence for Shahn in his own fresco painting. From the older
artist he learned how to organize his own murals with the
monumental simplicity of design that makes them outstanding
examples of this branch of art in America.

From 1935 to 1938 Shahn was a photographer and artist for
the Farm Security Administration, and during World War II
he was employed by the Office of War Information. He also
did specially selected commercial assignments, designed, let-
tered, and illustrated books, and donated his services in behalf
of many liberal causes.

Shahn was a powerful and consistent realist, but his realism
was not of the kind generally associated with the word. His

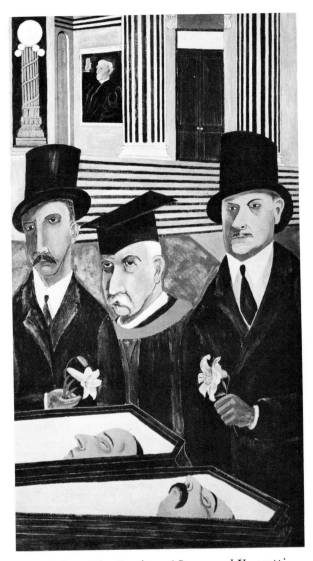

Ben Shahn: *The Passion of Sacco and Vanzetti,*
from a series of 23 paintings (1931–1932).
Courtesy of the Whitney Museum of American
Art, New York, gift of Mr. and Mrs. Milton
Lowenthal in memory of Juliana Force.

work was sharply stylized, modern in feeling, yet still repre-
sentational. He painted mainly in tempera—opaque, water-
based paints—outlining his forms with a fluid, eloquent line
and using a moderate distortion to emphasize character.

In the 1940's Shahn moved away from the larger problems of society. Increasingly his concern centered on the loneliness, frustration, and anxiety of individuals caught in a world of conflict and confusion. Elderly people, drawn together by age, sit huddled against each other, uncommunicative; a lone little boy hits a ball against an enormous brick wall; scarecrow children improvise swings from the rubble of war.

Shahn never separated his art from his principles; he painted what he felt most deeply. His later canvases, which dealt with the effects of nuclear power, were more elegant in design, more luminous in color, and heavily symbolic in content, but they lacked the conviction and emotional punch of his earlier work.

Philip Evergood (1901–) shared Shahn's solicitude for mankind. But Evergood bypassed the literal world to invent a world of rich fantasy. His viewpoint is as varied as his technique—sometimes ironic, sometimes wistful, sometimes haunted. "I want my pictures to affect people . . ." he said, "to disturb, excite, entertain by a little of the poetry I feel in human expression." A painter who has earned the respect of the abstract expressionists as well as more academically minded men, Evergood has imagination and a certain originality of style. But he is also an uneven painter whose ambition often outstrips his talents.

Evergood was born in New York and raised in England. He was educated at Cambridge University and London's Slade School of Art, where he studied sculpture. In 1923 he came to work at the Art Students League, and it was at this time that his instructor, George Luks, turned Evergood's interests to painting. In 1931, after two trips abroad, Evergood settled permanently in New York.

Like Shahn, Evergood did not believe in separating art from life. His paintings do not spell out a clearcut social message. Evergood didn't bemoan the cramped environment of a poor city child. Instead, he pictured the child's ability to

create her own enchanted world by feeding a city sparrow. His little black farm girl daydreams hopefully, as all children do, about the world beyond her shabby confines; his old lady sits straight-backed and unyielding, a symbol of America's enduring pioneer spirit.

Social realism was on the wane by the time the depression ended in 1939. A new style of art was being incubated. But 1939 was a fateful year. Having seized the Rhineland, Austria, and Czechoslovakia, Hitler invaded Poland and triggered the outbreak of World War II. The United States contributed the vital machinery of war to aid France, England, China, and the many other nations battling the Axis powers—Germany, Italy, and Japan—but was unwilling to enter the conflict.

Then on the morning of December 7, 1941, Japan attacked Pearl Harbor, seriously crippling American naval power. Within twenty-four hours the United States was at war on two fronts—with Japan in Asia and with Germany and Italy in Europe.

Once again art was swept aside by the tides of history. But, oddly enough, this time American art became an accidental beneficiary of war.

XVIII A Distant Landscape

T HE WAR in Europe was over by May 1945. The United States then issued an ultimatum warning Japan that unless she agreed to an immediate and unconditional surrender, she would be bombed. Japan would not capitulate. On August 6, 1945, the United States dropped the first nuclear bomb on Hiroshima and on August 9 a second and more potent bomb on Nagasaki. Japan surrendered on August 10. World War II had ended; the nuclear age had begun.

All through the years of the war an artistic revolution had been brewing—this time in American art. The first cohesive statement in this new development took place in the 1940's. But the initial signs had begun to be seen in the late 1930's. During these years many of Europe's leading intellectuals, painters, and other citizens had come to the United States fleeing from the horrors of war and Nazi persecution. Among them were a number of prominent abstract and surrealist painters who settled in New York. For the first time since World War I, when Picabia and Duchamp were living in New York, American painters could learn about what was happening in the world of art from the very men involved in the making of modern art.

For a group of young American painters known as the "New York school," the theories and the work of these European artists assumed a sudden and profound significance. Taking impetus from the precepts of European abstraction and especially from surrealism, the New York artists invented a radically new image called abstract expressionism.

Abstract expressionism was the first new movement to originate in the United States. In time it became the most influen-

tial and most pervasive international style and established America's leadership in the world of art. The movement started as a revolt against the antiprogressive academism that permeated American art during the late 1920's and the greater part of the 1930's.

To better understand the complexity of this revolution, let us review the development of modern art from traditional painting. The traditional painting, as we know, presented a definite, recognizable image; it had a theme or subject matter that was derived from nature. The action of the painting was focused in the center of the canvas, and color was employed as a means of simulating, as closely as possible, the actual appearance of real objects. As we have seen, the impressionists by making light itself the subject of their paintings, freed art from its tie to traditional subject matter. At the same time, they released color from its menial function and made it an important element in its own right.

The postimpressionists Vincent Van Gogh and Paul Gauguin began to use color as a means of intensifying emotion. Taking their cue from these men, the Fauvists carried color a step further toward total abstraction. They realized that color—that is, pure color that bore no relation to the color in nature—possessed its own rhythmic, emotional, and decorative qualities. Using nature as a starting point for their abstractions, the Fauvists created mood, movement, and depth by placing areas of vivid color alongside each other. The Norwegian painter Edvard Munch and the German painters known as *Die Brücke* (the Bridge) and *Der Blaue Reiter* (the Blue Rider), all of whom were part of the expressionist movement, also used intense colors to heighten the emotional content of their pictures. Like the Fauves, the expressionists employed line, color, and distortion to achieve a less naturalistic, more emotionally expressive style. The cubists, on the other hand, avoided color because of its emotional content. They invented

a more static, formal abstraction of space and volume, based on geometric form.

Up to this point the new language of abstraction still contained elements that were visibly and recognizably rooted in nature. It was but a short leap into total abstraction, and that leap was soon taken. The new art was completely nonrepresentational. Known as nonobjective art (or nonfigurative art, as it is sometimes called), it had no basis in physical reality; it had no readily understood or definable subject matter, and it bore no relation to nature, even as a point of departure. Thus a painting no longer had to mirror the visible world or contain vestigial elements of recognizable objects to be considered a painting. It could be an emotional expression based on such abstract factors as line, color, space, movement, or form.

As we saw earlier, the jump into total abstraction was made by Wassily Kandinsky, a Russian member of the Blue Rider group, who in 1910 painted what is probably the earliest nonobjective work of art. "Objectiveness, the depiction of objects," Kandinsky declared, was of no importance in art. Color and line were the vital ingredients. They had, he felt, meanings of their own, had their own emotional impact, their own life and, like music, were capable of inspiring profound feelings. Each color, each kind of line, he insisted, could rouse a "corresponding vibration in the human soul." He therefore eliminated all reference to real objects and dispensed with all subject matter. To emphasize this complete departure from tradition into the realm of nonobjectiveness, he called his pictures "improvisations" and gave them numbers instead of titles—a procedure that the later abstract expressionists would follow.

Just three years after Kandinsky's historical innovation, a Russian named Kazimir Malevich started another revolution in the field of geometrical abstraction. Malevich was the founder of a movement known as suprematism, which was based on the supremacy of pure feeling in the pictorial arts.

He felt that "any plastic surface"—i.e., the surface of a painting—"is more alive than a [painted or drawn] face from which stare a pair of eyes and a smile." Like Kandinsky, Malevich believed that the "object itself is meaningless . . . and the ideas of the conscious mind are worthless." Only through feeling could art arrive at "non-objective representation," thus achieving a purity beyond which it was impossible to go. In demonstration of his "system of absolutely pure geometric abstraction," he painted in 1913 a black square on a white ground, which he felt "rid art of the ballast of objectivity." Five years later he carried his theory to its furthest simplistic limits by painting a white square on a white ground.

During these same years a Dutch painter named Piet Mondrian was evolving another important kind of geometric abstraction, which he called neoplasticism and which was based on the theory that the rectangle was the simplest and most universal form of artistic expression. His canvases were severely simple, composed of horizontal and vertical black lines that crossed each other to form rectangular areas. Color was limited to small areas and restricted to the primaries—red, yellow and blue—in their pure, unmixed state. All traces of technique were eliminated. Areas were painted flatly, showing no signs of brushstrokes or any personal technical mannerisms.

A third, and minor, movement known as purism is worth mentioning at this point, because several American painters affected a similar style. Purism, which was another form of geometric abstraction, was founded in 1918 by two Frenchmen, the artist Amédée Ozenfant and the architect Le Corbusier. They felt that cubism had deteriorated into mere decorative invention and needed to be purified of its embellishments, its imaginative touches, and the individual imprint of the artist. Taking their inspiration from the clean, angular lines of the machine, the purists then took from cubism only its sharp, clearly defined, geometric patterns. The movement

produced little painting of any importance, but left its mark in the fields of architecture and sculpture. In the industrial landscapes of Sheeler and Demuth one can find the sharpness and clarity of purist forms, although neither artist was an actual follower of the movement.

While all these revolutionary concepts were transforming the face of European art, American painters were just becoming aware of cubism and still trying to fathom its mysteries. In 1924 a new European movement called surrealism was born, which within fifteen years became of crucial consequence in the evolution of a truly indigenous form of abstract American art. Surrealism was the offspring of dadaism, a literary and artistic movement that originated in neutral Zurich, Switzerland, where its members took refuge during World War I. Dada (from the French word meaning hobbyhorse) was an expression of profound disillusionment with mankind's moral, social, and political principles. The Dadaists believed that since there was no order or sanity in the world, then everything, including art, was a meaningless manifestation of chaos. Dada was completely nihilistic in concept, intended to shock and outrage society. It was anti tradition, anti morality, anti reason, anti art—in fact, it was anti everything.

The "granddaddy" of the pop "happenings of the 1960's," dada performances included lectures at which thirty-eight people spoke simultaneously; concerts played entirely on percussion instruments, during which dancers pranced about dressed only in gloves; an exhibition at which spectators were given an ax and invited to smash the displays. Dada art consisted of nonsensical inventions, which were intended to emphasize the artist's denial of order and his contempt for tradition—a moustache painted on a reproduction of the *Mona Lisa;* engravings ripped from medical and technical books, then startlingly retouched and given long, absurd titles; pictures made of odd bits of cloth, torn paper, and random pieces of junk that were glued to the canvas in the positions in

which they happened to fall; pictures of strange mechanical devices bearing provocative and irrelevant titles. Marcel Duchamp, who had shocked Americans with his *Nude*, declared his contempt for all aesthetic and material pretension and gave to the artist the sole right to judge what was art. He produced a number of "ready-mades"—manufactured objects removed from their functional context, which were signed and titled by the artist—such as a wine bottle rack; a bird cage stuffed with small marble blocks resembling sugar cubes and other unrelated items; a urinal entitled *Fountain* and signed R. Mutt.

Dada expired in 1922, and the remnants of the group were swept up into a new, more affirmative movement called surrealism, officially founded in Paris in 1924 under the leadership of the poet-painter André Breton. The groundwork for this new revolt had been laid by the Dadaists in their use of accidental effects and unconventional, nonartistic materials and in their complete freedom of expression. Though surrealism borrowed freely from Dada sources, it was not, like Dada, dedicated to the destruction of art.

Surrealism was largely an outgrowth of Sigmund Freud's psychoanalytic probings into the dream world of man's subconscious mind. Its adherents believed in the "omnipotence of the dream" and declared that "nothing but the astonishing was beautiful." According to the surrealist credo, the "involuntary memory" (that is, the subconscious mind) was the only true reality, a superior reality, hence the term *surreality*. And the means by which this superior reality was transmitted was psychic "automatism," an action or thought that operated independently of all rational, moral, or aesthetic control. In effect, the surrealists believed that each line, each gesture, each accidental effect (each doodle, as it were), made on the canvas by the artist was an "automatic" response of the artist's hand to the dictates of his unconscious mind.

The aim of surrealism was to liberate the artist from con-

ventional pictorial ideas and from the accepted forms of expression, so that he could create solely according to the whims of his "involuntary memory." Of the many twentieth-century movements in art, surrealism has been one of the most influential, particularly in its insistence on total artistic freedom, even, as one critic states, "to the point of anarchism."

Surrealism developed in two distinctive styles. Typical of the first were nonfigurative "automatic" drawings, characterized by free-form, abstract shapes and nervous, suggestive line. The other and far better known style was based on hallucinatory fantasies, which Salvador Dali, its most celebrated exponent, described as "hand-painted dream photographs." These were strange visions of the dream world, of reality transformed into a frightening unreality whose eeriness was still further intensified by a meticulously detailed rendering.

The impact of all these movements and particularly of surrealism on American painting began to take effect in the latter part of the 1930's. At that time Peggy Guggenheim held the first American exhibition of the works of a number of avant-garde and surrealist painters at the Art of This Century Gallery. Founded by Peggy Guggenheim, one of the earliest and staunchest patrons of the abstract expressionists, the gallery became the center for vanguard artists. She introduced the new generation of American painters to surrealism and to the surrealists.

Aside from the surrealists, two German-born abstractionists—Joseph Albers and Hans Hofmann—arrived in America during this period. As the most outstanding teachers of their time, they both exerted considerable influence on contemporary American painting. Albers, a professor at the Bauhaus, Germany's famous new art academy, came to the United States in 1933 after Hitler closed the school. He resumed teaching at Black Mountain College in North Carolina, an important center for experimental art from the 1930's to the 1950's, and later became chairman of Yale University's art

department. The father of hard-edge painting—a form of abstraction in which flat shapes are delineated with razor-sharp clarity—and the grandfather of op art, Albers spent many years studying the behavioral characteristics of color. His severely simple geometric canvases of squares within squares of color, in the tradition of Malevich and Mondrian, were based on the action and interaction of color.

Hans Hofmann directed his own art school in Munich before settling in New York in 1933. As teacher to many of the American insurrectionists, he was an important figure in the growth of abstract expressionism. A friend of Picasso, Matisse, and other important French modernists, Hofmann brought to his students an intimate knowledge of their radical doctrines. Hofmann started out as a cubist and spent many years working his way to a totally nonfigurative art. His principle of composition was founded on the bold manipulation of pigment and the use of vivid color and active line to create a feeling of tension within the canvas—a movement and countermovement, the balance of "push-pull," as he called it. "Pictorial life is not imitated life," he explained, "it is, on the contrary, a created reality based on the inherent life within every medium of expression." He saw the surface of the painting as a "world within itself," arising from the forces involved in painting, from the artist's inner emotions and his response to his environment—ideas that were to provide incentive for some of the dynamic innovations of abstract expressionism.

Abstract expressionism, or "action painting," as the critic Harold Rosenberg named it, became closely identified with the New York school. They were a heterogeneous group of painters opposed to the static, cubist-type of abstraction that in the 1930's was considered the last word in American art. Most of them first came to know each other when they were employed on the Federal Works of Art Project. Drawn together initially by the kind of radical idealism that permeated intellectual thinking during the days of the depres-

sion, they wanted to forge an image that was both relevant to and expressive of their times. And though all modern movements were to have a greater or lesser influence on the eventual development of American art, it was in surrealism's "automatic" improvisations and total creative freedom that these rebels found the key to a new, and as yet unknown, language of art.

Using surrealism as a springboard, the abstract expressionists evolved an imageless, formless, individualistic art from the spontaneous impulses of their subconscious—an art that had no shred of visible connection with the real world, but instead grew out of the very *act* of painting. Self-nourishing, self-sustaining, it needed no outside stimuli, no subject matter, and made no attempt to communicate. Where once art had been a dialogue between the artist and the spectator, now art became a dialogue solely between the artist and his creation. The spectator, in fact, was expected to bring something of himself to the painting rather than the other way around.

Abstract expressionism was an art that refused "to serve ends other than itself." And, curiously, at this point when art stopped being intelligible in a conventional sense, it gained its widest and most enthusiastic audience.

THE NEW MASTERS

ONE OF THE EARLIEST disciples of the new art and a vital figure in the evolution of abstract expressionism was Arshile Gorky (1904–1948). It was his persistent, almost obsessive reverence for the inventions of Picasso and the Spanish surrealist painter Joan Miró that helped point out to his colleagues the revolutionary potentials of cubism and surrealism. Gorky was one of the first to recognize that in surrealism lay a whole new concept of artistic thinking.

Arshile Gorky, whose real name was Vosdanig Adoian, was

born in a small village in Turkish Armenia. He was the only son of a tradesman who came to the United States in 1908 to avoid military duty, leaving behind his wife, his son, and three daughters. Gorky went to a mission school where he learned to speak English, and when the family moved to Tiflis, he began studying art at the Polytechnic Institute. During this time his two older sisters left for the United States. In 1920, after his mother's death, Gorky and his younger sister came to America. He lived for a short while with his father in Providence, Rhode Island, and with a sister in Watertown, Massachusetts.

Between 1920 and 1925, when he moved to New York, Gorky pursued his study of art at the Rhode Island School of Design, Providence Technical High School, and the New School of Design in Boston. During these years he supported himself at various odd jobs, including a stint in a rubber factory and as a quick-sketch artist in a Boston theater. After his move to New York he taught painting at the New York School of Design and at the Grand Central School of Art. In 1930 Gorky exhibited three works in the Museum of Modern Art's group show of young American painters and sculptors, and in 1934 was given his first one-man show at Philadelphia's Mellon Galleries. That same year he shared a studio with Willem de Kooning, who was then on the Federal Works of Art Project. Gorky was employed by that same agency from 1936 to 1938. During this time he completed two murals, one for the Newark airport and another for the aviation building at the New York World's Fair. Around 1940 he moved to Connecticut, where he spent the rest of his life.

Willem de Kooning once said of his friend Gorky: "He was a Geiger counter of art. In a room in the museum, he always ran to the right painting, and in the painting he always picked the really interesting thing." Gorky's tastes were eclectic, his masters the most advanced of modern artists. "I was with Cézanne for a long time, and then naturally I was with Picasso," he

said. He borrowed freely from both these artists as well as from Kandinsky, Miró, and the Chilean surrealist Roberto Matta, memorizing the forms in their paintings, a critic said, as one would memorize a line of poetry. Yet Gorky did not so much imitate as try to capture the essential spirit of each artist. From the late 1920's to the late 1930's Gorky "went to school" with Picasso. He painted heavily brushed still lifes, whose forms were derived from geometric cubism, and produced a number of flatly painted, representational, Picasso-ish portraits of his family. One of the best-known of this series, *The Artist and His Mother*, has a solemn and haunting intensity that is most appealing.

By the late 1930's Gorky had learned what he could from Picasso, and Miró became his new master. Working in a more fluid, looser, and more colorful style, Gorky developed an imagery of floating, amoeba-like shapes bound in thin strands of undulating black lines. Then in 1941, prompted by Matta's demonic fantasies and surrealist improvisations, Gorky finally found the key to a mature and independent expression. While on a visit to the country, he discovered in nature a fresh, emotional approach to his art. André Breton said that Gorky treated nature as a "cryptogram," which, when decoded, revealed "the very rhythm of life." Using nature as a springboard, Gorky created a mysterious world of fantasy based on his emotional and associative response to nature. These late nonobjective landscapes are populated with strange, improbable floral and organic shapes, which constantly shift and slide from one position to another, moving weightlessly in thinly washed, luminous fields of color.

In 1941 Gorky married the daughter of a United States admiral and became a well-to-do, respectable member of society. His reputation was growing rapidly, and he had reason to be pleased with life. Then, in 1946, he was struck by the first of a series of disasters. His studio went up in flames and most of his work with it. Soon thereafter he underwent an

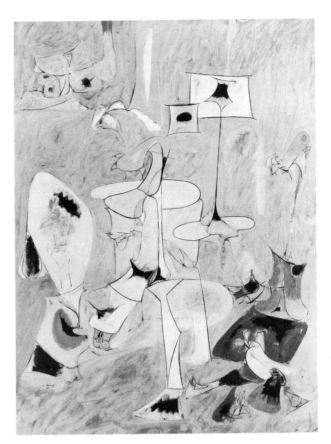

Arshile Gorky:
The Betrothal II
(1947).
Courtesy of the Whitney
Museum of American Art,
New York.

operation for cancer. Then he and his wife separated, and finally he was seriously injured in an auto accident which paralyzed his right arm. So, weary with misfortune, he took his own life. In his late works, thin, attenuated, forbidding shapes drift loosely through unbounded areas of color, seeming, in some inexplicable way, to reflect his anguish.

Gorky was a forerunner of abstract expressionism and occupies an important position in the development of that style. He was a suave and elegant stylist who devised a new vocabulary of abstract form. Even before Pollock had begun to do so, Gorky employed accidental effects such as running, dripped, or splashed paint to convey inner emotion. However, Gorky lacked the dynamic force and vigor essential to this type of expressionism. In the end, says the critic Hilton Kramer, Gorky remained "the votary of an established idiom, however much he may have pointed a way out of it"

The most decisive and most crucial expression of the new movement came from Jackson Pollock (1912–1956). The center of furious controversy, he became notorious for his heretical denial of established traditions. His opponents denounced him as a complete fraud, the ultimate "symbol of artistic anarchy," while his admirers hailed him as the prophet of the new art and the greatest painter of his time. Not since the Armory Show had a painter so enraged the American populace. Yet by the time he died, Pollock was regarded as the dominant figure in the most thorough, the most savage rebellion in the history of American art. Even the most ferocious of his antagonists could not deny the revolutionary influence he exerted on contemporary art throughout the world. Pollock opened conceptual doors, which, says the art historian Sam Hunter, "still pose a challenge to advanced styles"

Pollock was driven by an inner desperation and eventually consumed by his own anguish. He flung himself at life with the same tortured frenzy with which he created his art. "He was like a trapped animal who should never have left Wyoming, where he was born," Peggy Guggenheim declared. Pollock came to New York when he was seventeen to study painting with Thomas Hart Benton. He made several trips back to the West and in 1935 settled permanently in New York, where he found life "keener, more demanding, more intense and expansive" From 1938 to 1942 he worked on the Federal Arts Project, and in 1943 married Lee Krasner, who was herself an avant-garde painter. In 1946, when he was able to devote himself full-time to painting, they moved to Easthampton, Long Island.

Pollock was too much an insurgent and an individualist, and his need for self-expression too obsessive, to permit any form of domination. After two years with Benton, Pollock found he could accept neither the older man's authority nor his extremely antimodern views. "He drove his kind of real-

ism at me so hard I bounced right into non-objective paint-
ing," Pollock said. In the jarring rhythms and violent dramas
of the Mexican artist José Orozco he found an emotional tur-
bulence more suited to his own vision. The figure and land-
scape paintings of this period were still representational,
though very freely so, murky in color and marked by an
aggressive physical energy that was characteristic of all his
work.

Striking out in his own direction, Pollock absorbed one
influence after another from the European modernists and
especially from Picasso. In 1936 he began the struggle to
divest his art of all representational elements. He was search-
ing for his own way of expressing his deepest emotions
through abstract forms. During the next few years he pro-
duced crudely painted, heavily textured canvases, crawling
with thick black lines and strewn with ambiguous shapes and
dismembered fragments of birds, animals, and humans. They
seemed like oppressive dreams of nightmarish intensity.
Indeed there was always an aura of suppressed violence in Pol-
lock's work, even in his most lyrical efforts.

The critical point in Pollock's development came in 1942,
when Robert Motherwell, a fellow abstract expressionist,
introduced him to Peggy Guggenheim. Miss Guggenheim
became Pollock's patron and provided him with a regular
income. She introduced him to the group of international art-
ists who gathered at her gallery, and here he came under the
influence of surrealism. His first one-man show was held at the
Art of This Century Gallery in 1943. Clement Greenberg,
the first critic to recognize Pollock, in a review of Pollock's
work hailed it as a "genuinely violent and extravagant art."

Taking his cue from surrealist ideas about the unconscious
and the automatic, unthinking movement of the hand, Pol-
lock began to strike out in a new and startling direction. By
1946 he had broken away from all semblance of representa-

tional form. The following year he began to produce the now-famous "drip" pictures—abstract inventions, which in part were inspired by the "sand paintings" of the Navajo Indians. These canvases were powerful images, which grew out of the very act of painting, from the physical and intuitive forces involved. "The source of my painting is in the Unconscious," Pollock stated. "When I am *in* my painting, I'm not aware of what I'm doing. It is only after a sort of 'get acquainted' period that I see what I have been about. I have no fears about making changes, destroying the image, etc., because the painting has a life of its own. I try to let it come through."

His methods of working were as unorthodox as his concept. Instead of the usual oil pigments, artist's brushes and palette knife, he used sticks, builder's trowels, house painter's brushes, aluminum and commercial paints, Duco enamels, and frequently added to these materials such foreign objects as cigarette butts, pieces of string, sand, and bits of broken glass. To create the effect of cosmic space, he used canvases of monumental proportions that had to be worked on the floor. "On the floor I am more at ease," Pollock explained. "I feel nearer, more a part of the painting, since this way I can walk around it, work from the four sides and literally be in the painting."

Pollock numbered his abstractions instead of giving them titles, just as Kandinsky had. Pollock's "drip" paintings were huge, incredibly intricate structures. In such pictures as *Autumn Rhythm* tangled, rhythmic lines were interwoven into shimmering webs of color, like visions of some vast and luminous, chaotic firmament.

Pollock's paintings were greeted by a storm of virulent criticism. As Duchamp and Matisse some thirty years earlier had been made the butt of academic fury, so Pollock now became the arch villain and symbol of the ultimate triviality of modern art. The unpleasant reception of his work and the widespread publicity and cheapness of his fame both wounded

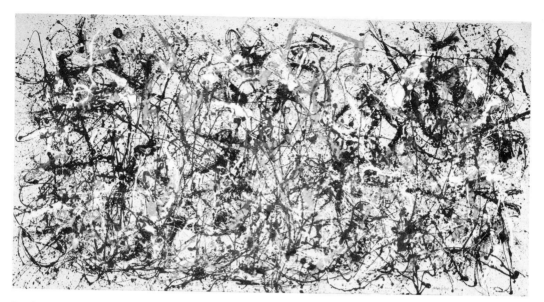

Jackson Pollock: *Autumn Rhythm* (1950). Courtesy of the
Metropolitan Museum of Art, George A. Hearn Fund, 1957.

and embittered him. Despite his unhappiness he continued
working in the same vein. For Pollock, art was an exploration
of his most personal emotions.

Then suddenly, in 1950, Pollock started to turn away from
the revolutionary "drip" paintings. In the years 1951 and 1952
he devoted himself almost exclusively to creating works in
black and white. With his usual unorthodoxy, Pollock painted
these new pictures, one alongside the other, on a single large
sheet of canvas. Using the white of the canvas for his back-
ground, he dribbled, spattered, and brushed on black Duco
enamel. When completed, the canvases were cut apart and
mounted separately. These black-and-white compositions were
dense, rhythmic, powerful, and aggressive, and again swirling
with suggestions of anatomical forms and what one critic
called "totemic *things.*" The old struggle between the figura-
tive and the nonfigurative had begun anew. Pollock's inner
devils had not been routed; they had just been dormant.

For the next three years he alternated between the "black"
pictures and his "drip" canvases, producing such impressive
works as *Blue Poles* and *The Deep*, one of his most tender and

lyrical canvases. But the mental and artistic anguish that had for so long plagued Pollock now reached a crucial stage. In 1954 his creative energies ran dry, and abruptly everything ended. Except for a canvas or two completed in 1955, he had stopped painting. He was killed one night in August 1956, when the car he was driving smashed into a tree. He was then forty-four years old and at the top of his career.

Pollock's style has never been imitated; it was too uniquely his own. Since his death he has become the "old master" of abstract expressionism. Pollock's action landscapes of the inner consciousness were the most original and provocative statements that had, up to this point, been made in American art. They became the most potent liberalizing influence on postwar painting throughout the world.

The most vital and compelling of the New York painters was Gorky's friend Willem de Kooning (1904–). It was de Kooning's style, rather than Pollock's, that became the model for the younger generation of vanguard artists throughout the world. De Kooning was born in Holland and attended art schools in Holland and Belgium. He came to New York in 1926 and for the next nine years supported himself as a house painter, a window decorator, and a mural painter for "speakeasies," concentrating on his serious work in his off-hours. In 1935 he spent a year working on the Federal Arts Project and thereafter devoted his full time to painting.

Though highly respected by the avant-garde, de Kooning was virtually unknown in official art circles until he was forty-four. Then, having emerged from his first one-man show as an artist of major stature, his rise was rapid. Within a few years his energetic, slashing style became the international uniform of the new abstraction. By 1960 he was regarded as the "dean" of abstract expressionism and the most influential painter of his day.

"Art never seems to make me peaceful or pure," de Kooning once said, and his art is neither peaceful nor pure. It is a

vigorous, contemporary, abstract statement, which is still tied to tradition, to the knowledge and appreciation of what had been done before. Of all the abstract expressionists, de Kooning is the one who, even more than Pollock, has most consistently retained his interest in the human figure.

De Kooning tried many styles before he arrived at his own. In the late 1930's, when he was sharing a studio with Gorky, de Kooning experimented with an abstract imagery of floating, disembodied, Picasso-like forms. At the same time, he painted a number of almost classically drawn male and female figure studies. Though they are evocative of Picasso's "rose" period paintings of women, de Kooning brought to these pictures a sensitivity all his own. They are probably the most moving of his works. During the next decade he began mutilating the figure, bringing it closer and closer to abstraction. In the late 1940's he embarked on the series of intricate, cubist-inspired abstract canvases which first brought him public notice. The majority of these abstractions were done in black and white commercial paints, because he could not then afford oils and did not trust the permanency of colored house paints.

It was at this time he began the paintings of the female figure that culminated in the now-famous series of gigantic canvases called *Woman*. These "terrible" visions of women, as de Kooning referred to them, are not intended to delight the eye. They are barbaric and grotesque apotheoses of American femininity. His goddesses are mammoth-chested, leering, overpowering Amazons—demented half-sisters of the smiling, bosomy females that dominate American advertising. De Kooning's images were rooted in nature, but painted in an abstract expressionist manner. Out of the welter of brutal, slashing brushstrokes and spilled, splashed, and dragged paint there emerges a whole and completely recognizable human form.

Having successfully integrated the human image with an abstract concept, de Kooning reversed the process in 1955. He

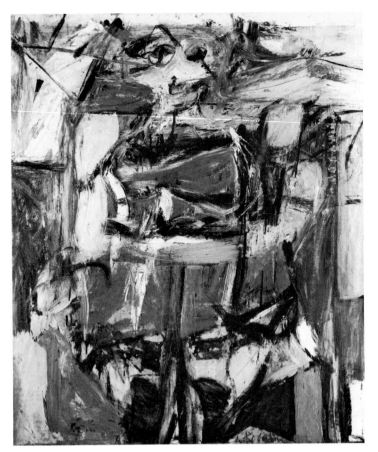

Willem de Kooning: *Woman VI* (1952–1953).
Courtesy of the Museum of Art, Carnegie Institute,
Pittsburgh, Pennsylvania.

dismembered the figure and transformed its shapes into abstract patterns. These canvases are filled with ambiguous forms. A slashing brushwork tears across the surface of the picture with the savage energy that has become the hallmark of his style. De Kooning's later canvases are simplified in form, enlarged arrangements of brushstrokes evolved from small sketches and painted in thin, clear color. More recently he has returned to the boldly brushed and energetic expressionist statement.

Though he was a comparative latecomer to art, Robert Motherwell (1915–) was one of the first of the contemporary abstractionists to recognize and adopt the "automatic"

principles of surrealism. A writer as well as an artist, he has been one of the most knowledgeable and articulate defenders of the art of his generation.

Born in Aberdeen, Washington, Motherwell had some art training in California. He received a bachelor's degree from Stanford University and did graduate work at Harvard's School of Philosophy, at the University of Grenoble in France, and at Columbia University's School of Architecture and Art. In 1941, having determined to follow a career in art, he went to Mexico to work with Matta, who first introduced him to surrealism. The following year he settled in New York and for a brief period painted canvases in the manner of Picasso and Matisse. In 1944 he was given his first one-man show at Peggy Guggenheim's gallery and shortly thereafter created the series of paintings called *Elegies to the Spanish Republic* which brought him fame.

Robert Motherwell:
The Red Skirt
(1947).
Courtesy of the
Whitney Museum of American Art,
New York.

Motherwell believed that the art of the past must be exchanged for a new reality. The artist's "emotional interest is not in the external world," he explained, "but in creating a world of our own." He has developed a distinctive symbolic imagery, which he calls an "intimate journal" of his feelings. His paintings contain abstract, oval-shaped forms, in varied contours and sizes, which are suspended between different-sized, rectangular uprights. Using colors in tones that equal black, white, and gray, he creates a balanced design and an "all over" slow and ponderous movement. And for the most part, he repeats this motif with little change in huge, somber-colored horizontal canvases. He has also produced a number of lively and quite sensitive torn-paper collages.

Like Motherwell, Mark Rothko (1903–1970) painted mammoth versions of a single concept. "The progression of a painter's work . . ." he felt, should be "toward clarity; toward the elimination of all obstacles between the painter and the idea, and between the painter and the observer." Rothko's work is the antithesis of "action painting." He has systematically eliminated all "obstacles," leaving his canvases serene, tranquil, and empty of all content save color.

Born in Russia, brought up in Oregon, he attended Yale University and studied briefly at the Art Students League with Max Weber. Along with a number of his colleagues, he worked on the Federal Arts Project in the late 1930's and in 1947 was cofounder with Motherwell of a short-lived vanguard art school.

Rothko began as a traditionalist, then turned to a more expressionist, emotional form of representational art. From there he worked his way through surrealism, producing fantasies of myriad cellular shapes and submarine vegetation. The turning point in his career came in 1947. Between that year and 1950 he did away with all forms of imagery, relying solely on color to create optical and emotional sensations.

Rothko's paintings are divided into rectangular areas of

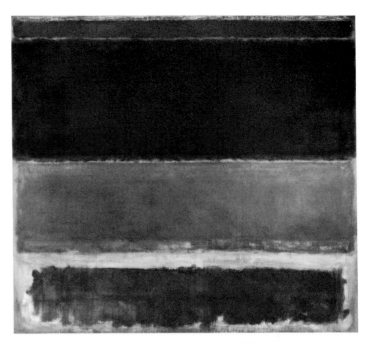

Mark Rothko: *Four Darks in Red* (1958). Courtesy of the
Whitney Museum of American Art, New York,
gift of the Friends of the Whitney Museum of American Art,
Charles Simon Fund, Samuel A. Seaver,
Mr. and Mrs. Eugene Schwarz.

vibrant stains of color, like huge, glowing windows. He uses
harmonious or opposing hues to intensify the vibration of his
colors. The outer edges are thinly painted and softly brushed
into the more densely stained areas so that the color seems to
float above the surface of the canvas. Self-contained and
impersonal, his paintings have a massive calm; they make no
statement, demand no involvement. Color is carried to its
ultimate abstraction; it becomes an entity in itself, enveloping
the spectator in its luminosity.

Other exponents of the first wave of abstract expressionism
were preoccupied with enormous, repetitive visualizations of
the single image. Franz Kline (1910–1962) magnified one-
inch brushstrokes to giant scale. These huge, black-and-white
strokes, which perhaps might be representative of the frenzied
vitality of the modern metropolis, surge across the canvas with
violent speed and energy. Adolph Gottlieb (1903–), who

in his youth studied with Henri and Sloan, created "pictographs"—pictures containing signs and symbols based on human and other natural forms or on inanimate objects set in separate compartments, which bear a resemblance to ancient hieroglyphic tablets. In the late 1950's he began painting the symbolic landscape abstractions which he calls "bursts." These compositions consist of a monochromatic background "sky" with a brilliant disk-shaped "sun" (sometimes two) hanging above a dark, exploding mass of "earth." They are simple, well-designed, unemotional canvases, which bring to mind the finality of nuclear warfare.

Like Rothko, Clifford Still (1904–) has based his art on color. He paints wall-sized canvases of flat areas of vivid color whose surface is broken by irregular patches of lighter and darker tones, as if they were leaves floating on the surface of a brightly colored pond. Barnet Newman (1905–) pinned mystical significance to his paintings in which slim, ruled lines cut through the vast monochromatic acreage of canvas. More recently he has expanded his art to include sculpture. He creates massively simple geometric forms in a field that is now known as "minimal" sculpture.

Bradley Walker Tomlin (1899–1953), was an Easterner grounded in solidly traditional art. He painted small, pale, angular shapes over the darker colored surface of his canvas. His kind of "writing" is a cubist version of the Orientally-inspired "white writing" of the Western painter Mark Tobey. William Baziotes (1912–1963) was one of the group of abstract expressionists working on the Federal Arts Project. He had his first one-man show at Peggy Guggenheim's gallery a year after Pollock made his debut. Baziotes painted somberly colored, brooding figures of surrealist origin. His contemporary, Canadian-born Philip Guston (1913–) believed that art was "a mirror of the self." He stirred vivid or somber masses of color into dramatic action. Ad Reinhardt (1913–1967), known as the "black monk" of abstract

expressionism, went Malevich one better in his search for a "pure esthetics." His enormous canvases of almost invisible patterns of black on black were purifications of art that reduced color to its ultimate minimum.

A few years after its inception, opposition to abstract expressionism had just about died. Once launched, the movement spread like wildfire to the four corners of the globe. From the 1940's to the 1960's it held center stage, virtually excluding all other styles of painting. It became the leading style in art school and university programs; it dominated national and international shows, and museum and gallery exhibitions. Rapidly, almost overnight, America rose from its historical position as apprentice to the European masters to leadership in the world of art. And, displacing Paris, New York now became the international Mecca of art.

The American public, eternally inimical to anything new or different, greeted abstract expressionism with unprecedented enthusiasm and chauvinistic pride. Eagerly, people flocked to see, to read about, to understand, and to buy the new kind of painting. In the long battle for artistic freedom and acceptance, the vanguard painters were suddenly and unexpectedly victorious. For so many years second-class citizens, American artists now took on stature and became prosperous, prominent, respected members of society. The rebels no longer had anything to rebel against. So, taking their place in the historical process, the avant-garde now became the new academy.

ZEN BUDDHISM, WESTERN STYLE

WHILE NEW YORK PAINTERS were shaping a revolutionary art from European sources, a few West Coast artists were exploring the culture of the Far East. Though Japanese paint-

ing did affect the art of the impressionists, it had only a minor influence on American art. Events before, during, and after World War II forced Americans into an abrupt awareness of China and Japan, and brought a new and enlightened respect for their ancient and remarkable cultures. Of those painters who sought their inspiration in the Orient, the most striking and original are Mark Tobey and Morris Graves.

Mark Tobey (1890–), who in 1934 went to Japan and China to study Oriental calligraphy, became a convert to Zen Buddhism. Born in Wisconsin, Tobey later moved to Seattle, Washington. He had little formal training. He started his career as a commercial artist, studying briefly with Kenneth Hayes Miller in New York. His knowledge of painting was gained by extensive travel throughout the world. Eventually he found his inspiration in the art of the Far East.

Out of his knowledge of Oriental calligraphy and philosophy, Tobey originated an involved private penmanship called "white writing" which he uses in all his paintings. His

Mark Tobey: *Universal Field* (1949). Courtesy of the
Whitney Museum of American Art, New York.

early canvases were realistic views of cities whose frenetic rhythms are written in agitated white lines. Increasingly, he eliminated concrete representation, pulverizing form into a densely tangled mass of white and colored lines in canvases that look like the galaxy of some mysterious universe.

Morris Graves (1910–), a friend of Tobey's, was born in Oregon, moved to Seattle in his infancy, and has also traveled to Europe and the Orient. He became a passionately devout believer in Zen Buddhism and affirmed his faith by spending some time living in a Buddhist monastery. From the principles of his religion, Oriental art, and Tobey's calligraphic style, Graves has evolved a singular imagery of haunting and lyrical power—an imagery endowed by his imagination, his mystical "inner eye," as he speaks of it.

Graves is not an abstractionist in the contemporary sense. Rather he simplifies recognizable subject matter, stressing the delicacy of line and rhythmic motion of his compositions. He uses water-based paints, tracing a filigree of fine white lines like thin strands of glowing wire to build his images. His pic-

Morris Graves: *Bird in the Spirit* (1940–1941). Courtesy of the Metropolitan Museum of Art, Arthur H. Hearn Fund, 1950.

tures are primarily of birds, birds that never were. They are mysterious incarnations of bird spirits clothed in silver and golden radiance—"little known birds of the inner eye."

OTHER VOICES

THOUGH ABSTRACT EXPRESSIONISM dominated the art scene, there were a number of gifted painters who pursued their own particular vision. All of these artists were, to a greater or lesser degree, realists, each of whom had his own private point of view and created his own individualistic style. While none of them established any consequential following, their work is as much a part of their own time as that of the abstract expressionists and all are important in their own rights.

An abstract expressionist painter once told Andrew Wyeth (1917–): "I enjoy your work I like it at a distance, but when I come near I am always disappointed to see that there are objects." The speaker didn't mean to belittle. He was only expressing his astonishment at the fact that any contemporary artist would work in a manner so completely at odds with the prevailing fashions in American art. For not only do Wyeth's pictures contain "objects," but his style is ultraconservative and explicitly representational. Wyeth is a phenomenon. In an age in which nonfigurative abstraction reigned supreme, his particular brand of realism established his reputation as a major American painter and earned him world wide popularity and fame.

Wyeth's subjects are the ordinary people and the familiar landscape of Chadd's Ford, Pennsylvania, where he was born, and Cushing, Maine, where he summers. He has never been to Europe, nor felt the need to go. His only teacher was his father, the noted illustrator N. C. Wyeth, with whom he worked in the Renaissance tradition of apprentice to master and from whom he learned the time-honored skills of his craft.

Wyeth composes his canvases in broad and simplified areas, which are handled with a precise and meticulous naturalism. His pictures are quiet, imbued with tender melancholy. His young people are filled with a bittersweet yearning for life, their elders with a sober acceptance of its finality. In his landscapes, portraits, and figure studies there is an air of brooding mystery that pervades even the most commonplace scene. Yet his work often seems studied and contrived. His paintings come close to commercial illustration, skirting it by a hair's breadth of subdued emotion. Wyeth's realism is gently sentimental and universally pleasing, but it lacks the powerful, perceptive honesty of Thomas Eakins', Winslow Homer's, or even John Sloan's realism.

But all this is of little import to his sea of admirers. They find in Wyeth's work an identification of their own personal joys and sorrows. *Christina's World*, a picture of a crippled young woman crawling up a grassy slope to the shabby farmhouse that is her universe, is one of the most widely

Andrew Wyeth: *A Crow Flew By* (1950). Courtesy of the Metropolitan Museum of Art, Arthur H. Hearn Fund, 1950.

reproduced paintings in American art, known and loved the world over.

Other talented representational painters, whose techniques are more in tune with the times, have gained recognition, though none on the scale of Wyeth. Edwin Dickinson (1891–), a pupil of Chase, paints large, highly finished canvases, fusing reality with unreality into a mysterious vision of nature. Milton Avery (1893–1965) was held in great esteem by the abstract expressionists. Though he worked in a semi-abstract style, his subject matter was still recognizable for what it was. His landscape and figure paintings are intriguingly simple in composition, rich in color, and have a haunting originality. Richard Diebenkorn (1922–) paints pictures of people in indoor and outdoor settings, using color rather than modeling or perspective to create a sense of solid form and to convey distance. He started out as an abstractionist, and has recently returned to this form of expression. Ivan

Milton Avery: *Green Sea* (1954). Courtesy of the Metropolitan Museum of Art, Arthur H. Hearn Fund, 1954.

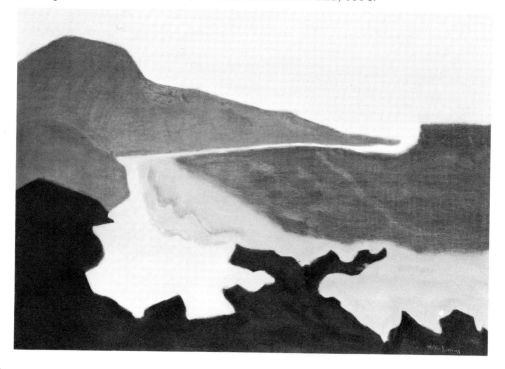

Albright (1897–) depicts the "controlled chaos" of human disintegration, recording the blistered, festering lacework of decay in microscopic and horrifying detail. George Tooker (1920–) creates a menacing portrait of anonymity in today's computerized, automated society in canvases of finished realism. Larry Rivers (1923–) has treated traditional subject matter with a loose abstract expressionist technique. More recently, he has introduced photographs and other mechanical forms of reproduction in his "pop" style canvases of famous historical events.

But the painters who still clung to representationalism and managed to make a name for themselves were the exception, not the rule. Once again the underground was rumbling with dissension. The avant-garde academy had to be overthrown, and the new art replaced by a "newer" new art.

XIX The Latest Word

THE MOVE to unseat abstract expressionism broke out in the late 1950's and the early years of the 1960's in a series of rapid rebellions, like the explosions of a string of Chinese firecrackers. The overthrow was finally accomplished by what seemed to be less an art movement than a vast practical joke. The victors introduced a completely novel form of realism. In an age when conflict and war are ever-present, and the threat of annihilation by the bomb hangs over the world, these new painters created an art that was anti art, anti emotion, anti individualism. These "new realists," as they saw themselves, announced the birth of pop art with paintings that were almost facsimile reproductions of all that was most banal, most common, most popular, in contemporary life. Waving a soup can in one hand and a plaster hamburger in the other, they ridiculed the trite, the vulgar, the American "washing machine" culture.

Pop exploded with comic-book violence. The public, still insecure about the provincialism with which it had at first dismissed two of the most important revolutions in contemporary art—the Armory Show modernism and abstract expressionism—had done a complete about face; it was now anxious to equate anything new or shocking with merit. The "hip" public, the museums, the galleries, with hardly a moment's hesitation snapped up pop art for huge prices. Without having fired a shot, the pop painters had won the battle. Abstract expressionism was out; pop was in.

The pop painters were partially influenced by the nihilism of the Dadaists, but even more by Duchamp, who, with his "ready-mades," had earlier rejected the validity and seriousness of art in a crumbling society. Taking their cue from

358

Duchamp, the pop painters have created an art that is cool, impersonal, generally devoid of painterly technique, and which mocks tradition, past and present.

Many of the pop artists use painting and sculpture as mediums for their expression, sometimes alone and sometimes in combination. Jasper Johns (1930–) produces American flags in two-dimensional and bas relief form, in full color or in monochrome. His pictures "imply human absence from man-made environment," a critic stated. "Only objects remain overgrown by paint as by indifferent vegetation." Johns also paints pictures of numbers, shooting targets, coat hangers, and other such objects. His sculpture of two cans of Ballantine ale was so perfectly reproduced that only by minute study can the "work of art" be distinguished from the manufactured product.

Robert Rauschenberg (1925–) makes collages of photographs, newspapers, drawings, scribblings, dribbled and flat applications of paint, which are more personal in style and more ambiguous in content than is customary in pop. More of a piece are his "combines"—painted canvases on which appear newspapers, pillows, and stuffed animals. One of these is a stuffed goat with a tire round its middle, standing on a platform full of junk.

Andy Warhol (1931–), the most publicized name in pop art, is known for his exact replicas of Brillo boxes, painted and sculptured Campbell's soup cans, and huge, hand-tinted blow-ups of cows' heads, flower blossoms, and smiling Marilyn Monroes and Elizabeth Taylors. Roy Lichtenstein (1923–), who admits to a long-standing admiration for Mickey Mouse and Donald Duck, paints outsize comic-strip portraits of tearful heroines and square-jawed heroes speaking in balloons in true comic-book style. James Rosenquist (1933–), a former billboard artist, now paints billboard pictures of dishes in a rubber drainer, automobiles, and other familiar objects. Robert Indiana (1928–) stencils reproductions of manhole covers, using the word LOVE in dif-

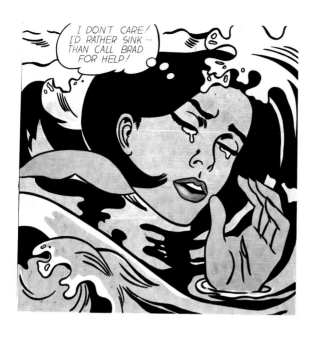

Roy Lichtenstein:
Drowning Girl
(1963).
Courtesy of Mr. and Mrs.
C. Bagley Wright.
Photograph courtesy
of Leo Castelli.

ferent colors and sizes. Tom Wesselmann (1931–) paints flat, posterlike female nudes in bathrooms installed with real toilet fixtures.

Claes Oldenburg (1929–) and George Segal (1924–), who work almost exclusively in sculpture, are so identified with pop art that they should be included with the painters. From his original small-scale plaster models of hamburgers, wedges of cake, and other drugstore luncheonette items, Oldenburg has gone on to build giant hamburgers, toothpaste tubes, typewriters, and a variety of such contemporary memorabilia out of oilcloth, wood, and canvas. He has also designed, at least on paper, "model" cities. Segal uses real people as his models and creates his sculptures by applying plaster of paris directly onto their bodies. He does the same with chairs, tables, coffee pots, etc., then groups his sculptures into an "assembled environment." Slightly larger than life, these plaster figures of a bus driver at the wheel or men and women seated around a kitchen table present an uncanny, ghostly vision of everyday life.

Pop painters do not believe in restricting their creative energies to a single accomplishment. Art, says Rauschenberg, is merely the "means to function thoroughly and passionately in

a world that has a lot more to it than paint." Unlike the protest painters, who were moved by a moral obligation to better the human condition, the pop artists have found their "passionate" engagement as entertainers. They invented "happenings"—an improvised acting out of the artist's image—in which people perform before an actively participating audience. Pop artists also double (and in some cases triple) as jazz musicians, actors, dancers, movie makers, choreographers, and theatrical entrepreneurs. Pop itself leads a double life. Having taken its original inspiration from the most hackneyed forms of mass culture, it now, ironically, finds itself taken up and exploited by one of the original sources of its inspiration— advertising.

Sometimes amusing, sometimes bewildering, sometimes startling, usually crude, pop is the art of cliché and mediocrity in the very terms of cliché and mediocrity.

Op art—perceptual abstraction, optical, retinal, or kinetic art, as it is variously termed—is in many ways much more diverting than pop. A "machine-age aesthetic," as its followers call it, op derives its stimulus from science and geometry. It is an artistic response to the atomic and space age and, like pop, opposed to the emotionalism of abstract expressionism. Even more than pop, op is cold and impersonal. It is art dehumanized, an ingenious spectacle of light, sound, and movement that entertains the eye without involving the emotions.

Op art derives in part from constructivism, a movement that was an offshoot of collage and was started in Russia about 1918 by Vladimir Tatlin. Its principal spokesmen, however, were the better-known sculptors Naum Gabo and Antoine Pevsner, who introduced the style into French and German art. The constructivists believed that movement in space rather than volume had importance in art. Using nontraditional man-made materials, they built simplified abstract shapes employing hollows and holes as "negative" volume— that is, air space. Eventually, they added movement to their

created works. Constructivism took on different aspects in the work of different artists. For example, Gabo motorized his linear plastic inventions so that spatial relations were constantly shifting. The American sculptor Alexander Calder created free-form mobiles suspended from thin strands of wire which moved according to the air currents, thus creating a never-ending variety of spatial relationships.

The optical painters have carried their experiments into the realm of scientific *trompe l'oeil*. Colors change identity, rise off the canvas, appear, disappear, and reappear in other places. Lines explode, move up and down, or spin around in giddy circles. Lights flicker and blaze; objects buzz, sputter, and crawl. Canvases of brilliant colors create vertigo or blind the onlooker. Op is an amazingly deft sleight of hand practiced on the human eye by performers skilled in magic.

Op focuses its attention on the optical illusions created by the eye's reaction to violent color. Richard Anuszkiewicz (1930–) says he investigates "the effects of complimentary colors of full intensity when juxtaposed and the optical changes that occur as a result." He paints vividly colored linear spokes radiating from a square and grids of different brilliant colors, which burst into instantaneous after-images of dizzying intensity. Larry Poons (1937–), whose canvases are comparatively serene, lays bright lozenges of color on a contrastingly colored, flatly painted background so that the dots seem to float above and sink below the surface of the canvas.

Pop and op have created the greatest stir and were the two most publicized movements of the 1960's. However, painters are carrying on explorations in a variety of directions. There are the hard-edge painters, such as Ellsworth Kelly (1923–) and the minimalists such as Frank Stella (1936–). Like their contemporaries, these artists have invented an art that is blank, neutral, and devoid of all human emotion or personal touch. Despite his hard-edge leanings, Ellsworth Kelly says

he is more interested in "mass and color" than in "edges." In opposition to the blurred, soft edges and stained surfaces of the color-field painters, Kelly creates large, simple, and sharply defined shapes vaguely reminiscent of geometric, biological, or human forms. These massive, sometimes ponderous, forms lie against each other, touching briefly and gently, and at the same time seem to push their way out of the confines of the canvas. Or vivid-colored ovoids like blinding lanterns are suspended against a brilliant backdrop.

Minimal art is yet another contemporary reaction against the romantic emotionalism of abstract expressionism. The minimalists think of the created work as an object, impassive and expressionless. Frank Stella, one of the leaders of this movement, invented the "shaped" canvas to emphasize his break with the whole concept of easel painting and the rectangular-shaped canvas generally associated with it. He sees his painting as an independent structure whose "pictorial" con-

Frank Stella: *Agbatana I* (1968).
Courtesy of the Whitney Museum of American Art, New York, gift of Mr. and Mrs. Oscar Kolin.

tent derives solely from the shape of the canvas. His work, he says, is "based on the fact that only what can be seen *is* there." He produces oddly shaped canvases whose angular or rounded edges jut out into the surrounding space. On these he paints sharply defined bands of a single color or bands of various colors and intensities, which echo and reinforce the shape of the canvas.

The chromatic explorations of such abstract expressionists as Mark Rothko, Barnet Newman, and Ad Reinhardt provided a springboard for a group of painters known as the post-painterly abstract or color-field painters. Morris Louis (1912–1962), Kenneth Noland (1924–　　), and Jules Olitski (1922–　　), who work in this manner, emphasize the emotional and poetic qualities of color. They employ thin "veils" of acrylic color, stained directly into raw, unsized canvas. In their paintings color becomes a vast spatial environment extending beyond the picture frame.

Morris Louis began experimenting with color in an effort

Morris Louis: *Alpha Pi* (1961). Courtesy of the Metropolitan Museum of Art, Arthur H. Hearn Fund, 1967.

to rid himself of all traditional artistic thinking. He began to see color, not as areas of light and dark, but as areas of space. He found that by staining his canvas in juxtaposed waves of different colors he could produce what one critic described as "a single, visually continuous configuration." Louis developed a personal and lyrical use of color. He created abstract images of irregular, vertical "pillars," stained in a spectrum of glowing colors, which he placed in asymmetrical banks on either side of a central "void" of unpainted canvas. Sometimes rising straight up through the top of the canvas, sometimes bending slightly away from the central area as if moved by a gentle breeze, the "pillars" or "unfurleds," as they are also called, seem to be forever opening and shutting on an area of limitless space.

Kenneth Noland, who spent a short time working with Louis, uses stain to achieve the "maximum opticality" of color. Noland took off in a different direction from Louis. Even though he began staining to get away from the hard-edged geometrical painting, Noland's canvases have a more mechanical aspect. He stains concentric circles, chevrons, and stripes in parallel, colored bands, which conform to the shape of the canvas. In some of his paintings, he leaves unstained areas of canvas between the bands of color so that his "image" can "breathe." In these works the color seems alternately to contract within and to expand outside of the edge of the canvas.

Jules Olitski thinks of his paintings as being "possessed by a structure—i.e., shape and size, support and edge—but a structure born of the flow of color." Olitski stains his canvases with a spray gun, alternating bare strips of canvas with bands of color. Lately he has taken to saturating the entire surface up to the edge, allowing a narrow margin of brushstroked color to serve as a frame. He uses rich, vibrant colors, which seem to rise gently off the surface of the canvas.

New movements in opposition to other new movements keep proliferating almost from week to week. At present in this

era of mass pollution of land, sea, and air, there is a group of young painters who feel that present-day technological advances have just about destroyed nature. So they are using nature as a medium for their creative expressions, attacking technology in their own unconventional fashion. The new painters, some critics say, feel that "the art and the art world we know has been used up." Their "art" has gone beyond the realm of canvas and has become colossal. It is impermanent, has no order, and flouts all tradition—modern, ancient, conservative, and avant-garde. One artist dug a "grave" in Central Park, then filled it up, thus creating what he called "an invisible sculpture of negative and positive spaces." Another artist filled a museum room with eight tons of "pure dirt, pure earth, pure land." Still another dug a linear "void"—a line of curving trench—in the California and Nevada flatlands. Some work with large bodies of water, in which they anchor T bars to sway with the tide, or run underwater equipment to create sound and light effects. Still others use snowfields and glaciers, cutting blocks of ice and setting them adrift to float freely. Or they put metal bars in snowbanks to be liberated by spring thaws. And some envision all of nature—the earth, the sea, and the sky—as the future tools of art.

All these movements, and those that will soon emerge, are a response of the artist to his times. However these movements may be judged eventually, they are a manifestation of the continuing vitality of American art. It is a long way from the raw provincialism of the colonial limners to the sophisticated levels of today's art, and in these years a great many styles have come and gone. In the future there will be other men and other movements. Only the passage of time can determine where they will all stand in the grand design. It is well to remember that art is long and movements are brief.

If these new art forms have made a contribution, it is, perhaps, in raising the question of what is art—a question that only the artist can ask and answer for himself.

What the future shape of art will be, none but a soothsayer can predict. Art will go on as long as man exists. More than a half century ago Americans were sure that the modern paintings in the Armory Show spelled the imminent death of art. A critic of that day, pleading for a more tolerant attitude toward the new and the revolutionary, said: "The main thing is that there is nothing final in art, no last word"

This is as true today as it was then.

Bibliography

AMERICAN ART

Abstract Painting: Background and American Phase by Thomas B. Hess: New York, Viking Press, 1951.

Abstract Painting in America by Andrew C. Ritchie: New York, The Museum of Modern Art, 1951.

Abstract and Surrealist Art in America by Sidney Janis: New York, Reynal and Hitchcock, 1944.

The American Academy of Fine Arts and the American Art-Union by Mary B. Cowdrey and Theodore Sizer: New York, Historical Society, 1953.

American Art: A Historical Survey by Samuel M. Green: New York, Ronald Press Co., 1966.

American Art Since 1900 by Barbara Rose: New York, Frederick A. Praeger, 1967.

The American Artist and His Times by Homer Saint-Gaudens: New York, Dodd, Mead & Co., 1941.

American Colonial Painting by Waldron P. Belknap, Jr.: Cambridge, The Belknap Press of Harvard Univ., 1959.

American Landscape Painting by Wolfgang Born: New Haven, Yale University Press, 1948.

American Negro Art by Cedric Dover: Greenwich, Conn., New York Graphic Society, 1960.

American Painters in Paris by Yvon Bizardel: New York, Macmillan Company, 1960.

American Painting by Virgil Barker: New York, Macmillan Company, 1950.

American Painting by Denys Sutton: London, Avalon Press, Lt'd., 1948.

American Painting: 1560–1913 by John Pearce: New York, McGraw-Hill Book Company, 1964.

American Painting: 1865–1905 by Lloyd Goodrich: New York, Whitney Museum of American Art, 1961.

American Painting from the Armory Show to the Depression by Milton W. Brown: Princeton, Princeton University Press, 1955.

American Painting in the Twentieth Century by Henry Geldzahler: New York, Metropolitan Museum of Art, 1965.

American Paintings by Albert Ten Eyck Gardner and Stuart P. Feld: New York, Metropolitan Museum of Art, 1965.

American Pioneer Arts and Artists by Carl W. Drepperd: Springfield, Mass., The Pond-Ekberry Co., 1942.

American Realists and Magic Realists edited by Dorothy C. Miller and Alfred H. Barr, Jr.: New York, Museum of Modern Art, 1943.

American Tradition in Painting by John W. McCoubrey: New York, George Braziller, 1963.

America's Old Masters by James Thomas Flexner: New York, Viking Press, 1939.

Art and Artists in Connecticut by H. W. French: Boston, Lothrop, Lee & Shepard Co., 1879.

Art and Life in America by Oliver Larkin: New York, Rinehart & Company, 1959.

Art in America by Suzanne LaFollette: New York, Harper & Brothers, 1929.

Art in America in Modern Times by Holger Cahill and Alfred H. Barr, Jr.: New York, Reynal and Hitchcock, 1934.

Artists and Illustrators of the Old West by Robert Taft: New York, Charles Scribner's Sons, 1953.

Artists of the Old West by John C. Ewers: Garden City, New York, Doubleday & Company, 1965.

The Book of the American West edited by Jay Monoghan: New York, Julian Messner, 1963.

Book of the Artists: American Artist Life by Henry T. Tuckerman: New York, G. P. Putnam's Sons, 1882.

The Decade of the Armory Show by Lloyd Goodrich: New York, Whitney Museum of American Art, 1963.

Early American Portrait Painters by Cuthbert Lee: New Haven, Yale University Press, 1929.

First Flowers of the American Wilderness by James Thomas Flexner: Boston, Houghton Mifflin Company, 1947.

Great American Paintings from Smibert to Bellows by John Walker and MacGill James: New York, Oxford University Press, 1943.

Great Artists of America by Lillian Freedgood: New York, Thomas Y. Crowell Company, 1963.

Highlights Among the Hudson River Artists by Clara Endicott Sears: Boston, Houghton Mifflin Company, 1947.

A History of American Art by Sadakichi Hartmann: Boston, L. C. Page & Company, 1932.

A History of American Art by Daniel M. Mendelowitz: New York, Holt, Rinehart & Winston, 1960.

A History of American Landscape Painting by Alan Burroughs: New York, Whitney Museum of American Art, 1942.

The History of American Painting by Samuel Isham and Royal Cortissoz: New York, Macmillan Company, 1936.

The History and Ideals of American Art by Eugen Neuhaus: California, Stanford University Press, 1931.

The History of the National Academy of Design by Eliot Clark: New York, Columbia University Press, 1954.

A History of the Rise and Progress of the Arts of Design in the United States by William Dunlap: Boston, C. E. Goodspeed & Co., 1918.

Landscape and Figure Painters of America by Frederick Fairchild Sherman: New York, privately printed, 1917.

The Light of Distant Skies by James Thomas Flexner: New York, Harcourt, Brace and Company, 1954.

Mississippi Panorama by Perry Rathbone: Missouri, City Art Museum of St. Louis, 1950.

Modern American Painting by Peyton Boswell, Jr.: New York, Dodd, Mead & Company, 1939.

Modern American Painting and Sculpture by Sam Hunter: New York, Dell Publishing Company, 1959.

New Art in America by John I. H. Baur: Greenwich, Conn., New York Graphic Society, 1957.

101 Masterpieces of American Primitive Painting from the Garbisch Collection: New York, American Federation of Arts, 1961.

Painting in America by E. P. Richardson: New York, Thomas Y. Crowell Company, 1956.

Pioneers of Modern Art in America by Lloyd Goodrich: New York, Frederick A. Praeger, 1963.

The Pocket History of American Painting by James Thomas Flexner: New York, Pocket Books, 1957.

Portrait of the Old West by Harold McCracken: New York, McGraw-Hill Book Company, 1952.

Primitive Painting in America by Jean Lipman and Alice Winchester: New York, Dodd, Mead & Company, 1950.

From Realism to Reality in Recent American Painting by Virgil Barker: Lincoln, University of Nebraska, 1959.

Romantic Painting in America by James T. Soby and Dorothy C. Miller: New York, Museum of Modern Art, 1943.

A Short History of Painting in America by E. P. Richardson: New York, Thomas Y. Crowell Company, 1963.

Still Life Painting in America by Wolfgang Born: New York, Oxford University Press, 1947.

The Story of the Armory Show by Milton W. Brown: Greenwich, Conn., New York Graphic Society, 1963.

That Wilder Image by James Thomas Flexner: Boston, Little, Brown & Company, 1962.

Three Hundred Years of American Painting by Alexander Eliot: New York, Time, Inc., 1957.

Yankee Stonecutters by Albert Ten Eyck Gardner: New York, Columbia University Press, 1945.

EUROPEAN ART

Art in the Western World by David M. Robb and J. J. Garrison: New York, Harper & Row, Publishers, 1963.

Art Treasures of the Louvre by Rene Huyghe: New York, Dell Publishing Company, 1962.

A Concise History of Painting by Michael Levey: New York, Frederick A. Praeger, 1962.

The English Masters by Horace Shipp: New York, Philosophical Library, 1956.

Fifty Centuries of Art by Francis Henry Taylor: New York, Harper & Brothers, 1954.

French Impressionists in the Louvre by Germain Bazin: New York, Harry N. Abrams, 1958.

The Harper History of Painting by David M. Robb: New York, Harper & Brothers, 1951.

A History of British Painting by Ernest Short: London, Pitman Publishing Co., 1953.

The Impressionists by François Mathey: New York, Frederick A. Praeger, 1962.

The Loom of Art by Germain Bazin: New York, Simon & Schuster, 1962.

MODERN ART

Apples and Madonnas by C. J. Bulliet: New York, Blue Ribbon Books, 1930.

Art Since 1945 edited by Will Grohmann, Herbert Read, Carlo Argan, J. P. Hodin, Marcel Brion, Sam Hunter: New York, Harry N. Abrams, 1958.

The Break-Up: The Core of Modern Art by Katherine Kuh: Greenwich, Çonn., New York Graphic Society, 1965.

The Dada Painters and Poets: An Anthology by Robert Motherwell: New York, Wittenborn, Schultz, 1951.

Discovering Modern Art by John P. Sedgewick, Jr.: New York, Random House, 1966.

Four Steps Towards Modern Art by Lionello Venturi: New York, Columbia University Press, 1956.

Futurism by Joshua C. Taylor: New York, Museum of Modern Art, 1961.

The History of Surrealism by Maurice Nadeau: New York, Macmillan Company, 1967.

Mainstreams of Modern Art by John Canaday: New York, Simon & Schuster, 1959.

Masters in Modern Art by James W. Lane: Boston, Chapman & Grimes, 1936.

Modern Art by Thomas Craven: Garden City, New York, Halcyon House, 1950.

Modern Art and the New Past by James Thrall Soby: Norman, University of Oklahoma Press, 1957.

Modern Painting: Contemporary Trends by Nello Ponente: New York, Skira International Corporation, 1960.

Paths of Abstract Art by Edward B. Henning: Ohio, Cleveland Museum of Art, 1960.

Pop Art by John Rublowsky: New York, Basic Books, 1965.

The Responsive Eye by William C. Seitz: New York, Museum of Modern Art, 1965.

The Restless Art by Allan Gowans: Philadelphia, J. B. Lippincott Company, 1966.

Revolution and Tradition in Modern Art by John I. H. Baur: Cambridge, Harvard University Press, 1954.

The Search for Meaning in Modern Art by Alfred Neumeyer: Englewood Cliffs, New Jersey, Prentice-Hall, 1964.

The Story of Modern Art by Sheldon Cheney: New York, Viking Press, 1941.

The Unknown Shore: A View of Contemporary Art by Dore Ashton: Boston, Little, Brown & Company, 1962.

BIOGRAPHY

Washington Allston by Edgar P. Richardson: Chicago, University of Chicago Press, 1948.

John James Audubon by Alice Ford: Norman, University of Oklahoma Press, 1965.

George Bellows by Peyton Boswell, Jr.: New York, Crown Publishers, 1942.

George Bellows by Charles H. Morgan: New York, Reynal & Company, 1965.

An Artist in America: Thomas Hart Benton by Thomas Hart Benton: New York, Robert M. McBride, 1937.

George Caleb Bingham of Missouri by Albert Christ-Janer: New York, Dodd, Mead & Company, 1940.

George Caleb Bingham: River Portraitist by John Francis McDermott: Norman, University of Oklahoma Press, 1959.

The Life and Work of David G. Blythe by Dorothy Miller: Pittsburgh, University of Pittsburgh Press, 1950.

Charles Burchfield by John I. H. Baur: New York, Whitney Museum of American Art, 1956.

Miss Mary Cassatt by Frederick A. Sweet: Norman, University of Oklahoma Press, 1966.

Mary Cassatt by Julia M. H. Carson: New York, David McKay Company, 1966.

Mary Cassatt by Achille Segard: Paris, Librairie Paul Ollendorf, 1913.

George Catlin and the Old Frontier by Harold McCracken: New York, Dial Press, 1959.

Pursuit of the Horizon: A Life of George Catlin by Lloyd Haberly: New York, Macmillan Company, 1948.

The Life and Art of William Merritt Chase by Katherine Metcalf Roof: New York, Charles Scribner's Sons, 1917.

John Singleton Copley by James Thomas Flexner: Boston, Houghton Mifflin Company, 1948.

Stuart Davis by Rudi Blesh: New York, Grove Press, 1960.

Stuart Davis by Stuart Davis: New York, American Artists Group, 1945.

Stuart Davis by E. C. Goosen: New York, George Braziller, 1959.

Willem de Kooning by Thomas B. Hess: New York, George Braziller, 1959.

Charles Demuth by Andrew C. Ritchie: New York, Museum of Modern Art, 1950.

Arthur G. Dove by Frederick S. Wight: Los Angeles, University of California Press, 1958.

Thomas Eakins: His Life and Work by Lloyd Goodrich: New York, Whitney Museum of American Art, 1933.

Thomas Eakins by Roland Joseph McKinney: New York, Crown Publishers, 1942.

Thomas Eakins by Fairfield Porter: New York, George Braziller, 1959.

Seth Eastman by John Francis McDermott: Norman, University of Oklahoma Press, 1961.

Robert Feke, Colonial Portrait Painter by Henry Wilder Foote: Cambridge, Harvard University Press, 1930.

William Glackens and the Ashcan Group by Ira Glackens: New York, Crown Publishers, 1957.

Arshile Gorky by Harold Rosenberg: New York, Horizon Press, 1962.

Philip Guston by Dore Ashton: New York, Grove Press, 1960.

Marsden Hartley by Elizabeth McCausland: Minneapolis, University of Minnesota Press, 1952.

Childe Hassam by Adeline V. Adams: New York, American Academy of Arts and Letters, 1938.

Martin Johnson Heade by Robert G. McIntyre: New York, Pantheon Press, 1948.

Winslow Homer by Albert Ten Eyck Gardner: New York, Clarkson N. Potter, 1961.

Winslow Homer by Lloyd Goodrich: New York, George Braziller, 1959.

Winslow Homer—A Portrait by Jean Gould: New York, Dodd, Mead & Company, 1962.

The Life, Art and Letters of George Inness by George Inness, Jr.: New York, Century Company, 1917.

George Inness, an American Landscape Painter by Elizabeth McCausland: New York, American Artists Group, 1946.

Jasper Johns by Leo Stienberg: New York, George Wittenborn, 1963.

John La Farge by Royal Cortissoz: Boston, Houghton Mifflin Company, 1911.

John Marin by MacKinley Helm: New York, Pellegrini & Cudahy, 1948.

William Sidney Mount by Cowdrey, Bartlett and Williams: New York, Metropolitan Museum of Art, 1944.

Jackson Pollock by Frank O'Hara: New York, George Braziller, 1959.

Jackson Pollock by Bryan Robertson: New York, Harry N. Abrams, 1960.

Maurice Prendergast by Margaret Breuning: New York, Whitney Museum of American Art, 1931.

Frederic Remington's Own Outdoors by Frederic Remington: New York, The Dial Press, 1964.

Albert P. Ryder by Lloyd Goodrich: New York, George Braziller, 1959.

John Sargent by The Hon. Evan Charteris: New York, Charles Scribner's Sons, 1927.

John Singer Sargent by Charles Merrill Mount: New York, W. W. Norton & Company, 1955.

Portrait of the Artist as an American: Ben Shahn by Seldon Rodman: New York, Harper & Brothers, 1951.

Ben Shahn by James Thrall Soby: New York, Museum of Modern Art, 1947.

Charles Sheeler by Constance Rourke: New York, Harcourt, Brace & Company, 1938.

John Sloan: A Painter's Life by Van Wyck Brooks: New York, E. P. Dutton & Co., 1955.

John Sloan's New York Scene edited by Bruce St. John: New York, Harper & Row, 1965.

John Smibert, Painter by Henry Wilder Foote: Cambridge, Harvard University Press, 1950.

Raphael Soyer by Walter K. Gutman: New York, Shorewood Publishing Co., (no date).

Gilbert Stuart; A Great Life in Brief by James Thomas Flexner: New York, Alfred A. Knopf, 1955.

Gilbert Stuart by Charles Merrill Mount: New York, W. W. Norton & Company, 1964.

Mark Tobey by Colette Roberts: New York, Grove Press, 1960.

Tobey by Wieland Schmied: New York, Harry N. Abrams, 1966.

The Autobiography of Col. John Trumbull edited by Theodore Sizer: New Haven, Yale University Press, 1953.

The Works of Colonel John Trumbull by Theodore Sizer: New Haven, Yale University Press, 1950.

John Twachtman by Eliot C. Clark: New York, privately printed, 1924.

Benjamin West and the Taste of His Times by Grose Evans: Carbondale, Southern Illinois University Press, 1959.

Nocturne: The Art of James McNeill Whistler by Denys Sutton: Philadelphia, J. B. Lippincott Company, 1964.

The Life of James McNeill Whistler by E. R. and Joseph Pennell: Philadelphia, J. B. Lippincott Company, 1911.

The Whistler Book by Sadakichi Hartmann: Boston, L. C. Page & Company 1910.

Artist in Iowa: A Life of Grant Wood by Darrell Garwood: New York, W. W. Norton & Company, 1944.

Alexander Wyant by Eliot Clark: New York, privately printed, 1916.

GENERAL

The Age of the Moguls by Stuart H. Holbrook: New York, Doubleday & Company, 1953.

The American Past by Roger Butterfield: New York, Simon and Schuster, 1957.

The Angry Decade by Leo Gurko: New York, Dodd, Mead & Company, 1947.

Art Anatomy by William Rimmer, introduction by Robert Hutchinson: New York, Dover Publications, 1962.

Art and Culture by Clement Greenberg: Boston, Beacon Press, 1961.

The Art Spirit by Robert Henri: Philadelphia, J. B. Lippincott Company, 1960.

The Artist in American Society by Neil Harris: New York, George Braziller, 1966.

Artists on Art edited by Robert Goldwater and Marco Treves: London, Kegan Paul, 1947.

The Artist's Voice by Katherine Kuh: New York, Harper & Row, 1960.

Confessions of an Art Addict by Peggy Guggenheim: New York, Macmillian Company, 1960.

Conversations with Artists by Selden Rodman: New York, Devon-Adair Company, 1951.

Critic's Eye by Maurice Grosser: Indianapolis, Bobbs-Merrill Company, 1962.

The Cultural Life of the American Colonies by Louis B. Wright: New York, Harper & Brothers, 1957.

Discourses on Art by Sir Joshua Reynolds: New York, Collier Books, 1966.

Embattled Critic by John Canaday: New York, Farrar, Straus & Cudahy, 1962.

Gist of Art by John Sloan: New York, American Artists Group, 1939.

The Great Collectors by Pierre Cabanne: New York, Farrar, Straus, 1961.

A Literary Chronicle, 1920–1950 by Edmund Wilson: New York, Doubleday & Company, 1956.

Made in America: The Arts in Modern Civilization by John A. Kouwenhoven: New York, Doubleday & Company, 1948.

The Mauve Decade by Thomas Beer: New York, Vintage Books, 1926.

Meaning in the Visual Arts by Erwin Panofsky: New York, Doubleday & Company, 1955.

The Proud Possessors by Aline Saarinen: New York, Random House, 1958.

The Romantic Rebellion by Eric Newton: New York, St. Martin's Press, 1963.

Selected Poems by Marsden Hartley: New York, Viking Press, 1945.

7 Arts edited by Fernando Puma: New York, Doubleday & Company, 1953.

Taste in America by Ishbel Ross: New York, Thomas Y. Crowell Company, 1967.

The Two Worlds of American Art by Barry Ulanov: New York, Macmillan Company, 1965.

The Victorian Conscience by Clarence R. Decker: New York, Twayne Publishers, 1952.

AMERICAN HISTORY

An American History by David Saville Muzzey: Boston, Ginn & Company, 1911.

Epic Of America by James Truslow Adams: New York, Blue Ribbon Books, 1931.

The New Larned History by J. N. Larned: Springfield, Mass., C. A. Nichols Publ. Co., 1924.

The Oxford History of the American People by Samuel Eliot Morison: New York, Oxford University Press, 1965.

Past to Present by Sidney H. Zebel and Sidney Schwartz: New York, Macmillan Company, 1960.

Index

(Italic page numbers indicate illustrations.)

About the Author

Lillian Freedgood is the author of *Great Artists of America*, a study of the development of American art through the lives and work of fifteen native painters. In addition to her writing, Mrs. Freedgood is also a painter, an illustrator, and a teacher of art. Her paintings and prints have appeared in exhibitions throughout the United States and in Europe. She has illustrated several books as well as stories in national magazines, and has contributed articles on art subjects to the *Junior Encyclopedia Brittanica.*

Mrs. Freedgood is a graduate of Pratt Institute, and has also studied at the Art Students League of New York, the Graphic Arts Center, and with Jean Charlot.